NATALIE WOOD

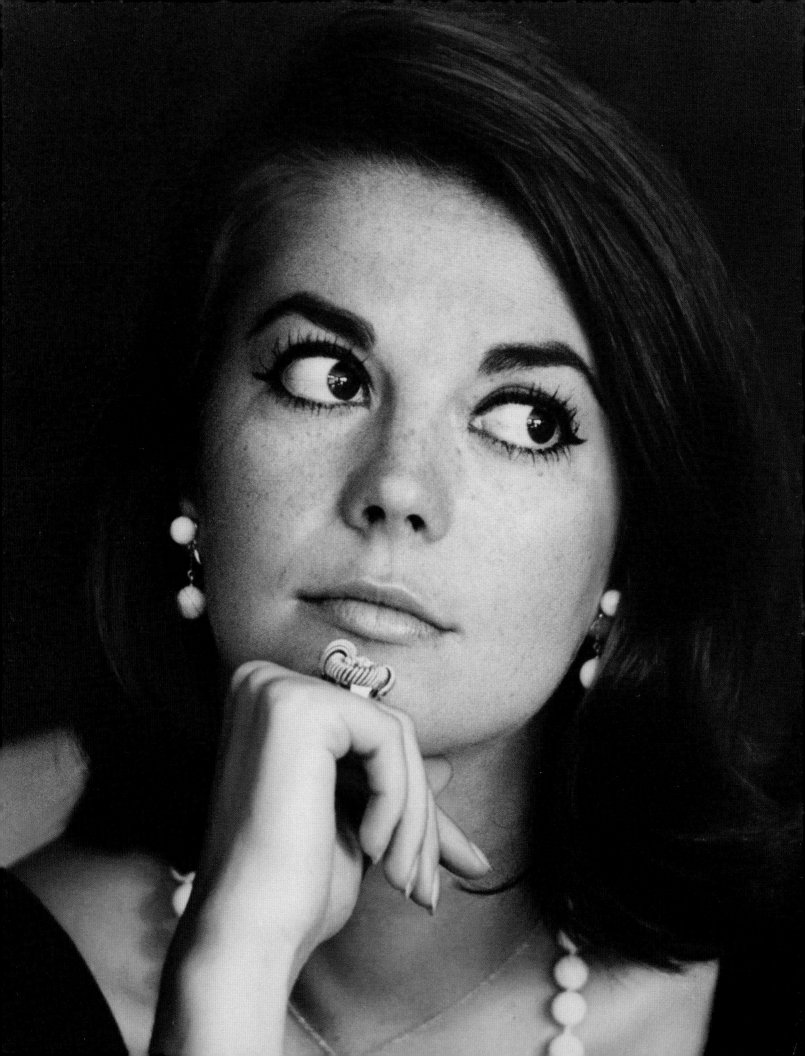

NATALIE WOOD

REFLECTIONS ON A LEGENDARY LIFE

MANOAH BOWMAN

With NATASHA GREGSON WAGNER Foreword by ROBERT J. WAGNER

Afterword by ROBERT REDFORD

Designed by STEPHEN SCHMIDT

Running Press
PHILADELPHIA · LONDON

Published by Running Press,
An Imprint of Perseus Books, a Division of PBG Publishing, LLC,
A Subsidiary of Hachette Book Group, Inc.

ISBN 978-0-7624-6051-9
Library of Congress Control Number: 2016944421

E-book ISBN 978-0-7624-6052-6

9 8 7 6 5 4 3 2 1
Digit on the right indicates the number of this printing

Edited by Cindy De La Hoz
Typography: ITC Avant Garde Gothic,
and Trade Gothic Bold Condensed

Running Press Book Publishers
2300 Chestnut Street
Philadelphia, PA 19103-4371

Visit us on the web!
www.runningpress.com

Page 1 Illustration courtesy of Don Bachardy
Page 2 photo courtesy of Bill Ray

For Clover

CONTENTS

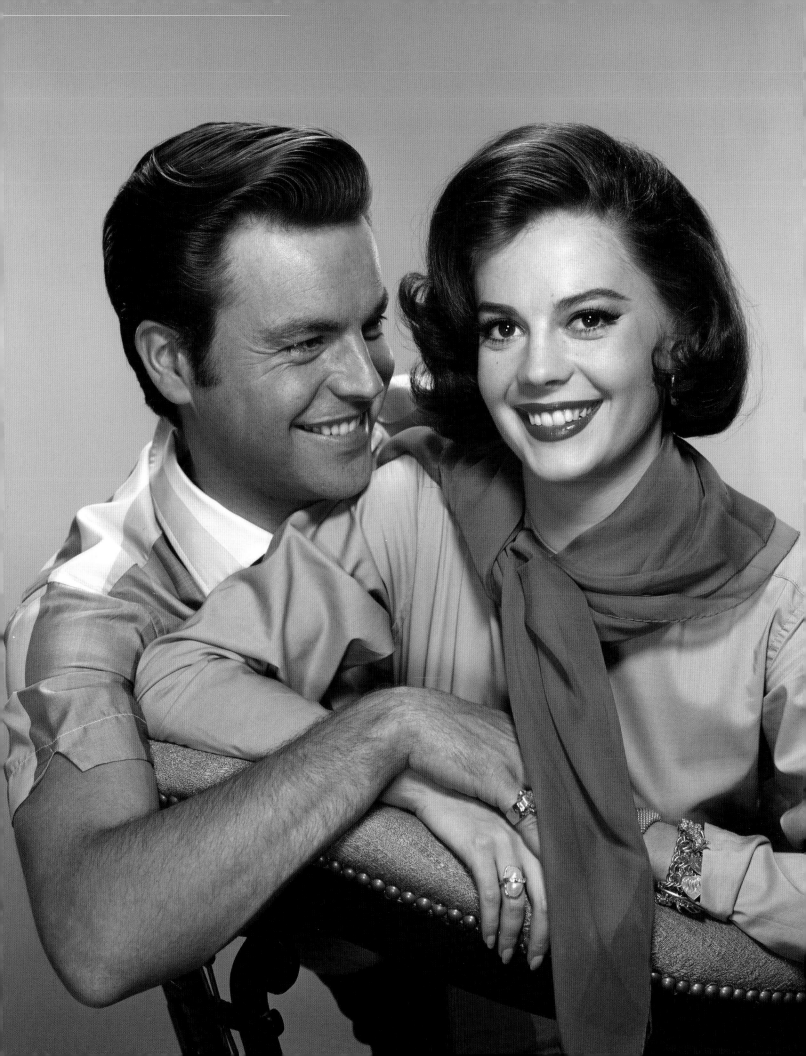

STAR LIGHT

BY ROBERT J. WAGNER

What makes someone a star? There is an indefinable quality, an x-factor I can only describe as a brilliant light that glows from within. It is not something that can be bought or artificially manufactured, but a god-given attribute. The first time I met Natalie Wood, I knew she had it. She was seventeen and in the glow of her post-*Rebel Without a Cause* fame. She had a reputation at the time for being wild, and she seemed fascinating to me. Her thousand-watt flame drew a lot of moths. I was one of them.

I had known plenty of attractive women, but she was special. Joyous, vivacious, humorous—her humor was so infectious. People naturally gravitated to her. Later, I found out that she'd had a childhood crush on me when we were both under contract at Fox, but I was unaware of it at the time. In 1956, we met at a fashion show at the Beverly Wilshire Hotel and I asked her to a screening of a picture I did with Spencer Tracy at Paramount, *The Mountain*. We just hit it off, and our relationship grew from there. As I fell in love with Natalie the woman, I also came to love and respect Natalie the actress. In her best work, she is extraordinary, and even in her lesser films, you can't take your eyes off of her.

It amazes me to think that she was discovered when she was six years old and brought to Hollywood. They dyed her hair blonde, told her to speak with a German accent, and suddenly there she was on the movie screen with Orson Welles and Claudette Colbert. How does that happen? That is

god-given talent. It has to be. It has to come from someplace. When you watch her as a child in her first film, *Tomorrow Is Forever*, you can see she had a real concept of what she was doing. Yes, she was being directed, but she had to receive that direction. She had to be able to take the director's guidance and use her own ability to make that process work. She had a gift.

She also had what it took to break away from her child roles and her oppressive parents and strike out on her own. Going from a child actress to an ingénue to a leading lady is not easy. Natalie was very much aware of how important *Rebel* was when she was up for the role. Man, did she want that, and she did everything to get it. During that time, she went to New York and did live TV shows,

OPPOSITE Robert J. Wagner and Natalie Wood, October 1959.
ABOVE The newlywed Wagners, 1958.

stretching all the time trying to find herself, and when she found her strength as an artist, she was on pretty solid ground.

She had the drive, the desire—she wanted more than anything to be a great actress. When she got the part of Deanie in *Splendor in the Grass*, working with Elia Kazan and William Inge, everything just clicked. The character of Deanie Loomis was perfect for her. She did tremendous work in *Splendor*, and evolved into one of the finest actresses ever on the screen.

Natalie and I shared a truly magical love affair. When we married in 1957, we made a pact that we would never do a film together, but broke it with *All the Fine Young Cannibals*. Though the movie turned out disappointing, the experience of acting with Natalie was wonderful. We worked together, lived together, and were in sync emotionally, mentally, and physically. It was worth breaking our pact.

When she started *West Side Story* right after *Splendor*, there was so much pressure on her, and on our marriage, which started to crumble at the same time her career was hitting its zenith. We were separated and in the midst of divorce proceedings when she was nominated for an Academy Award for *Splendor* in the spring of 1962. I sent her a note that read, in part:

> You were great in the film, and should and do deserve to get the award. I know it's what you've always wanted and wished for and now it's all coming true. The work and the dreams are there, and as you probably know you've got my vote. My thoughts will be with you and for you on Oscar night and believe me, Nat, I hope with all my heart that when they open up the envelope, it's you.

Natalie did not win that night; Sophia Loren received the Oscar for *Two Women*. Sophia's performance was certainly award-worthy, but I sometimes wonder. If Natalie's name had been in the envelope, would she be a cinema legend today the way Sophia Loren is? Or Audrey Hepburn? Would her talent be better remembered and appreciated today? Probably.

After we broke up, I spent years trying to move on, but she was never out of my heart for a minute. She was everything to me. It was such an exciting experience to have a second chance with Natalie, to come back together and get married all over again. Her sensitivity, her warmth and sincerity, those are the things that drew me to her—the same qualities that drew fans to her films.

As a performer, I remain in awe of the energy she brought to her roles, and the effort she put into creating a character. She tried very hard to get out of her own way and let the character take over. My favorite piece of work that she did is *This Property Is Condemned*. She had a profound sense of story and of character arc, and she used those gifts to bring Alva to life. Before she left us, she was going to do *Anastasia* on the stage, and I think that would have been very exciting, to see how her talent would have evolved in live theater.

Looking back at her career, she played such a variety of roles, and yet the star quality is always there, in every character. The light that burned within Natalie was so magnificently bright, so strong, I thought it would go on burning forever. I could not imagine that light ever being switched off. When we lost her, a big piece of me was taken away. The personal loss was indescribable, and professionally, the world lost an extraordinary talent.

Yet, I know that her light is not really dimmed, because I still see it flashing. I see it within our daughters, Courtney and Natasha, and in our granddaughter, Clover. Sometimes when I look at Natasha, she looks so much like Natalie that memories come leaping back and I'm overwhelmed. I also see Natalie's inner light shining on the screen in her movies. I can feel it. I can sense it. And I feel very happy knowing that her spirit endures.

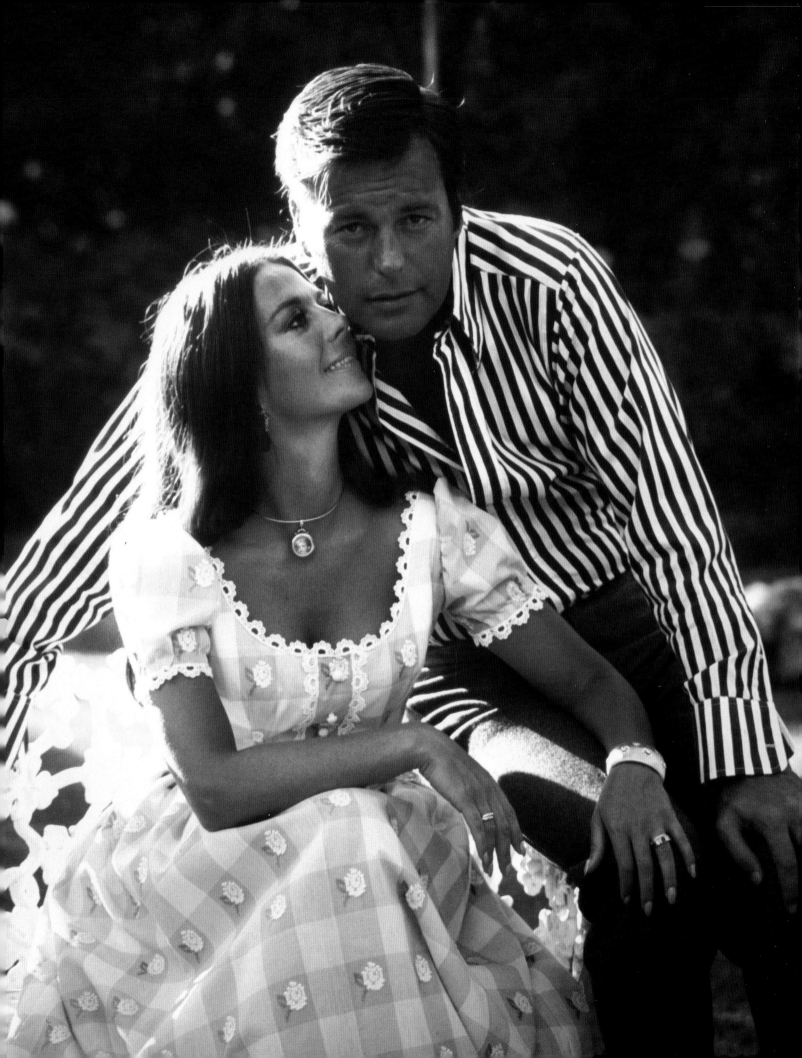

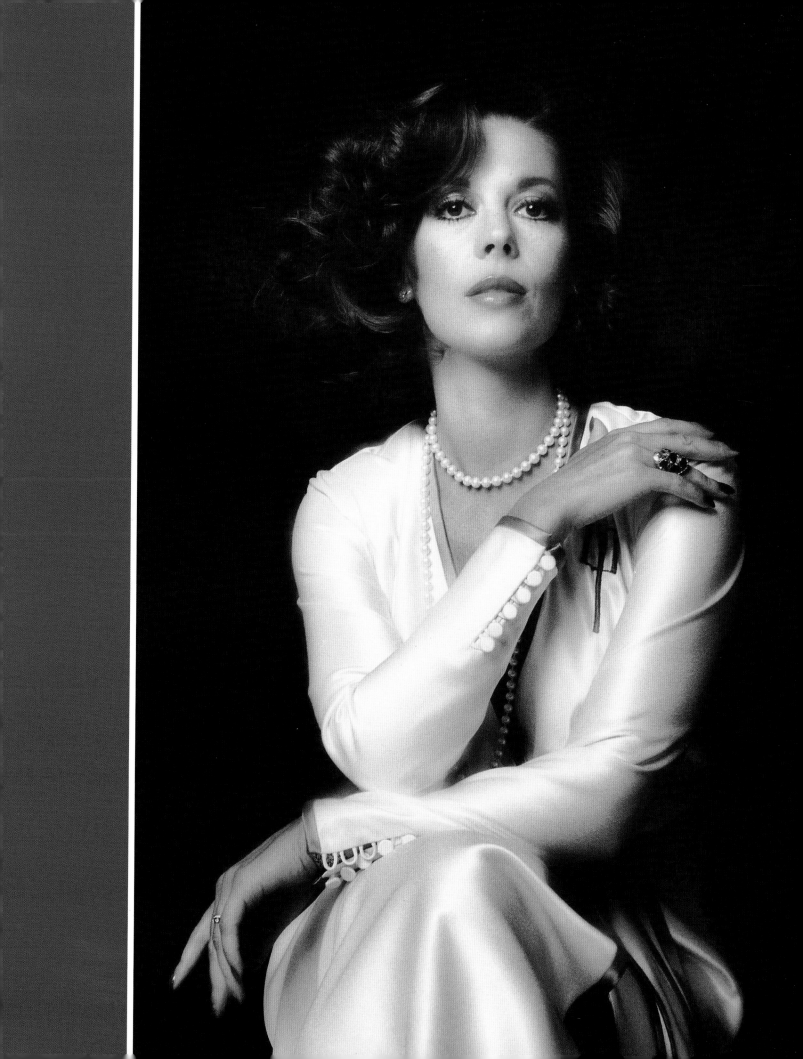

RESTORING
A LEGACY

"I don't think anyone, not even Marilyn Monroe, touched as many hearts as this beautiful actress whom so many Americans watched grow up and felt they knew."
—Danny Peary, 1991

"Ever since her drowning death off Catalina in 1981, Natalie Wood has been slowly easing into that limbo populated by stars who don't transcend their period."
—Scott Eyman, 2004

While the above two quotes may seem some-what incongruous, they do a stellar job of not only expressing an important contradiction inherent in Natalie Wood's life, career, and memory, but also of explaining the purpose of this unique book.

One of the cruelest ironies of Natalie's untimely passing is that her accidental death would eventually overshadow her extraordinary life—a life of deliberate actions, a journey that was far from accidental. A rather unfortunate byproduct of this contradiction is that she is now remembered more for joining the likes of Rudolph Valentino, James Dean, and Marilyn Monroe in the "died too young" cult than for her lifelong accomplishments in cinema. For over three decades since her death, endless speculation and sensationalistic tabloid headlines about Natalie Wood's demise have kept

her name firmly in the public's consciousness, but at a terrible price: the tarnishing of an otherwise distinguished legacy.

Though several biographies on the actress have been published, few books succeed in presenting the real Natalie, the woman friends and family remember for her vivacity, her laughter, and her thirty-year reign as a beloved industry professional. As one of the most stunning beauties Hollywood ever beheld, and boasting a lengthy résumé of bona fide classics impressive enough to generate envy in any actor, Natalie deserves to be properly canonized in print for the world to appreciate and rediscover.

At the apex of her fame in the early 1960s, the former Natasha Gurdin was nothing short of a sensation, a back-lot child who had blossomed into a sophisticated sex symbol and three-time Academy Award nominee by age twenty-five. A 1962 *Newsweek* cover story paints Natalie as a strikingly contemporary icon with a postmodern sensibility: "In an age which is keenly conscious of its own contradictions, she is somehow able to suggest hope and confusion, sincerity and mockery all at once. Her large brown eyes fire off bursts of emotion. Her mouth is always on the verge of falling with sadness or breaking across her face in a wave of laughter." It is easy to see why Natalie Wood is ripe for resurgence.

Assembling a deluxe illustrated work on Natalie Wood's life and career, however, would prove a daunting task for many reasons. Not only was the subject herself a fascinating human being with

OPPOSITE Natalie Wood, October 1974. Photo by Michael Childers.

a multitude of layers and facets to uncover and examine, but she was an avid collector of her own legacy. The first step in this author's process was scanning over 5,000 photographs, papers, and varied pieces of memorabilia, only a fraction of which would fit into this book.

Much has been written about Natalie Wood's mother, Maria Gurdin, both positive and negative, but Maria's unwavering dedication to preserving her daughter's accomplishments cannot be debated. She taught Natalie the importance of cataloging her career by keeping meticulous scrapbooks containing virtually every magazine article, advertisement, and photograph featuring Natalie since she was five years old.

Natalie proved to be both sentimental and pragmatic in her approach to documenting her own life. She incorporated a file system of her movies, her art collections (one of which, an important treasury of ancient ceramics, she gifted to UCLA during her lifetime), her brief foray into interior design, and every professional project she participated in, from TV commercials to tributes. An articulate writer, she chronicled her life and thoughts in diaries and notebooks. She saved every card that came with flowers, every note or telegram of congratulations, and had all her film scripts bound and embossed for posterity. Amongst her possessions are dozens of framed photographs that hung for years in her various homes, capturing highlights from her films, her friends, portrait sittings, and, most of all, her family.

A staggering array of scrapbooks and albums exist in the Wood-Wagner archive today, and their contents proved invaluable in the making of this book. The magazine and newspaper clippings document a complete timeline of a career, and the personal correspondence and family photos offer rare insight into the private corner of a public life. They reveal the woman behind the veil of fame, and inadvertently invalidate the trappings that come with the carefully manufactured illusion of movie stars and what the public expects them to be. One of Natalie Wood's triumphs was straddling a fine line—she managed to be a very real person, yet also every inch the glamour queen her public expected.

In November 2015, the Wagner family made a decision to part with some of Natalie's possessions in a highly publicized public auction. As the family had kept the items safely in storage for thirty-five years, some wondered why they would suddenly allow them to be sold. Natalie's daughters, Natasha Gregson Wagner and Courtney Wagner, decided to release the part of their mom that the world had known, but they had not. They believed that relinquishing a portion of their mother's movie memorabilia would generate a buzz among fans and ignite the spark of a revival. What they kept were the scrapbooks, the personal photo albums, and items especially important to Natalie: files and scripts for *Splendor in the Grass*, *West Side Story*, *Gypsy*, and *Inside Daisy Clover*. Though the auction may have appeared to be a complete record of Natalie's life and career, quite the opposite is true. Natalie Wood's personal archive—documenting the child, the wife, the mother, the woman, and the movie star—remains intact and preserved.

Following the birth of her own daughter, Clover, Natasha became more aware of the importance of maintaining her mother's legacy for future generations. It was time to come out of the shadows and reclaim Natalie from the tabloids and conspiracy theorists, and re-introduce Natalie Wood the actress, one of precious few stars in Hollywood history to successfully transition from child to adult on screen, and anything but a tragic victim.

After decades of taking the high road by ignoring or declining to comment on rumors surrounding Natalie's death, the Wagners have broken their silence with honest, eloquent contributions to this book. Coinciding with the book and auction is another special tribute: Natasha and Courtney's creation of "Natalie," a fragrance inspired by the natural gardenia scent that their mother wore and loved.

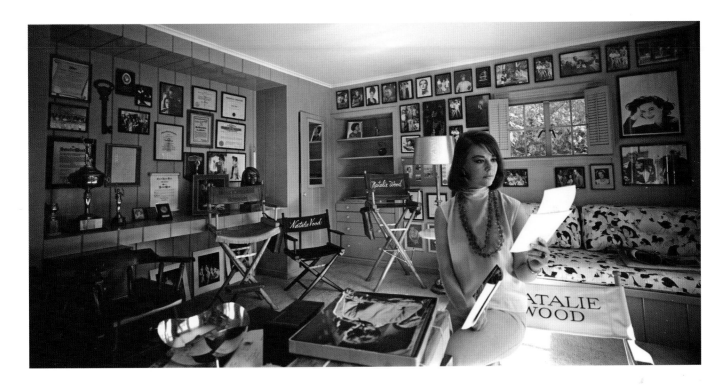

Creating *Natalie Wood: Reflections on a Legendary Life* has been a rewarding experience for everyone involved. From the recreation of private scrapbooks and family albums for the world to appreciate, to thoughtful writings that reassess the one major twentieth-century actress most in need of rediscovery, to the priceless participation of her family and colleagues, such a study could never be replicated in quite the same way again. Having preserved every artifact of her life, Natalie Wood is truly the architect behind this book. She was keenly aware of her image and her place in film history, and seemed to have a sixth sense regarding her own purpose and meaning. Her voice is honored in these pages; her opinions and reflections appear throughout. An abridged version of "Public Property/ Private Person," an autobiographical piece written by Natalie in 1966 for *Ladies' Home Journal* (that never appeared in the magazine), is published here for the first time.

In an age when people who possess neither discernible talent nor glowing personalities can rise to the heights of celebrity, Natalie Wood reminds us that, once upon a time, there were real movie stars who looked, dressed, and behaved like movie stars, seeming to effortlessly exude above-average glamour. While she may have eventually shed her Hollywood image to raise a family, Natalie never ceased to be larger than life. "We are not average people," she once observed, "and our fans don't want us to be average. Don't call us the folks next door! If we were, people would visit their next door neighbors instead of going to the movies to see us." If any star ever seized the day and took all that fame had to offer and more, it was Natalie Wood.

Though she was gone much too soon, she left so much behind. Her carefully maintained archive stands as one consolation to her early death; another consoling factor is the exuberance and energy with which she lived. "The way a life ends doesn't define that life; the way a life is lived does," Robert Wagner has contemplated. "Natalie had a tragic death, but she didn't have a tragic life. She lived more in her forty-three years than most people—felt more, experienced more, did more, gave more." Natalie herself has the final word on her legacy and legend: "I have absolutely no complaints about a moment of my life."

Family Album

The Gurdins 1938–1957

Maria Stepanovna Gurdin

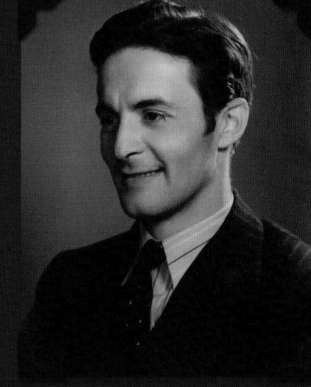

Nikolai Stephanovich Gurdin

Natasha Nikolaevna Gurdin

Russian River, California

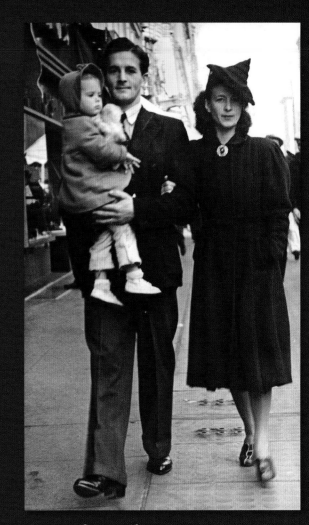

San Francisco, 1940

Mama & Natasha

Sweet dreams

Natasha's first dance recital

a farm outside Santa Rosa

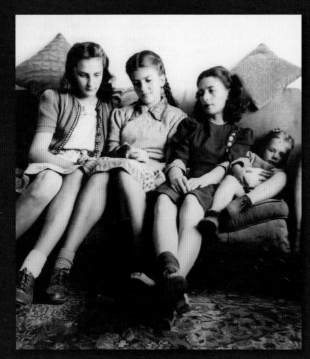

Olga & friends, Natasha

in Los Angeles

Halloween 1946

Natalie & Lana

1946

a home performance, 1948

Natalie & her uncle, 1950

high school dance, 1953

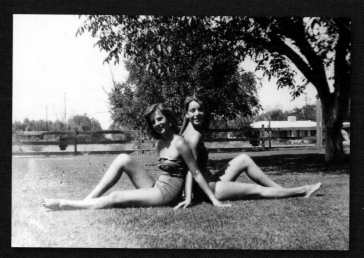

with girlfriend Alice

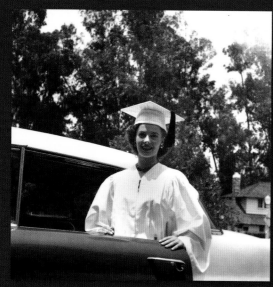

Graduation day — June 1955

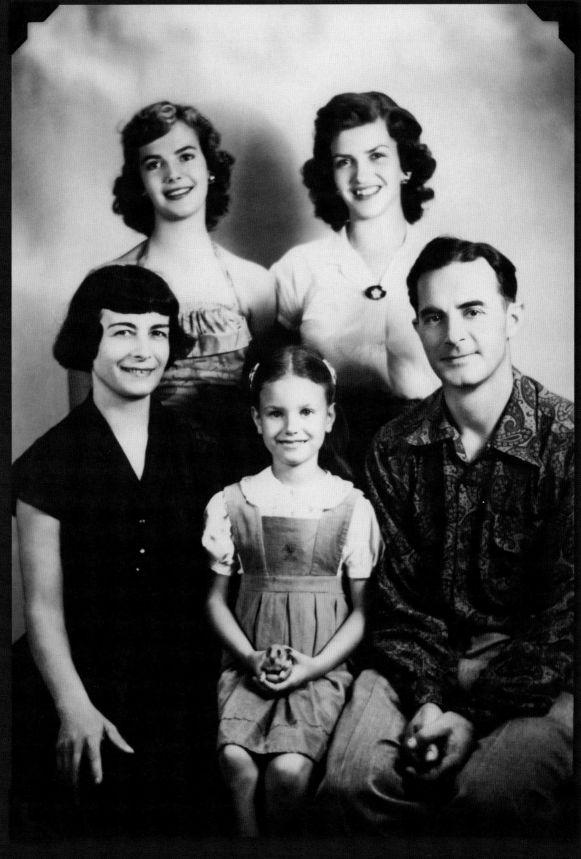

Natalie, Olga, Maria, Lana, Nick

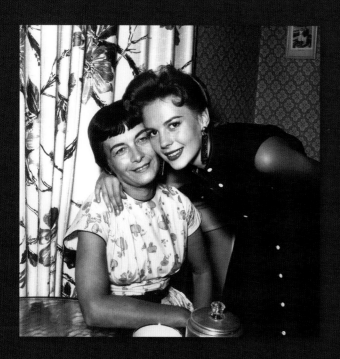
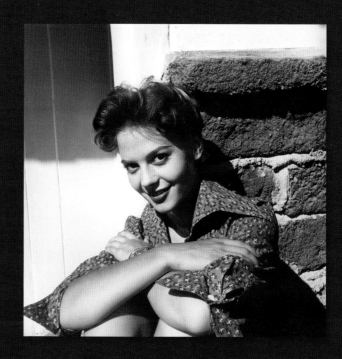
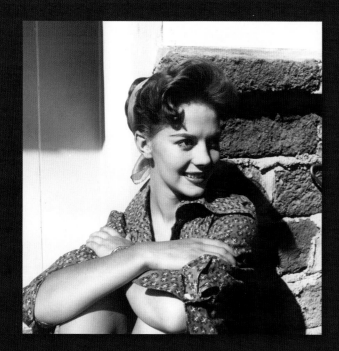
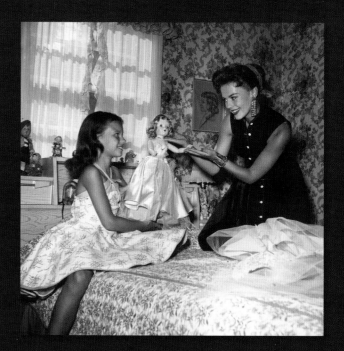

Natalie, "Mud" and Lana

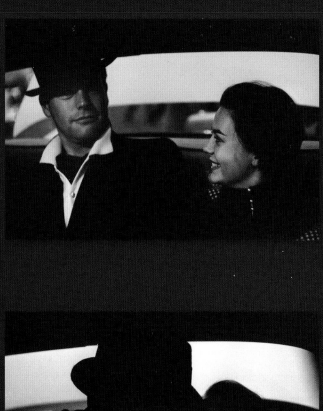
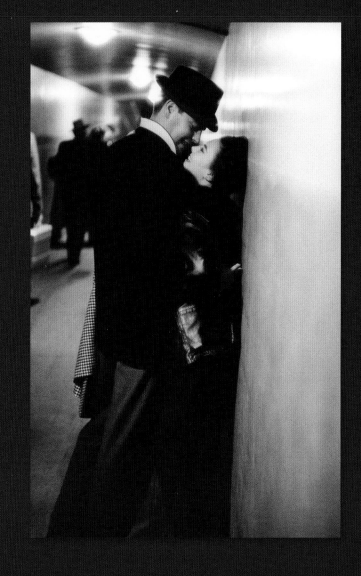

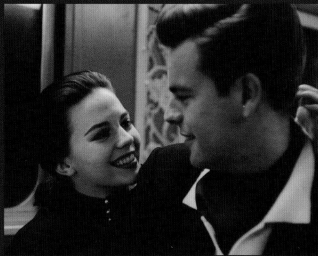
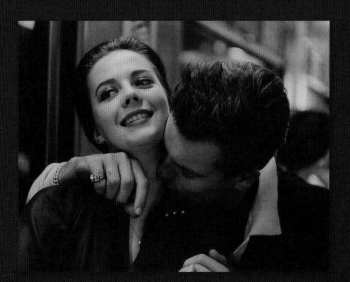

on the way to marry R.J., 1957

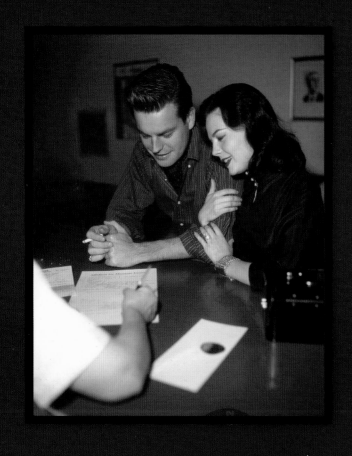

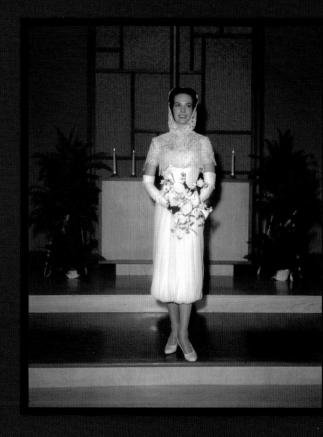

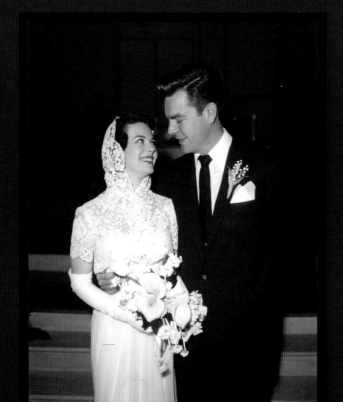

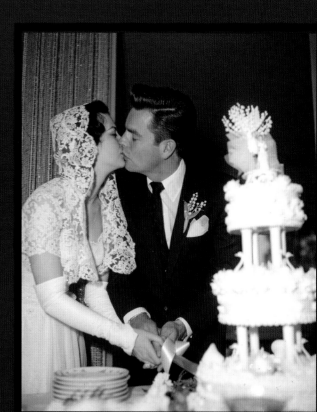

Certificate of Marriage

This Certifies That

Robert J. Wagner Jr.

and

Natalie Wood

were

United in Marriage

at Scottsdale Methodist Church

according to the Ordinance of God

and the laws of the State of Arizona

on the 28th day of December 19 57

Witnesses

Barbara Gould

Robert J. Wagner

Frank E. Krouse
Methodist Minister

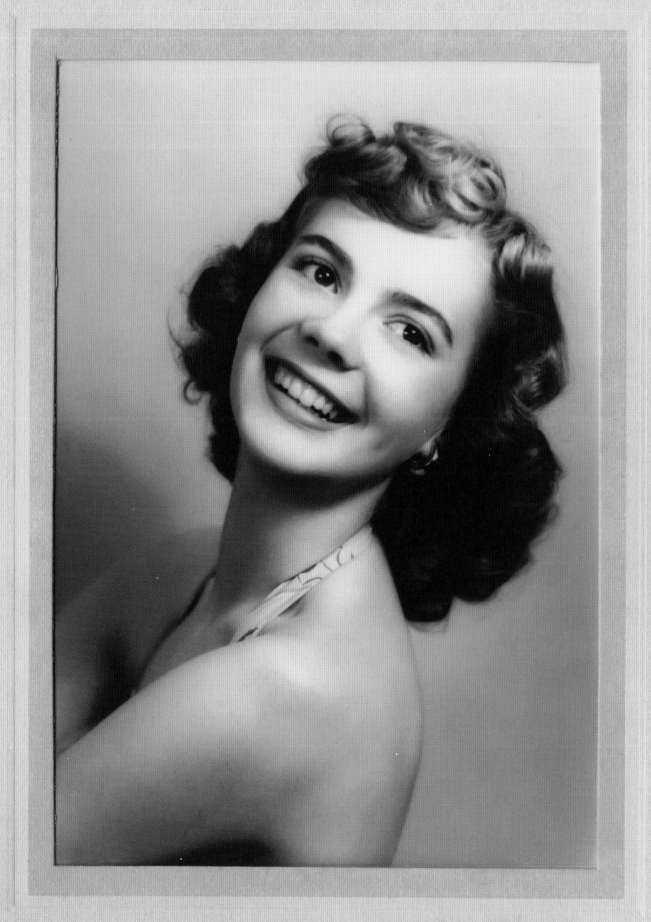

De Pauk
VAN NUYS

BECOMING Natalie

"This little girl debuted in a spectacular way. Natalie had 'Le Cinema' in her blood."

—*Cinémonde* magazine

As a teenage girl, I thought "Natalie Wood" was synonymous with "Hollywood." Forget Marilyn Monroe, Elizabeth Taylor, and both Hepburns. For me, Natalie was the center of the classic film universe. I was twelve when I first saw her—as Maria in a TV broadcast of *West Side Story* (1961)—and in the following years she popped up everywhere. I saw her in John Ford westerns, Alan J. Pakula dramas, Blake Edwards comedies, and Joseph L. Mankiewicz classics. She was an adorable 1940s child, a vivacious 1950s teenager, a beautiful 1960s woman, a musical star, a dramatic tour de force, and a game comedienne. I had never seen anything like her. I wondered how, as a child, she had squeezed so much talent into such a tiny frame, and how, as a young adult, she managed to make that nearly impossible transition into glamorous, Oscar-

OPPOSITE Natalie as a teenager at Van Nuys High School.

nominated leading lady. How had little Natasha Gurdin become big Natalie Wood?

According to Natalie, the secret of success requires three factors: talent, timing, and luck. "I've had all three," she once said. But as I unearthed the story of her early years, more factors came to light—such as the potent mix of destiny and determination that seemed to guide her—and one undeniable truth became clear: If anyone was ever born to be a star, it was Natalie Wood.

Natalie was unique, and the first of her kind: a professional actress who worked consistently from the age of four until thirty-one, when she chose to shift her focus from films to family. Countless scores of others have tried for such a career and failed, as child stardom almost always ends with the onset of puberty. Child stars Shirley Temple and Margaret O'Brien grew into pretty young women, and made valiant attempts to remain relevant onscreen into adulthood, but their great fame dissolved with adolescence. Judy Garland and Deanna Durbin remained stars as adults, but they were not young child actors; both debuted in films as teenagers. Roddy McDowall had started acting in films at twelve, and managed a lengthy career, but his path to adult success was not a smooth one. Even Natalie's most

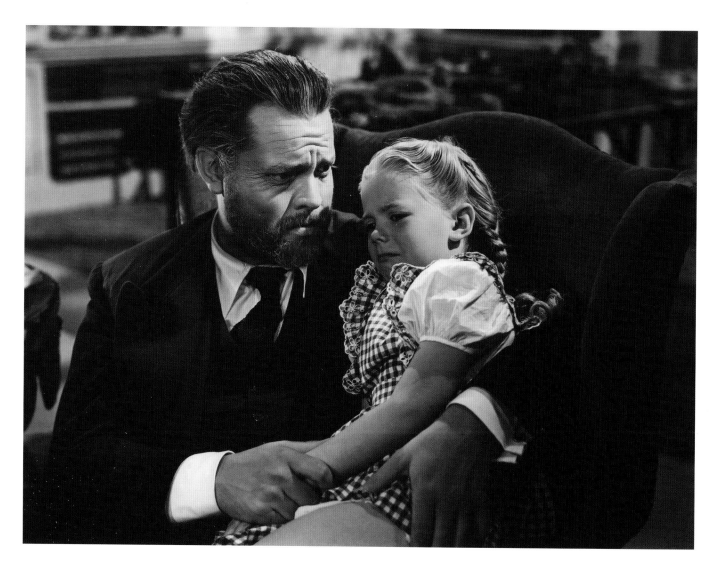

celebrated predecessor, Elizabeth Taylor, was not technically a child star, not having achieved screen fame until twelve. Natalie actually lived up to the "Wonder Child" title she was given by film critic Edwin Schallert in 1946. The only contemporary performer with a career comparable to Natalie's is Jodie Foster, a child prodigy who made her acting debut at age six and worked steadily for decades to become one of the most lauded stars of her generation.

Orson Welles, who had been a child prodigy himself, famously described Natalie Wood as "so good she was terrifying" in her first major film role, as Welles's adopted daughter in *Tomorrow Is Forever* (1946). For any actor to hold his own onscreen with the venerable Welles is commendable, but for a six-year-old to upstage the legendary actor-director is uncanny. Yet that's exactly what Natalie did; critics

even credited her with surpassing Welles. "The others in the cast do not have much chance in *Tomorrow Is Forever*," wrote a Washington, D.C. reviewer, "except possibly a small child named Natalie Wood, whose innocent charm is armor against Welles's Jovian wrestling with the story." With no training, only her instincts and director Irving Pichel to guide her, first-grader Natasha Gurdin was more than an actress. She was a force of nature.

Born on July 20, 1938, in San Francisco, Natalia Nikolaevna Zakharenko soon became known as Natasha, and her Russian immigrant parents Maria and Nikolai changed their surname to the easier-to-pronounce Gurdin. Nikolai further Americanized his name to Nicholas or Nick and hoped to find steady employment during the Great Depression, but only worked occasionally as a day laborer. With the new

baby and Olga, Maria's eleven-year-old daughter from a previous marriage to support, the family struggled.

Maria had a vivid imagination. Consumed by fairy-tale fantasies and fascinated by motion pictures, she was thrilled to discover Natasha naturally possessed the type of outgoing charisma Hollywood favored, and encouraged her daughter to play dress-up, sing, and dance for anyone who would watch. She also created a film fan by nursing Natasha on movies—literally. As a baby, Natasha was reportedly able to sit through a movie without crying and Maria would often carry her to matinees. In the dark theater, no one noticed if her mother breast-fed her and rocked her to sleep when she grew restless.

Olga was starstruck too, and before Natasha could read she had learned the names of ninety-four of the screen's top stars from her sister, and could identify their pictures in fan magazines. Russian was often spoken at home, but when Natasha learned English her favorite word was "pretend." It was also her favorite pastime. Each morning she would check into her movie studio—the family's garage—and announce, "Today I am Lana Turner." After a lunch break, she would check in again as Bette Davis, Joan Crawford, or Vivien Leigh. Maria did her part by curling her daughter's hair in the obligatory Shirley Temple ringlets and photographing her in precocious poses, daring to dream of movie stardom for Natasha. If luck is the result of preparation meeting opportunity, Maria was not about to be caught unprepared.

Incredibly, Hollywood responded to the signals Maria and Natasha were sending out. In 1942, the Gurdin family moved from San Francisco to Santa Rosa, California. Although Hollywood was still over 400 miles away, and location filming was

uncommon at the time, Alfred Hitchcock insisted on an authentic backdrop for his typical American town in *Shadow of a Doubt* (1943). He not only brought Hollywood to Santa Rosa, but mined the community for screen talent. Edna May Wonacott, the daughter of a grocer—and an unlikely candidate for stardom with her glasses, baby fat, and freckles—was given a major role in the film by Mr. Hitchcock and whisked off to Hollywood with a seven-year studio contract. Maria clipped an article about Edna May's discovery from the local newspaper and pasted it into a scrapbook. If it could happen to a girl in their own neighborhood, why not little Natasha?

Enter character actor-turned-director Irving Pichel, who followed Hitchcock to Santa Rosa in June and July of 1943 to capture the same sleepy-town feel in his home-front drama *Happy Land* (1943), starring Don Ameche and Ann Rutherford. Santa Rosa once again went movie-crazy and half the town flocked

OPPOSITE "Natalie acts from her heart, not from the script," Orson Welles said of his *Tomorrow Is Forever* costar in 1946. RIGHT Before Natasha appeared in movies, Maria was already shaping her daughter's baby-starlet image in the mold of Shirley Temple.

to watch the first day of shooting. As luck would have it, Pichel needed a few locals for bit roles, including a little girl just Natasha's age who could drop an ice cream cone and cry realistically on cue. Opportunity had come calling, and Maria was ready. She maneuvered Natasha into the director's lap, told her to be friendly to him, and then coached her little girl into tears to get her in the movie.

So many variations of Natasha's legendary discovery have been published over the years that separating fact from fiction is almost impossible. Because she was so young when it happened, Natalie herself seemed confused, alternately claiming the whole thing was an accident, or a deliberate scheme of her mother's, or that it was her own idea to sit in the director's lap. One unlikely fan-magazine scenario had Pichel himself knocking on the door of the Gurdin home and offering Maria a bit part in the film, telling her daughter, "You could join Mother if you want, Cinderella." Years later, actress Ann Rutherford even claimed that she spotted an "adorable" child cleaning her trailer one day (supposedly the Gurdins rented trailers to the *Happy Land* cast) and suggested Pichel "put the little girl in the picture."

However it happened, Maria did encourage Natasha to charm Mr. Pichel that summer day. She succeeded, dropped the ice cream cone, cried, and won the part. Just days before her fifth birthday, talent, timing, and luck conspired to give Natasha Gurdin a one-in-a-million chance at stardom. Though the part in *Happy Land* was only an uncredited bit role, she had made a valuable connection.

Among the creative retellings of her Cinderella story, one important fact has been lost in the shuffle. It was more than her cute-as-a-button curls and turned-up nose that impressed Pichel—it was her extraordinarily high intelligence. Little Natasha was a bilingual language and mathematics whiz whose IQ reached the gifted range. The director spotted her unusually quick mind and sharp memory, and imagined how well she might do if given a speaking role. Soon he had a part in mind for Natasha that would require another cascade of real tears and plenty of dialogue.

After posting several letters to Natasha that Maria enthusiastically answered, in early 1945 Pichel invited his protégée to screen-test for the role of Austrian war orphan Margaret in *Tomorrow Is Forever*, an implausible melodrama he was directing with Claudette Colbert, Orson Welles, and George Brent. Maria took Natasha to Hollywood by train, and by sheer force of will landed that part for her daughter, herself, and the whole family. By now, the Depression had given way to a world war, but Nick had begun drinking heavily and was still unable to secure steady work. Necessity aside, it seems Natasha wanted to perform as much as her mother wanted it for her. "I think there's something within every child that either goes along or doesn't," she later reflected. "In my case I complied. So I must have wanted to act."

Wanting to act and possessing the ability to emote on cue are two different things, and Natasha failed her first screen-test attempt. Maria begged Pichel for a second chance and made sure Natasha turned on the waterworks by using any means necessary, from reminding the girl of her dead dog (named Terry because he liked to tear things) to making cruel threats. Harsh as her mother's actions may have been, the adult Natalie recognized the importance of that transitional moment. "Painful as it was, it nevertheless changed the course of my life. And for that I'm grateful," she recalled. When all the timing and luck in the world failed to produce success, Maria Gurdin resorted to force—and was teaching her daughter to do the same.

"Natalie took her first acting assignment in stride," wrote biographer Christopher Nickens. She was too young to feel intimidated by her illustrious costars or the difficulties of the role, and was simply playing her favorite game, "pretend," on a grand scale. Now a bleached blonde courtesy of studio stylists, Natasha used her high IQ to quickly master the German

Twentieth Century-Fox Film Corporation

STUDIOS
BEVERLY HILLS, CALIFORNIA

July 17, 1943

Dearest little Natasha,

Do you remember the day when you sat
on a stool and we took pictures of you? I am sending
you the pictures so that you will be able to remember
what you looked like when you were a little girl. Because,
unless I am mistaken, you have a birthday Tuesday and will
then be a very big girl.

I am keeping a copy of this picture for
myself to remind me of the sweet little girl I met in Santa
Rosa whom I hope to see many times again. To make sure that
you remember me, I am having a company in New York send you
a nice book every month during the next year. Even if you
can't read them yet yourself, your Mama will read them to
you and they will have lovely pictures to look at. Very
soon now you will learn to read and very soon after that you
will learn to write and then you can write me a letter telling
me all about the books.

Even though your Daddy and Mama wouldn't
let you come to stay with me, some day you are sure to make
a visit to Los Angeles and then I shall see what a lovely
big girl you are growing to be.

I am sending you all my good wishes for a
very happy birthday and a very happy year.

Your friend,

Irving Pichel
Irving Pichel

IP:md

Miss Natasha Gurdin
2168 Humboldt Street
Santa Rosa, California

words and accent required for the role, and to effortlessly memorize her lines as big sister Olga read them aloud. Just for good measure, she memorized everyone else's dialogue too, and could always cue the adult actors if they forgot a line. Natasha's biggest problem on the set of *Tomorrow Is Forever* was losing her baby teeth in the middle of scenes, delaying production while she was rushed to the dentist for a false tooth. Most kids traded teeth for money from the tooth fairy, but Natasha collected her pearly whites in a small box and when Gary Cooper visited the set, she offered to swap them all for his autographed photo. Here was a girl who knew what she wanted and was already negotiating to get it.

ABOVE LEFT Pichel and his discovery in Hollywood, 1946. Natasha Gurdin had just become Natalie Wood. ABOVE RIGHT The first letter Irving Pichel sent to Natasha shortly after discovering her on the set of *Happy Land*.

Her one losing battle was over her name. When producer William Goetz informed Natasha Gurdin she would now be known as Natalie Wood, she "hated it." She recalled requesting the surname "Woods" instead so she could "think of trees and forests." But Goetz insisted. "Don't fret," he told her. "When you see Natalie Wood up in lights, you'll love it.'"

Nick took Natalie to see her new name in lights at New York City's Winter Garden for the premiere of *Tomorrow Is Forever*, though they left before the film even started, as it was past the star's bedtime. Besides, she had "already seen it out in Hollywood at a sneak preview." Her review? "It was all right."

Critics agreed with Natalie, singling her out as the brightest spot in a "trivial" and "unbelievably hammy" film. She was named the Most Talented Juvenile Star that year by *Parents* magazine and received a Blue Ribbon award from *Box Office*. Costar Claudette Colbert was so impressed with Natalie's performance she wrote a letter to Academy president Walter Wanger charging the organization with being "unfair and discriminatory" for not giving Oscars to children. Maria clipped this story—and all of Natalie's reviews—for the scrapbook. Her daughter was already outshining Edna May Wonacott, and she was just getting started.

"They call me One-Take Wood."

—Natalie Wood in 1947

By the time *Tomorrow* wrapped, the Gurdins had relocated permanently to Los Angeles. Natalie's success as a film actress was now all-important; Nick was unemployed and the family had a new mouth to feed. Svetlana, known as Lana Lisa or

"Sweet Lana" to Natalie, was born in March of 1946. Through his daughter's connections, Nick landed work as a studio carpenter, but Natalie's income would support the family for the rest of their days.

In an unpredictable industry rife with empty promises and fleeting fame, Natalie was fortunate. World War II had just ended, ushering in an era of wholesome family pictures featuring clean-cut kids, and Natalie was the perfect age to exploit the trend. Right on cue, Irving Pichel followed through with another role for his new discovery—though the most memorable scene in the flimsy comedy *The Bride Wore Boots* (1946) happened off camera. Natalie developed a rapport with her screen mother, Barbara Stanwyck, and a fondness for the actress's signature scent, Jungle Gardenia. Later, Stanwyck sent her a bottle and it became Natalie's signature scent too. It seems Natalie got more than perfume from tough, tenacious Stanwyck, who served as a strong female role model for a young, impressionable girl.

Critics scarcely noticed Natalie as Gene Tierney's daughter in Joseph L. Mankiewicz's supernatural period romance *The Ghost and Mrs. Muir* (1947), and when they did, they referred to her as Natalie "Woode" or "Woods." If her breakout performance in *Tomorrow* was quickly forgotten, the world would always remember her next movie.

While simultaneously filming *Ghost*, Natalie shot her definitive childhood role as Susan Walker, the girl too sophisticated to believe in Santa Claus, in *Miracle on 34th Street*. Natalie adored her costars Edmund Gwenn ("I thought he *was* Santa Claus"), handsome John Payne ("I had a terrific crush"), and screen mother Maureen O'Hara ("Mama Maureen"). The respect was mutual. "We used to tease and call her a little old lady," O'Hara recalled, "and she was. She was the finest, most professional

LEFT "I raised my daughter to be a movie star," Maria once said. The autographed photo of Orson Welles on the piano is inscribed "For my darling daughter Natasha with love."
OPPOSITE Natalie developed genuine friendships with her *Miracle on 34th Street* costars, and later admitted having a crush on romantic lead John Payne.

young actress in the picture business." Adults were often awed by the child's ability to deliver her lines perfectly in one take. Director George Seaton was impressed by Natalie's "instinctive sense of timing and emotion. . . . She was so businesslike she amazed me."

Seaton recalled the efficiency of his young star during the scene where Susan lies in bed popping her bubble gum. Director, assistant director, costars, cameraman, and a crew of a hundred more stood in silence and waited patiently while Natalie chewed methodically. After several tense minutes, she announced with authority, "It's all right now, Mr. Seaton." Her gum had finally reached the proper consistency for blowing bubbles, and the scene could be shot.

"*Miracle* was a sleeper," Natalie remembered. "No one figured it would do business." Twentieth Century Fox had little faith in the film, releasing it in the summer, when kids bought more movie tickets. Still, critics and audiences responded warmly to the clever story and exited the theater believing—just a

little bit—in Santa Claus. "Natalie Wood impresses as a totally unactorish child," the *Hollywood Reporter* observed. "She will bring an honest lump to audiences' throats when she goes around muttering 'I believe. It's silly, but I believe.' Strangely enough, you are likely to believe, too."

From A-list Fox, Natalie went to B-studio Republic for something she had never had before, and something she would not have again for another ten years—the lead role in a movie. Though the adult stars (Dean Jagger, Ruth Warrick, and Walter Brennan) are given top billing, Natalie as Jenny carries *Driftwood* (1947) on her tiny shoulders. She is the titular character; Brennan mutters "driftwood" under his breath when Jenny explains she is an orphan who was found roaming in the wilderness of rural Nevada. When Jenny's minister great-grandfather dies, she and her collie are adopted by a country doctor who accidentally exposes Jenny to Rocky Mountain spotted fever, then saves her life by curing her.

An odd, darkly hopeful little small-town drama, *Driftwood* came and went without much fanfare. But it proved that Natalie could carry a film. "She was a natural," director Allan Dwan remembered. "She had a real talent for acting, an ability to characterize and interpret. . . ." Though her Jenny lacks some of the spontaneity of *Miracle*'s Susan, Natalie charms the movie to life when she sings the folk song "I Wish I Was a Mole in the Ground" to her dog, and when she revels in her first bubble bath. If not a full-fledged child star, Natalie Wood was now a name to be reckoned with.

"I had great fun," Natalie said of her next project, the ridiculously titled *Scudda Hoo! Scudda Hay!* (1948), a misguided romantic comedy-drama involving mules. "We filmed most of it on the Fox Ranch and I was always catching turtles, feeding the chickens, swimming in the river. . . ." *Scudda Hoo!* flopped with the public, but it gave Natalie a chance to add welcome comic relief to an otherwise downbeat story, and to appear in glorious three-strip

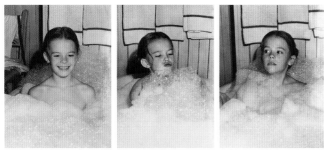

Technicolor. The film is remembered today for one brief scene where Natalie and costar June Haver stand in front of a church while a young, unknown Marilyn Monroe passes behind them in her first bit part.

In 1947, Fox signed Natalie to a seven-year, $1,000-a-week contract. She was now a cog in the studio machine, carefully controlled and legally bound to spend several hours a day in studio classrooms and have on-set tutoring between scenes. A welfare worker was required by law to chaperone her at all times, though Maria was usually present too. "I couldn't even go to the bathroom alone," Natalie remembered of those years.

Oddly, once Fox secured Natalie with a long-term contract, they did not use her in a film for six months. They booked her on publicity tours and radio shows, and finally threw her into the family comedy *Chicken Every Sunday* (1949), almost as an afterthought. Meanwhile, she excelled in her studies at the Fox school, and pushed herself to succeed in ballet, horse riding, and piano lessons in her spare time. Television was a brand-new medium, but Natalie conquered that too, playing Alice (of Lewis Carroll's *Alice's Adventures in Wonderland*) in *Once on a Golden Afternoon* (1948). Reportedly, ten-year-old Natalie set a record as the youngest actress ever to star in a TV program up to that time. In between pictures, the Wonder Child was loaned out to other studios for profit.

When character actor Walter Brennan was cast in the independent feature *The Green Promise* (1949), he suggested Natalie for the part of his youngest daughter, Susan. "It's rural but it's riotous!" claimed ads for *The Green Promise*, which is in fact a low-on-laughs (and low-on-budget) affair best defined by *Newsweek* as "a lean mixture of bucolic drama and helpful hints for progressive farmers."

THIS PAGE The press jokingly referred to Natalie's *Driftwood* bathtub scene as "the movies' first almost nude bath," pronouncing it racier than Jean Harlow's in *Red Dust*. Natalie wore only a pair of bloomers. **OPPOSITE** Natalie gets the platinum blonde treatment for a 1948 publicity gimmick.

Ostensibly a family film concerning agriculture and 4-H clubs, *The Green Promise* is actually a subversive anti-communist statement funded by oil millionaire Glenn McCarthy and distributed by his buddy Howard Hughes, then head of RKO.

Capitalist propaganda aside, the supporting role allowed Natalie to shine. She runs away with a variety of scenes, ranging from the physical comedy of pumping the handle right off a church organ to the heartwarming bottle-feeding of her two baby lambs. *Variety* called Natalie "easily the star of the picture. She plays her role with convincing enthusiasm and a sincere depth of emotion." One smitten reviewer even named Natalie "the most beautiful and talented actress in all Hollywood" after seeing *The Green Promise*. "The man who made the deeply philosophical observation that all young girls are beautiful probably was right," he went on, "but Natalie Wood is beautifuller."

Natalie said she retained "very happy memories" of *The Green Promise*, despite one harrowing scene late in the film where Susan braves a raging thunderstorm to save her pet lambs, crossing a bridge that collapses and throws her into a flooding creek. Due to an error in timing, the bridge fell too soon and the winds (whipped up off-camera by airplane propellers) were too strong, and Natalie was nearly swept into the current. She clung to a timber as the cameras rolled, emerging unscathed when director William Russell called "Cut!" Though it has since become notorious as a "near-death experience," the incident left Natalie unharmed, except for a small splinter embedded in her left wrist that became infected. Once the infection healed, Natalie's wrist remained twisted with a visible bump that she camouflaged with bracelets for the rest of her life. Child stardom has its hazards, but Natalie soldiered on. "If I felt any resentment toward the adults who put me in that situation," she later wrote, "I wasn't aware of it at the time."

The bridge mishap reinforced Natalie's lifelong fear of drowning, a phobia encouraged by her mother. As a teenager, Maria was once cautioned by a gypsy fortune-teller to avoid "dark water" as she would drown in it. Maria passed her fear of dark water on to Natalie, and frequently repeated another prediction the gypsy supposedly made— that her second-born daughter would be "a world-famous beauty." Whether the gypsy story was fact or fiction, Maria believed it with all her heart, and was determined to make the prophecy about Natalie's beauty and fame come true.

Fox abruptly dropped Natalie in 1949, but by this point in her life, Natalie was just as determined as Maria to fulfill her destiny. She auditioned incessantly, winning "a lot of parts," she recalled, at a variety of studios. When casting directors asked her age, she invariably replied, "How old is the girl supposed to be?" and responded accordingly. With her first handful of films, Natalie had cemented her screen

LEFT David (Robert Paige) rescues Susan (Natalie Wood) after the harrowing bridge collapse in *The Green Promise*. "I wasn't seriously hurt," Natalie said of the on-set accident that left a permanent bump on her left wrist. OPPOSITE Natalie signs autographs in a theater lobby to promote child safety, February 1948.

persona as "the skinny, gawky tomboy with pigtails," as she put it. She cornered the market as Hollywood's go-to kid sister, and would play variations of this type for the next several years.

A typical precocious little sister role was in *Father Was a Fullback* (1949), a comedy that reunited Natalie with Maureen O'Hara, and introduced her to a new screen father, Fred MacMurray, who would remain a supportive friend for life. The off-screen Natalie—constantly surrounded by adults—was becoming so mature and professional, her public sometimes got confused. At age ten she was given the distinction of "Woman of the Month" by movie magazine *The Exhibitor*, then at eleven she was named "Child of the Year" by the National Children's Day Council.

As the '50s dawned, Natalie was unstoppable. While she never quite reached Margaret O'Brien-level childhood fame, she was an astonishingly steady worker, appearing in four features in 1950 alone. Among them was the classic weeper *No Sad Songs for Me* (1950). Natalie landed a memorable role as the daughter of Mary (Margaret Sullavan), a woman who orchestrates her own husband's remarriage when she is diagnosed with terminal cancer. Natalie delivers the final, tear-jerking line of the film as she plays a triumphant Brahms piece on the piano and the camera ascends toward the heavens like her mother's soul.

Reputed to be obedient and cooperative, Natalie was a sensitive girl who was driven by guilt to please everyone—parents, costars, and directors—and earn their approval as well as earning money. "She was the paycheck," Robert Wagner later observed of the Gurdin family dynamic. "She was pretty well smothered by her mother and father." Nevertheless,

Natalie was nobody's puppet. A strong will and the seed of what journalist Rob Baker would later term "a defiant streak" were beginning to emerge at home and at work. On the set of *Never a Dull Moment* (1950), Natalie had a scene on horseback, but was strictly forbidden to ride between takes. "When the director hollered 'Cut,' I was supposed to return to school," she recalled. "Instead, I flicked the reins and the horse took off." The ever-present welfare worker raged and director George Marshall grumbled, but Natalie shouted "I can't stop him," and enjoyed "a nice, forbidden ride." Such moments of rebellion were few, but her defiant streak would eventually flower into a full-blown revolt.

"One reason that I worked a lot as a child is that I looked like an ordinary kid," Natalie observed. But kids grow up so fast. In 1952, Natalie hit fourteen—the age when child stardom typically comes to a grinding halt. The cute years are over, giving way to awkward growth spurts, self-consciousness, weight gain, and other Hollywood no-nos. But puberty was kind to Natalie. "Physically I'm slight and small," she said. "I never went through that whole awkward plump growing-up stage with braces and the whole bit."

She slid smoothly into teenage roles with *The Rose Bowl Story* (1952), an otherwise forgettable football feature that marked Natalie's debut as a screen teen. The pigtails are history—her chestnut hair is curled in a long bob, her dungarees cuffed at the calf, her mouth adorned with orange-red lipstick. She talks to her boyfriend on the phone day and night, and, in a hint of things to come, her mom and dad are Ann Doran and Jim Backus, future screen parents of James Dean in the film that would change Natalie's life in just a few years.

By this time, Natalie's roster of onscreen mothers (or mother figures) included Claudette Colbert, Barbara Stanwyck, Gene Tierney, Maureen O'Hara, Celeste Holm, Margaret Sullavan, Jane Wyman, Irene Dunne, Joan Blondell, and Bette Davis, whom she had just worked with in *The Star* (1952). Natalie idolized Bette, and Bette in turn treated Natalie with kindness and respect, insisting she be given close-ups and equal star treatment. Critics took note. The *Hollywood Citizen-News* declared, "Second to Miss Davis should be placed the ingenuously appealing performance of Natalie Wood as her daughter. Miss

ABOVE LEFT Natalie and costar Norman Kraft prepare to play Alice Liddell and Lewis Carroll in the TV special *Once on a Golden Afternoon*, the story behind *Alice's Adventures in Wonderland*. **ABOVE RIGHT** With Viveca Lindfors in the final scene of 1950's *No Sad Songs for Me*. "Natalie Wood is no precocious film moppet," declared *Variety*. "She is an excellent actress." **OPPOSITE** *The Rose Bowl Story* allowed Natalie to flirt with a college athlete (James Dobson) in her first teenage role.

Wood displays a grace and naïveté that go straight to the heart."

Natalie had always received favorable notices, but reviewers are kind to youngsters. Though she enacted her roles with sincerity, she had not yet learned to dig deep within her psyche to deliver a truly authentic performance; she was still playing "pretend" for the cameras. She told a reporter, "What I'm interested in is acting. I want to do character parts—something with substance—the kind of roles Bette Davis and Vivien Leigh have done."

Unfortunately, Bette Davis-caliber parts are nonexistent for fourteen-year-olds, especially in Natalie Wood's day. Though she had gracefully glided from child to teen, making the leap to honest-to-god adult roles was another hurdle entirely. Even without the pigtails, the little-girl stigma was tough to shake. "I knew I had to get out of that image," she said, but breaking free from the type she had spent eight years establishing would require drastic measures.

"Although her angelic face belies it, the girl has the tenacity of an octopus and the determination of a battering ram."

—Columnist Lloyd Shearer

Maria was in no hurry for her daughter to become a woman, and neither was Hollywood. Capitalizing on Natalie's slender frame and baby face, studios kept her as young as they could for as long as they could. As she grew, they squeezed her into bigger and bigger ruffled pinafores and insisted she could "pass for seven," according to *Modern Screen*. Hyper-protective Maria agreed that her daughter was safer (and more likely to turn a profit) if she looked like a freshly scrubbed girl. When Natalie entered public school—first at Fulton Junior

High and then Van Nuys High School—she was culture-shocked to see her peers in tight skirts, high heels, and an abundance of cosmetics. Natalie engaged in a series of heated battles with her mother, who would only reluctantly consent to "a bit of pink lipstick." But that was not enough.

In July of 1953, Natalie turned fifteen and Maria surrendered in defeat. Natalie not only began wearing makeup, she enlisted the help of studio professionals to completely overhaul her look. Her hair was lightened, her brows re-shaped, and liner pencil was deftly maneuvered to give her thin upper lip a fuller appearance. Someone told her that jewelry made her look older, so she decorated herself until she sparkled like a Christmas tree. She posed for countless swimsuit photos to display her flawless mini-figure. She announced her intention to appear "sexy," which now replaced "pretend" as her favorite word.

Her glamour makeover attracted attention (a soldier in Korea named his fighter plane after her) but did not result in any "sexy" roles. In fact, she got no movie roles at all. Nabokov's *Lolita* had not yet been published and nobody in Hollywood knew what to do with a ninety-five-pound, brown-eyed blonde bombshell who was still too young to drive. Natalie settled for another typical daughter part—on TV, a step down from film—with one big change:

her character was eighteen. *The Pride of the Family* cast her as Ann, the high-school-darling daughter of Fay Wray. "It's the first time I've played an *older* girl," she gushed to the press. "I'm so happy!"

Natalie turned sixteen during the making of the biblical clunker *The Silver Chalice* (1955), her only film in two years. She appeared on *Pepsi-Cola Playhouse* and *Juke Box Jury*, biding her time on television until film offers picked up. Maria—now nicknamed "Mud"—still kept Natalie on a tight leash. She could date boys and attend Hollywood parties, as long as Mud chaperoned or was phoned every hour. Natalie struggled against the "terrible web of dependence" her mother spun around her, Robert Wagner recalled. "If a fire engine went by her house, Mud would rush over to see if Natalie was all right." In spite of Maria's control issues and Nick's alcohol-induced mood swings, the Gurdins tried to be hip '50s parents. They used the money their daughter earned to buy her a sporty Thunderbird, and even allowed Natalie a small glass of champagne at her sweet-sixteen party. "Nothing happened," she sighed. "Maybe I didn't have enough."

Raised on a steady diet of movie stardom, Natalie soon wearied of TV's mediocrity and wondered if she had a future as an actress at all. She soul-searched, considering giving up the business. Her movies (twenty-one in less than twelve years) had earned enough money to secure her future. The moment of truth had arrived. "I realized I had a choice," she remembered. "I didn't have to be an actress if I didn't want to be one. And I wondered about it very seriously." She could no longer go through the motions of auditioning and acting just to support her family and please her mother— she knew she must either give it up entirely, or do it because she wanted to do it. The deciding factor arrived in the form of a film script. When Natalie read a new screenplay entitled *Rebel Without a Cause*, about a troubled young man who falls in

love with an equally troubled girl named Judy, her mind was made up. "I realized I had to do it. And I had to be an actress." Whether it was luck, destiny, or sheer determination, she had never been more certain of anything in her life: the part of Judy was going to be hers.

Whereas M-G-M's *Blackboard Jungle* (1955)— the film that kicked off Hollywood's "juvenile delinquent" trend—had examined inner-city hoodlums, Warner Bros. had developed a story about privileged suburban delinquents, based on a treatment by director Nicholas Ray. Many of Ray's previous films (especially 1951's *On Dangerous Ground*) demonstrated his keen understanding of violent, psychologically disturbed outsiders; he was just the man to tell the story of alienated teen Jim and the two kids who become his makeshift family, misunderstood bad-girl Judy and dangerously lonely Plato. And an up-and-coming actor named James Dean, who had recently worked with Natalie in the TV drama *I'm a Fool*, was just the man to play the lead.

Natalie met Dean at the perfect moment in her life and career. She was dissatisfied, searching for a way to break free from the Hollywood conventions she had followed since age six. Dean, fresh from the New York Actor's Studio and steeped in the Method, represented exciting new possibilities. "He was already somewhat of a legend among young actors . . . he seemed very exotic and eccentric and attractive." She knew he was slated as the rebel in *Rebel*, fueling her desperation to get the part of Judy.

Her parents objected to her even trying out. The story was anti-parent, anti-family, they said, and playing a juvenile delinquent would ruin her career. Natalie threw a tantrum, sobbing, "If I don't get this part, I'll just die!" When tears failed, she resorted to threats. "If you don't let me do this, I'll run away from home. I'll become a juvenile delinquent. I'll do something awful." Mud and Nick relented; they knew she really meant it. Besides, they were in no position to argue with the family breadwinner. Legend has it

that Mud even drove her daughter to the Chateau Marmont for a rendezvous with Nicholas Ray, who became Natalie's first lover shortly after she tested for *Rebel*. Was she genuinely in love with Ray, or following the casting-couch tradition of seducing her director to get a part? Apparently, a little of both.

"Nick was the first person who ever talked to me about integrity," she said. "I was drawn to his strength, maturity, and sensitivity." Ray, old enough to be Natalie's father but with a deep understanding of youth, taught the actress to trust her own instincts. He listened, he encouraged, and he respected her. He also had the power to convince Warner Bros. she could play a role they felt she was too young and wholesome for, a role that she would stop at nothing to get. After testing for Judy, she waited nerve-racking weeks for the official decision.

The child actress had grown up, practically overnight. Suddenly she ran with a whole new crowd. In order to play Judy, Natalie actually *became* Judy—defying her parents, running wild with fast

company, exploring a new, exciting way of acting that tapped into her own long-buried resentment against authority. One rainy night, she took a ride in the Hollywood Hills with fellow *Rebel* hopeful Dennis Hopper and a girlfriend. Dennis "pulled a pint of bourbon from the glove compartment," Natalie remembered, and "passed the bottle around." They slid into a curve and collided with an oncoming car; Natalie was thrown from the wreck and rushed to the hospital. Terrified her parents would find out, she insisted the nurse call Ray instead of the Gurdins. "Nick," she said, "the doctors called me a 'goddamned juvenile delinquent.' Now do I have the part?" He leaned close and whispered the words Natalie longed to hear. "You already had it."

The car crash may have been accidental, but her rebellious behavior was deliberate, and served a practical purpose. Unlike most teenagers, Natalie was rebelling with a cause. A smart and savvy Hollywood veteran, she knew that her off-screen antics would chip away at her kid-next-door image, earning her juicier, more daring roles. She was already looking the part, thanks to a makeover supervised by Ray: the hair shorter, curled, and swept back, the lips a red cupid's bow, the figure re-shaped to fit Judy's bad-girl overtones—Ray had costume designer Moss Mabry fill out Natalie's tight sweaters and skirts with padding in just the right places.

Shortly before she started filming *Rebel*, Warner Bros. signed Natalie to a long-term contract, then promptly loaned her out to Universal to play a minor character named Seely in the Anne Baxter-Rock Hudson melodrama *One Desire* (1955). Natalie was miserable, forced to regress to the disgrace of pigtails, but only temporarily. In her early scenes she is a sloppily-pigtailed waif, then is allowed to explore her range as she transforms into a headstrong young

ABOVE An early hair and makeup test for *The Silver Chalice*, 1954. **OPPOSITE** At sixteen, Natalie was mortified at having to play a child in pigtails again for *One Desire*. Her contempt for the part made her performance more authentic. **OVERLEAF** Natalie's sweet-sixteen present was a white Thunderbird. She later wrecked it and upgraded to a pink convertible model.

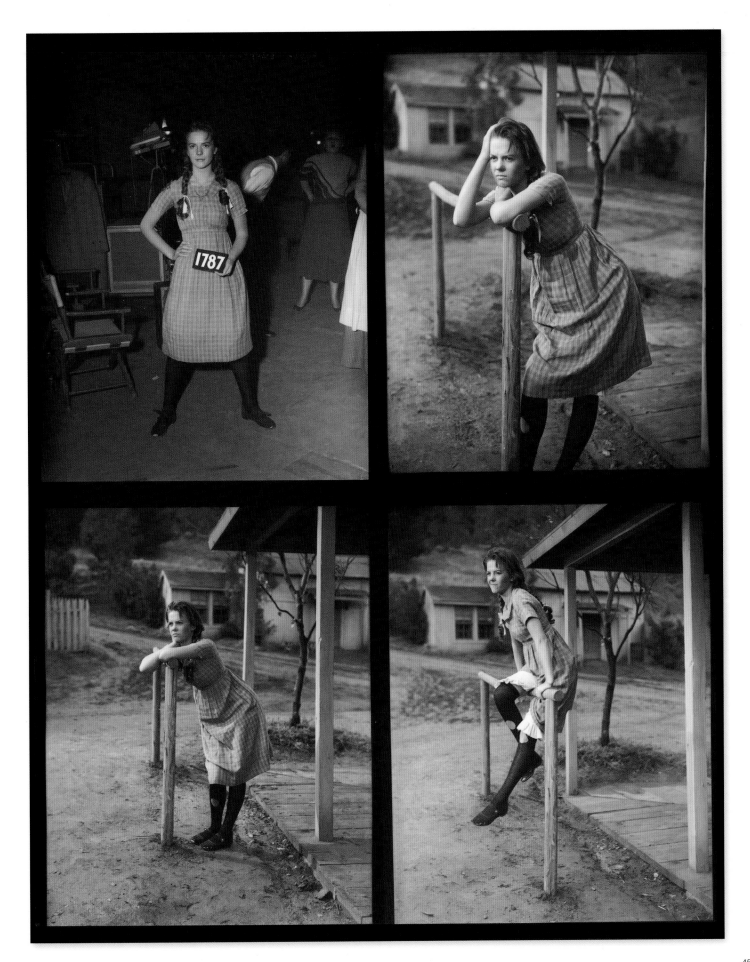

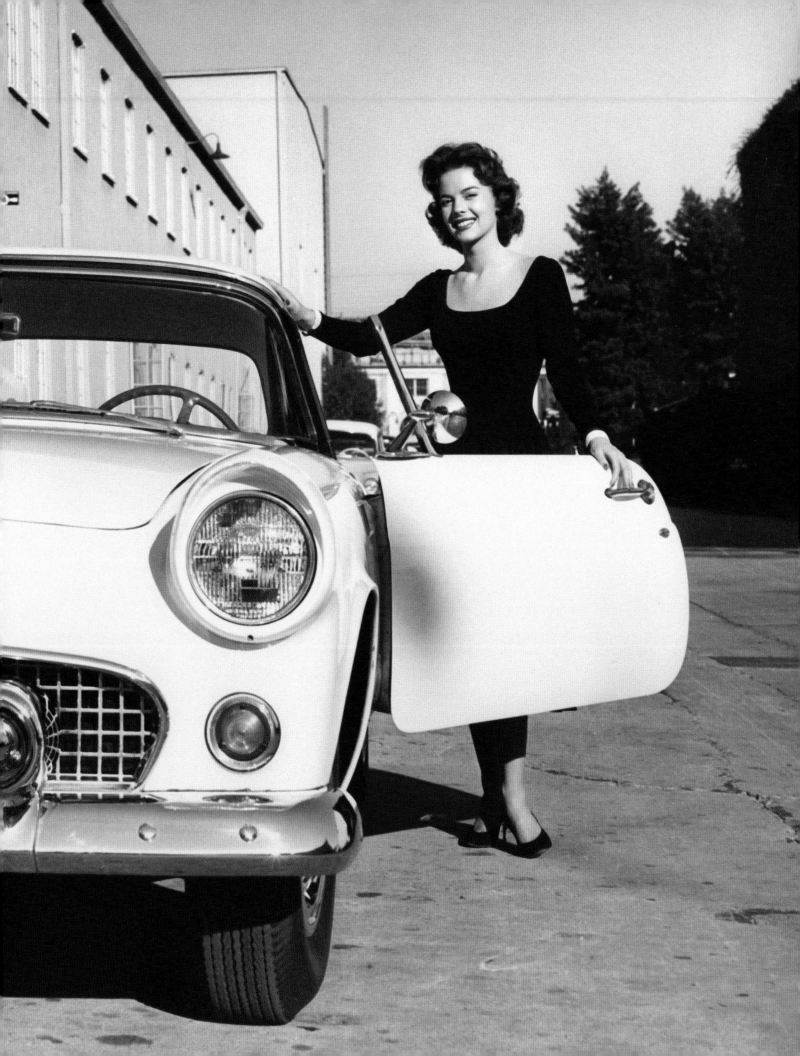

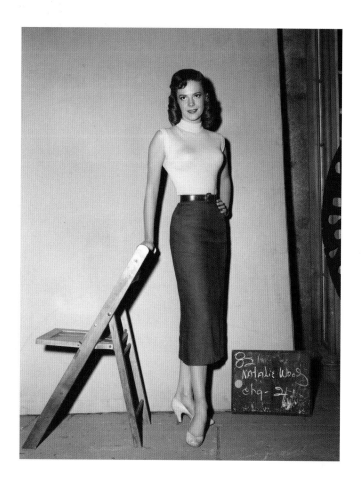
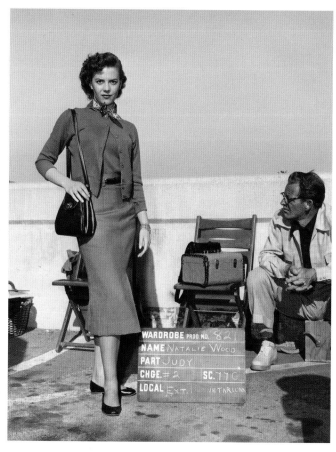

woman in love with a married man. *One Desire* gave her a chance to flirt with the Method and gave the world a brief glimpse of a new, unrestrained Natalie.

"I know everything," Seely brags as she casually pulls up her ragged dress, exposing her dirty, patched bloomers, and throws her legs over the monkey bars in a gesture of blissfully ignorant defiance. Before she matures, Seely fights boys, breaks windows, and sticks her tongue out at the world—a rougher, more provocative girl than any ever portrayed by Natalie Wood. Her inner rebel was starting to seep through the cracks.

For *Rebel Without a Cause* (1955), Natalie would push herself much further. Her lack of formal training served her well as Judy. She was a bundle of raw talent, emotion, and instinct, with no acquired technique to interfere with Ray's direction or Dean's guidance. "Nothing is unimportant, Natalie," Dean told her on the set. "Always listen. Always observe. Always read. Always remember. As an actress, you don't know what you'll be called upon to do." As

filming progressed and Ray saw what Natalie could do, he replaced her Wonder Child title with a new distinction: "The greatest young actress since Helen Hayes."

In a multi-layered characterization—Judy goes from wounded daughter to tough chick to surrogate mother in one day—Natalie hits all the right notes. In the first reel of *Rebel*, before James Dean and Sal Mineo utter more than a few words, Natalie spills her guts in a solid five-minute crying scene, tying the record previously set by Bette Davis in *Winter Meeting* (1948). Against all the odds, at sixteen years old, Natalie had nabbed her Bette Davis-caliber role.

Along with the rest of the cast and crew, Natalie was devastated when James Dean was killed in a car wreck less than a month before *Rebel* was

ABOVE An early costume for *Rebel Without a Cause*, and Judy's final look. Costume designer Moss Mabry made Natalie's lithe figure appear more voluptuous with padding and a specially designed push-up bra. **OPPOSITE** The *Rebel* gang: Natalie, Corey Allen, Nick Adams, Dennis Hopper, James Dean, and an unidentified extra.

released. But his sudden death immortalized his celluloid image, and hers too. A Warner executive explained, "When Jimmy Dean died the kids made him a martyr and latched onto Wood and Mineo." Dean's screen magic rubbed off on his costars, who both became bona fide teen idols in their own rights.

Once again, timing was on Natalie's side. She turned seventeen in the summer of 1955, on the cusp of the rock 'n' roll teen culture explosion. When Natalie's Oscar nomination for *Rebel* was announced, Hedda Hopper declared her "the hottest teenager in town." She was everywhere, gracing magazine covers, glittering on the arms of various actors, flying to Memphis with Elvis. Mud sat at home clipping every news story for the scrapbooks (by now multi-volumed), shocked at the headlines her daughter was generating. "Who are these men?" she asked. "Do you want to torture your mother and father?" In fact, the bulk of the stories published about Natalie were false, or at least exaggerated.

Natalie fought the rumor mill, even managing to convince four nationally syndicated columnists to print retractions of statements they had published.

Ultimately, the gossip helped more than harmed her career. Natalie Wood won a 1956 *Motion Picture* popularity poll, beating out Hollywood giants like Marilyn Monroe, Grace Kelly, and Joan Crawford. No former child actor had ever achieved such a feat: she was the most popular adult female star in the business. The press called it a "jinx-breaker," and her next film appearance confirmed her place at the top. Though her role of Debbie, the object of John Wayne's search in *The Searchers* (1956), was a small one, it made an impact. John Ford's epic western was big box-office and an instant classic. One critic designated Natalie's scene "in the chief's tent, where her eyes silently meet those of her would-be rescuers," as "one of the most chilling moments ever filmed."

Natalie and friends celebrated her eighteenth birthday by sending a box of cigarette butts to

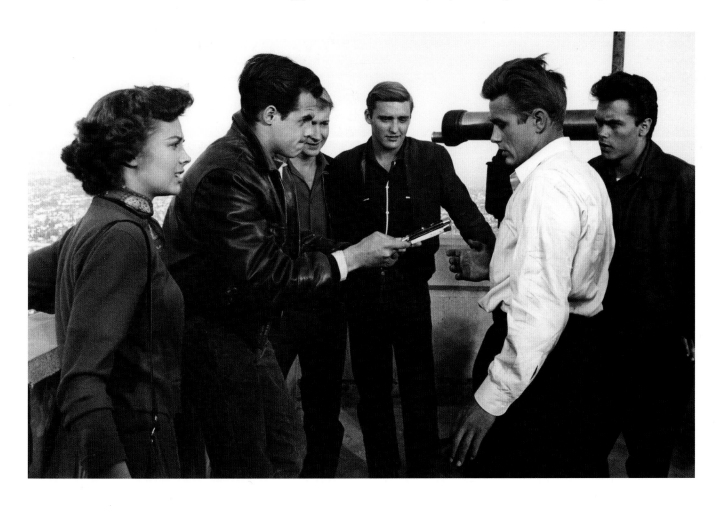

the Board of Education and burning an effigy of a welfare worker in her backyard. She still lived at home with her parents and Lana (who had recently followed her sister's career path, appearing as a young Debbie in *The Searchers*), but Natalie was legally free at last—no more chaperones, no more parental authorization required. She had her own phone line, her own bank account, and her own cigarettes. She had officially made the leap from girl to woman onscreen, but had paid a hefty price for it; she had sold her soul to the brothers Warner.

"Somehow, this indomitable, adorable woman-child, product of a system, has managed to come through."
—Screenwriter Arnold Schulman

Her child-actor curse broken, Natalie was left locked into an exclusive seven-year contract with Warner Bros., who had no idea how to handle their young talent. It was not entirely the studio's fault; the frenzy of teen energy that struck the 1950s was such a shock to the establishment, it took Hollywood years to catch up and create decent parts for teenage actors. So Warners exploited Natalie's popularity by teaming her with blonde beefcake Tab Hunter in two not-so-hot properties "merely to keep [them] busy until something better can be found for them to appear in," according to critic Wanda Hale.

"Don't call them kids—not anymore!" cautioned ads for *The Burning Hills* (1956), a teen romance-western that gave Natalie the role she would later

call her worst ever—Maria, a half-Mexican farmer's daughter who falls for Hunter's cowboy, Trace. Like a campy precursor to Maria in *West Side Story*, *The Burning Hills*' Maria points a gun at her enemies, fires it into the air, and hisses in a pseudo south-of-the-border accent, "Next time, I don't miss!" Critics had a hard time suppressing their laughter, calling Natalie's characterization "quite entertaining," and saying of Hunter, "Tab bares his manly chest and is the male Gina Lollobrigida." No matter. Teenage America adored it, and it earned a profit.

Briefly, Natalie and Tab were movie magazine darlings, photographed all over Hollywood together, the victims of a studio-manufactured relationship. Before the *Burning Hills* fire fizzled, Warners rushed the duo into a follow-up, *The Girl He Left Behind* (1956), jokingly referred to off-screen by Natalie as "The Girl With the Left Behind." Hunter plays army

OPPOSITE Natalie in 1956, the year she was voted Hollywood's most popular actress by readers of *Motion Picture* magazine.
ABOVE "Miss Wood has a lot of dark Max Factor goo on her face in *The Burning Hills*," one reviewer noted of Natalie's Anglo-Mexican makeover.

draftee Andy, and Natalie makes an effort to inject some authenticity into her thankless role as Andy's girlfriend, Susan. But the drama is overwrought and the military gags fall flat. The *New York Times* dismissed the film as a "plaything, which we desperately trust is a farce."

Forgotten in the Natalie-Tab flurry was a film Natalie had fought to be cast in after completing *Rebel*, hoping to stretch her dramatic skills in a gritty psychological thriller. Instead, *A Cry in the Night* (1956) proved another disappointment, though she and costar Raymond Burr hit it off and began dating. Never a homebody, Natalie enjoyed dining out in the company of interesting men, many of whom—Burr, Nicholas Ray, on-again-off-again boyfriend Scott Marlowe, and pal Tab Hunter—were

later revealed to be gay or bisexual. In retrospect, it seems Natalie longed for male companionship without the burden of a serious relationship.

Natalie got a chance to look radiant in WarnerColor and rate top billing in her next project. Unfortunately, the gesture was in name only. *Bombers B-52* (1957) pays more attention to aviators Chuck and Jim (Karl Malden and Efrem Zimbalist, Jr.) than it does to Natalie's Lois, Malden's teenage daughter who is smitten with Jim. Natalie manages to squeeze a few seconds of emotion from the stale family drama—or is it a thrilling airplane adventure? A soap opera of forbidden love? The film's uncertainty even carried over into the title. After marketing it as *No Sleep Till Dawn*, the studio changed it at the last minute. The best critics had to say was that *Bombers*

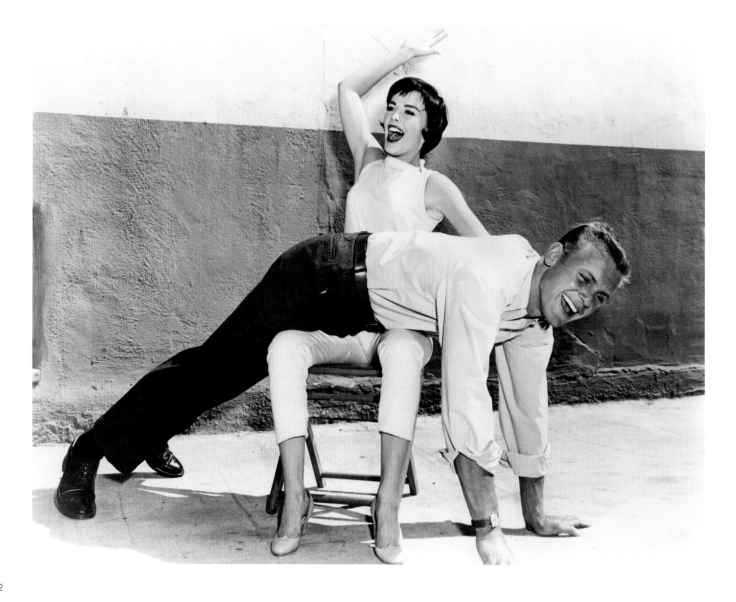

B-52 "could have been much, much worse," a serviceable assessment of every film Warners had given Natalie since *The Searchers*.

Determined to be cast in meatier stories, Natalie heard the studio had recently purchased rights to Herman Wouk's novel *Marjorie Morningstar*, and set her heart on winning the lead role of a young Jewish woman torn between her acting ambitions and her first love, Noel, an entertainer at a Catskills resort. Twenty-two other actresses were up for Marjorie, but when Natalie decided a part was hers—as she had with *Rebel*'s Judy—she was unshakeable. "I campaigned for it like a politician would," she said, "using every trick I could think of." But when she met with Wouk in New York, he was not sold. "It was

obvious to me, almost from the moment I saw her, that she was wrong for the part."

Natalie eventually screen-tested and convinced Wouk (and the studio) to cast her, but her victory was a case of "be careful what you wish for. . . ." Hiring Irving Rapper to direct was Warners' first mistake. Rapper's days of helming Bette Davis dramas were long behind him, and Natalie was an actress who needed a strong director. Script rewrites, budgetary restrictions, and uncertain producers added to the trouble. A superb supporting cast—Gene Kelly, Claire Trevor, Carolyn Jones—and location shots in the Adirondacks helped, but Wouk's first instinct may have been right. Natalie is charming as Marjorie, but she is not the starry-eyed Bronx stenographer-turned-aspiring actress of Wouk's novel. Her performance, like the entire film, is a lackluster effort.

Marjorie Morningstar (1958) was Natalie Wood's first true starring vehicle as a young woman, and its failure represents another missed opportunity for Warner Bros. Three decades later, a similarly-

OPPOSITE "What Natalie needs, perhaps, is an old-fashioned spanking," Tab Hunter told reporters during the making of *The Girl He Left Behind*. Natalie decided it was the other way around.
ABOVE LEFT "I was a wreck during filming," Natalie later said of *Marjorie Morningstar*. "It was a very schizoid performance."
ABOVE RIGHT Following in the footsteps of Olivia de Havilland and Bette Davis, Natalie fought Warner Bros. and won.

themed movie about a sheltered Jewish girl who falls for a suave entertainer at a Catskills resort, *Dirty Dancing* (1987), would be a box-office smash. If the studio had put more effort and money into *Marjorie*, they might have struck *Dirty Dancing*-level gold. But Natalie took her disappointment in stride. While shooting *Marjorie*, she had fallen in love with Robert Wagner, an actor she had admired since the days when they were both at Fox, she shooting *Father Was a Fullback*, he a young contract player. By the time *Marjorie Morningstar* opened to mixed reviews (verdicts on Natalie's performance ranged from the *Hollywood Reporter*'s "practically flawless" to the *New Yorker*'s "no more spiritual content than a Bobbsey twin," and everything in between), Natalie was too busy planning her wedding to suffer much.

She and R.J. (as Wagner is known off-screen)

were a match made in movie heaven, though unlike many of her high-profile dates, their love was the real thing. Both were starstruck stars, raised on Golden Age Hollywood and entranced by its glamour. R.J. had recently ended a long affair with 1930s–40s screen icon (and Natalie's former movie mama) Barbara Stanwyck, and his prized possession was a personally autographed photo of Norma Shearer; Natalie had a collection of over 100 movie star signatures and a parakeet named Gregory Peckwood. They shared a passion for films, for acting, and for each other.

They also adored Frank Sinatra—both the man and his music—and Natalie could not refuse when he insisted on casting her as Monique, a mixed-race French girl caught in a WWII love triangle with Sinatra and Tony Curtis in *Kings Go Forth* (1958). Natalie's

French accent is less than convincing, and her role should have been played by an actress of mixed ethnicity, but the film is a well-intentioned, fairly well-acted allegory of racial prejudice. Ultimately, *Kings* did nothing either to harm or advance Natalie's career, and she remained stuck in the Warner Bros. quagmire.

If Jack L. Warner, head of Warner Bros., expected Natalie to fall back into the same rut of uninspired pictures after her wedding, he was in for a surprise. A stronger, more self-assured Natalie returned from her honeymoon in January 1958, one who would waste none of her talent on mediocre material. Previously, Natalie had agreed to "films I knew weren't so great, hoping all along they'd turn out well, which they didn't. . . . Today, when I'm presented with a weak script, I face up to it and decline it."

When Warner sent her two scripts, for *The Devil's Disciple* and *The Young Philadelphians*, she flatly refused them both. They were not terrible parts, but not right for her. Mr. Warner responded by suspending Natalie without pay for fourteen months—a lifetime in Hollywood. She rejected Warner's offers, but was not allowed to accept work from other studios either.

"I wanted the right to outside pictures and to have more freedom. Money wasn't an issue," Natalie said. Warner Bros. was a powerful corporation, but in July of 1958 they admitted to the *Los Angeles Examiner* that Natalie was their "top box-office draw," so she knew they needed her more than she needed them. While her agents renegotiated her contract, Jack Warner threatened she would never work again, but Natalie stood firm. "There'll always be another picture," was her composed response. "It was fun, I enjoyed it," she said of her suspension. Natalie and R.J. bought and decorated a new home, spent time aboard their yacht, and formed their own production company.

"I'd been working steadily and needed a rest. When you're away from movie-making for a while it gives you a fresher perspective."

Natalie, at last, was her own woman, free from the control of both Mud and Jack Warner. The manic drive to keep acting that had charged her childhood no longer motivated her. She had tasted Oscar-worthiness with *Rebel*, and wanted more. "I'll leave comedy to Debbie Reynolds," Natalie quipped; she yearned for a truly extraordinary role in a powerful, heart-wrenching drama, and she was willing to hold out for it, unemployed, as long as necessary. As luck would have it, master director Elia Kazan and eminent playwright William Inge had a career-defining dramatic role ready for Natalie, and Warner Bros. owned the property, titled *Splendor in the Grass*.

"Little Natalie Beats the Giant" proclaimed a news headline when the actress won her battle with Warner Bros. In the spring of 1959, Natalie returned to the studio in triumph, with more freedom,

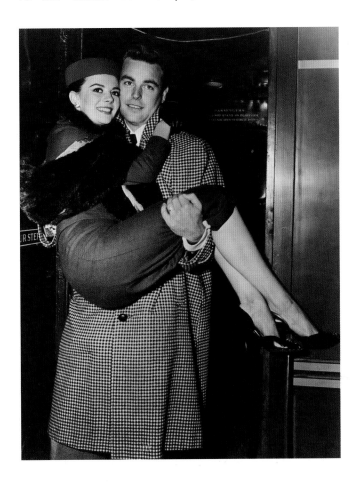

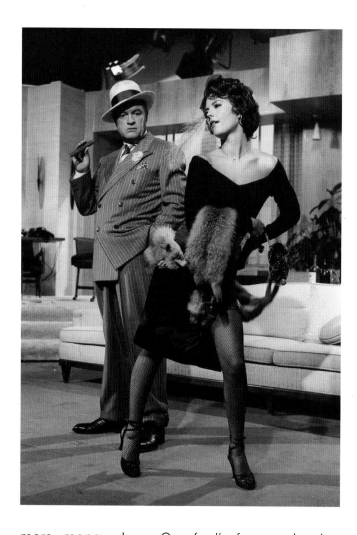

more money, Joan Crawford's former dressing room (the best on the lot), and a dream role as Deanie in *Splendor*. The price for her victory was a minor embarrassment: she agreed to costar with James Garner in the dreary *Cash McCall* (1960), a triviality, but a necessary evil if *Splendor in the Grass* (1961) depended upon it. Under the expert direction of Kazan, Natalie would finally realize her acting potential in *Splendor*, the potential six-year-old Natasha had demonstrated in her scenes with Orson Welles in *Tomorrow Is Forever*. By igniting her adult career, as both respected actress and glamorous movie star, *Splendor* would allow Natalie to fulfill the destiny her mother had foreseen for her since she was a baby—but on her own terms. With her newly gained freedom, she would decide for herself which film to make after *Splendor*, and would choose *West Side Story*.

As the 1950s came to a close, Natalie was a seasoned veteran with a stellar fifteen-year career behind her, and still the best was yet to come. At twenty-one, she had overcome the pitfalls of the film industry and was poised and prepared for the next phase of her life, as one of Hollywood's brightest stars.

Seventy years after her first major film role, Natalie Wood is still unique in twentieth-century Hollywood. Among a generation of actors that came of age in the 1950s—ranging from teen sensations (Connie Stevens, Frankie Avalon, Annette Funicello) to enduring adults (Jane Fonda, Jack Nicholson, Dustin Hoffman)—Natalie is the one and only to start as a 1940s child celebrity, become a 1950s pin-up princess, and transition to a major 1960s star, a three-time Oscar nominee.

She may not have been aware of it at the time, but in retrospect, Natalie is an important link between distinct periods in film history. Studio-era stars like Barbara Stanwyck, Jimmy Stewart, and Fred MacMurray had little in common with the post-Brando crowd that included James Dean, Dennis Hopper, and Steve McQueen. Their approach to acting was radically different, and they ran in incompatible social circles. But their one common link was Natalie, who always remained as fond of MacMurray as of McQueen. As she bridged the gulf between child and adult onscreen, she also bridged the generation gap between Old Hollywood and the New Vanguard. Her star quality was mutable, shifting with ease through a variety of styles and trends, making her seem fresh and vital today—yet somehow still a product of a glamorous Hollywood that exists no more. For over a quarter of the twentieth century, Natalie Wood *was* Hollywood.

Sloan De Forest

ABOVE "I think Natalie Wood is the most tremendous young talent in our business," Bob Hope said when she appeared on his TV special in 1959. OPPOSITE Natalie Wood "may be destined to return to Hollywood some of the color and excitement it lost," observed a reporter in the late 1950s.

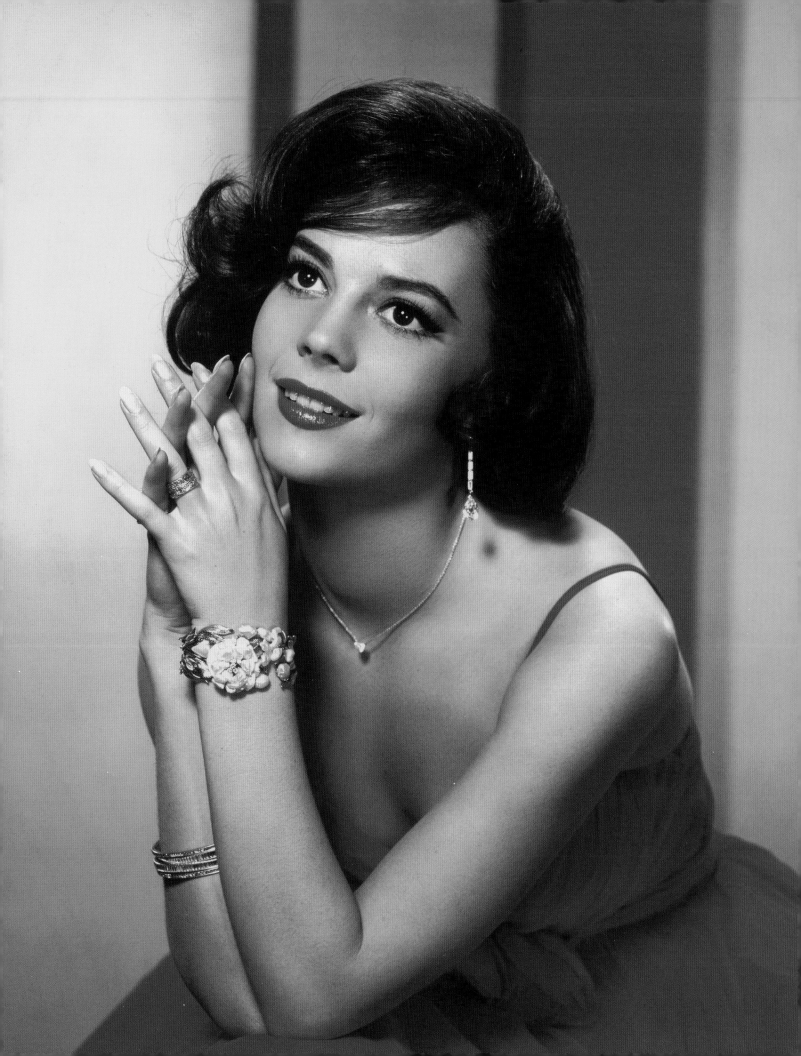

Scrap Book

NATALIE WOOD

Childhood Career 1943-1955

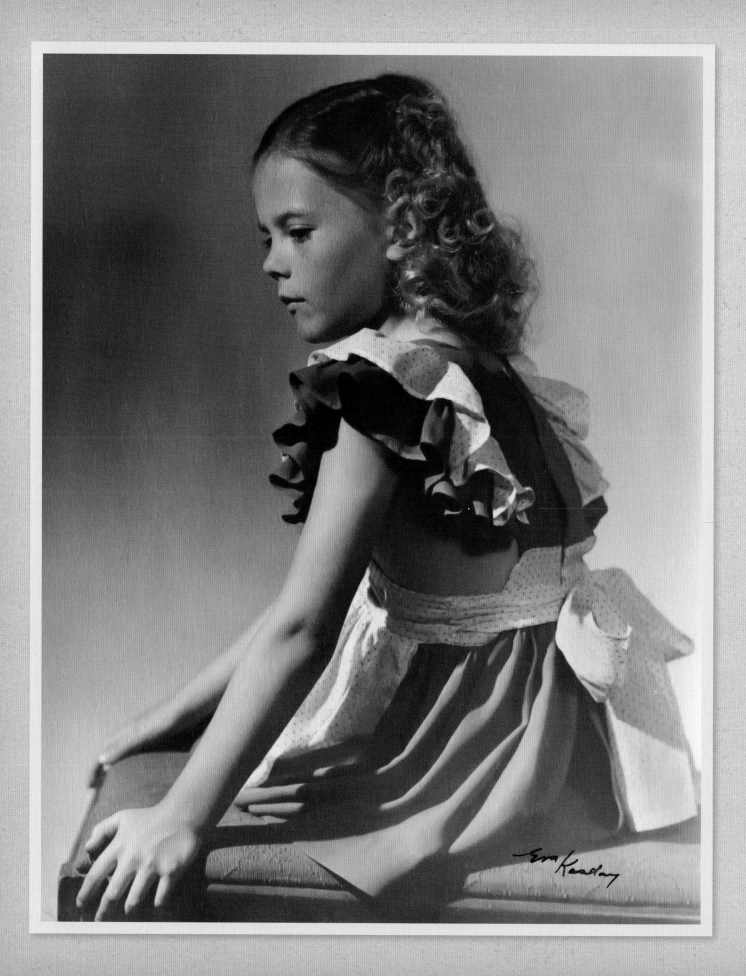

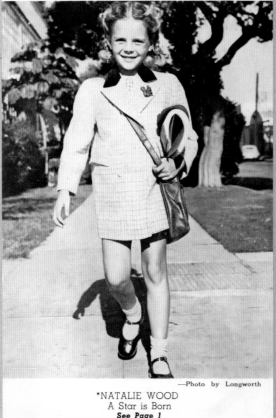

Santa Rosa 'Starling' Now 'Natalie Wood' in Movies

Another Santa Rosa "Cinderella," little Natasha Gurdin, 6, whose alert personality attracted the eye of Director Irving Pichel while he was in Santa Rosa directing filming of a picture two years ago, is making good as a "moppet" star in Hollywood, where she has appeared in three pictures under her new name, Natalie Wood.

Natalie, daughter of a Russian engineer who resided in Humboldt street here, was just four years of age when she attracted Pichel's interest.

Result of his interest was a seven-year contract and impor-

tant parts in "The Bride Wore Shoes," and in "Tomorrow is Forever," starring Orson Welles.

Life Magazine gives the new child star a two-page spread in the current week's issue, and predicts that her future in pictures will be bright.

The Gurdin youngster, like Edna Mae Wonacott who is also making a Hollywood success, was "discovered" by the director on a downtown street. Edna Mae was whisked into pictures by Alfred Hitchcock, famous British director, who gave her an important part in his first picture filmed in Santa Rosa, "Shadow of a Doubt."

OPPOSITE An early portrait of Natalie commissioned upon her arrival in Hollywood, 1945. CLOCKWISE FROM TOP LEFT Natalie's film debut in the 1943 feature *Happy Land* consisted of this fleeting glimpse of the crying four-year-old being carried away by her screen mother; One of Natalie's first magazine covers was the November 5, 1945 issue of *Copy: This Week in Hollywood*; Natalie's fame is used to promote Little Lady, a line of cosmetics for young girls; Scrapbook clipping from a Santa Rosa newspaper.

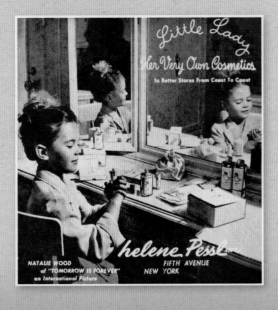

Little Lady
Her Very Own Cosmetics
In Better Stores From Coast To Coast

NATALIE WOOD
of "TOMORROW IS FOREVER"
an International Picture

helene Pessl
FIFTH AVENUE
NEW YORK

61

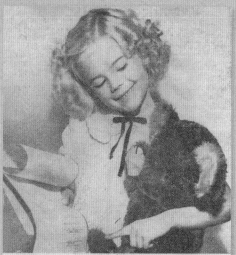

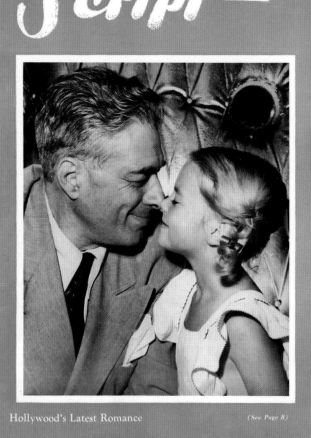

Child Actress Has Contract Approved

Carrying a big brown teddy bear and a seven-year contract with International studios, 6-year-old Natalie Wood appeared before Superior Judge Emmet H. Wilson yesterday with her parents, who were ordered to invest a percentage of her week in War Bonds.

Natalie lives with her parents, Mr. and Mrs. E. Gurdin, in Beverly Hills. She attends West Hollywood Grammar School and plans to be an actress when she grows up, she said.

Times photo
SEVEN-YEAR CONTRACT—Natalie Wood, 6, as she appeared in court for permission to work in pictures.

Rob Wagner's
Script

December 1, 1945
15 Cents

Hollywood's Latest Romance (See Page 8)

CLOCKWISE FROM TOP LEFT Natalie signs her first studio contract with International Pictures, May 1945; An early color portrait, circa 1945; Caricature of George Brent, Richard Long, Orson Welles, Claudette Colbert, and Natalie Wood in *Tomorrow Is Forever*; Natalie appeared with her mentor Irving Pichel on the December 1, 1945 issue of Rob Wagner's *Script*, a trade publication.

ABOVE In 1945, Martha Holmes photographed Natalie with her cat Vosca for a feature in *Life* magazine. The six-year-old's menagerie of pets included three dogs, a cockatiel, five parakeets, two finches, three turtles, and a few hamsters.

NATALIE WOOD was born Natasha Gurdin in San Francisco, July 20, 1938, the second daughter of Maria and Nicholas Gurdin, who came from Russia to China and then to San Francisco where they met and were married. In 1943 the Gurdins moved to Santa Rosa, California, where as "volunteer extras" they met Director Irving Pichel, then filming "Happyland." Pichel wrote the Gurdins about their daughter several times after returning to Hollywood and, two years later, when he had an opportunity to give her a screen test, he sent for her. After an amazingly fine performance in the test, Natalie was given a long-term contract by International Pictures and assignment of the role of Margaret, one of the most dramatic parts in "Tomorrow Is Forever." Later, when International loaned Director Pichel to Paramount for "The Bride Wore Boots," Natalie won a second featured role, supporting Barbara Stanwyck. When Natalie started to West Hollywood school (September, 1945) she skipped from the first grade to the third in four months and continued to lead her class. She also studied dancing and piano. When "Tomorrow Is Forever" had its premiere at the Winter Garden, New York City, Natalie went East with her father to attend. It was Natalie's first train trip, her first experience with cold weather and snow. She visited Cincinnati, Chicago, Salt Lake City and San Francisco en route home, arriving to find her mother had gone to the hospital for the birth of a baby sister, Svetlana. Natalie was 46 inches tall and weighed 46 pounds, March 15, 1946. She has brown eyes and light brown hair. Soon she'll have starring roles. She is a quiet, very observing, unusually talented but unaffected mite. Her baby sister, a girl school chum across the street, and 34 dolls occupy most of her attention outside of school and studio hours. She also answers some of her increasing number of fan letters with personal notes in addition to autographing her fan photos.

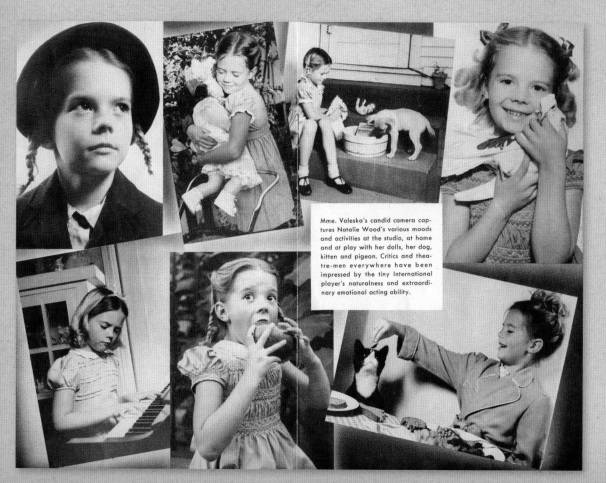

Mme. Valeska's candid camera captures Natalie Wood's various moods and activities at the studio, at home and at play with her dolls, her dog, kitten and pigeon. Critics and theatre-men everywhere have been impressed by the tiny International player's naturalness and extraordinary emotional acting ability.

ABOVE AND LEFT To illustrate a 1946 publicity pamphlet exploiting her daughter's talents as an actress, Maria Gurdin hired photographer Madame Valeska to capture images of Natalie's "various moods and activities at the studio, at home, and at play."

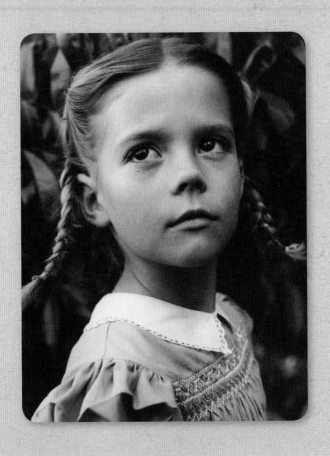

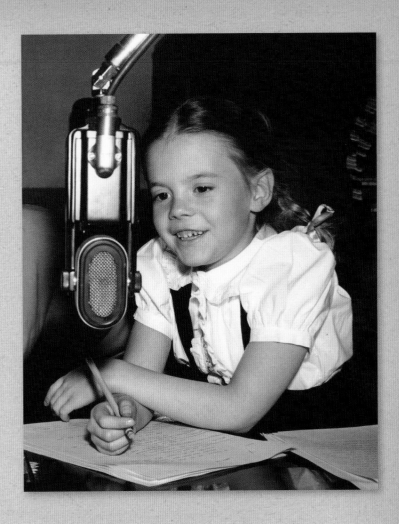

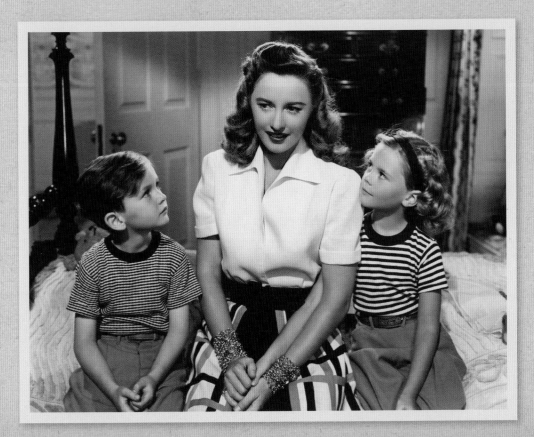

ABOVE LEFT A 1946 candid by Valeska. ABOVE RIGHT Natalie got her first taste of the studio publicity machine when she traveled to several U.S. cities to promote the release of *Tomorrow Is Forever*, where she met with the press and made radio appearances. LEFT In 1946, Natalie (with costars Gregory Muradian and Barbara Stanwyck) was loaned to Paramount for *The Bride Wore Boots*, her third and final film directed by Irving Pichel. Though contemporary sources credit her with a role in Pichel's 1943 drama *The Moon Is Down*, Natalie was not cast in that film, and does not appear in it.

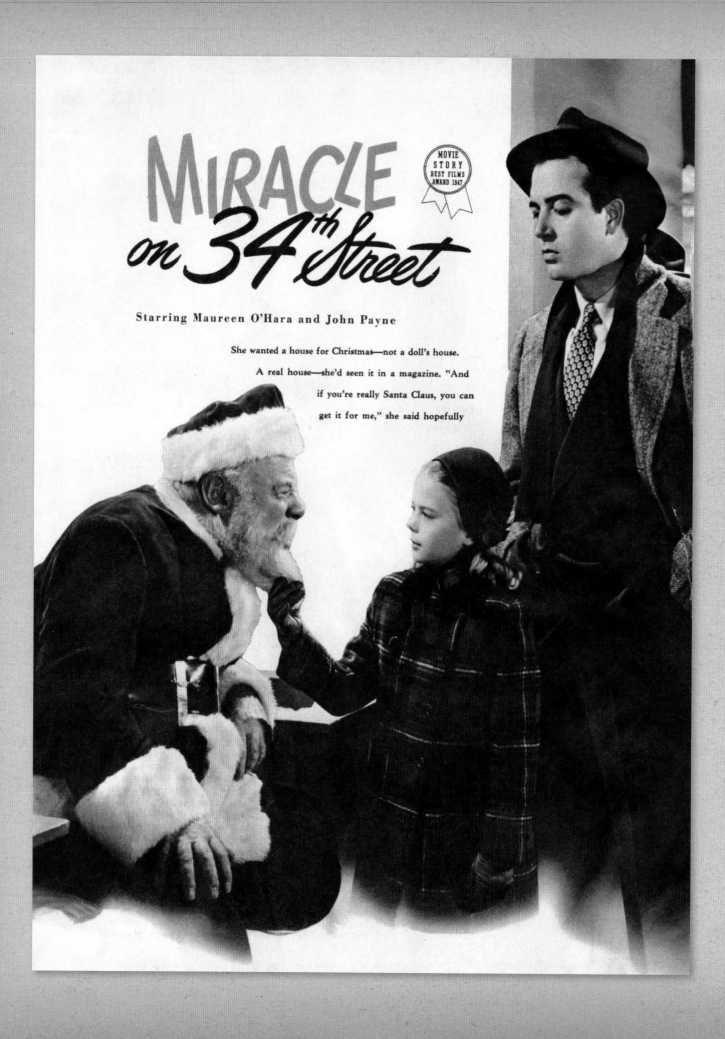

MIRACLE on 34th Street

Starring Maureen O'Hara and John Payne

She wanted a house for Christmas—not a doll's house.
A real house—she'd seen it in a magazine. "And
if you're really Santa Claus, you can
get it for me," she said hopefully

OPPOSITE *Miracle on 34th Street* features a young girl named Susan (Natalie with John Payne) who has been raised by her mother to be skeptical about Santa Claus (Edmund Gwenn). **ABOVE LEFT** A typical little girl, Natalie loved her dolls, including this life-sized Dutch boy that she lovingly carries on the *Miracle* set. **ABOVE RIGHT** Natalie loved working with Edmund Gwenn, who won an Oscar for his portrayal of Kris Kringle. "He was a really rare, rare person," Natalie remembered, "very warm. And there was just something about him that was extraordinary." **LEFT** Natalie enjoyed bringing gifts to the set for her beloved "Mama Maureen." O'Hara said later, "Of course, I loved Natalie Wood. She was a sweetheart of mine."

LEFT The costumes for *Miracle on 34th Street* were designed by Kay Nelson, whose credits include *Leave Her to Heaven* and *Gentleman's Agreement*. **BELOW LEFT** In 1947, Natalie worked on Joseph L. Mankiewicz's *The Ghost and Mrs. Muir* and George Seaton's *Miracle on 34th Street* simultaneously. Here, Seaton confers with Natalie about *Miracle* while she prepares for a scene in *Ghost*. **BELOW RIGHT** Natalie chats with a young extra on the set of *Miracle on 34th Street*. **OPPOSITE** A color-tinted magazine ad for *Miracle*.

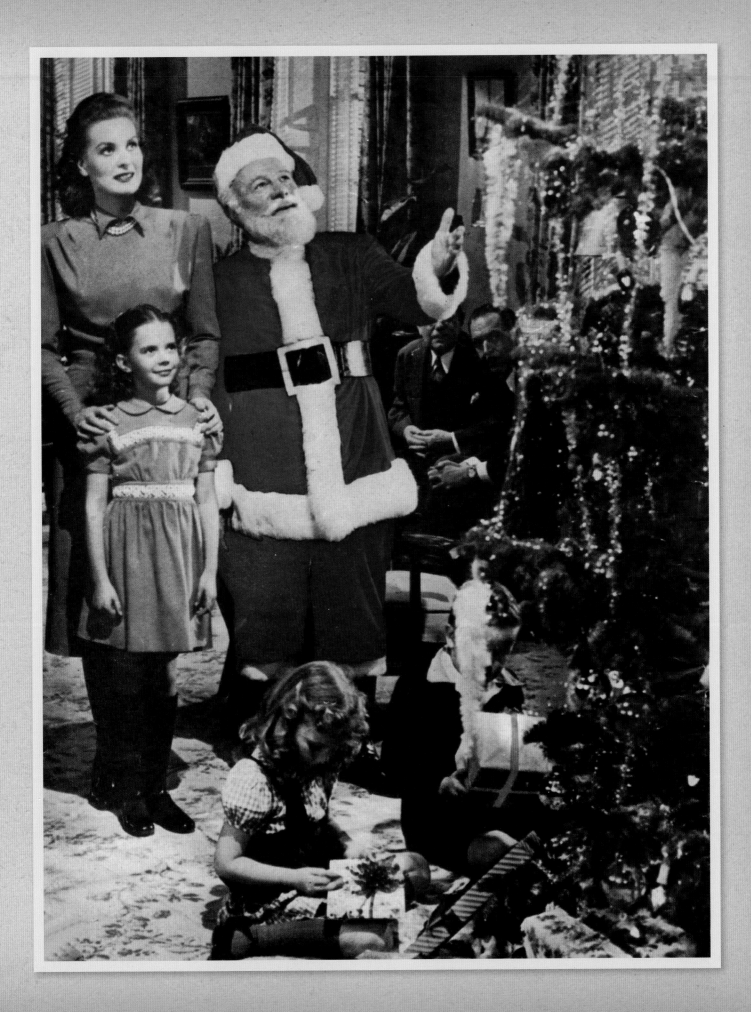

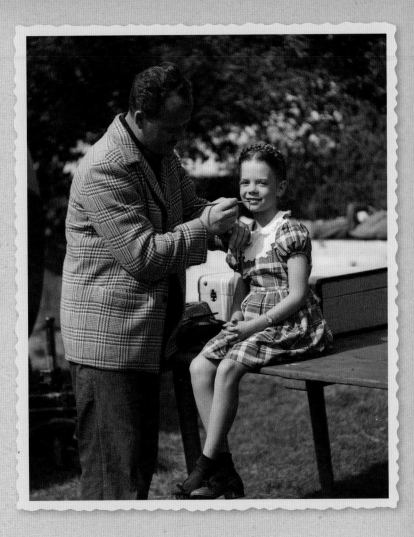

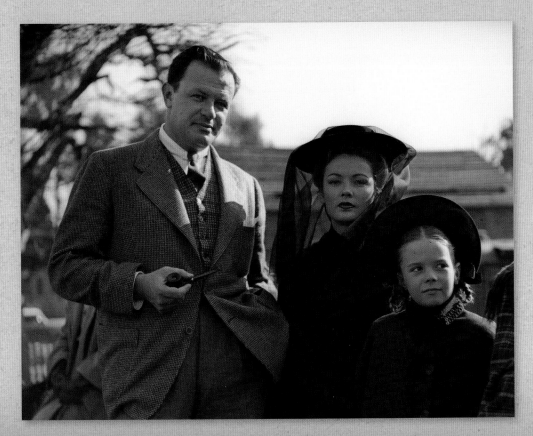

OPPOSITE Natalie's role as the young Anna in *The Ghost and Mrs. Muir* was small, but effective. Natalie's resemblance to Gene Tierney helped win her the part. **TOP LEFT** Natalie plays director while sitting on David Thursby's lap. **TOP RIGHT** Already a pro at age eight, Natalie sits patiently as a makeup artist gets her camera-ready. **LEFT** Director Joseph L. Mankiewicz on location with his *The Ghost and Mrs. Muir* stars, Gene Tierney and Natalie Wood. The California coastline doubled for the fictitious English village of Whitecliff-by-the-Sea.

ACTION
TWENTIETH CENTURY FOX STUDIO CLUB......

STOP

Golf Tournament · 1947

ABOVE *Action* was an official publication of Twentieth Century Fox Studio Club. The August 1947 issue featured Natalie along with Roger DeWeese, son of Fox employee Al DeWeese, in a back-to-school motif. **LEFT** Original slides from the *Action* photo session.

Natalie Wood Contract OKd

Natalie Wood is a little pigtailed blonde with a big salary and savings plan.

Yesterday Superior Judge

← Frank G. Swain approved the eight-year-old girl's seven-year contract with 20th Century-Fox Studios.

Miss Wood will put 30 per cent of her $1000-a-week salary into government bonds.

She was discovered at the age of four by Director Irving Pichel while he was on location in Santa Rosa.

SAVING MISS—Natalie Wood, 8, attends to her knitting, especially in financial matters. With a seven-year film contract, she proposes to save 30 per cent of her $1000 a week salary.
—Los Angeles Examiner photo.

MISS NATALIE WOOD

TOP LEFT In July of 1947, Twentieth Century Fox signed Natalie to a long-term contract. While the judge reviewed the paperwork, Natalie knitted a blue sweater. **TOP RIGHT** The 1947 movie *Driftwood* gave Natalie her most substantial role to date. **LEFT** In the late 1940s, Natalie made several appearances on *Family Theater*, a faith-based radio program. Here, Natalie joins Edgar Barrier and Phillip Terry for "Descent into Paradise," a half-hour drama about a crippled composer, his young daughter, and a famous concert pianist.

73

ABOVE AND RIGHT Magazine ad and scene still from *Driftwood*, featuring Jenny (Natalie Wood) and her dog "Hollingsworth," who becomes her companion in the film. The country was in the midst of a Collie craze and Republic Pictures was cashing in on the current popularity of M-G-M's famous canine, Lassie.

TOP Natalie performs candle-lighting duties at the investiture service for Girl Scout troop 116 of Bret Harte School in Burbank. **ABOVE** Natalie meets her favorite cowboy star, Roy Rogers, on the set of *Driftwood*. **RIGHT** Natalie is awarded the statuette for Most Talented Juvenile Motion Picture Star of 1947 from Phil Willcox of *Parents* magazine.

Twentieth Century-Fox Film Corporation

STUDIOS
BEVERLY HILLS, CALIFORNIA

Dear Little Natalie:

About 10 years from now when you're a grown up movie star, I will be telling people proudly that I had you in my first picture when you were just a little bean.

Just stay as sweet and natural as you are now, and you will always remain, as you are already today, a fine little actress.

I loved having you in SCUDDA HOO! SCUDDA HAY!, and hope to have you in many more pictures.

Affectionately,

TOP LEFT Natalie measures up in her first color film, *Scudda Hoo! Scudda Hay!*, with costar Tom Tully. **TOP RIGHT** A 1948 letter from F. Hugh Herbert, writer/director of *Scudda Hoo! Scudda Hay!* **BOTTOM LEFT** Natalie's Twentieth Century Fox report card. **BOTTOM RIGHT** Natalie as she appears in the 1949 comedy *Chicken Every Sunday*.

REPORT CARD
FOR
Natalie Wood

PUPIL'S NAME *Wood, Natalie* GRADE *B-5*

TERM ENDING *June 18, 1948*

QUALITIES OF CITIZENSHIP
KINDERGARTEN, GRADES ONE THROUGH SIX

QUALITIES	FIRST TEN WEEKS			SECOND TEN WEEKS		
	Outstanding	Satisfactory	Unsatisfactory	Outstanding	Satisfactory	Unsatisfactory
Effort	✓			✓		
Accomplishment	✓			✓		
Obedience	✓			✓		
Dependability	✓			✓		
Promptness	✓					
Cooperation				✓		
Courtesy	✓					
Enthusiasm	✓			✓		
Habits of thrift						
Habits of good health						

A CHECK (✓) WILL INDICATE QUALITIES OF PUPIL CITIZENSHIP AS OBSERVED BY TEACHERS

ELEMENTARY SCHOOL SUBJECTS
GRADES ONE THROUGH SIX

SUBJECTS	FIRST TEN WEEKS					SECOND TEN WEEKS				
	A	B	C	D	F	A	B	C	D	F
Reading						✓				
Language						✓				
Handwriting						✓				
Spelling						✓				
Arithmetic						✓				
Geography						✓				
History						✓				
Science						✓				
Music *Spanish*						✓				
Art										
Practical Arts										
Physical Education										

A—Excellent B—Good C—Average D—Fair F—Unsatisfactory

A CHECK (✓) WILL INDICATE TEACHERS' EVALUATION OF PUPIL ACCOMPLISHMENT

RECORD OF ATTENDANCE

	FIRST TEN WEEKS	SECOND TEN WEEKS
Number of days present		
Number of days absent		
Number of times tardy		

LOS ANGELES CITY SCHOOL DISTRICT

SCHOOL **Twentieth Century-Fox**

ADDRESS **10201 W. Pico Blvd.**
LOS ANGELES, CALIFORNIA

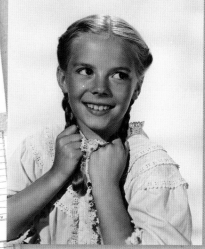

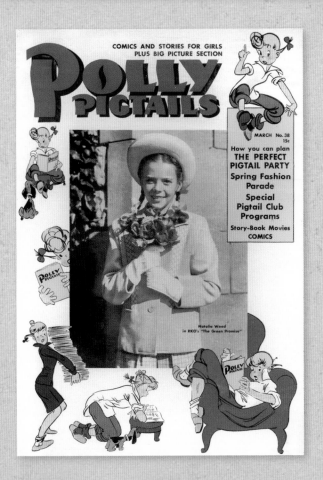

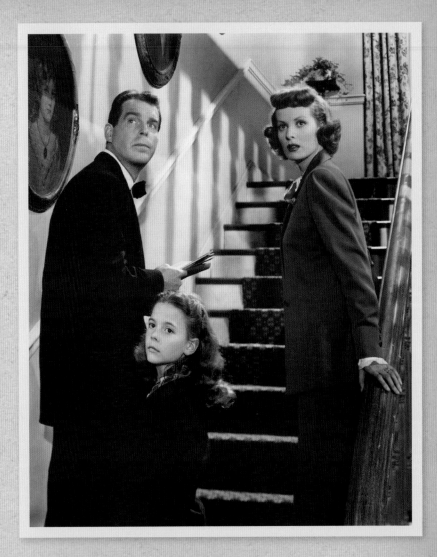

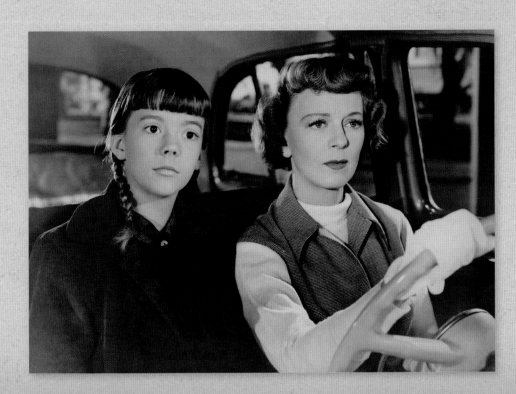

TOP LEFT Natalie was a 1949 cover girl for *Polly Pigtails*, a specialty magazine aimed at young girls. **TOP RIGHT** Like Maureen O'Hara (right), Fred MacMurray (left) twice portrayed a parent to Natalie on screen. This first time was in the family comedy *Father Was a Fullback*. **LEFT** Natalie costarred with Margaret Sullavan in the 1950 drama *No Sad Songs for Me*, Sullavan's final film appearance.

TOP LEFT The 1949 film, *The Green Promise* promoted the 4-H youth development organization popular at the time. The four H's stand for "head, heart, hands, and health." **TOP RIGHT** Natalie's character, Susan, dresses up as a bunny rabbit for a costume party, a pivotal sequence in *The Green Promise*. **RIGHT** With Tommy Rettig and the legendary James Stewart in 1950's *The Jackpot*. At twelve, Natalie was cast as a child of eight, a gimmick that was beginning to wear thin.

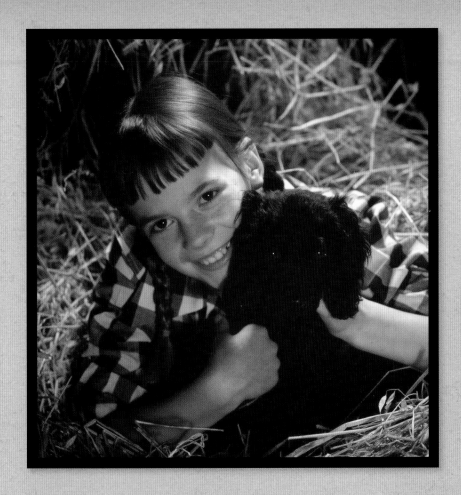

CLOCKWISE FROM TOP LEFT A portrait taken during the filming of *Never a Dull Moment* in 1950; Maria packs Natalie's lunch at home, circa 1950; Radio producer Les Mitchel hosts Natalie and athlete-turned-actor Michael Kirby at his swim party; Natalie gives Edward Arnold a kick in the forgettable 1951 comedy *Dear Brat*.

ABOVE Years before he knew them, three key women in Robert Wagner's life attended ballet class together. Natalie is second from the left, and the two girls on the far right are Jill Oppenheimer and Taffy Paul, better known as Jill St. John and Stefanie Powers. On the right is Robert Banas, who would later appear with Natalie in *West Side Story*. **RIGHT** Friend and dance partner Robert Banas visits Natalie on the set of the 1950 film *Our Very Own*.

NATALIE WOOD

Plays

Barbara Blake

"Just for You"

A Paramount Picture

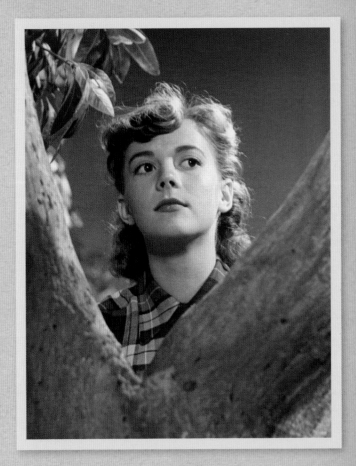

LEFT Jane Wyman, here in *The Blue Veil*, played a mother figure to Natalie in two different films. **BOTTOM LEFT** A trade ad announces Natalie's role in *Just for You*, starring Bing Crosby and Jane Wyman. **BOTTOM RIGHT** In a 1952 episode of the NBC series *Hollywood Opening Night* titled "Quite a Viking," Natalie appeared opposite Ann Harding and former *Driftwood* costar Dean Jagger.

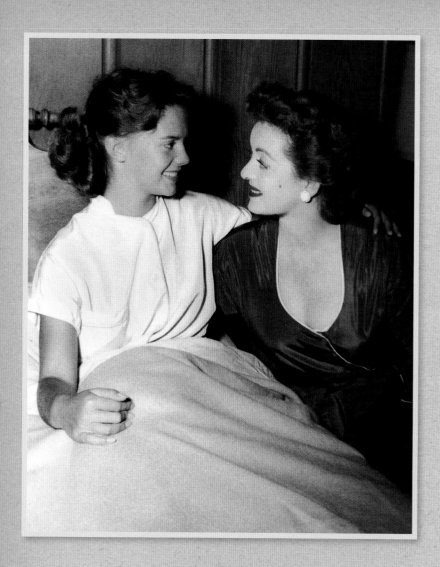

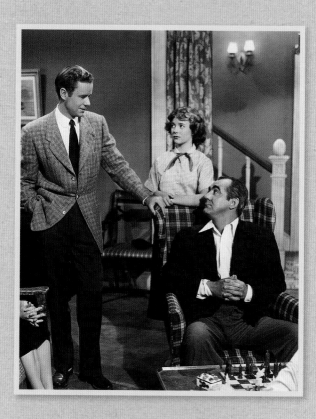

TOP LEFT Years after working with Bette Davis in 1952's *The Star*, Natalie said, "She couldn't have been kinder. She couldn't have been more helpful and generous …I love her." **TOP RIGHT** With Marshall Thompson and Jim Backus in *The Rose Bowl Story*. **RIGHT** After finishing *The Star*, Bette Davis sent out a mass telegram inviting cast and crew to a dinner party.

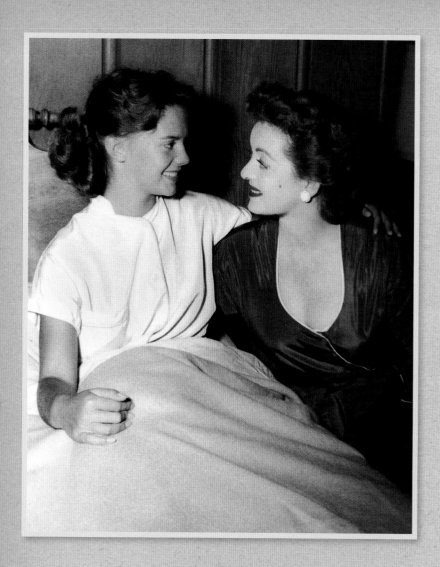

WESTERN UNION

1201

W. P. MARSHALL, PRESIDENT

CLASS OF SERVICE
This is a full-rate Telegram or Cablegram unless its deferred character is indicated by a suitable symbol above or preceding the address.

SYMBOLS
DL=Day Letter
NL=Night Letter
LT=Int'l Letter Telegram
VLT=Int'l Victory Ltr.

The filing time shown in the date line on telegrams and day letters is STANDARD TIME at point of origin. Time of receipt is STANDARD TIME at point of destination

1952 SEP 5

OA284 LK159

L.HDB048-050 PD=HD HOLLYWOOD CALIF 5 NFT=

NATALIE WOOD=

 17160 GRESHAM ST DI 3-3742 NORTHRIDGE CALIF=.

SINCE WE HAVE SPENT SO MANY NIGHTS WORKING TOGETHER IT IS
TIME WE SPENT A NIGHT EATING AND DRINKING TOGETHER. YOU AND
YOUR WIFE, HUSBAND, GUY OR DOLL ARE INVITED TO THE CAPTAINS
TABLE 301 LA CIENEGA BLVD ONE BLOCK SOUTH OF BEVERLY BLVD
SUNDAY EVENING AT SEVEN THIRTY FOR DRINKS AND TEN O'CLOCK
DINNER. HOME TO BED, WHO KNOWS. PLEASE BRING THIS TELEGRAM
FOR ADMITTANCE=

 BETTE DAVIS=

THE COMPANY WILL APPRECIATE SUGGESTIONS FROM ITS PATRONS CONCERNING ITS SERVICE

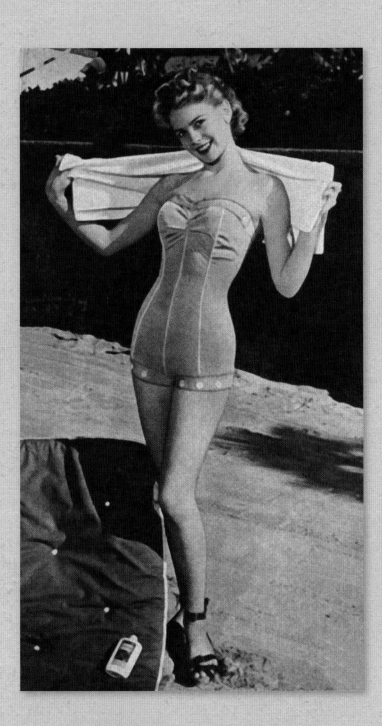

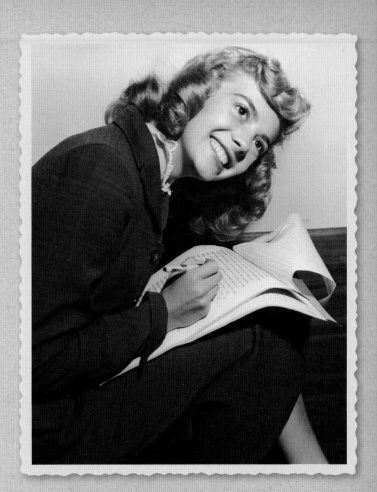

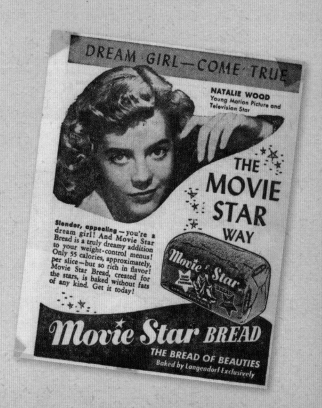

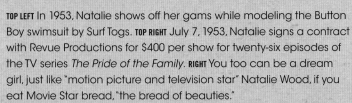

TOP LEFT In 1953, Natalie shows off her gams while modeling the Button Boy swimsuit by Surf Togs. **TOP RIGHT** July 7, 1953, Natalie signs a contract with Revue Productions for $400 per show for twenty-six episodes of the TV series *The Pride of the Family*. **RIGHT** You too can be a dream girl, just like "motion picture and television star" Natalie Wood, if you eat Movie Star bread, "the bread of beauties."

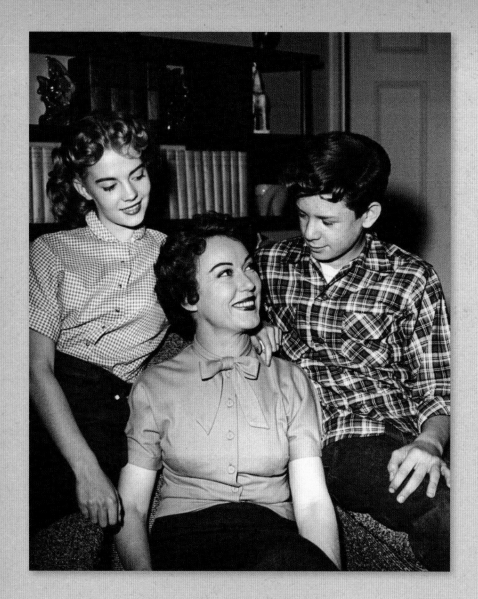

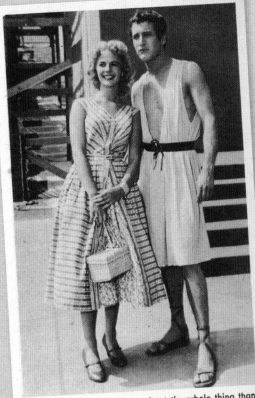

Natalie looks much happier about the whole thing than her companion, Paul Newman, as they stroll on the lot.

CLOCKWISE FROM TOP LEFT Natalie, Robert Hyatt, and Fay Wray in the 1953 TV sitcom *The Pride of the Family*, which ran on ABC for one season; With Paul Newman on the Warner Bros. lot in 1954, during production of *The Silver Chalice*. The two never appear together on screen; B.G. Norman, Gigi Perreau, and Charles Boyer starred with Natalie on a 1955 *Four Star Playhouse* episode titled "The Wild Bunch."; Natalie's ticket for the Hollywood preview of *The Pride of the Family*. OPPOSITE TOP With Rock Hudson on the set of the Ross Hunter-produced period drama *One Desire*. Natalie said she found Rock "lots of fun" and appreciated his "wolf-whistle" at her when she walked on set in a wasp-waisted hoopskirt and upswept hairdo. OPPOSITE BOTTOM Natalie transforms from a child to a woman in *One Desire*, 1955. OVERLEAF Nicholas Ray guides Natalie in her breakout role as Judy in *Rebel Without a Cause*, 1955.

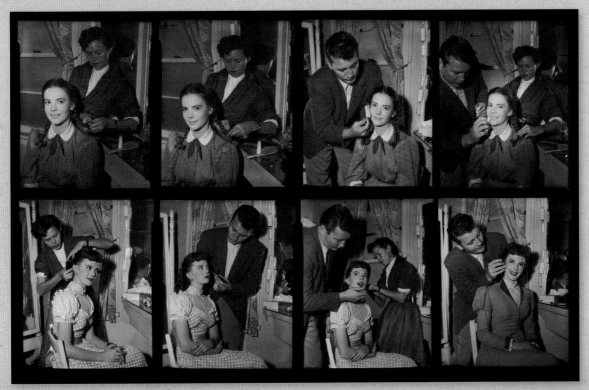

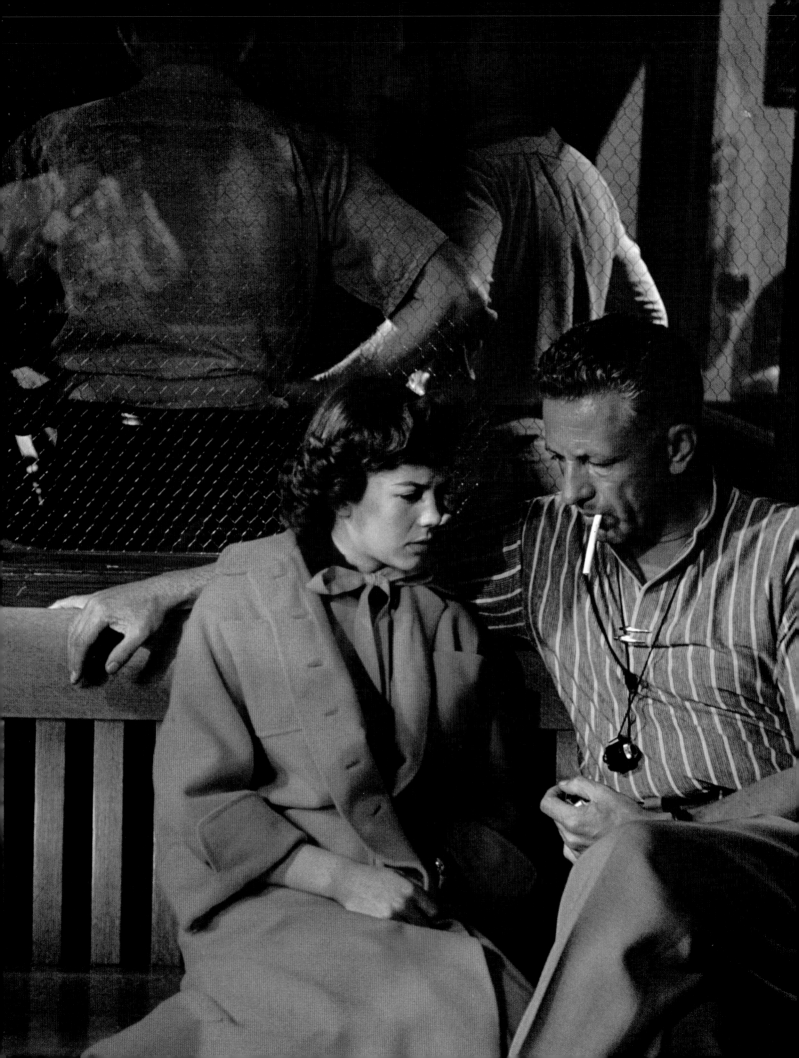

REBEL WITH A CAUSE

Natalie vs. Hollywood

1955–1960

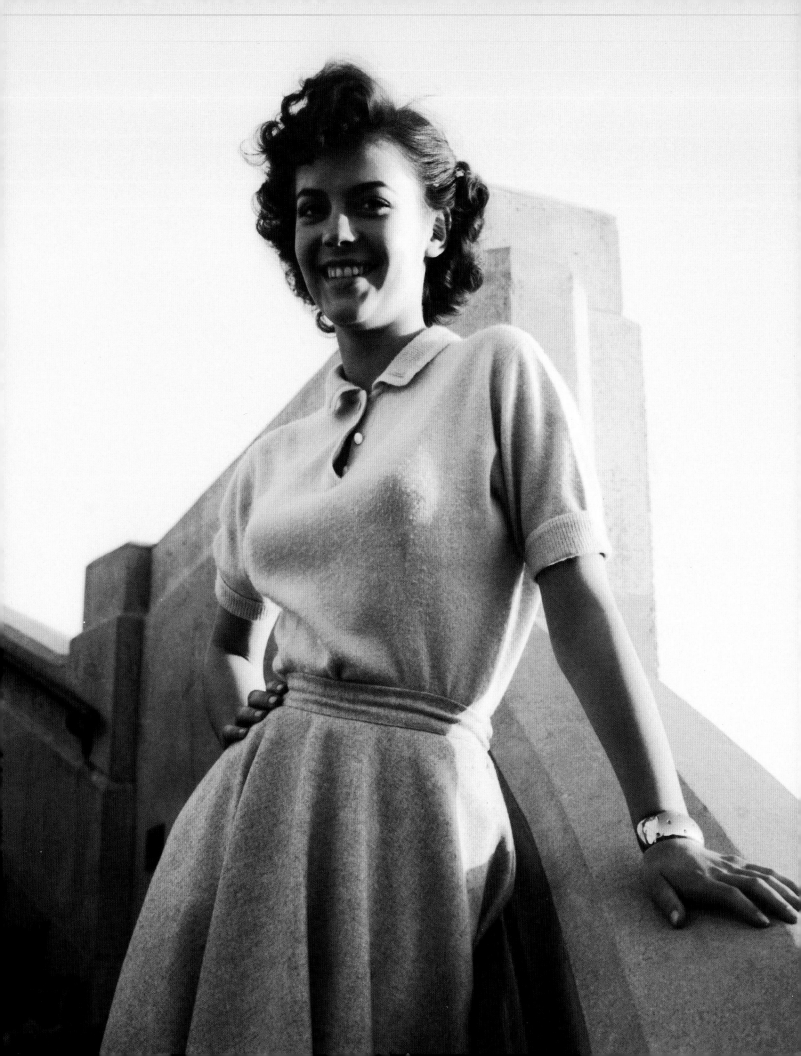

REBEL WITHOUT A CAUSE

"All the time, I've been looking for someone to love me. And now I love somebody."

At its core, *Rebel Without a Cause* is not a story about rebellion, but about love; the need for familial as well as romantic love. Natalie related to her character's quest for parental affection, and she relished the chance to fall in love on screen with James Dean. Costar Sal Mineo recalled, "He was all she could talk about. Every night, for weeks in a row, she went to see *East of Eden*—she must have seen it over fifty times." Off the screen, Natalie and Dean were merely good friends.

Natalie was involved with the movie's director, Nicholas Ray, long before the role of Judy was hers. "I think there were fifty of us to begin with," Natalie said of the screen-testing process. Carol Lynley and Lee Remick were among the hopefuls. "But the big problem was that. . . I was finding it difficult to convince—and Nick was [as well]—the studio that I was out of pigtails." Their affair was a well-kept secret, Ray being over forty, Natalie not yet seventeen.

Rebel was a passion project for Ray. "Kids. I want to do a film about kids growing up, the young people next door, the middle-class kids. Their problems. The misfits." He wrote a treatment he called *The Blind Run* as an "attention grabber." Warner Bros. already owned the rights to a nonfiction book with the title

OPPOSITE Natalie waits for sundown, in order for night scenes at the Griffith Observatory to be shot in the spring of 1955. RIGHT Posters for *Rebel* had been designed before James Dean's sudden death a month before the film's release.

Rebel Without a Cause: The Hypno-Analysis of a Criminal Psychopath. The picture was greenlit as an amalgam of treatment and title.

Ray, with co-writer Stewart Stern, imagined a "teenage trinity," an "idealized family," at the film's center. Jim Stark (the surname a scramble of the last name of Dean's *Eden* character, Cal Trask) is the new teen in town, lost and prone to trouble at school and at home. Judy, pretty and popular, desperately seeks out fast company to provoke the attentions of her neglectful father. John (Mineo), called Plato, is in the care of the housekeeper, his parents absent without leave. As the photo of Alan Ladd in his locker and his laser focus on Jim suggest, Sal Mineo, in his own words, played "the first gay teenager in feature films." The trio is bound by what Stern called "object tracks"; Jim's jacket, Judy's compact, and Plato's gun unite the three in the tight twenty-four-hour scenario.

Corey Allen, Dennis Hopper, and Nick Adams are the provocateurs of the loose high-school gang, supporting Ray's concept of keeping "youth . . . in the foreground and adults, for the most part, only to be seen as the kids see them." Those adults are represented by Jim Backus, Ann Doran, Edward Platt, and Hedda's son, Edward Hopper. Depicting parents as distant, ridiculous figures was a radical move; Hollywood in 1955 had not yet gone anti-establishment. In fact, Hollywood *was* the establishment, run exclusively by middle-aged men who gave little thought to teenage problems.

Ray envisioned his teenagers gathering at a planetarium; three suburban refugees "seeking shelter under its great dome and artificial sky." The Griffith Observatory in Los Angeles bookends the story, more as a backdrop for violence—the switchblade fight, the fatal shooting of Plato—than as a hall of science and education. The chickie-run, played out to the death on a high cliff above the rocky shore, is staged as a teen ritual to settle a score. Ray's original blind-run would have faced off two drivers speeding toward each other in a black tunnel, car-lights out. The abandoned hilltop mansion (the same one

that housed Norma Desmond in 1950's *Sunset Boulevard*) is a decaying sanctuary for the trio, until invaded. Jim and Judy's touching love scenes take place there just before the mood turns ominous, the day's events rapidly rising to a tragic climax.

As the production got underway, Jack L. Warner viewed the first week's rushes and ordered a re-start, this time in color. Ray seized the opportunity to replace Dean's black leather jacket with the red windbreaker, a warning flag when seen against the black glint of his Mercury Eight coupe. The pictorial commotion of the film is abetted by super-low angle shots, camera revolves, and tall crane set-ups composed by Ray and his cinematographer, Ernest Haller. Insistent music scoring by Leonard Rosenman threatens to render the action mainstream, rather than keep it a tale of outsiders.

Rebel Without a Cause was ready for an autumn release, but on September 30, 1955, everything took on a sudden and sorrowful significance. James Dean was killed in a high-speed auto crash in Northern California. Millions of fans were shocked

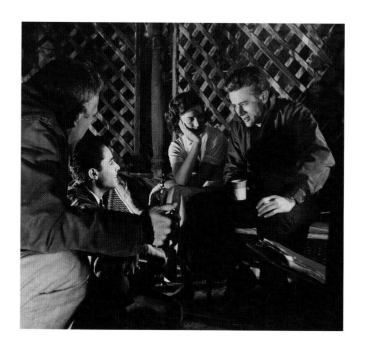

ABOVE Nicholas Ray makes screen history with Mineo, Wood, and Dean. OPPOSITE "I think he was really not a rebel," Natalie said of Dean's character, Jim, "in the sense that he was not rejecting his parents. . . . He was really saying 'Listen to me,' you know. 'Hear me, love me.'"

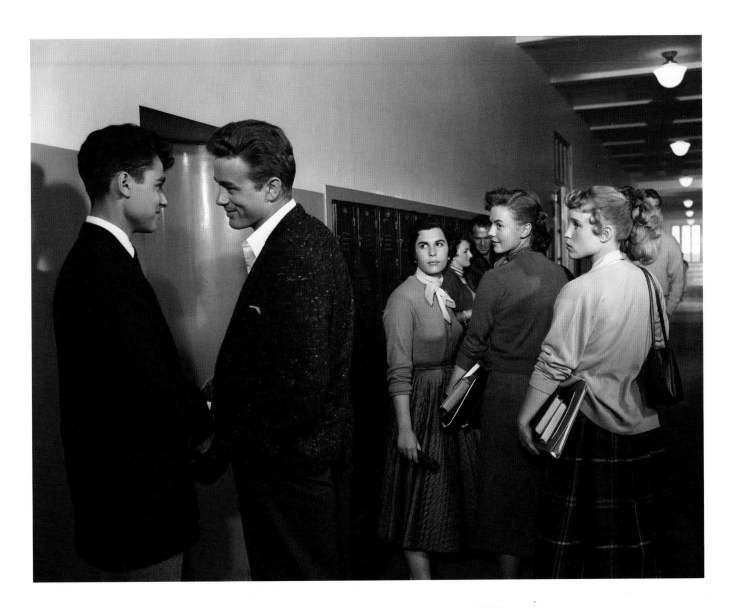

and inconsolable, Natalie included. An early screening with cast and crew triggered mixed emotions. Natalie broke down in tears. Ray arrived drunk and told a friend, "Much as I love the picture, it's a little like going to a funeral."

Warner Bros. forged ahead with its release schedule, opening the picture on October 27. Critics were confounded, simultaneously praising the film as "rooted in ghastly reality" and condemning it as "far-fetched." To young movie fans, an instant classic was born. Mercury sales skyrocketed. Fan letters to Dean poured into the studio for a year after his death. Natalie and Sal were subsequently rewarded with Oscar nominations in the supporting categories, as was Nicholas Ray for his story. James Dean was a Best Actor nominee, posthumously, for

East of Eden (1955).

Years later, Sal Mineo revealed, "When we were shooting *Rebel*, we became good friends. Jimmy really believed in this stuff: 'We're all cursed. We are the young ones put on the earth to make the old ones wake up.' He had some sort of odd idea that since Natalie and I were getting close to him, we would be cursed too . . . [and] all die violent deaths." Jim Backus picked up on Dean's mystique. "There was a supernatural atmosphere on the set. I always had this terrible feeling of doom while we were making the movie."

Natalie did not agree—to her it was "a lucky picture." James Dean was no prophet of doom in her eyes. "I didn't see that side of him," she reflected later. "Perhaps I was too young."

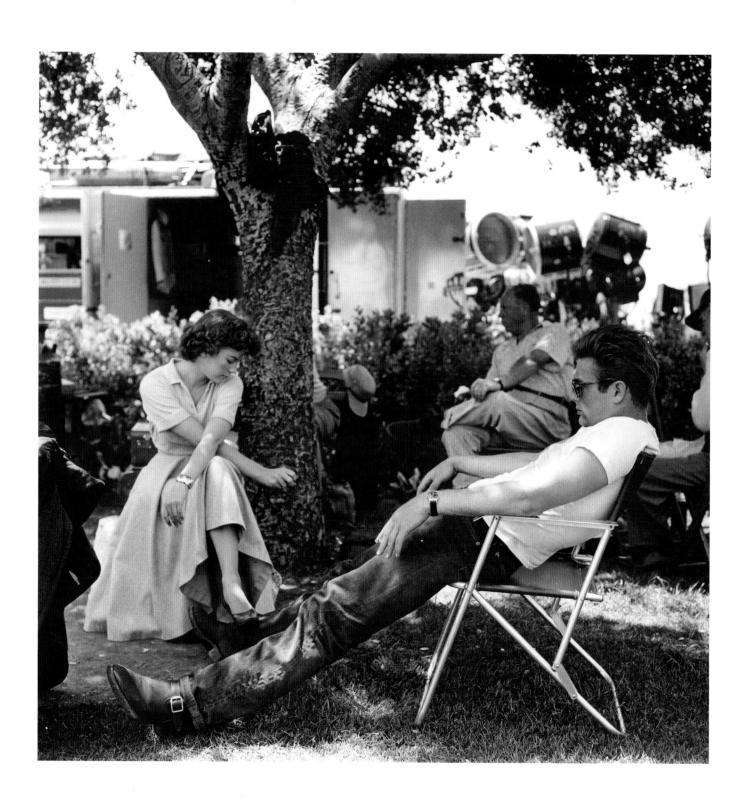

ABOVE Between takes on the film William Faulkner would call "a masterpiece . . . the American cinema's only Greek tragedy."

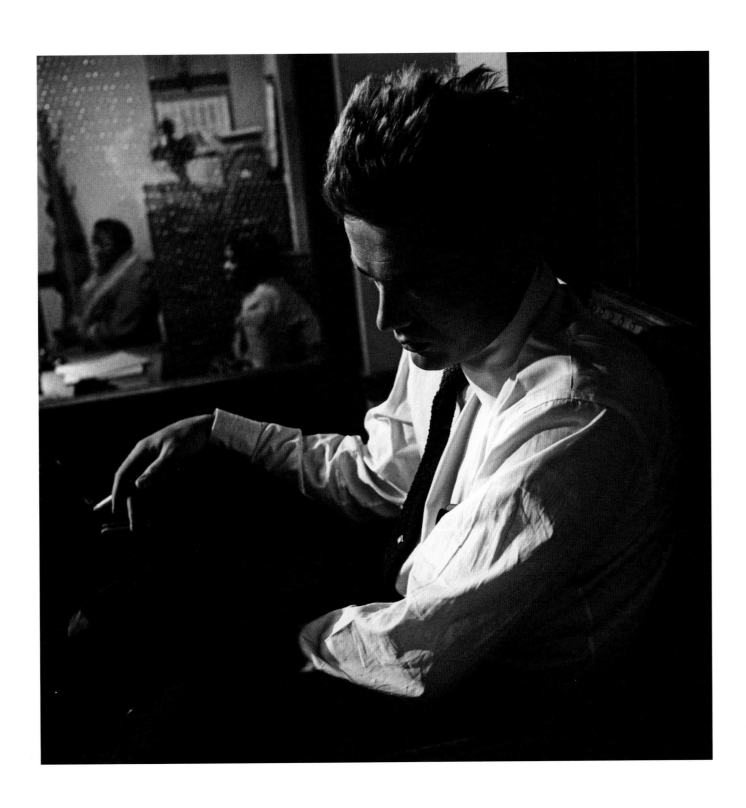

ABOVE Years after *Rebel*, Natalie pondered the mystery of James Dean. "He had secrets. He was like the Little Prince, full of secrets. You always wanted to find out his secrets, and you always suspected there were secret tears, too."

OVERLEAF Ray observes his protégée before Judy's intense police-station scene.

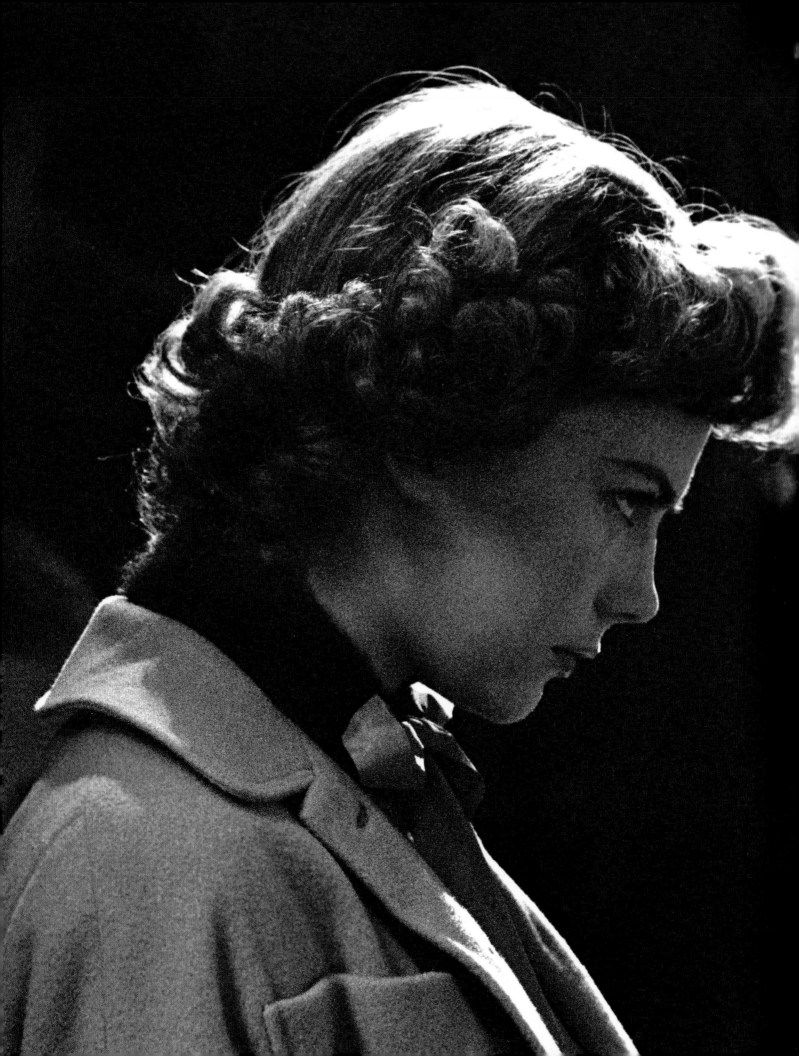

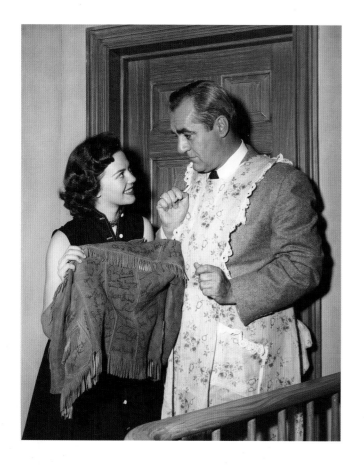

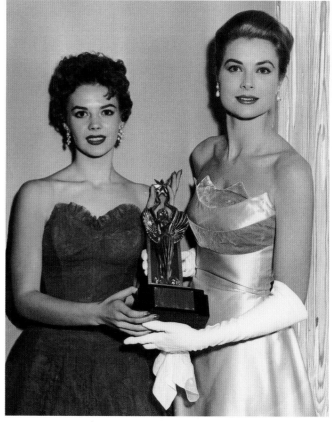

CLOCKWISE FROM TOP LEFT Natalie (with Jim Backus) collected celebrity autographs on a suede jacket—Dean's was the 100th signature; At the 1955 Audience Award Polls, Grace Kelly presents James Dean's Best Actor award to Natalie. "I accept this award on behalf of all the people who were touched by Jimmy, who was touched by greatness."; Natalie mingles with fellow 1956 Oscar nominees Ernest Borgnine, Marisa Pavan, Jack Lemmon, Eleanor Parker, Arthur O'Connell, and Susan Hayward; Glittering at the film's premiere. **OPPOSITE** Natalie's French poodle, Fifi, is a court witness as her new Warner Bros. contract is approved, October 1955.

THE SEARCHERS

"He had to find her..."

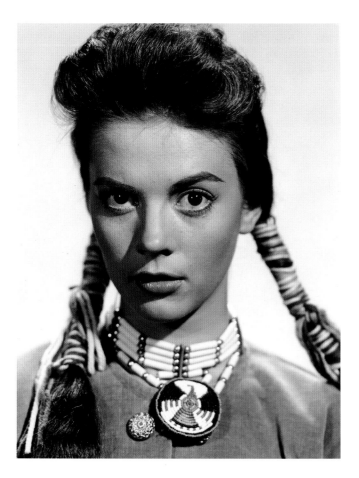

Master of the A-list western John Ford had a reputation for directing his actors with a touch of brutality. Natalie had heard he was a bully, and was "scared to death" when she was cast in what has since been judged one of the best westerns ever made. "Several people told me he was an ogre... well, he was wonderful to me." Natalie's brief encounter with the Duke was another pleasant surprise. "John Wayne was a giant to me, and when he picked me up in that scene near the end of the picture, he was able to lift me as though I were a doll."

The Searchers is not a story, it is a saga, stretching over five years in Texas, spreading north beyond Colorado, and west to New Mexico. A Comanche raid on the Aaron Edwards homestead results in a rape, four deaths, and the abduction of young Debbie, Natalie's later role. Debbie's uncle Ethan (Wayne) sets out with Martin (Jeffrey Hunter), who is one-eighth Cherokee, on a mission of rescue and vengeance. The tale was first told in Alan LeMay's novel, and then adapted for the screen by Frank S. Nugent.

Ford chose Monument Valley, near the Arizona-Utah border, as the film's scenic backdrop. Wayne, another monument in the valley, dominates the narrative and the ensemble cast, which includes Ward Bond, Vera Miles, Pippa Scott, and Henry Brandon as the Comanche chief known as Scar. There was a family atmosphere on set; Wayne's son Patrick appears as a young lieutenant, and Natalie's little sister, Lana, aged nine, is Debbie, the child taken captive. Olive Carey plays the mother of Brad Jorgenson, portrayed by her real-life son, Harry Carey, Jr.

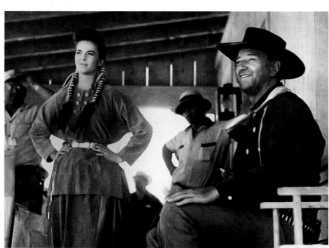

TOP Natalie as Debbie in full Comanche regalia. **BOTTOM** With John Wayne and crew in Monument Valley. **OPPOSITE** With Pat Wayne on location. Instead of the cast and crew's regular nightly poker games, when Pat was on the set, "We played Scrabble for a few days," Natalie recalled.

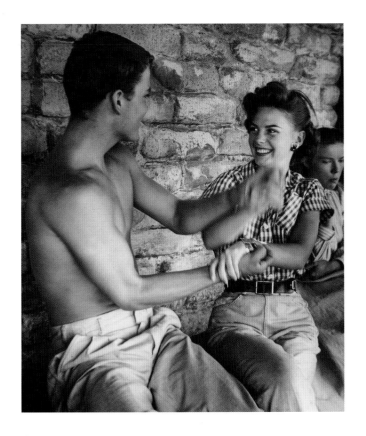

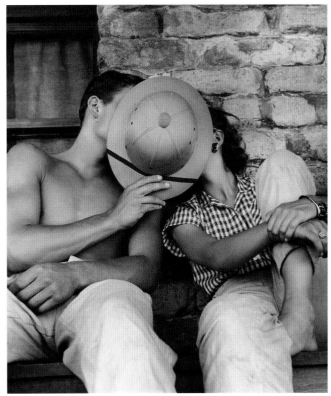

A good measure of out-west violence saturates *The Searchers*, but there are also generous helpings of comedy to break the tension. Wayne/Ethan kicks an old man in the behind, calls Martin "chunk-head," and caps many scenes with the drawl, "That'll be the day" (the inspiration for Buddy Holly's hit song). There is a frontier wedding, and a farcical brawl to interrupt it. A lonesome cowboy ballad by Stan Jones is sung by the Sons of the Pioneers under the opening credits, and familiar western folksongs weave in and out of the soundtrack. Also in the mix are hard-to-hear doses, typical of the time, of racial prejudice.

Ford scooped up all these western clichés and blended them into a towering tale of revenge and mercy that stands as an American classic, influencing the work of Martin Scorsese, Jean-Luc Godard, and Steven Spielberg, among others. *The Searchers* is spectacularly photographed by Winton C. Hoch, and the only Warner Bros. production filmed in VistaVision.

Monument Valley scenes were shot in the summer of 1955, and Natalie remembered that "we all had to live on location. There was me, my mother, and my sister Lana, and we lived at a trading post outside Flagstaff. We were smack in the middle of the desert with nothing but sand for miles. . . . One day Ward Bond was bitten by a scorpion. I watched them draining the poison from the bite, and I actually felt faint at the sight of it. I was always on the lookout for scorpions after that." Patrick Wayne, she recalled, "didn't look a lot like his father. . . . Duke had a real rugged kind of handsomeness, but Patrick, who was the same age as me, had a really boyish face. Just my type. I had a deep crush on him."

The film's quiet climax pivots on Ethan's reaction to finally tracking down the now bronzed and beautiful Debbie. He and Martin ride away from the Comanche-conditioned captive, but she follows. Will Ethan kill her as a squaw, one of Scar's wives, or will he embrace her—as the picture hints—as his daughter by his brother's wife? Ethan approaches Debbie ominously. He seizes her, gathers her up high, and finally cradles her as he delivers the less-is-more line, "Let's go home, Debbie."

THE BURNING HILLS

"I'm sorry. I know how you must feel."

"You can't. You are a man."

The above is a sample of the dialogue that characterized the script of *The Burning Hills*, taken from a Louis L'Amour western novel written to star John Wayne and Katy Jurado in an eventual movie. Irving Wallace penned the film adaptation, which was then developed by Warner Bros. as a vehicle for what it hoped would be a golden movie team: Tab Hunter and Natalie Wood.

Each young star was coming off a major hit—*Battle Cry* (1955) and *Rebel Without a Cause*. The two were thought perfect to, as the movie poster would declare, "flame with the fire of first love," on the big screen. Filming began February 10, 1956, on the set used for *Juarez* (1939) in the Calabasas hills, in the far western reaches of the San Fernando Valley. Hunter is Trace Jordan, a cowhand on the run from a misunderstood murder; Natalie plays Maria-Christina Colton, a fiery half-Mexican girl, his hostage and then his love.

Hunter helped Natalie perfect her riding at his stables in Chatsworth. Stallions were the usual choice for film work, but Hunter rode his own mare, Swizzlestick, in the picture. He praised his mount and distanced himself from the movie all at once by saying, "the best thing in it was my horse." After her training sessions with Tab, Natalie would go on to become the 1956 Los Angeles Sheriff's Championship Rodeo Queen.

To play Maria, Natalie was outfitted with a long, dark wig and deep tan makeup. On the wide screen, fully WarnerColored and CinemaScoped, she appears quite alluring, but also restless. As a clichéd "Mexican spitfire," her Chihuahua accent is problematic. At the time, there were serious studio

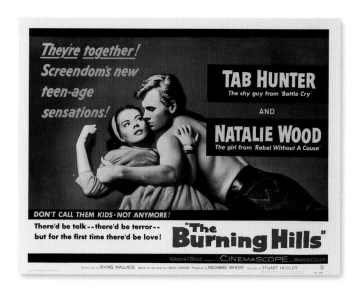

discussions about dubbing her speaking voice entirely.

The Warner machine ramped up promotion for *The Burning Hills*, sending Tab and Natalie to New York, Chicago, and St. Louis on a publicity tour. The two, touted as an "item," were mobbed by fans. Tab being a young gay man, although tucked away in the closet, and Natalie involved with the equally closeted Raymond Burr, the "it" couple were more like fond siblings.

Despite tepid reviews—"merely an exercise in horse opera pedestrianism" was one description—*The Burning Hills* was a substantial hit for Warner Bros. in 1956, justifying the studio's investment in the Tab and Natalie teaming. By the time of its release, a follow-up movie, *The Girl He Left Behind*, had already been filmed. "So popular are Tab and Natalie," the *Los Angeles Examiner* noted, "I suspect they could appear in a broken-down version of *Pollyanna, the Glad Girl* and still make the box office rock 'n' roll."

ABOVE Warner Bros.' advertising campaign exploited the popularity of its attractive young stars more than the film itself. Nobody who saw the poster would guess it was a western.

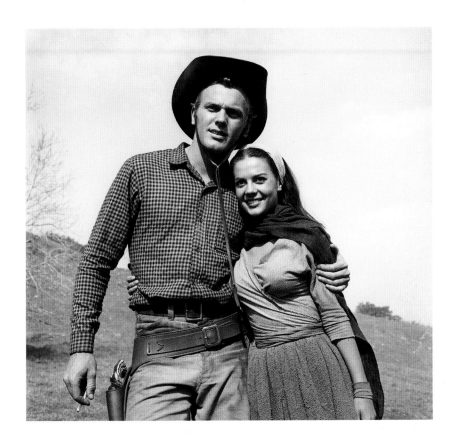

TOP Tab Hunter later reflected, "Besides the pleasure of working with Natalie—who for a seventeen-year-old was completely professional and totally focused— there isn't much to recall about *The Burning Hills*." **ABOVE** "It was the toughest role I've ever been asked to play," Natalie said after the film wrapped. "The director couldn't make up his mind what type of Mexican accent I should use. You know, there are four different Mexican accents." **RIGHT** Natalie and Tab on location at Kern River Canyon in the southern Sierra Nevada.

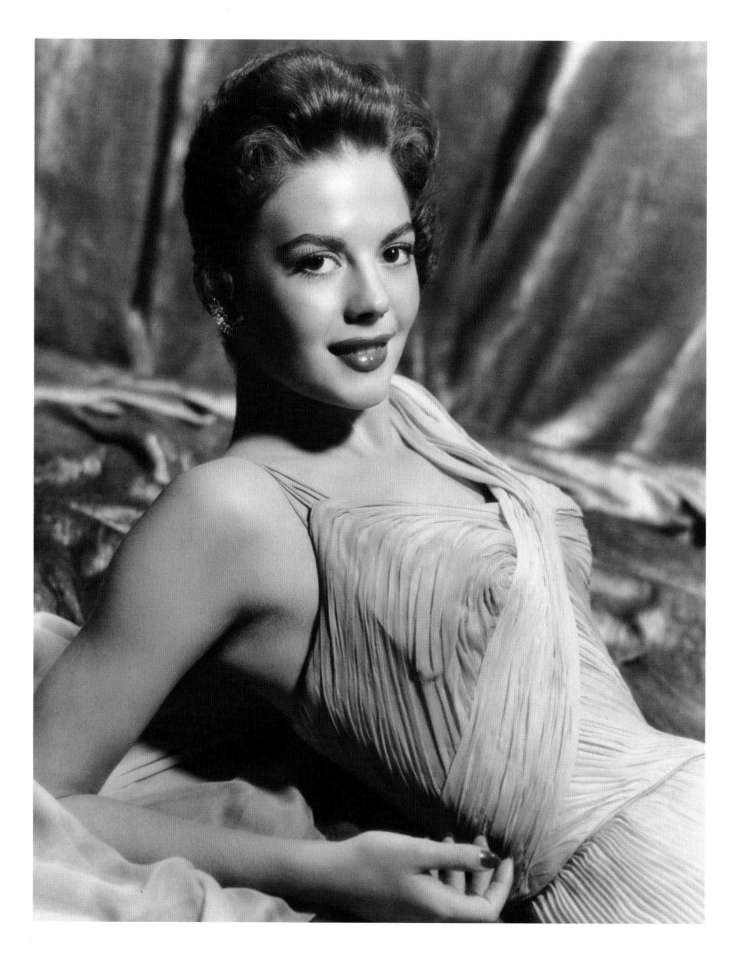

ABOVE AND OPPOSITE Like all contract stars in the studio era, Natalie posed for countless glamour and cheesecake photos for promotion and fan magazines.

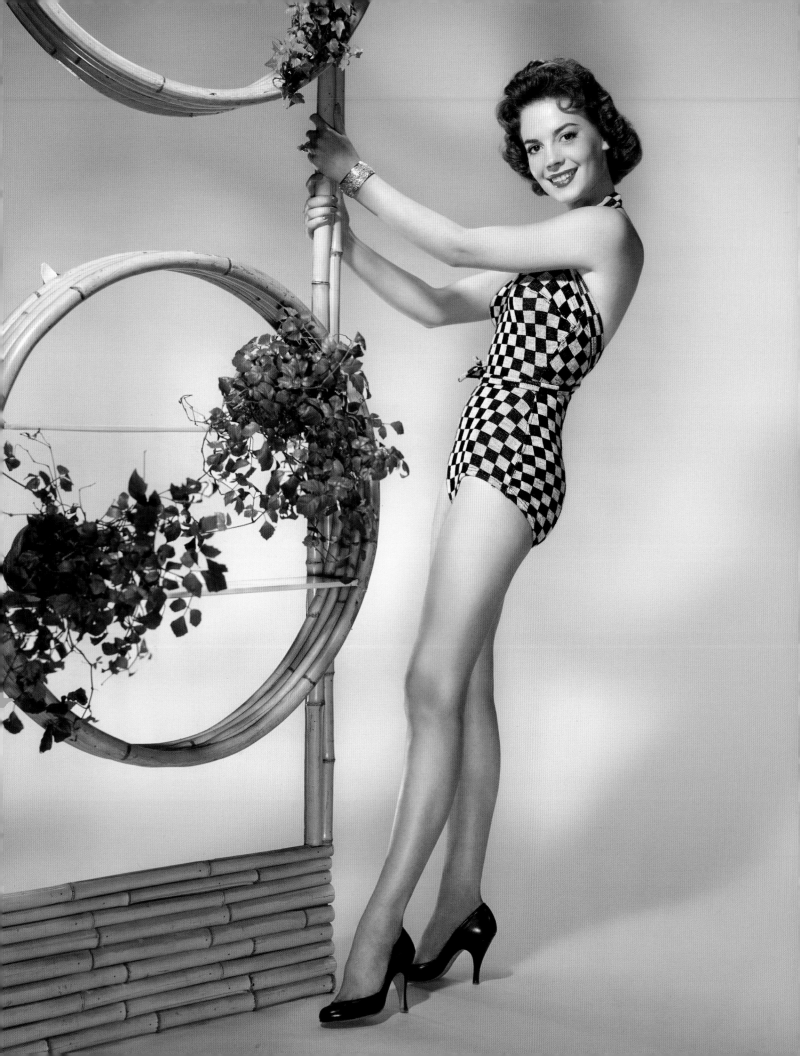

A CRY IN THE NIGHT

"Girl stealer in Lover's Lane!"

Eager to show her range, Natalie portrayed a girl terrorized by a mentally disturbed kidnapper, played by swarthy veteran Raymond Burr. She caused a bigger sensation off screen, spending evenings out with her much older costar, on the town and at his home. "I'm sure Natalie saw him as a father figure." Tab Hunter, Natalie's Warner Bros. dream-team movie partner, shared this insight from the time they were up-and-comers on the studio roster.

Well before being cast, Natalie heard buzz around the Warners lot about the dark script of *A Cry in the Night*, adapted by the author of *The Ox-Bow Incident*, David Dortort, from a novel by Whit Masterson. Natalie saw possibilities in the lead character, Elizabeth Taggart, a teen snatched from her boyfriend's car at a spot called Lover's Loop. Elizabeth starts as a victim, but gradually gains power over her abductor. Spotting a role she could sink her dramatic chops into, Natalie waylaid the producers, Alan and Sue Ladd, and begged to be cast.

Two respected Hollywood leading men, if no longer in their primes, were enlisted to play police captains on the case: Brian Donlevy as Ed Bates, and Edmund O'Brien as Dan Taggart, Elizabeth's father. With Burr included, and Frank Tuttle (*This Gun for Hire* [1942]) as director, there was a significant scent of *noir* on the set.

During the taxing abduction scenes, Natalie did her job with admirable freedom, throwing herself physically into the role. She lost weight, juggling the daily demands of filming and publicity with nights out with Burr.

The movie ready to open, Natalie agreed to attend a buzzed-about sneak preview. Ads promised a personal appearance by the star of

Rebel Without a Cause. She called the experience "sort of traumatic," the entire audience "laughing and jeering and talking back to the screen." Taken by surprise, Natalie felt that some of her dedication to her work was misplaced; she had given her all to a grade-B exploitation film.

A Cry in the Night became one of three movies in 1956—with *The Searchers* and *The Burning Hills*—that featured Natalie as a captive, a hostage, or kidnapped. In the *New York Times*, critic Bosley Crowther wondered "what it is about Natalie . . . that keeps bringing out the worst in all these characters?"

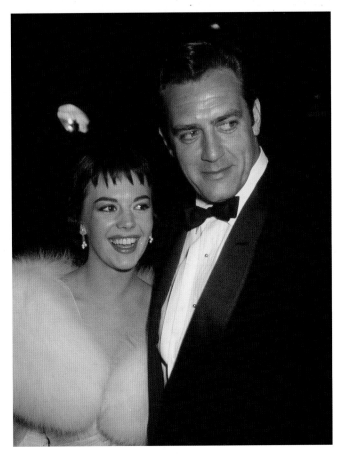

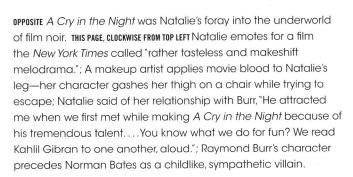

OPPOSITE *A Cry in the Night* was Natalie's foray into the underworld of film noir. **THIS PAGE, CLOCKWISE FROM TOP LEFT** Natalie emotes for a film the *New York Times* called "rather tasteless and makeshift melodrama."; A makeup artist applies movie blood to Natalie's leg—her character gashes her thigh on a chair while trying to escape; Natalie said of her relationship with Burr, "He attracted me when we first met while making *A Cry in the Night* because of his tremendous talent....You know what we do for fun? We read Kahlil Gibran to one another, aloud."; Raymond Burr's character precedes Norman Bates as a childlike, sympathetic villain.

THE GIRL HE LEFT BEHIND

"...but not too far behind!"

Natalie Wood and Tab Hunter were paired once more in 1956 for the feature *The Girl He Left Behind*. Hunter elaborates, "I played a spoiled rich kid (Andy Schaeffer) who learns his lesson after being drafted into the peacetime army. Natalie was my fiancée (Susan Daniels). The brilliant stage actress Jessie Royce Landis played my mother. David Butler was more of a traffic cop than a director, keeping us on time, under budget, and thoroughly uninspired."

The screenplay, taken from a novel by Marion Hargrove, is an inexplicable combination of serious romantic drama and forced humor, courtesy of a condescending narrator. "This is American youth," the voiceover states, and Natalie is the "typical American girl." Sulky Andy spends his first month in the army mouthing off to his superior officers, prompting the *New York Times* to wonder, "What would happen to a draftee if he acted the way Mr. Hunter does?"

Natalie made it known that her part was too small and pedestrian for an Oscar nominee. "The studio made me do it," she complained. They also made her "date" Hunter; photos of the dining and dancing duo were splashed across movie magazines. Hunter, seven years older than his teenage leading lady, remembers Natalie as "my kid sister. She was like a little filly finding her legs. I made fun of her for internalizing in preparation for her scenes. I'd say, 'Thank you, Rod Steiger!'"

The two remained chummy, though their lovingly antagonistic friendship was tested during the

making of *The Girl He Left Behind*. "She's making too many mistakes too fast," a concerned Hunter told the press of Natalie, who was heating up headlines with rumors of broken engagements and brokenhearted suitors. There may have been a touch of jealousy on Tab's part; Natalie was juggling dates with his pal Scott Marlowe, father figure Raymond Burr, and the King himself, Elvis Presley. "I'm in love," she teased. "I'm all shook up."

Natalie and her parade of men made headlines, and the buzz paid off for Warner Bros. The very low-budgeted movie—shot in black and white to save money—performed well at the box office, despite

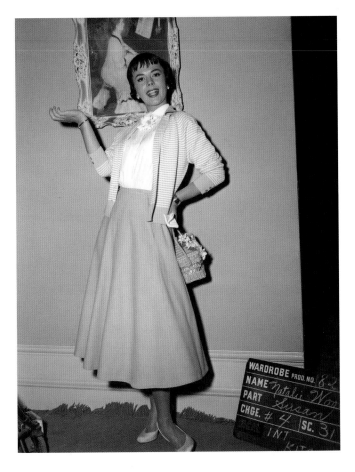

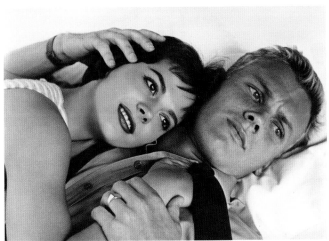

scathing reviews. Hundreds of servicemen went to see it, but only as part of a publicity gimmick: present your army induction papers and get in free. Released just one month after *The Burning Hills*, it climaxed the sideshow that was Tab Hunter and Natalie Wood.

OPPOSITE Tab and Natalie on set, summer 1956. **TOP LEFT** Moss Mabry designed Natalie's wardrobe for the film. **BOTTOM LEFT** "Her development between *The Burning Hills* and *The Girl He Left*

Behind was incredible," Hunter later said. "She became freer with herself in the way she used her face and body." **TOP RIGHT** "There never was anything between Elvis and me," Natalie said at the time. "How could there be? We never had enough time alone." **BOTTOM RIGHT** In the spring of 1956, Natalie took a well-deserved (and much-publicized) vacation to Hawaii.

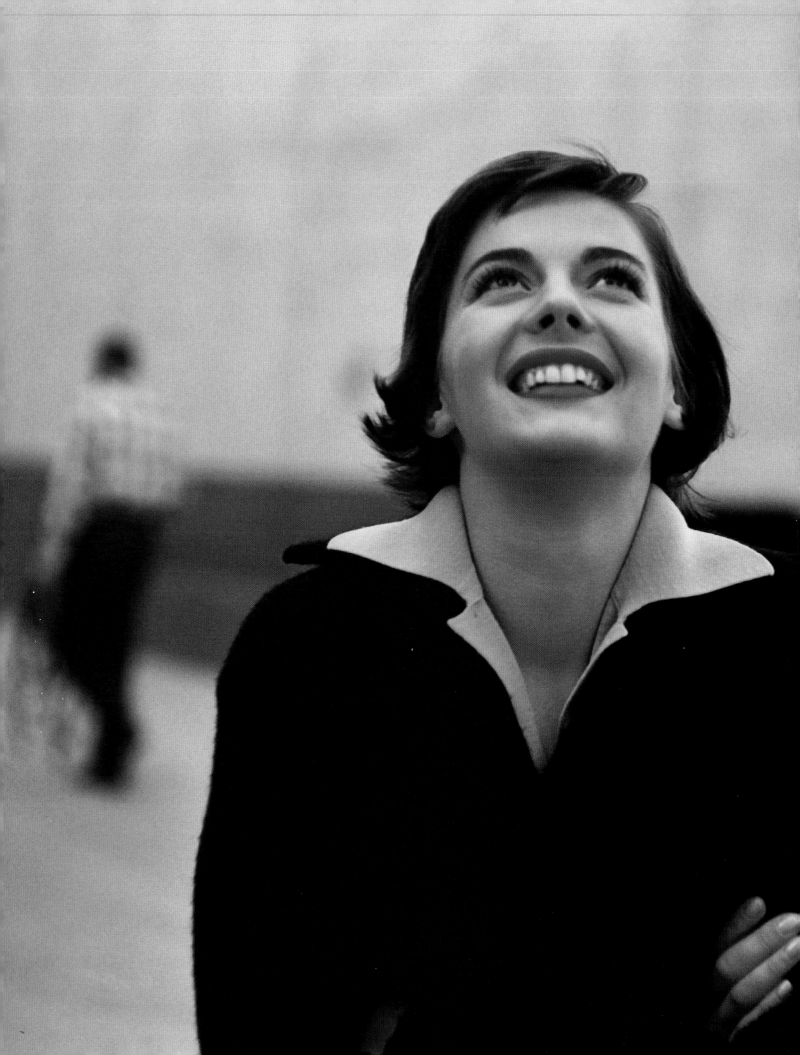

"A few days after I finished *A Cry in the Night*... I did something that had been on my mind for weeks. I walked into the beauty parlor and told my hairdresser to cut my hair short—real short!"

109

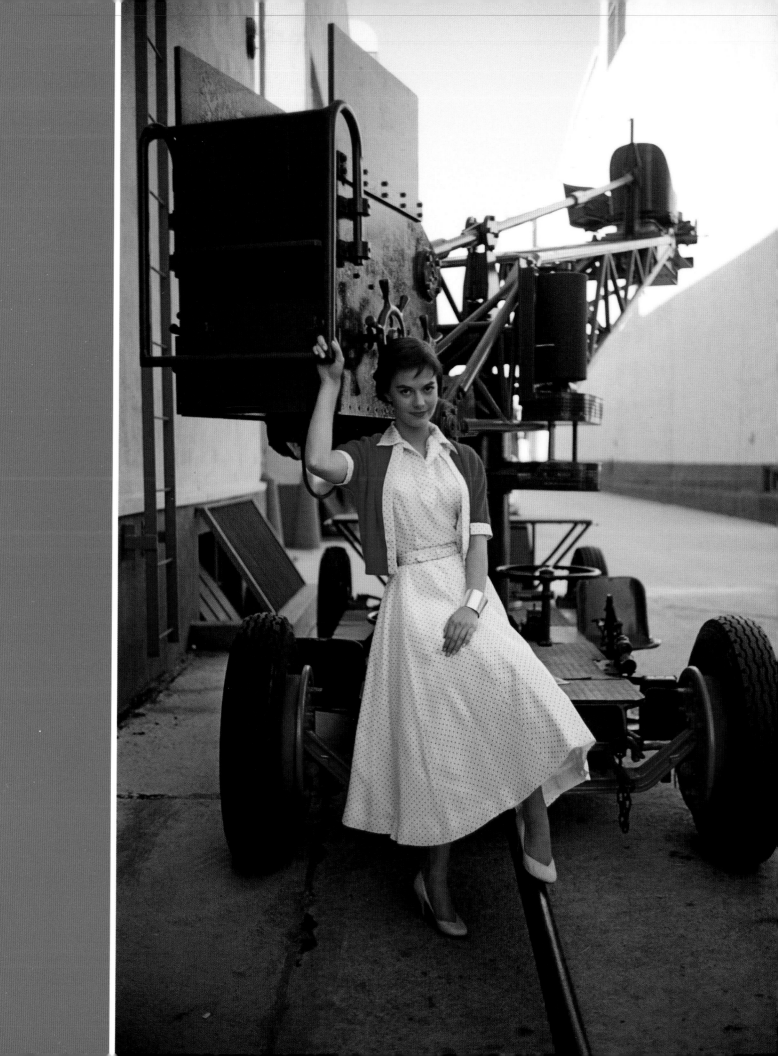

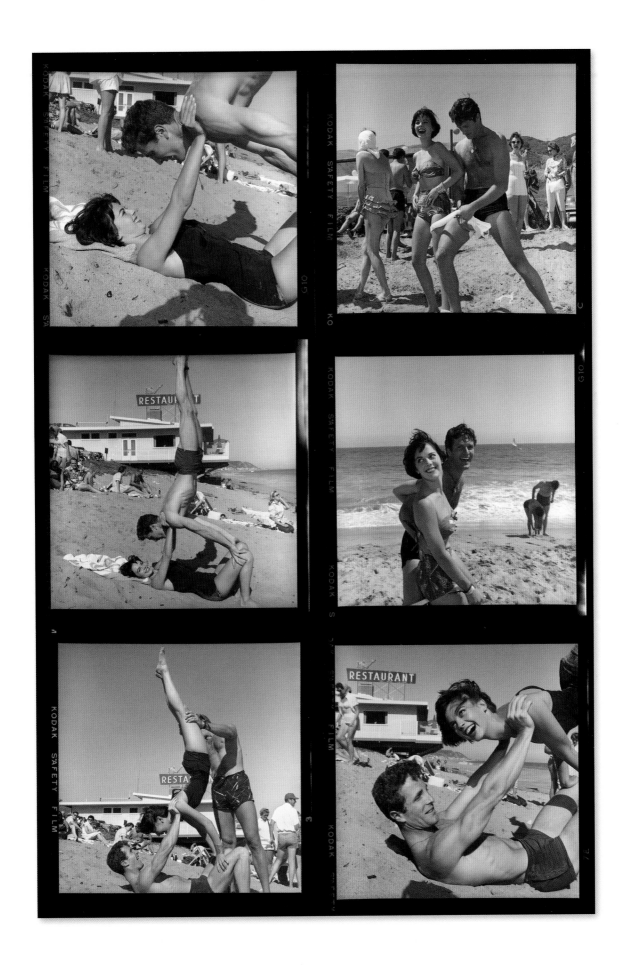

OPPOSITE The Warner Bros. lot was Natalie's second home for over a decade.
ABOVE Natalie frolics with *Wyatt Earp* star Hugh O'Brian at the Thalians Beach Ball in Malibu, July 1956.

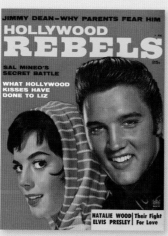

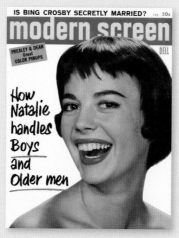

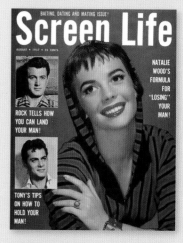

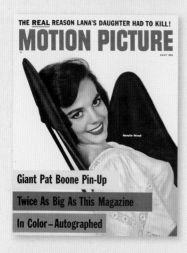

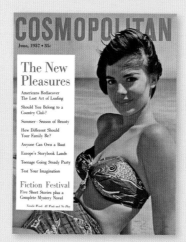

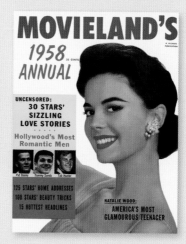

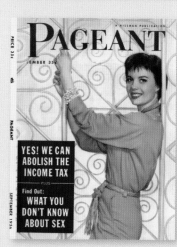

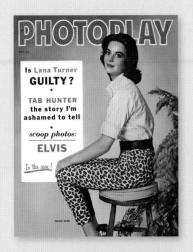

PHOTOPLAY

Is Lana Turner GUILTY?

TAB HUNTER the story I'm ashamed to tell

scoop photos: ELVIS

In this issue!

MOVIELAND

OCTOBER · 25 CENTS

NATALIE WOOD TEEN-AGE DREAMBOAT

IS PRESLEY ON THE WAY OUT?

WHAT IT'S LIKE TO DATE TONY PERKINS

WHY SINATRA SAYS— "NOBODY KNOWS THE TROUBLE I'VE SEEN"

Natalie Wood

PHOTOPLAY

AUGUST · 25¢

Exclusive untold stories of filmland's fallen stars

JAYNE MANSFIELD: IS HER BOOM A BUST?

CAN NATALIE BEAT THE HOLLYWOOD JINX?

MORE STARS, MORE PAGES THAN ANY FAN MAGAZINE!

FEB.-APR. · 25¢ · DELL

SCREEN ALBUM

Natalie Wood: RIDING FOR A FALL

SAL MINEO: "my search for the real Sal"

KIM NOVAK: "my diary of a cra-azy year"

ELVIS PRESLEY: "my fan letter just for you"

SAL MINEO: kisses that changed his life

MOVIE STARS

TV CLOSE-UPS PARADE

JUNE 15

TOO MUCH— MUCH TOO SOON the tragic story of teens warped by Hollywood

plus DEBBIE REYNOLDS RICK NELSON · JOHN SAXON THE MOUSEKETEERS TOMMY SANDS · PAT BOONE

MOTION PICTURE

APRIL 25¢

THE ONLY EYE-WITNESS ACCOUNT OF NATALIE AND RJ'S WEDDING!

IF I HAD BUT ONE DAY TO LIVE by Rock Hudson

YUL BRYNNER: Hollywood Ghost Man

THE DEADLIEST SIN OF ALL by Janet Leigh

MEET JAMES GARNER! he's manly, he's mighty, he's MAVERICK!

Natalie Wood

PEYTON PLACE POWERHOUSE! Lana Turner · Hope Lange · Diane Varsi

DELL

MORE STARS · MORE PICTURES THAN ANY MAGAZINE

SCREEN ALBUM

AUG.—OCT. 35¢

TAB HUNTER: 6 pages of photos plus color

Spend a weekend with DEBBIE, EDDIE and THE BABY

PIER ANGELI writes her Love Story

Meet the new, sweet Natalie Wood on page 2

FRANK AND INTIMATE—NATALIE WOOD'S DIARY

PHOTOPLAY

DEC.

First Report: ELVIS PRESLEY in Hollywood PLUS Pinups in Full Color

The Men in KIM NOVAK'S "Lavender Life"

Win a DATE With SAL MINEO See details in this issue

LAST CHANCE TO ENTER THE $2,000 "NAME THE STARS" CONTEST

20¢

JANUARY · 1958 · 25 CENTS · CDC

Screen Life

Scoop! "I'M READY for a HOME and BABIES!" ...NATALIE WOOD

Special! ARE THE "IMPORTS" SPICIER than the "DOMESTICS"? FANS! Write us your opinions for a prize.

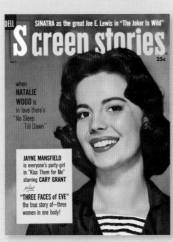

DELL

SINATRA as the great Joe E. Lewis in "The Joker Is Wild"

Screen stories

OCT.

25¢

when NATALIE WOOD is in love there's "No Sleep Till Dawn"

JAYNE MANSFIELD is everyone's party-girl in "Kiss Them for Me" starring CARY GRANT

plus "THREE FACES OF EVE" the true story of—three women in one body!

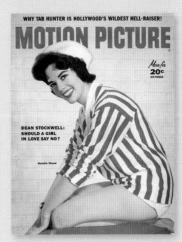

WHY TAB HUNTER IS HOLLYWOOD'S WILDEST HELL-RAISER!

MOTION PICTURE

More for 20¢ OCTOBER

DEAN STOCKWELL: SHOULD A GIRL IN LOVE SAY NO?

Natalie Wood

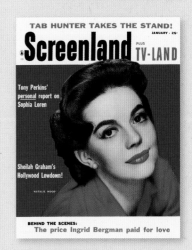

TAB HUNTER TAKES THE STAND!

Screenland PLUS TV-LAND

JANUARY · 25¢

Tony Perkins' personal report on Sophia Loren

Sheilah Graham's Hollywood Lowdown!

NATALIE WOOD

BEHIND THE SCENES: The price Ingrid Bergman paid for love

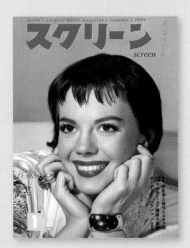

Japan's greatest movie magazine · January · 1959

スクリーン screen

MEET NATALIE'S ROCK 'N' ROLL SET!

Young **MOVIE** Lovers

NO. 1 25¢

Confidential! YOUR STARS TALK: DEBBIE & EDDIE ELVIS PRESLEY PAT BOONE SAL MINEO TAB HUNTER

BONUS! Inside Hollywood: Hangouts Parties Morals

NATALIE WOOD

Silver Screen

by an eye-witness: The Day Elvis Blew His Top!

AUGUST · 25¢

How to solve the riddle of Marilyn Monroe

EXCLUSIVE: Is Tony Perkins Fooling Hollywood?

NATALIE WOOD

MOVIELAND

MARCH · 25 CENTS · A HILLMAN PUBLICATION

15TH YEAR OF PUBLICATION

Natalie Wood

NATALIE WOOD— Boy-Crazy Teen-Ager?

See Elvis Presley rock 'n roll Turn to page 27 and flip the pages

BOMBERS B-52

"The might of it...the sight of it...stuns the screen!"

Natalie Wood's *Bombers B-52* character, Lois Brennan, is the demure, even straitlaced, daughter of Air Force Master Sergeant Chuck V. Brennan. The publicity department at Warner Bros., however, set about playing up her burgeoning sex symbol status: her simmering appeal to young men, her fresh beauty to young women. While the movie was in production and then promoted, she was named the "Sweetheart of Castle Air Force Base," as well as "Miss Stratosphere" by the Strategic Air Command.

An early poster for the film reads, "Now her whole world turned on one decision—which man... which love... which shame?" Yet Natalie's character faces no decision between men, and no shame. Warners' publicity department was grasping at straws.

Bombers B-52 was intended to be the third go-round for Natalie and Tab Hunter, who, upon reading the script, turned it down, pointing out that "the planes had more dimension than the characters." Good sport Natalie did her contractual best. The part of her love interest was handed to Efrem Zimbalist, Jr. in his first movie role. Marsha Hunt is Mrs. Brennan, and Karl Malden, who plays her husband, noticed that on set, "The boys hung around Natalie all the time. I used to kid her about it. But she always came prepared...she worked hard as well as having fun."

The movie's director, Gordon Douglas, was literally in charge of air traffic control. The Burbank studios of Warner Bros. provided a home base, with location shooting taking place at Castle Air Force Base in Merced, California, and at March Air Force Base in Riverside, spotlighting the latest

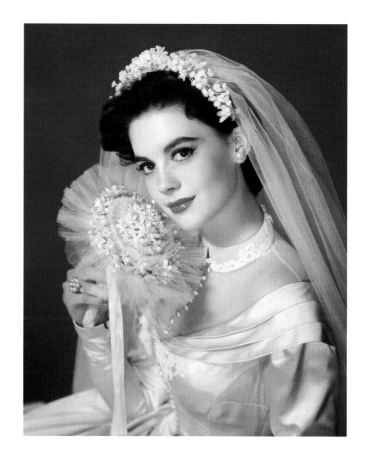

in air-flight and weaponry. The serviceable yet flat script, from a Sam Rolfe novel, is notable only for some unintended sexual innuendo, bellowed mid-flight: "Request jet penetration!" and "She's unable to receive fuel!" Natalie found a kindred spirit in the picture's costume designer/wardrobe supervisor, Howard Shoup. He became her personal wardrobe advisor, and later, Shoup designed Natalie's gown for her wedding to Robert Wagner.

Bombers B-52 was shot over the winter of 1956–57, and released November 22. *Variety* praised it as "magnificently mounted, with breathtaking scenes of the new B-52s." Warner Bros. itself declared it "the strangest assortment of passions and conflicts since *The High and the Mighty*." *Time* may have summed up the spirit of the movie best, calling it "a $1,400,000 want-ad for Air Force technicians."

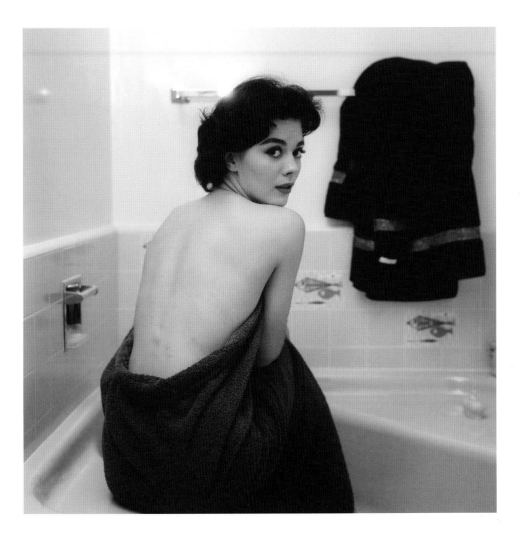

OPPOSITE Natalie posed for publicity photos in a wedding dress, though there is no wedding in the film. LEFT Sexy photos of Natalie in her bath further established her as grown up and past her teenage years. BELOW LEFT Paper dolls were a common merchandising item for popular stars at the time. BELOW RIGHT A wardrobe test on location. Before shooting began, Natalie told a reporter that she worked every day. "Some people have the idea that you only work when you're in front of the camera," she said of the movie business.

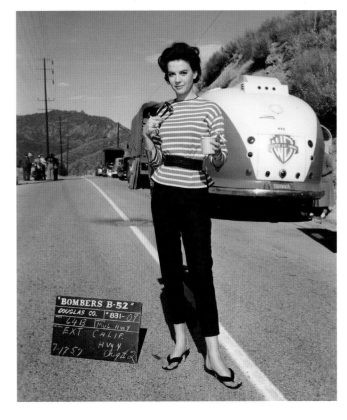

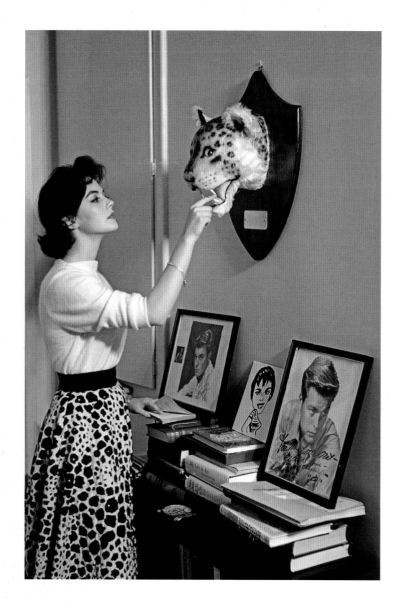

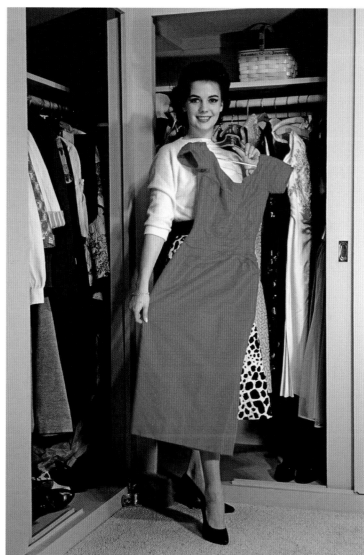

THIS PAGE AND OPPOSITE In 1956, Natalie redecorated her large bedroom suite in the Laurel Canyon home she shared with her parents and sister. Signed photos of Robert Wagner, a small bust of James Dean, and her collection of stuffed tigers personalized the modern black-and-white color scheme. Photos courtesy the Everett Collection.

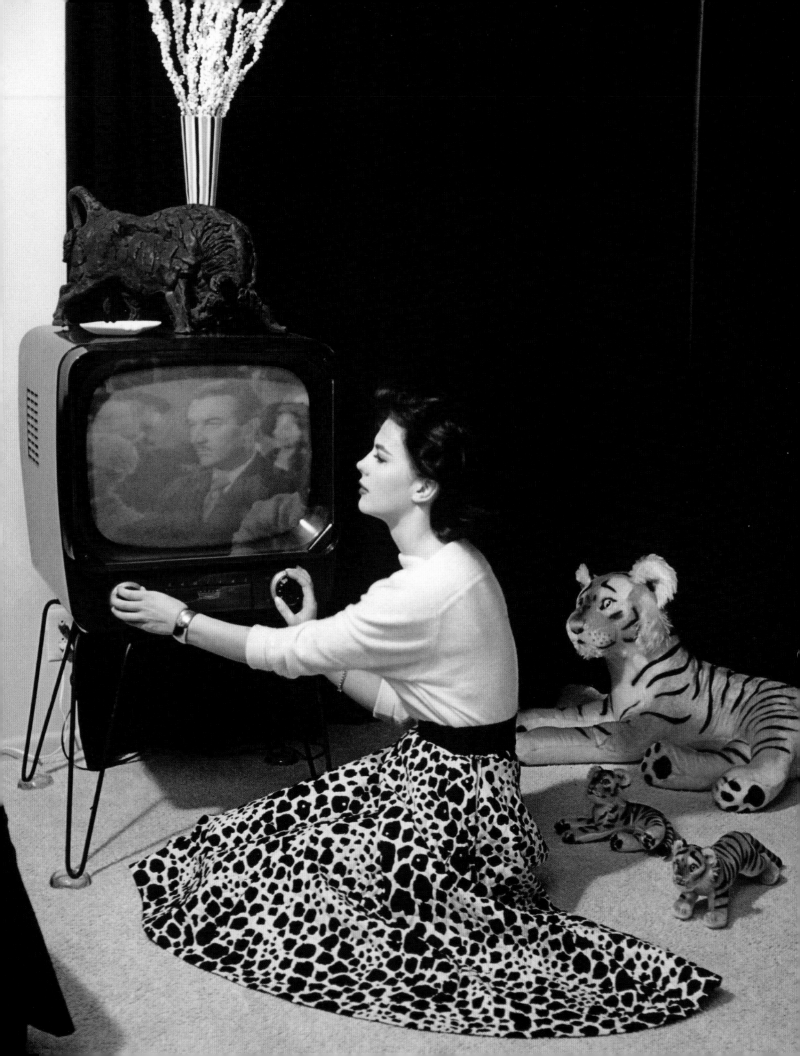

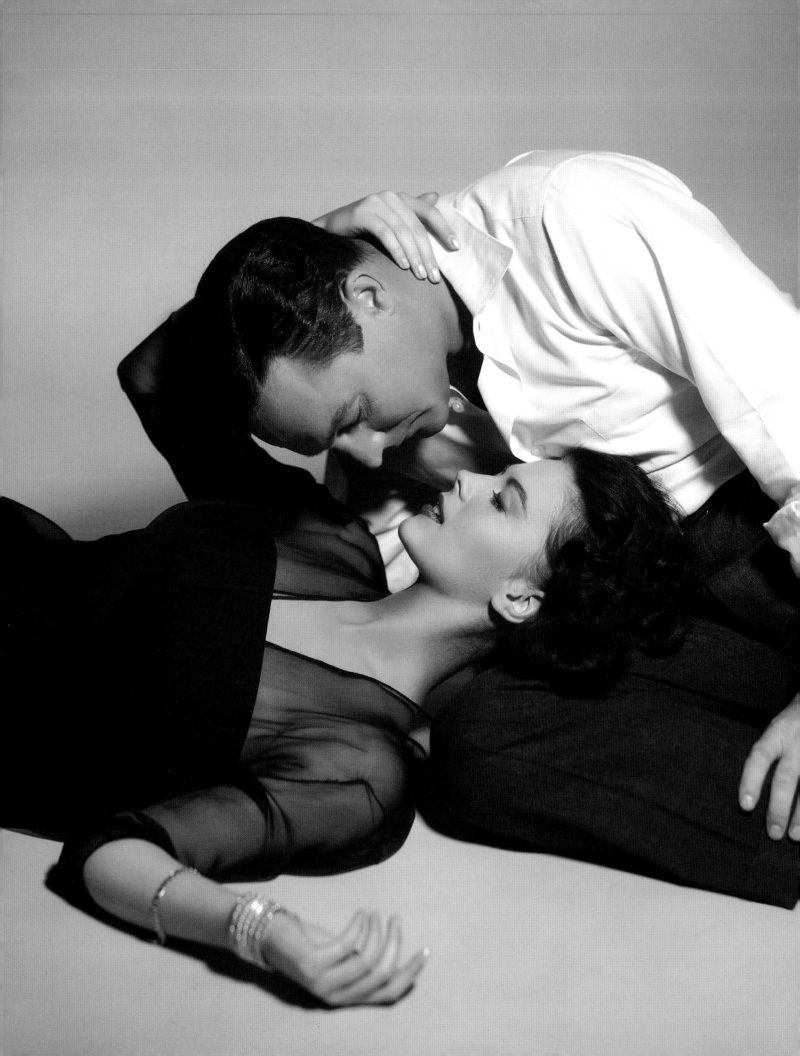

MARJORIE MORNINGSTAR

"Maybe what I'm doing is wrong. I don't know—I'm in love!"

Herman Wouk's popular 1955 novel, set in Manhattan and the Adirondacks in the '30s, chronicles the dilemmas of Marjorie Morgenstern, a Bronx-to-Upper West Side Jewish girl in a battle with herself: heritage and tradition versus art and aspiration, a conflict tinged with the excitement of first love. Would she remain, as born, Morgenstern, or Morningstar, a stage-name tailored to a neo-bohemian downtown lifestyle? Natalie Wood ached for the chance to bring Marjorie to life.

Wouk was anticipating the development of the film project when he had lunch with Natalie in New York City in 1956. She arrived dressed as her favorite character, a movie star. "She had a precocious, worldly look and an assured, fetching manner, which made her entirely different from my poor Central Park West dreamer."

But Natalie detested the movies she had recently been forced into, and saw *Morningstar* as her true star vehicle, her big opportunity. Natalie screen-tested successfully early on, in January 1957, but the producers at Warner Bros. delayed the announcement in order to make the most of their highly publicized search for the perfect Marjorie. The lengthy process tortured Natalie, but when he saw the tests, even Wouk sang her praises. "She was electrifying. *This* was my Marjorie."

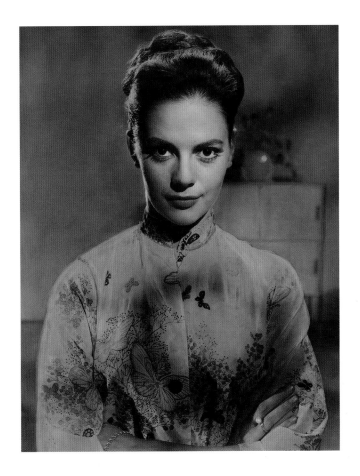

OPPOSITE *Marjorie Morningstar*'s May-December romance. Gene Kelly celebrated his forty-fifth birthday during filming, while Natalie was only nineteen. **ABOVE** A hand-colored image of Natalie as Marjorie.

The screen adaptation, by Everett Freeman, re-set the story to the present, a ploy for relevance and a budget-saving strategy. Rumor has it that Jack L. Warner paid so much for the story rights he refused to put sufficient funds into the production. There was some skimping, but not in the stellar supporting cast: Claire Trevor and Everett Sloane as Marjorie's parents, Carolyn Jones as her best friend, Ed Wynn as her uncle Samson, Martin Milner, Ruta Lee, Martin Balsam, and Edd Byrnes.

Gene Kelly takes top billing but second lead as Noel Airman, who has cast off his given name, Saul Ehrman. Paul Newman was considered for

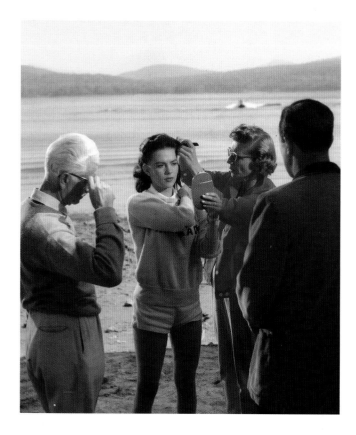

the role, but it was decided that Kelly's song-and-dance persona would come in handy for the South Wind Resort entertainment scenes. For the opening credits, Kelly recorded "A Very Precious Love," a song that would go on to an Academy Award nomination and a popular recording by the Ames Brothers.

As filming progressed in Manhattan and Schroon Lake in upstate New York, Natalie became discontented with director Irving Rapper's nervous manner and lack of expertise, confiding in Carolyn Jones that Rapper reminded her of "a butterfly in heat." A consolation came in the form of Howard Shoup, her confidant and the movie's costume designer. The direction may have been second-rate, but Natalie had never looked more glorious on the screen. In the glow of love with soon-to-be-fiancé Robert Wagner, who joined cast and crew on location, Natalie exudes youthful romance as Marjorie.

The film is notable for its progressive depiction of religious rites and inclusion of some spiritual imagery. A Passover meal and synagogue sequences are embraced as intrinsic to the storytelling, as well

as Jewish iconography in the home. Specifics like these had not been depicted in a major Hollywood production since *The Jazz Singer* (1927).

Publicity for the movie entailed a massive cross-promotional advertising campaign. Natalie was photographed for national print ads for Lustre-Creme Shampoo, with *Morningstar* part of the tie-in copy. The name Natalie Wood was now of great value to the people at Vendome, makers of costume jewelry, who draped the actress in antique-inspired baubles—two dollars for earrings, five dollars for a necklace—and called it the "Morningstar Collection."

Considered a major release at the time of its opening, the picture is not well remembered today. The reviews were lukewarm at best; the *New York Times*' A.H. Weiler singled out the star for some mild praise. "Natalie Wood, who only yesterday was playing with dolls in films, has blossomed into a vivacious, pretty brunette who very likely is as close to a personification of Marjorie as one could wish." Her looks were lauded more than her acting, which Weiler deemed "competent," but "rarely a glowing performance." Natalie later agreed. "During the time we were filming it," she recalled, "the producer and director could never decide . . . One day they would come and tell me, 'Okay, we've made the decision. She does want to be an actress,' and I'd say, 'But last week we filmed a scene where she didn't want to be an actress!'"

Though romantic lead Gene Kelly may not have been the ideal screen partner for Natalie, the two struck up a friendship that outlasted *Marjorie Morningstar*'s strained production and cool reception. In fact, their relationship, like the bond she formed with costar Claire Trevor, would last for the rest of Natalie's life.

ABOVE Natalie's hair is styled by Jean Burt Reilly for a scene with Gene Kelly on the shores of Schroon Lake. OPPOSITE During filming, *Movie Life* magazine predicted that Natalie's dance number in her white short-shorts might be too "wild" for the censors. Director Irving Rapper edited out any wildness before it reached the screen.

WARNER BROS. STUDIOS
WARDROBE TEST
FOR

"MARJORIE MORNINGSTAR" 429

OF

NATALIE WOOD

AS

MARJORIE

ALTERNATE
WARDROBE CHANGE # 5

WRONG
SHOES

WORN IN { SET TAMARACK
SCENE 35

 8-8 57

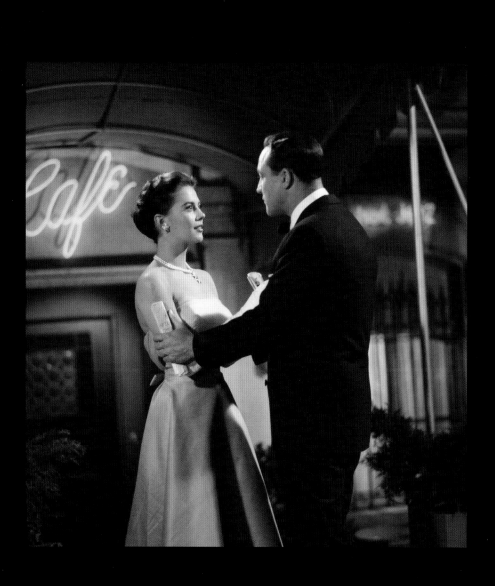

ABOVE "Gene I adore. I think he's a wonderful talent and we're friends, but Gene works in a very precise way . . . he likes to rehearse a lot; I generally tend personally not to like to rehearse very much. I think I learned a lot from doing that." RIGHT Natalie's first onscreen dancing was in the frenzied Spanish-themed rock 'n' roll number "Rock Cucaracha," staged by Jack Baker.

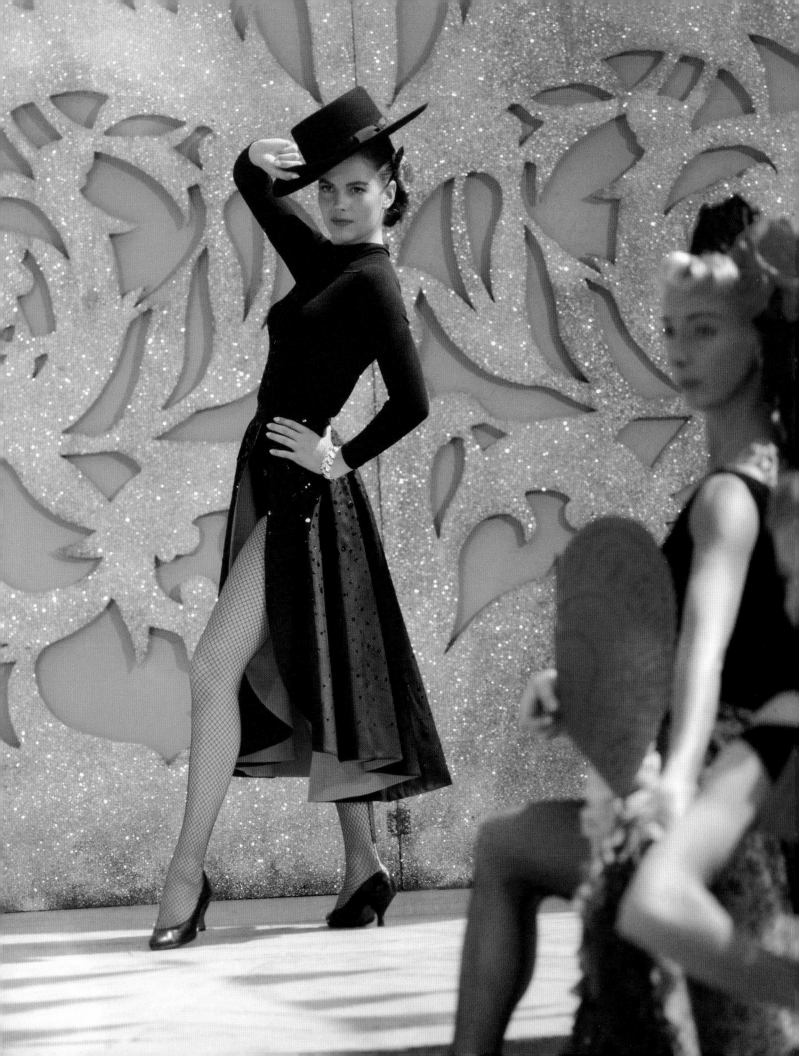

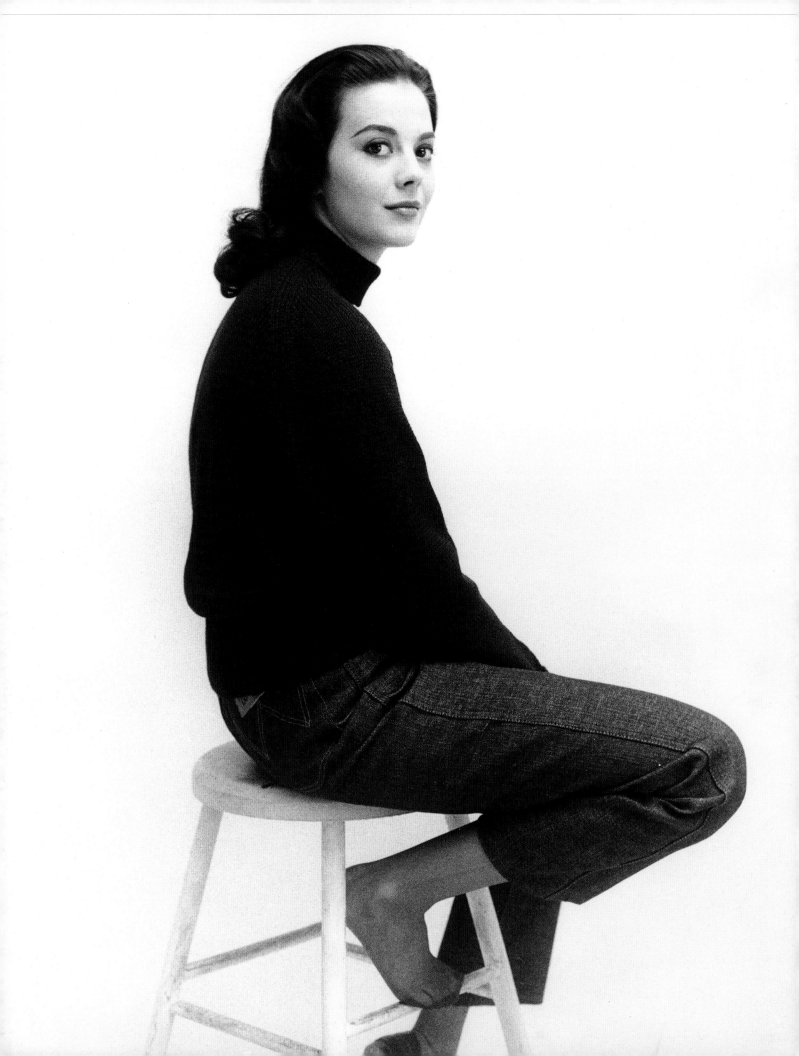

OPPOSITE A very casual look was circulated in print ads to tout the release of *Marjorie Morningstar*. ABOVE A series of hair tests for *Marjorie*. RIGHT A telegram author Herman Wouk sent a month before the film premiered.

CLASS OF SERVICE
This is a fast message unless its deferred character is indicated by the proper symbol.

WESTERN UNION
TELEGRAM
W. P. MARSHALL, PRESIDENT

SYMBOLS
DL=Day Letter
NL=Night Letter
LT=International Letter Telegram

1201

The filing time shown in the date line on domestic telegrams is STANDARD TIME at point of origin. Time of receipt is STANDARD TIME at point of dest (21).

•||0B206 SSU459 0 BNA350

(L NC041) DL PD=NEW YORK NY VIA BURBANK CALIF 6=

NATALIE WOOD=

99681/2 DURANT DR BEVERLYSHILLS CALIF: 1958 MAR 6 PM 2 44

=DEAR NATALIE WOOD YESHIVA UNIVERSITY WHERE I AM
PROFESSOR OF ENGLISH HAS TAKEN THE OCCASION OF THE
MIAMI PREMIER TO SCHEDULE A LUNCHEON IN MY HONOR AT
THE FONTAINBLEAU ON MARCH 18TH. I WILL REGARD IT AS
A PERSONAL PLEASURE IF YOU AND YOUR HUSBAND WILL JOIN
ME AS GUESTS OF HONOR PLEASE LET ME KNOW IF YOU CAN.
MILTON HAS SURELY TOLD YOU HOW COMPLETELY SATISFIED
I AM WITH YOUR EXTRAORDINARY PORTRAYAL OF MY HEROINE
SINCERELY YOURS=
 HERMAN WOUK 116 EAST 68 STREET NEW YORK CITY==

THE COMPANY WILL APPRECIATE SUGGESTIONS FROM ITS PATRONS CONCERNING ITS SERVICE

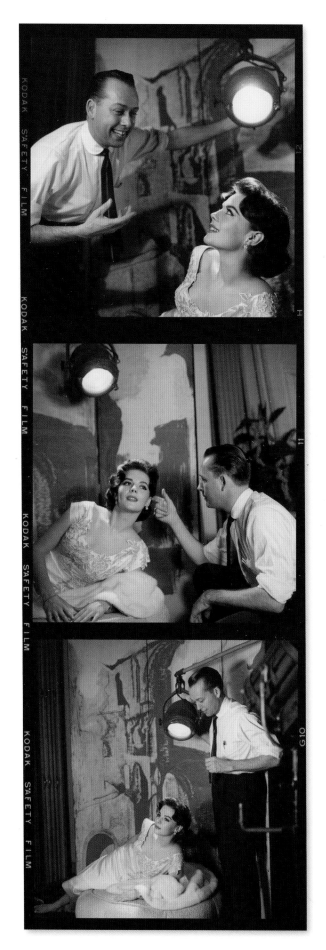

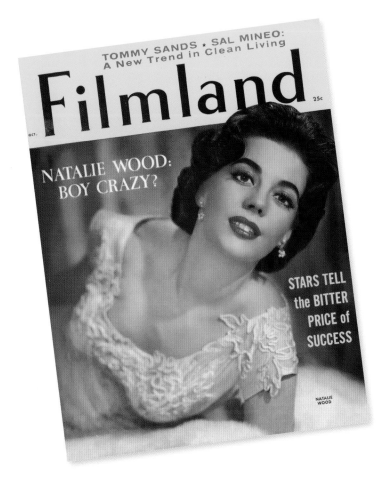

TOMMY SANDS ★ SAL MINEO:
A New Trend in Clean Living

Filmland

25¢

NATALIE WOOD:
BOY CRAZY?

STARS TELL
the BITTER
PRICE of
SUCCESS

NATALIE
WOOD

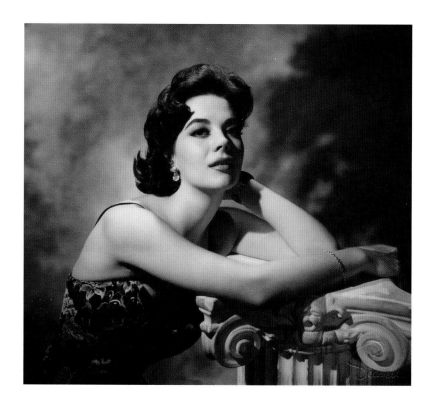

THIS PAGE Portrait photographer Wallace Seawell lights Natalie for a series of glamour portraits. One Elizabeth Taylor-esque shot was used on the cover of *Filmland* magazine, October 1957. Photos courtesy Wallace Seawell/mptv.

KINGS GO FORTH

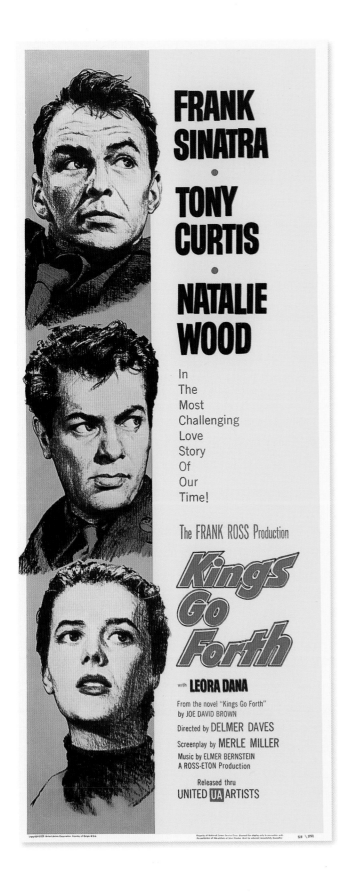

FRANK
SINATRA
· TONY
CURTIS
· NATALIE
WOOD

In
The
Most
Challenging
Love
Story
Of
Our
Time!

The FRANK ROSS Production

Kings Go Forth

with **LEORA DANA**

From the novel "Kings Go Forth"
by JOE DAVID BROWN
Directed by DELMER DAVES
Screenplay by MERLE MILLER
Music by ELMER BERNSTEIN
A ROSS-ETON Production

Released thru
UNITED **UA** ARTISTS

"My father was a great man. He was also a Negro."

The screenplay of *Kings Go Forth* was written with Dorothy Dandridge in mind to costar as the mixed-race young woman at the center of a wartime love triangle with two white soldiers. Producer Frank Ross, silent producer Frank Sinatra, and United Artists decided to play it safe (the Production Code of the day had strict rules against interracial screen pairings) and cast Natalie Wood instead.

Sinatra, always eager to make a statement against racial prejudice, latched onto the story early and suggested Natalie as Monique Blair, the half-black ex-patriot American living in France during the liberation of 1944. Tony Curtis plays Corporal Britt Harris, who loves and leaves Mlle. Blair upon learning that her father was black. Sinatra cast himself as Lieutenant Sam Loggins, in love with her but destined

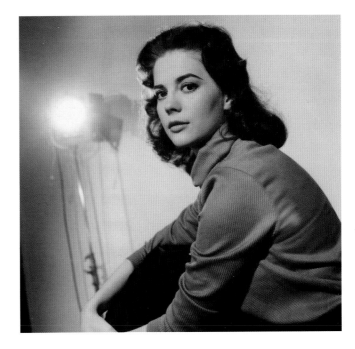

ABOVE "The pride and joy of the Warner lot, Natalie Wood, joins Frank Sinatra and Tony Curtis in *Kings Go Forth*," reported Louella Parsons.

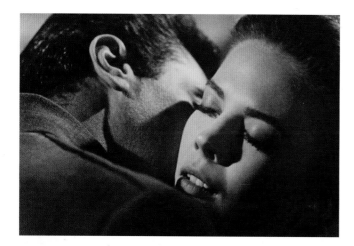

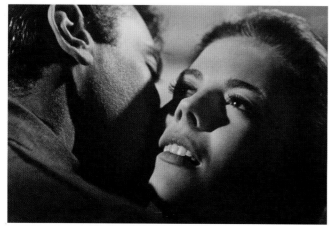

TOP As co-producer and star of *Kings Go Forth*, Sinatra started the picture and then shut it down, at great expense, to wait for Natalie to finish *Marjorie Morningstar*. ABOVE *Kings Go Forth* was the first of three films Natalie would make opposite Tony Curtis. OPPOSITE In their review, *Variety* credited Natalie with "an intensity and depth she has seldom shown before."

for only friendship, even after he helps her recover from a failed attempt to take her own life.

Director Delmer Daves and cinematographer Daniel L. Fapp gave the film a semi-documentary feel in black and white, while Elmer Bernstein infused the meandering narrative with a jazz-inflected background score. Location filming took the company to Nice, and Villefranche-sur-Mer, Alpes-Maritimes, in France. Natalie, planning her upcoming wedding to Robert Wagner, spoke with *Brides* magazine on set, and admitted that she listened only to Sinatra records in her downtime. "He's from greatsville!" she enthused, in proto-Rat Pack speak.

In the movie's trailer, Sinatra appears as himself to introduce the story as taking on ". . . a question almost never talked about in films." To quote Natalie as Monique, "'Nigger' is one of the first words you learn in America." The racial divide ran wide and deep.

Natalie's Monique is caught in the middle, passing for white, then cruelly victimized when her mixed race is discovered. "Miss Wood plays a touching role simply and well," wrote critic Paul V. Beckley, in a flawed film, but one with "the soft yearning quality of a ballad." *Kings Go Forth* may present its theme in less-than-eloquent terms, but for a picture in wide release not three years after Rosa Parks took her seat on the bus in Montgomery, Alabama, *Kings* was a small step forward for 1950s Hollywood.

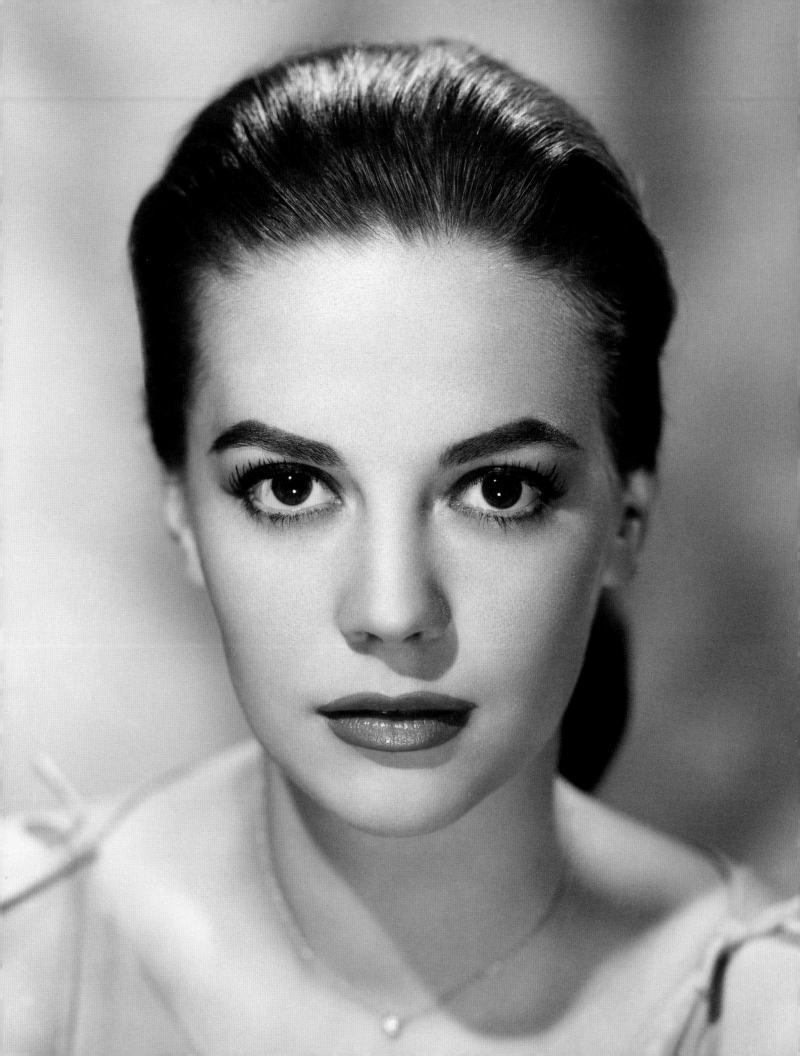

COSTUME DEPT. PROD. 852
NAME NAT. WOOD
PART LORY
CHG. # 10 (ALT. HATS)
SC. # TAG (NO MAKEUP)

CASH McCALL

"This fellow—he's a zillionaire—
But this girl—she keeps giving him
the 'air'…!"

As light-headed as the movie itself, the lines above are a snippet of the rhyming come-on for the *Cash McCall* publicity campaign. Warner Bros. sent Natalie the script as the "something modern" they had promised upon her return to the studio after a fourteen-month suspension—she had refused a few assignments, demanding better material. Natalie was so unimpressed with the screenplay she decided "to read only the scenes I was in."

The disputed script was based on a novel by Cameron Hawley (*Executive Suite*), and adapted by Lenore Coffee and Marion Hargrove, presumably to mimic the tone of Hollywood romantic comedies of the '30s and '40s. But those fast-paced, sexy concoctions were something for which the studio system had lost its touch. *Cash McCall*, packed with endless scenes of people standing and discussing high finance, could not possibly compare.

In his first leading role in a feature film, James Garner, at the time riding high as the star of TV's *Maverick*, was perhaps a less-than-perfect choice to partner with Natalie's commercial artist, Lory Austen. Garner as McCall is a likeable tycoon, but his leisurely Oklahoma drawl hardly suits the "whiz kid of Wall Street" the novel describes.

When Cash targets Lory's father's plastics company for takeover, restructure, and resale, he also sets his sights on Mr. Austen's daughter for conquest. The two had a summer fling that ended badly the year before, and their mutual dislike

morphs into romantic love in a typical scenario. The supporting cast is comprised of a few of Hollywood's most respected character actors: E.G. Marshall, Henry Jones, and Nina Foch, with Dean Jagger, Natalie's old *Driftwood* costar, as Mr. Austen. Journeyman Joseph Pevney directed the small ensemble in undistinguished style.

Released in January 1960, *Cash McCall* proved a disappointing welcome-back for Natalie. Of the film's New York debut, the *Herald Tribune* observed the audience laughing "in the wrong places at some of the pretentiousness of the movie," possibly including the revelation that "Cash" is not a descriptive nickname after all, but merely McCall's mother's maiden name. "Miss Wood makes the most of a difficult role," admitted the *Motion Picture Herald*, while the *Hollywood Reporter* safely praised Miss Wood's "smart wardrobe." In the words of Carole Lombard, "I knew the picture was bad when people talked about how nice my wardrobe was."

OPPOSITE Testing a hat for the film. **ABOVE** Natalie steps behind the camera. James Garner summed up the *Cash McCall* experience: "Not much of a movie, but I liked Natalie."

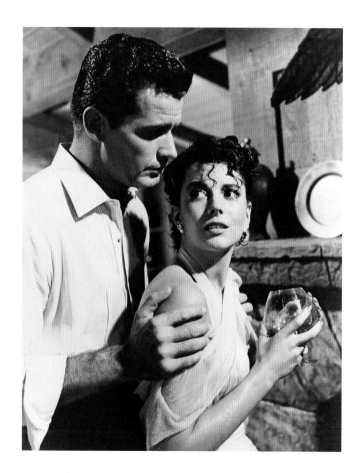

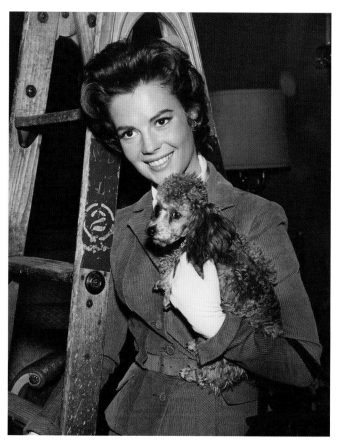

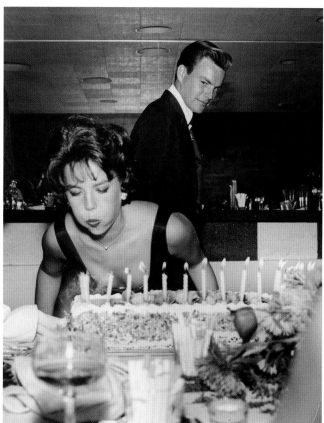

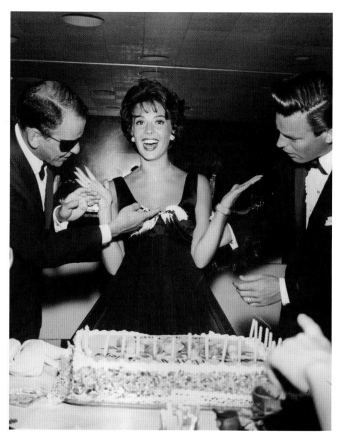

TOP LEFT Cash and Lory's love scene. **TOP RIGHT** Natalie on set with her poodle, Chi Chi. **BOTTOM** In July 1959, Robert Wagner threw his wife a surprise twenty-first birthday party at Romanoff's. Frank Sinatra (pictured) and Dean Martin sang "Happy Birthday." **OPPOSITE** Publicity photo, 1959.

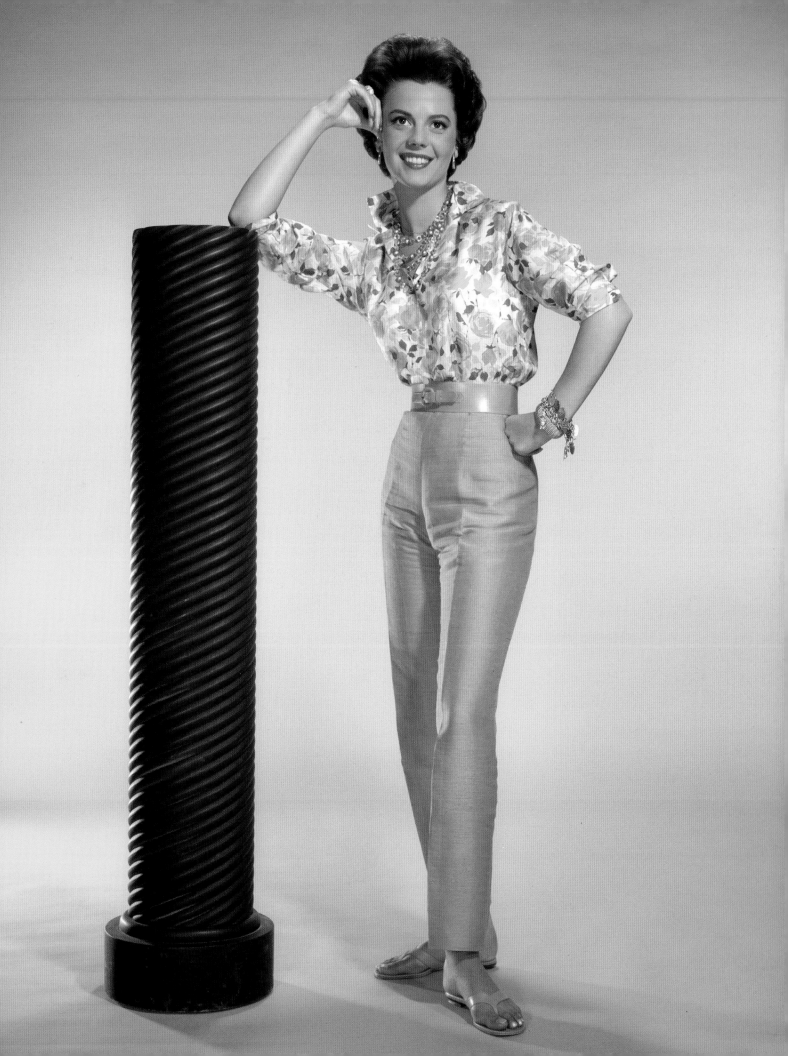

ALL THE FINE YOUNG CANNIBALS

"Chad, why are you laughing?"

"It's less painful that way."

Purchased by M-G-M as a possible vehicle for the unlikely pairing of Elvis Presley and Elizabeth Taylor, Robert Thom's adaptation of Rosamond Marshall's post-WWI historical romance *The Bixby Girls* was rejected by Presley. Instead, M-G-M borrowed Robert Wagner from Fox, who brought his wife Natalie Wood onboard as costar. For *All the Fine Young Cannibals*, Natalie and R.J. set aside their casual agreement not to work together, enticed by juicy roles that gave both actors plenty of room to shine.

Wagner is jazz trumpeter Chad Bixby—a character vaguely suggestive of troubled jazz musician Chet Baker—and Natalie is young, beautiful Salome (born Sarah) Davis. Chad and Salome escape the poor Texas bend-in-the-road Pine Alley, but not together; Chad flees to New York City with blues singer Ruby Jones (Pearl Bailey). Pregnant with Chad's baby, Salome boards the exit train, encounters wealthy Tony MacDowall (George Hamilton), and follows his money to Yale in Connecticut. Tony's sister Catherine (Susan Kohner) arrives, Salome and Chad meet in NYC, and the soap suds get deep.

Modernizing the 1920s-set novel to the present (1960) deflated some of the "forbidden" drama of jazz music, but maestro Vincente Minnelli added some visual flair and panache to the film when original director Michael Anderson abandoned

OPPOSITE Examining film frames. Natalie had approval and "kill" rights on all images taken of her. RIGHT Artwork publicized the Wagners as a major selling point.

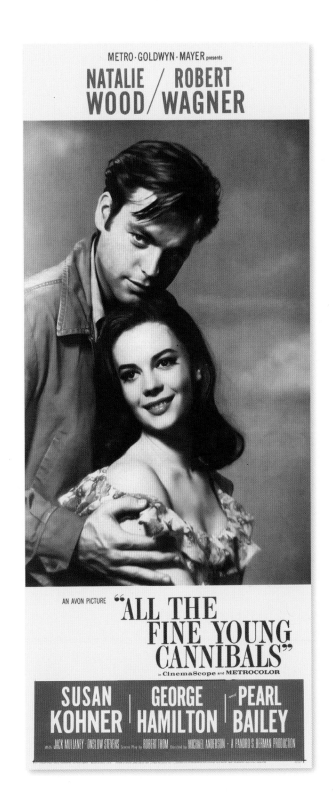

METRO·GOLDWYN·MAYER presents

NATALIE / ROBERT
WOOD / WAGNER

AN AVON PICTURE "ALL THE FINE YOUNG CANNIBALS"
in CinemaScope and METROCOLOR

SUSAN KOHNER | GEORGE HAMILTON | and PEARL BAILEY

with JACK MULLANEY · ONSLOW STEVENS Screen Play by ROBERT THOM Directed by MICHAEL ANDERSON · A PANDRO S. BERMAN Production

the production before its completion. Unfortunately, Minnelli stepped in too late. Wagner regretted that "Instead of being a really good movie, *Cannibals* was just an ordinary movie with a couple of good scenes."

Early in production, dissatisfaction crept in for Natalie and R.J. In 1959, Wagner recalled that "everyone broke out laughing" when he publicly announced the movie's title, "like it was a joke or something." Natalie agreed the title was "terrible." Despite the concerns, "Any way you look at it," Natalie admitted, "we're having fun working together."

Controversy tailed the picture's promotion and release. The unpopular title was questioned by the Production Code Administration, as was the movie's treatment of "illicit affairs, brothel scenes, and blasphemous dialogue." Afraid of scandal, M-G-M lost its nerve concerning the intimacy displayed between characters Chad and Ruby. Race relations still behind the times, the studio side-stepped the issue and an opportunity was lost. Bailey gave a wise and witty performance, but her Ruby Jones-in-full remained on the cutting-room floor.

For her Salome, Natalie was attended to by Hollywood's finest: costumer Helen Rose, makeup artist William Tuttle, and hairstylist Sydney Guilaroff, who modeled Natalie's hairdo on actress Gina Lollobrigida's coiffure. She radiates youth and beauty, somewhat wasted here in a bloated melodrama the *New York Herald Tribune* called "infinitely pretentious fol-de-rol." Even the title of *All the Fine Young Cannibals* could not escape critical slaughter. "The title is unexplained," sneered the *New York Times*, "for these four principals exist on an exclusive diet of alcohol and scenery."

LEFT TOP According to Natalie, *Cannibals* "was the story of four neurotics in the South. . . . All of us paraded around in wigs!" **LEFT BOTTOM** George Hamilton, Natalie, and Robert select still photographs for promotion. **OPPOSITE** Natalie runs through a scene with director Michael Anderson. **OVERLEAF** M-G-M production notes boasted that the *Cannibals* fashions "forecast chic modes for next fall and winter and run the gamut from riding habits to négligées, and from tailored suite to formals."

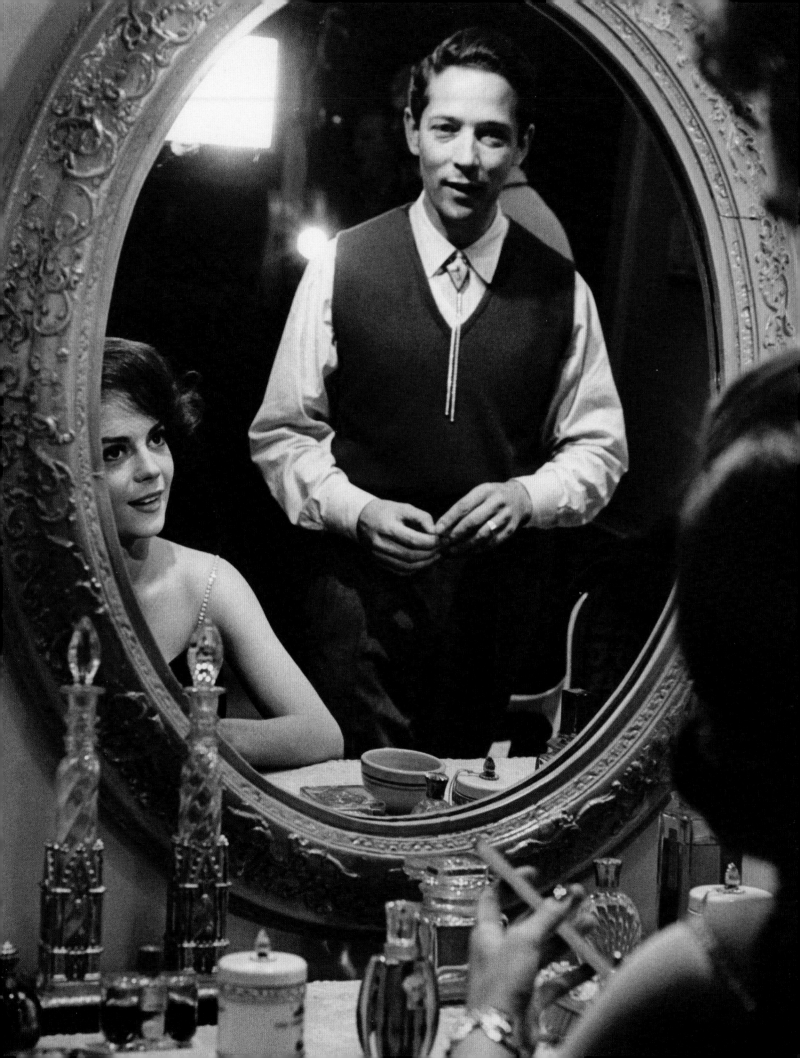

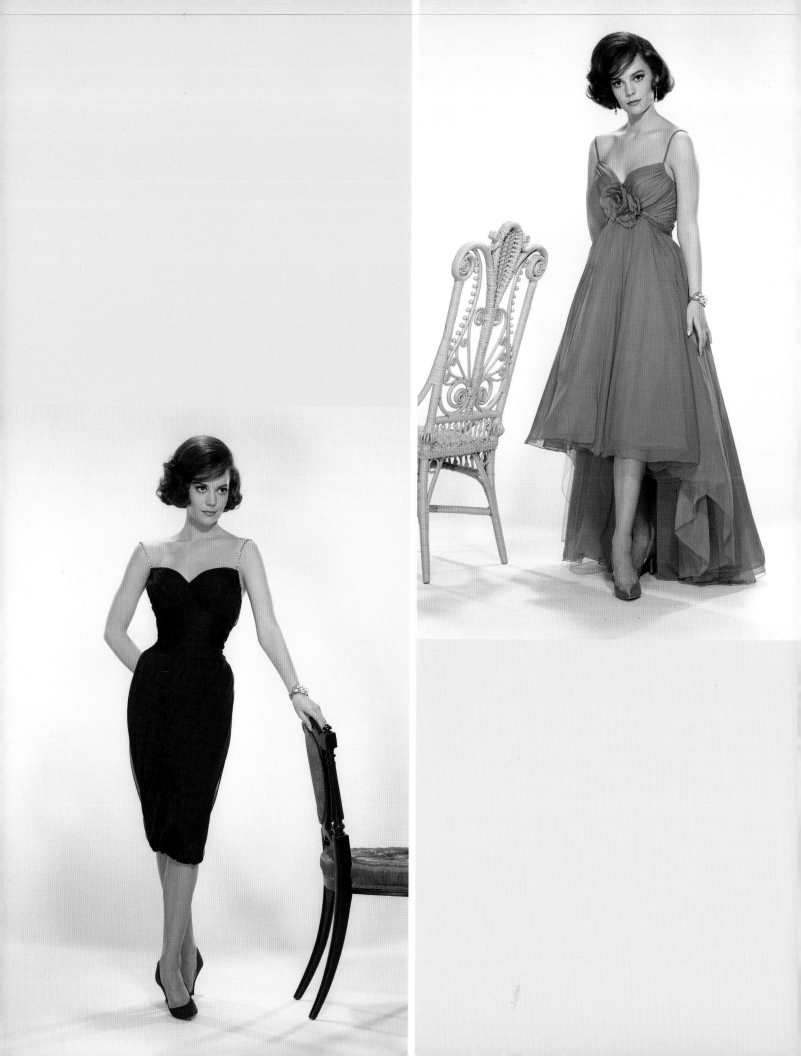

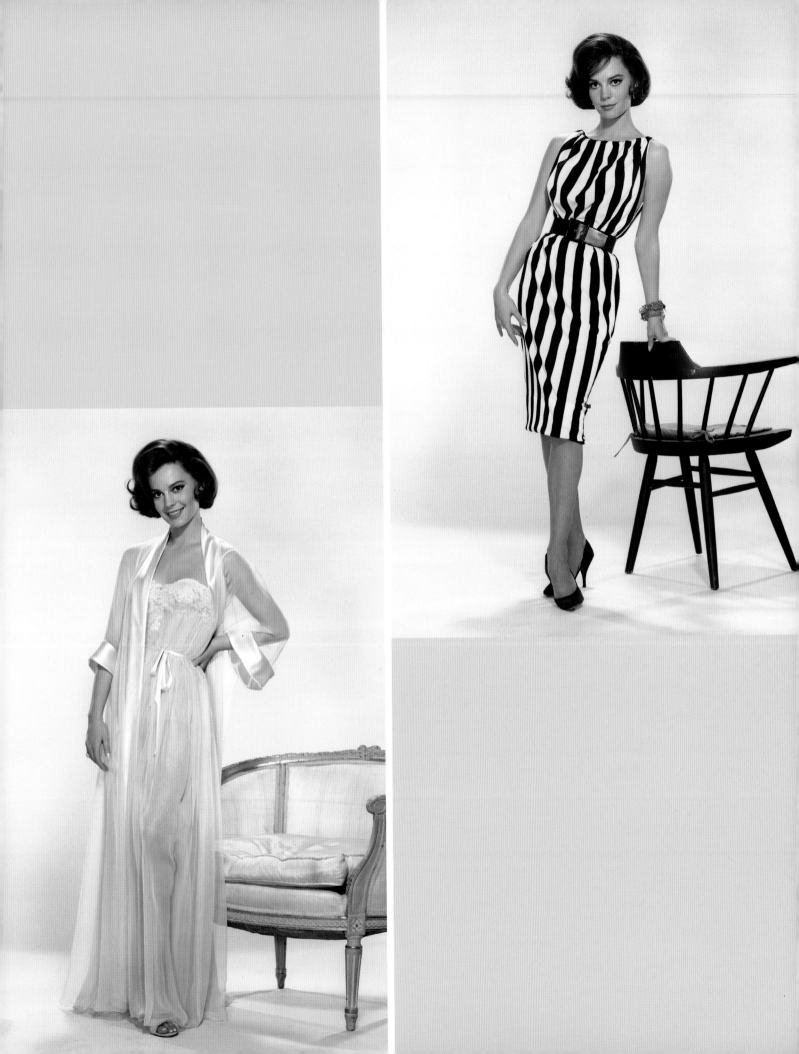

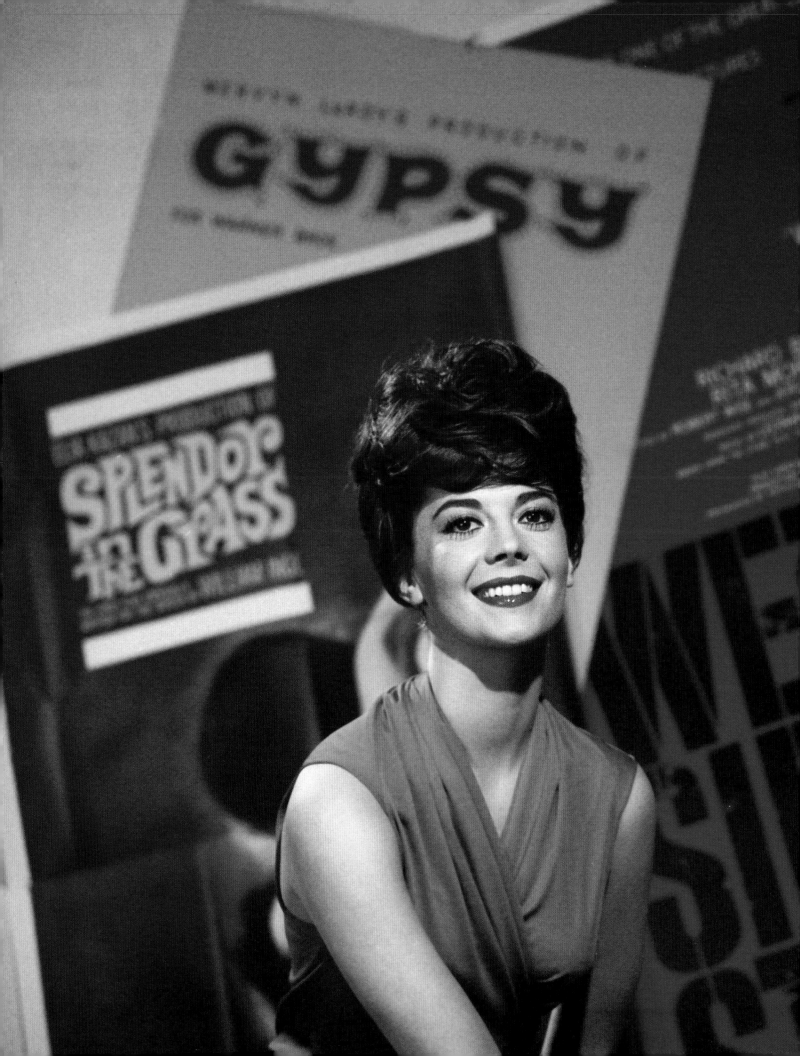

TRIPLE THREAT

Splendor in the Grass

West Side Story

Gypsy

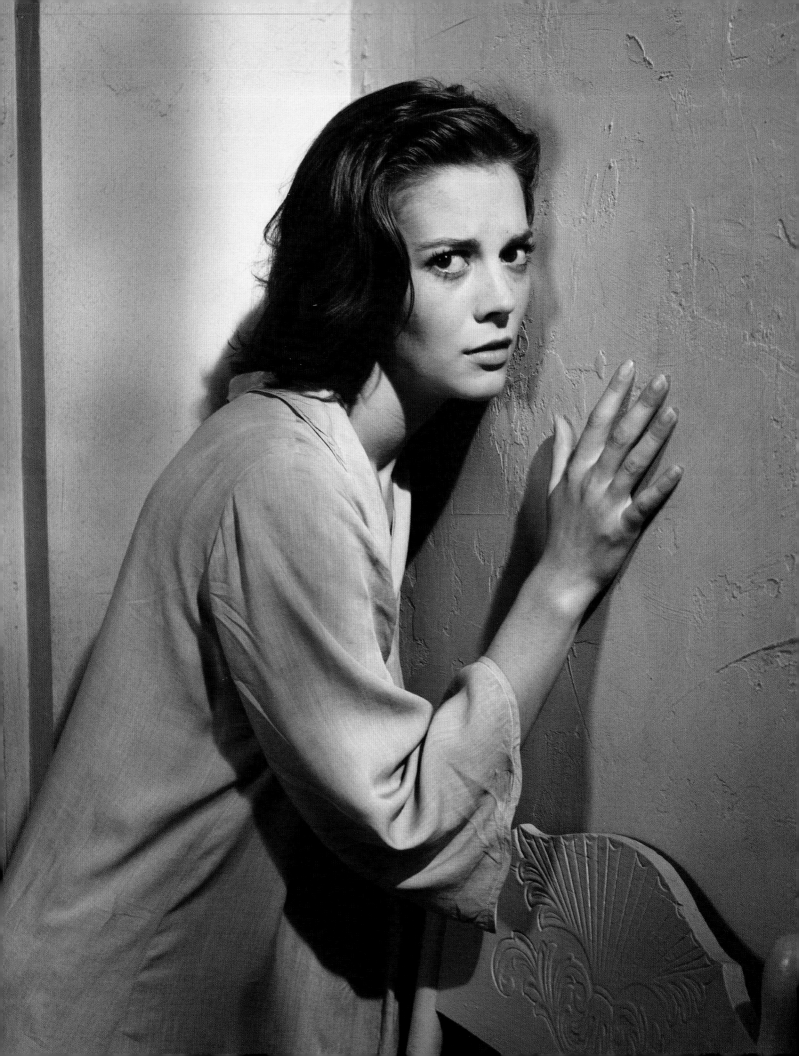

SPLENDOR IN THE GRASS

"Somebody was here … Somebody was here …"

With these words, Natalie Wood as Wilma Dean "Deanie" Loomis wakes from her trance. Hospitalized and unresponsive following her suicide attempt, she is restored to her senses by hearing the voice of her first love, Arthur "Bud" Stamper. Deanie's connection to Bud is so strong that her catatonia is broken only by his muffled sobs from the hospital hallway. Is he really there, or is she dreaming? She never sees him that night, they never reconnect or consummate their love, and the tragedy of a missed opportunity is played out brutally—and beautifully— in *Splendor in the Grass*, a film that gave Natalie perhaps the single greatest role of her career.

Splendor is an evocation of small-town America, an indictment of social and religious repressions, and a plea for the care and nurture of young hearts and minds. Deanie and Bud are the film's seemingly idyllic high school couple, the captain of the football team and the prettiest girl in the class. But their love escalates to a devastating climax as they are torn from each other to satisfy everyone's plans but their own, resulting in mental breakdown and the destruction of youthful spirit.

Thanks to a string of masterpieces, including *A Streetcar Named Desire* (1951), *On the Waterfront* (1954), and *East of Eden* (1955), Elia Kazan had become one of Hollywood's most critically acclaimed

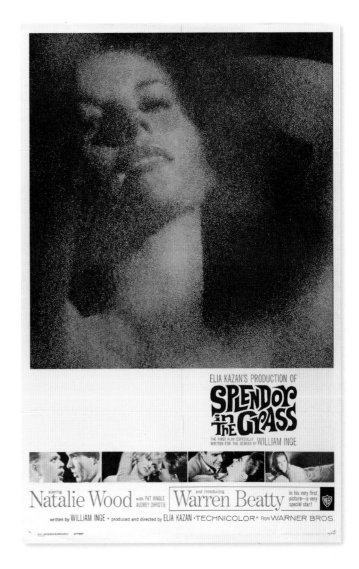

ELIA KAZAN'S PRODUCTION OF
SPLENDOR in The GRASS
THE FIRST PLAY ESPECIALLY WRITTEN FOR THE SCREEN BY WILLIAM INGE

starring **Natalie Wood** with PAT HINGLE AUDREY CHRISTIE and introducing **Warren Beatty** in his very first picture—a very special start!

written by WILLIAM INGE · produced and directed by ELIA KAZAN · TECHNICOLOR · from WARNER BROS.

OPPOSITE Natalie as Deanie Loomis in a scene cut from the final film. **RIGHT** Advertisements played up the strong sexual undercurrent of the film by featuring Natalie nude in the bathtub.

directors by the end of the 1950s. To Natalie, he was a god, the man behind her idol Vivien Leigh's Oscar-winning Blanche DuBois, and another of Natalie's favorite screen characters, Marlon Brando's Terry Malloy from *Waterfront*. In 1958, Kazan ("Gadge" to his friends) personally selected a provocative piece of unpublished writing by William Inge for his next film, and coaxed a first-time screenplay out of the

Pulitzer Prize-winning playwright that would go on to earn an Academy Award.

Inge not only wrote the story, but cast the leads, envisioning a young, unknown actor named Warren Beatty as Bud. Warner Bros. signed the newcomer on Inge's promise that "He's going to be bigger than Marlon Brando and James Dean put together!" Kazan was initially hesitant to cast Inge's choice for the fragile Deanie, until Natalie's fee was "discounted" by Warners. Meeting the actress in person convinced him that she had the potential to be great. When informed by a journalist that Natalie had "only been good in two pictures," Kazan replied, "Then I say she's got it. Two pictures is a hell of a lot of pictures."

Natalie's career since *Rebel Without a Cause* had been a string of glossy disappointments. She desperately needed to be associated with a prestige production, and aspired to work with the revered Kazan. Yet, she later admitted, "I was very frightened of this role because I felt it would require of me to feel certain things that I, Natalie, still had bottled up inside of me. I thought it would be painful, and it was." Natalie knew there would be no Hollywood

make-believe with Kazan; her own personal pain would be necessary to breathe life into Deanie. "I used paint remover on her," Kazan later said, "took off her glamorous clothes and put her in front of the camera, naked and gasping."

Stripped of her glamour, Natalie's natural dramatic power emerged in full force. Though she had acquainted herself with Stanislavski and Method acting during her *Rebel* days, she had never pursued it very far. Once she understood its principles, she realized she had always called upon emotional memories instinctively, without making a big fuss about it. "Method—shmethod!" she said just before shooting *Splendor.* "Anyone who acts follows his ideas, and uses some method. Like Katharine Hepburn and Spencer Tracy, who have been using it for years. Yet you never hear of them being referred to as 'Method' actors."

ABOVE LEFT Kazan with his leading lady. Natalie said of her director, "I've never found myself working so fully. He freed me as an actress and gave me the greatest confidence I've ever had." **ABOVE RIGHT** Deanie hears Bud's voice in the hospital. **OPPOSITE** Natalie's highly charged performance in the bathtub was filmed only once. Kazan advised her: "Be bold, be brave, shock yourself . . . embarrass yourself."

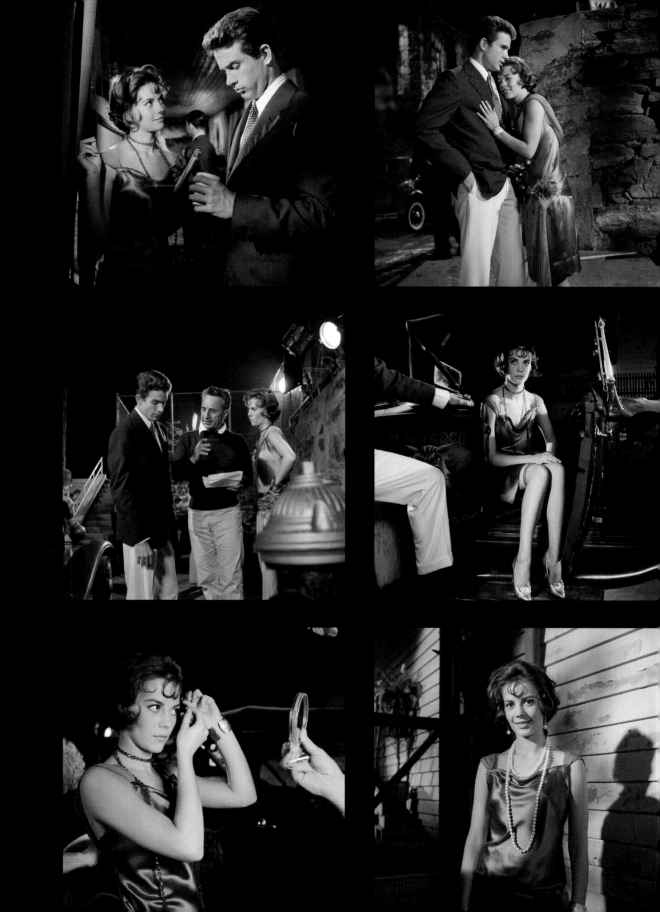

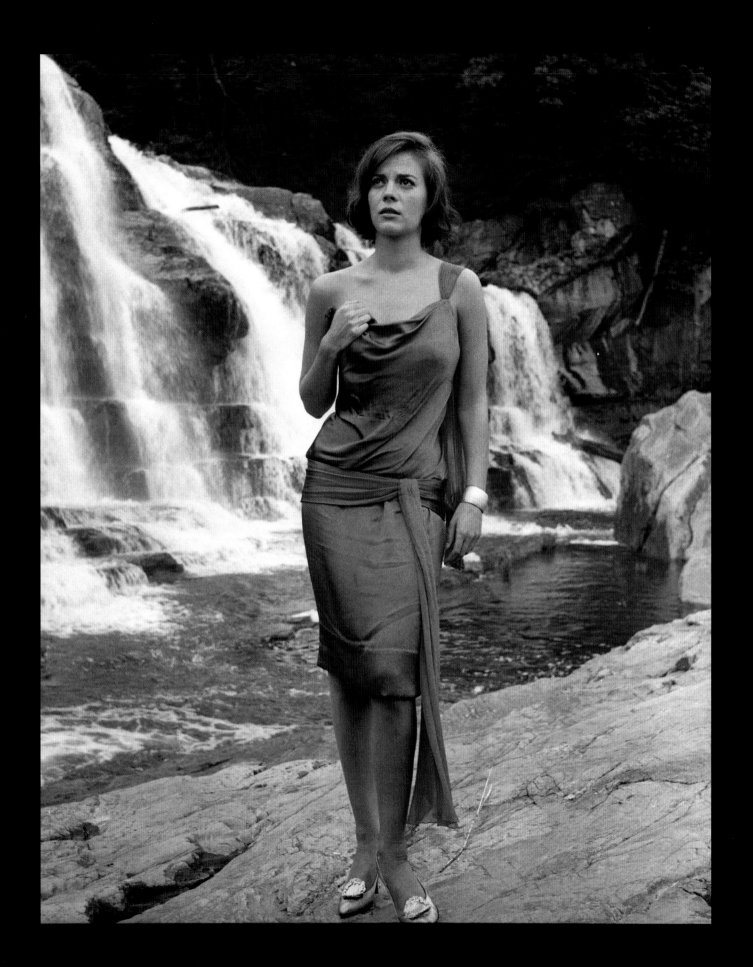

OPPOSITE Natalie, Beatty, and Kazan prepare for the school-dance scene. ABOVE Natalie did her own swimming in the film.
"Kazan can make you do most anything," she said. "I don't know how he did it, but there I was jumping right in for him."

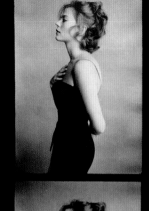
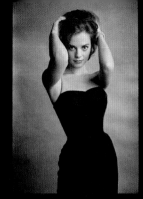
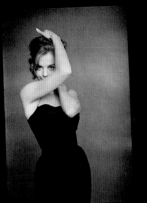
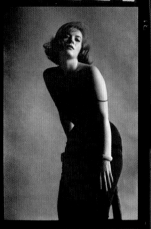

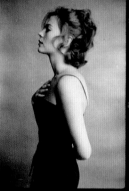
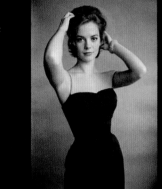
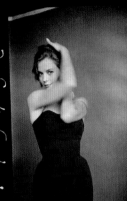
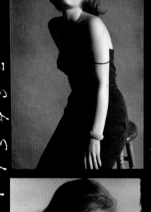

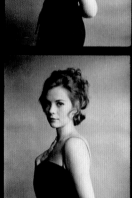
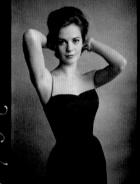
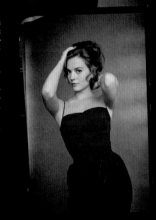
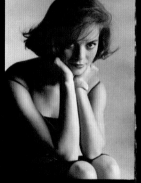
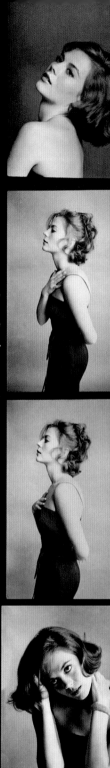
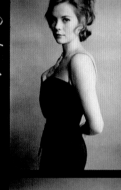
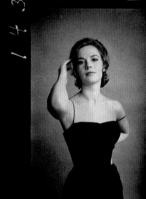
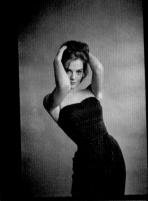
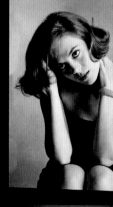
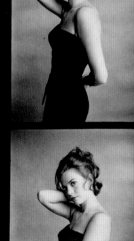
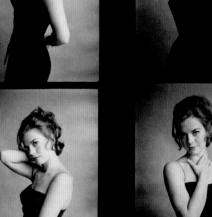
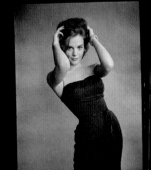
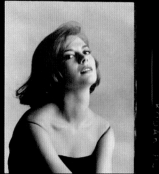

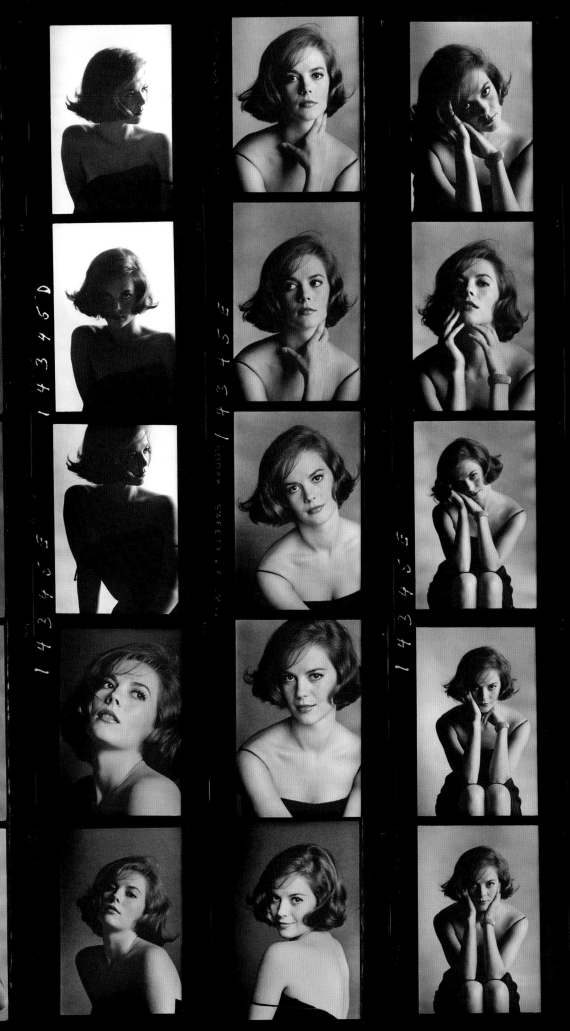

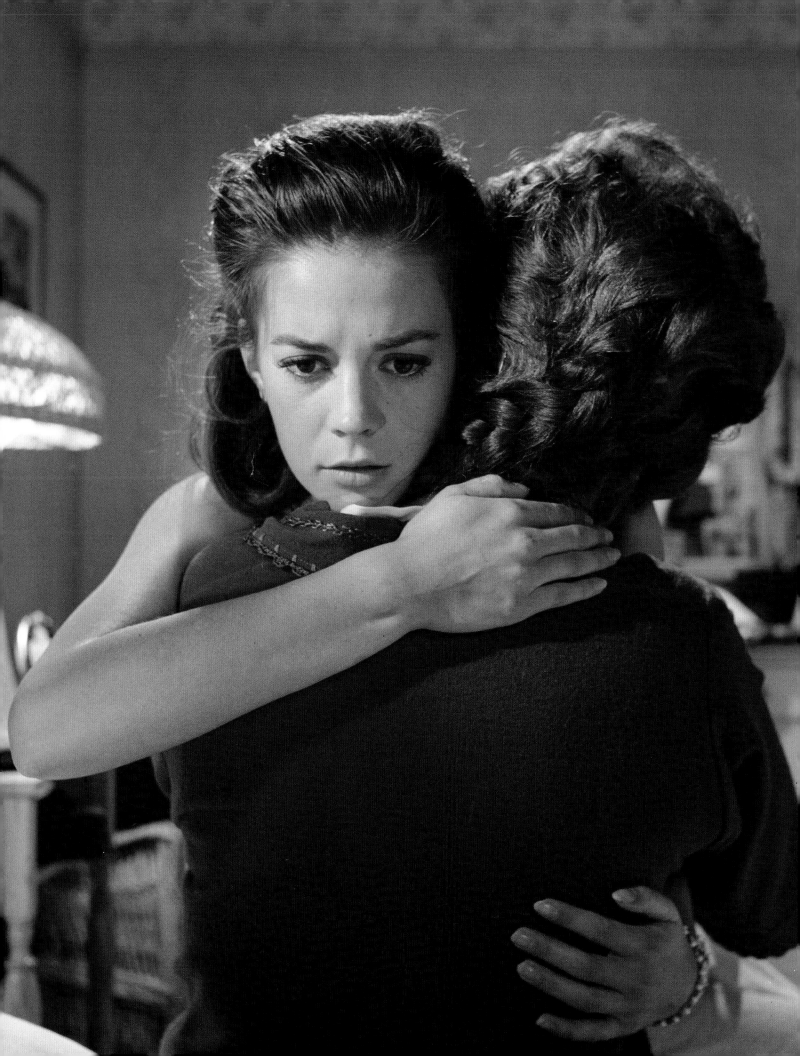

Warren Beatty, in his film debut, brought more than a little bit of Method pretension to the New York locations (standing in for late 1920s Kansas), irritating Natalie, other actors, the crew, and even Kazan on occasion. Despite romance rumors, Warren and Natalie were indifferent toward each other off-camera. Indifference soon turned to resentment, as Warren heard gossip that Natalie was displeased about being teamed with a newcomer. "As the coolness between us became apparent," Natalie recalled, "Gadge started to worry. He was afraid the rift might show up in the love scenes." But they went smoothly, and the two stars warmed up to each other, eventually engaging in a tumultuous two-year affair after *Splendor* wrapped and Natalie separated from Robert Wagner.

Despite some moments of Brando-and-Dean-inspired squinting and brooding, Beatty is ideal as Bud, though Natalie's pure portrayal of Deanie Loomis outshines her costar's dramatic efforts. In the scene where Bud half-jokingly pushes Deanie to her knees, Beatty strains to convey inner torment, while Natalie shifts instantly from playful to authentically shattered. "I would go down on my knees to worship you if you really wanted me to," she murmurs, the hint of real tears glistening in her eyes.

The parents of both lovers are shackled by societal restraints and gender double standards. Deanie's mother firmly asserts that "no nice girl" has sexual feelings, while Bud's blustering businessman father forces his son to graduate from Yale before entering into a sexual relationship with Deanie, encouraging Bud to take up with a different "kind of girl" in the meantime. The town's minister reinforces denial of earthly pleasures in his sermon. "Lay not of

treasures for yourself on earth. . . ."

When sexual frustration, heartbreak, and fear of her own urges overwhelm Deanie, she throws herself into the rushing waterfall near lover's lane—a terrifying ordeal for Natalie. She had promised Kazan that she would do whatever he asked, with one exception: the near-drowning in the dark waters of the river, her one specific and longstanding fear. Yet it seemed that Natalie continually gravitated to films that forced her into the deep end. When a stunt double proved inadequate, Natalie the professional rose above her terror. "The crew tied a rope around my waist, and two men held my hands for additional security." When she heard Kazan whisper, "Let go of her hand," she knew her director was trying to trick her into registering genuine anguish, and became so enraged that her fear vanished. "Natalie," Gadge laughed after the take, "you gave me exactly what I wanted."

Her other pivotal scene also involved water: the layered and tense bathtub sequence. Kazan used his directorial privilege to get what he wanted, threatening Natalie with cutting away to a close-

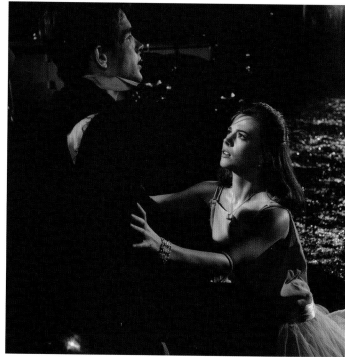

CLOCKWISE FROM TOP LEFT A candid moment with Beatty and Kazan; The New Year's Eve party scene; Deanie reads a Wordsworth poem in class: "Though nothing can bring back the hour/Of splendour in the grass, of glory in the flower/We will grieve not, rather find/Strength in what remains behind."; William Inge with Natalie. Inge, who plays Reverend Whitman in the film, won an Oscar for his script. **OPPOSITE** Filming Kazan's favorite scene. "I remember the day we discussed the white hat, and how much that meant to her," he recalled. "She looked beautiful in it."

up of Audrey Christie (Mrs. Loomis) during Deanie's emotional breakdown if Natalie could not handle the water-thrashing fury. "I guess *that* made me hysterical," Natalie reflected. Again, Kazan achieved the desired outcome.

Wood and Beatty look perfect together on screen, and are supported to equal perfection by Pat Hingle, Zohra Lampert, Gary Lockwood, Barbara Loden (Bud's sister, the wild flapper, Ginny), a young Sandy Dennis, and Phyllis Diller as the entertainer Texas Guinan. The production designer was the soon-to-be master Richard Sylbert, with set decoration by another future industry whiz, Gene Callahan. Cinematographer Boris Kaufman managed to evoke the pastoral Kansas setting while shooting in the Bronx, Harlem, Staten Island, and upstate New York, and Broadway's Anna Hill Johnstone crafted the costumes. For an era when Hollywood adhered only loosely to period settings, *Splendor* captures the past with admirable accuracy, conjuring a harrowing yet lyrical slice of Americana.

Like *Rebel* had in 1955, *Splendor* seemed to bewilder 1961 critics, who babbled that it was "unpleasant," yet "fascinating to watch." One celebrity fan, Catherine Deneuve, once called *Splendor in the Grass* "one of the most beautiful love stories I've ever seen in cinema." Even Audrey Hepburn, nominated for a Best Actress Oscar for *Breakfast at Tiffany's* (1961) in competition with Natalie for *Splendor*, took a moment at the 1962 ceremony to confide in Natalie that she thought her performance as Deanie was "magnificent." Audrey's praise stayed with Natalie, who observed, "It is gratifying to hear this from a fellow performer. Not all actresses are jealous competitors." Perhaps the most heartfelt tribute Natalie received came from Gadge himself. "I loved her—as a human first. As an actress, she did perfectly anything I asked."

As a story of forbidden love, does *Splendor in the Grass*—a movie already set over thirty years in the past when it was new in 1961—still resonate in today's ultra-permissive society? It does, because the agonizing failure to obtain the heart's deepest desire is *Splendor*'s powerful poetry, and such pain is universal and eternal.

Deanie and Bud's despair was not unique, and was especially common in their time period. Like virtually everyone who experienced the Great Depression, *Splendor*'s lovers are forced to reevaluate their dreams, and to redefine personal happiness. In stark contrast to the majority of Hollywood romances, *Splendor in the Grass* has no happy ending. Deanie, cloaked in angelic white for the film's finale, fares better than Bud, but neither fully recovers from their crushed adolescent hopes. Love, in this case, does not conquer all.

ABOVE Bud playfully torments Deanie. "He seemed very pleasant as well as very talented," Natalie recalled of her first meeting with Warren Beatty. **OPPOSITE** Natalie later wrote of her relationship with Beatty that began after *Splendor*. "It was like a highly charged movie script—but somebody forgot to write a happy ending. Ironically, we became better friends after we separated. We can laugh about it now."

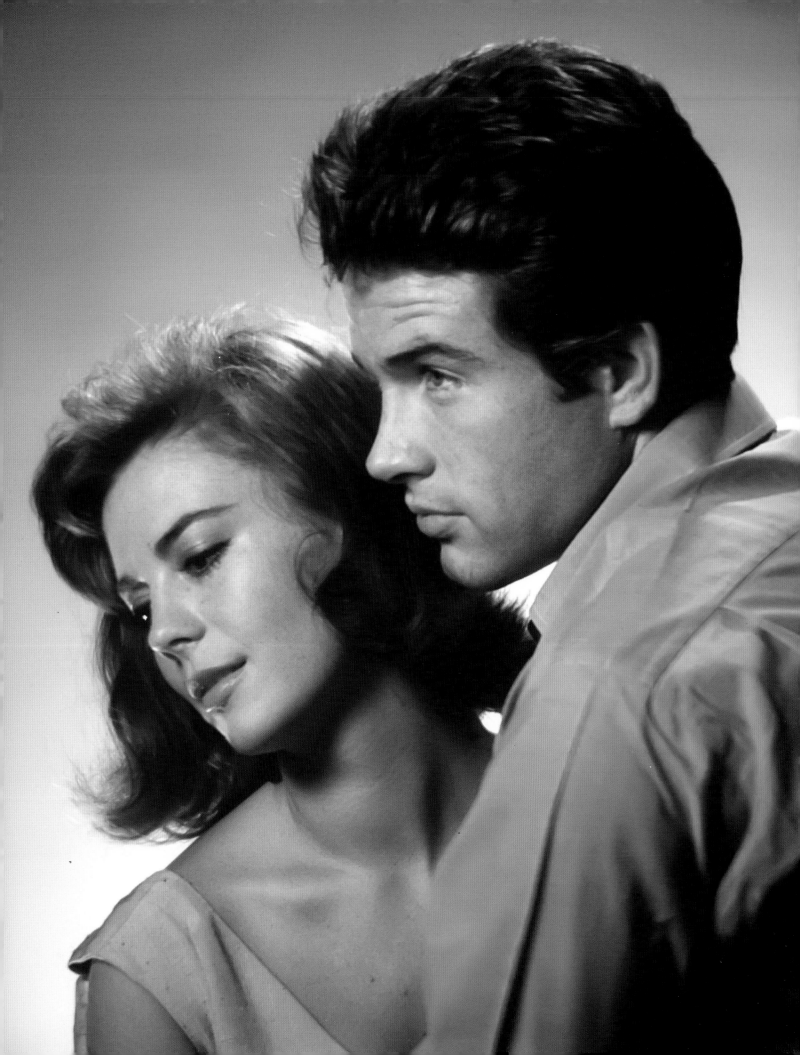

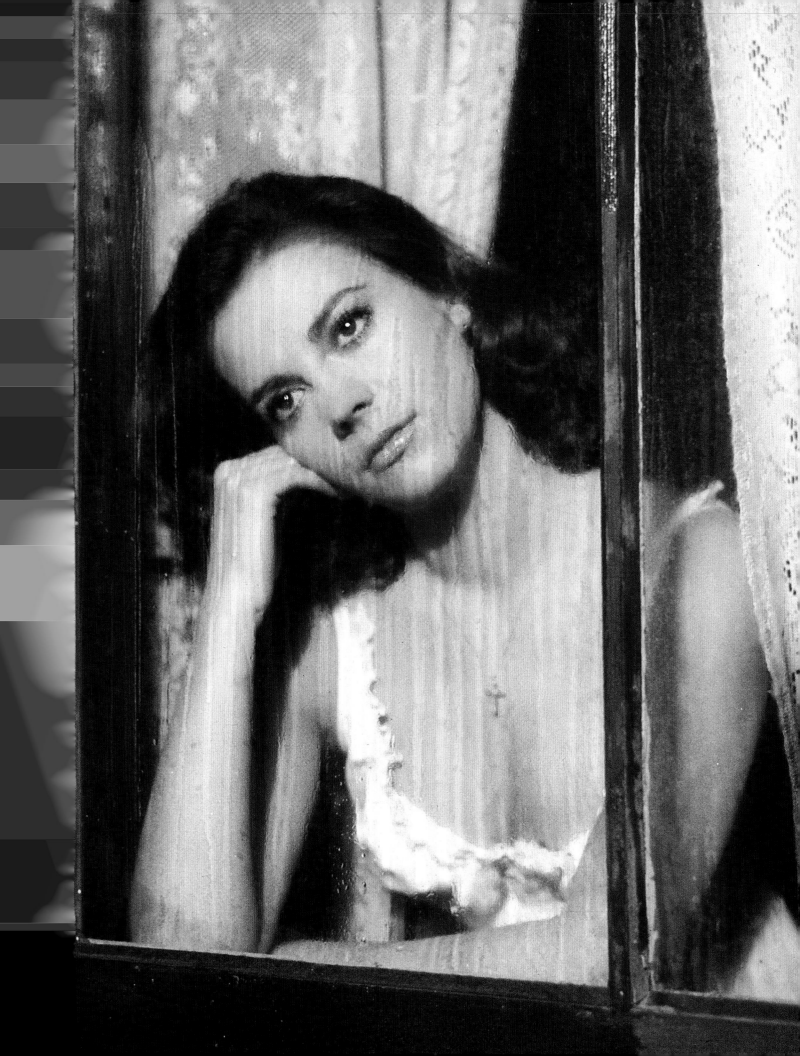

ART AND SOUL
NATALIE WOOD IN WEST SIDE STORY

When the film version of *West Side Story* premiered in October 1961, I was less than a month old and oblivious to the fact that film history was being made. As a kid, I became familiar with Natalie Wood by reading old movie magazines, and the first thing that struck me was her gorgeous, welcoming smile. Sometime in the mid-1970s, I finally experienced *West Side Story* for the first time. Everything about it was thrilling: the music, the dancing, and the stunning color photography, even on the small television screen in my family's living room. But nothing drew me in more than the performance of Natalie as Maria. Behind the makeup and the Puerto Rican accent, I could sense something genuine shining through; a unique spirit that was Natalie's alone. Just as millions before me had, I fell in love with her instantly. Her presence and her beauty riveted me, and her gentle grace was perfect for the role of the young, naïve girl falling in love for the first time. And on top of all this, she could sing! Well . . . I thought so at the time.

Natalie's journey with *West Side Story* began fortuitously in January 1958, when she and newlywed husband Robert Wagner visited New York City on their honeymoon. The couple took in several Broadway shows, including *The Dark at the Top of the Stairs* and a modern-day musical retelling of *Romeo and Juliet* with a book by Arthur Laurents, music by Leonard Bernstein, lyrics by Stephen Sondheim, and

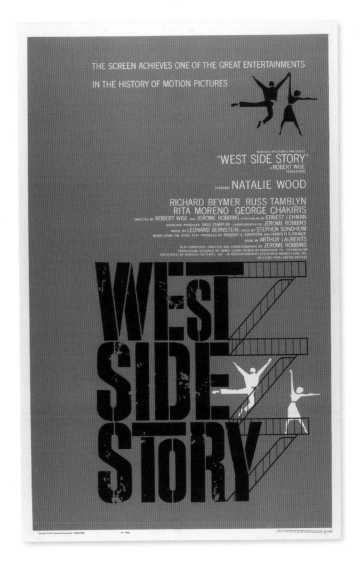

conceived, directed, and choreographed by Jerome Robbins. The Wagners enjoyed the show, but acting in a film version had not yet entered Natalie's mind.

Just as *Oklahoma!* had fourteen years earlier, *West Side Story* broke new ground, not only with its fresh and innovative use of music and dance to further story and plot, but with its hard-hitting depiction of prejudice, juvenile delinquency, racial tension, gang warfare, and murder—hardly the

OPPOSITE "Natalie Wood is radiant as Maria in love, deeply moving in her tragic moments," wrote *Saturday Review* critic Arthur Knight in 1961. ABOVE Saul Bass created the bold, contemporary title treatment for the original one-sheet poster, and also designed the film's main and end titles.

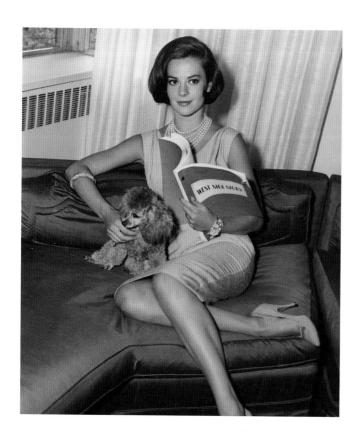

corporation owned by Walter Mirisch and his brothers, Marvin and Harold, became interested in the property. On July 22, 1959, Army Archerd reported in his *Variety* column, "Natalie Wood and Elvis Presley for *West Side Story*—that's only part of the plans Harold Mirisch has for this big one" Archerd noted that the filmmakers would also include "platter favorites" Fabian, Paul Anka, Bobby Darin, and Frankie Avalon as members of the west-side gangs. This was yet another "dream casting" fantasy that never went beyond the rumor stage. In fact, during the pre-production period, the filmmakers vacillated between using stars or "no-names" in the lead roles.

In August 1959, "An Announcement of Major Importance to the Entertainment Industry Throughout the World" officially graced the trade papers: the Mirisch Company and Seven Arts would make *West Side Story* with producer-director Robert Wise.

kind of fare Broadway audiences were used to at the time. The musical tragedy opened at the Winter Garden Theatre in New York on September 26, 1957, and ran for 732 performances; a very respectable run, but not exactly a juggernaut. "Its reviews were good, not great," co-producer Harold Prince remembered. "Walter Kerr referred to it as 'cold.' We drew audiences. We got no awards. The big hit that year was *The Music Man*."

But *West Side Story* was bursting with big-screen possibilities. Rumblings of a movie deal surfaced in the summer of 1958, when *Variety* reported that Seven Arts Productions was negotiating to acquire film rights, to be released by United Artists. Big plans were already in the works for the cinematic *West Side Story*: it would be photographed in one of the three major widescreen processes of the time—Todd-Ao, Cinerama, or CineMiracle—and would be geared as a blockbuster. *Variety* discussed a "dream cast" for the film: Marlon Brando as Tony, Harry Belafonte as Bernardo, and Elizabeth Taylor as Maria.

Natalie's name did not enter the picture until the Mirisch Company, an independent production

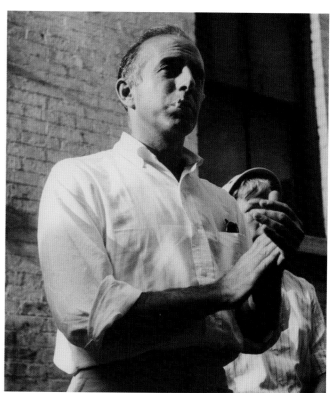

ABOVE LEFT Images of Natalie reading the *West Side Story* script with the ever-present Chi Chi were circulated in the press before she started filming. **ABOVE RIGHT** "She was fierce about friendship," recalled Jerome Robbins. "She viewed Hollywood with a great deal of ironic humor. You might say she was shrewd-eyed in Babylon." **OPPOSITE** Natalie steps into her leotard for dance rehearsals.

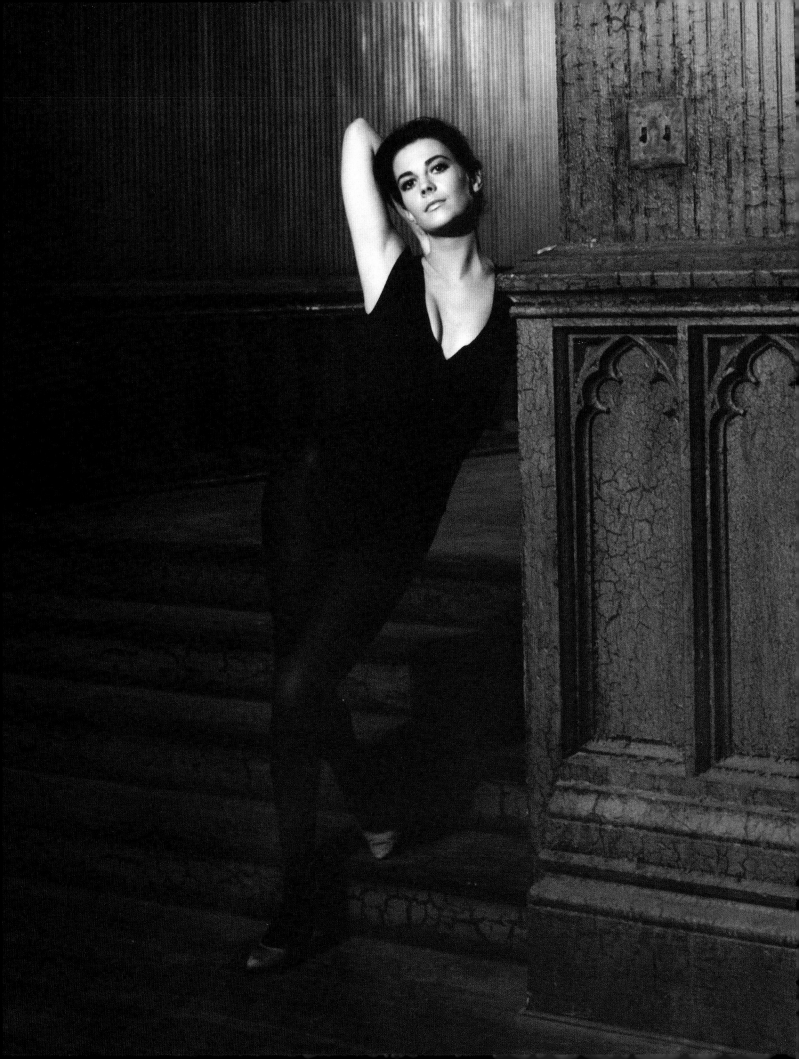

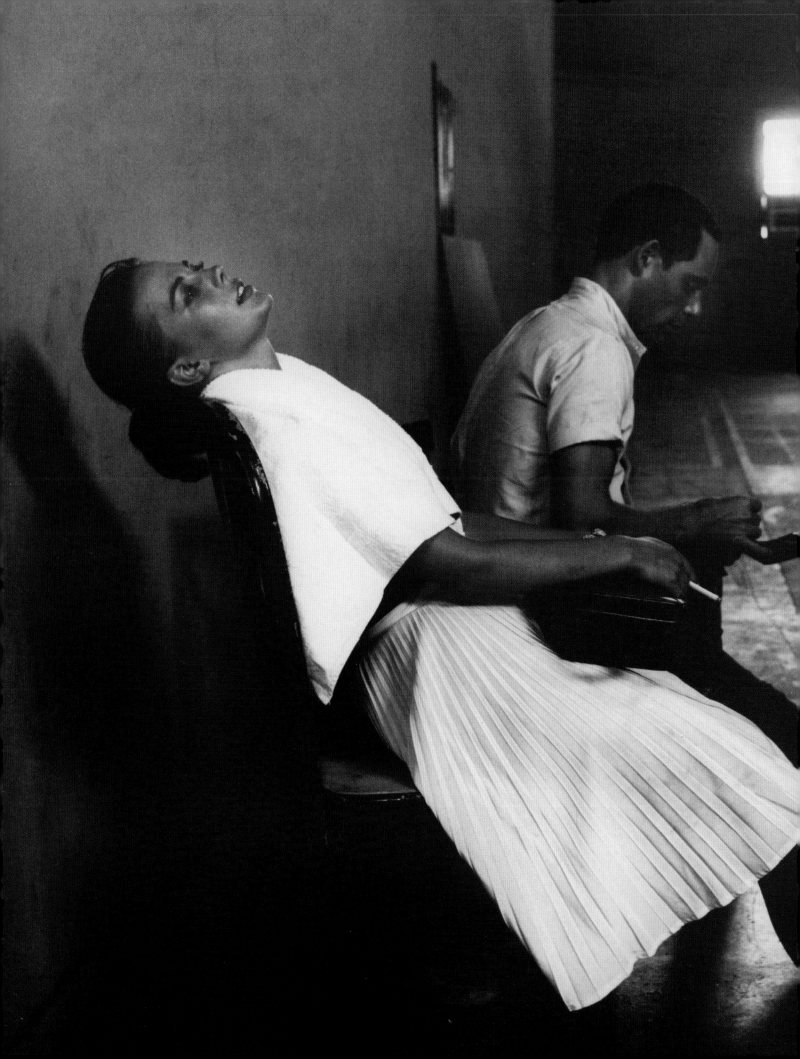

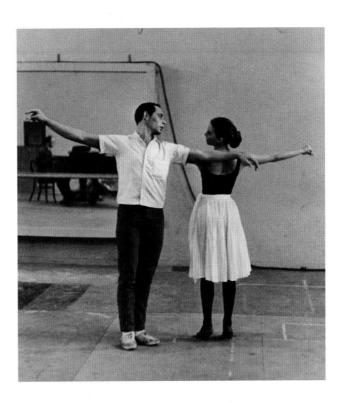

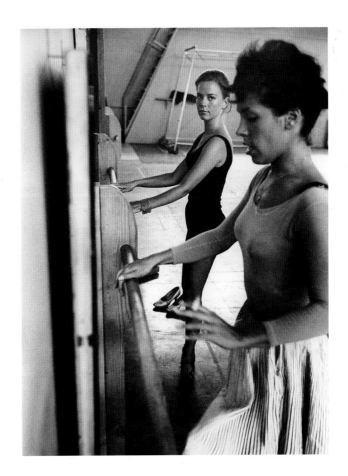

LEFT When told she was rehearsing exhaustive dance numbers on the same stage where Susan Hayward suffered the gas chamber in *I Want to Live!*, Natalie replied, "Now I know what she went through." TOP Practicing Maria's steps with choreographer Howard Jeffrey. BOTTOM Natalie warms up at the barre with Yvonne Othon Wilder. Years later, the two would appear onscreen together in *The Last Married Couple in America*.

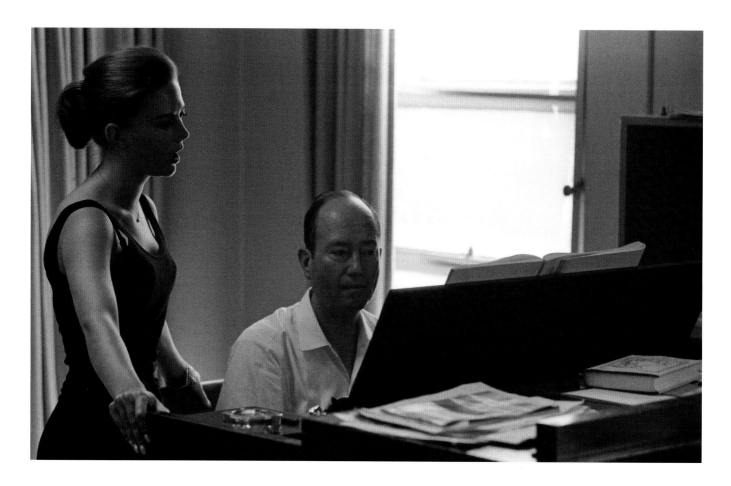

Wise, who began his Hollywood career as an editor before moving on to directing, had garnered Oscar nominations for editing 1941's *Citizen Kane* and directing the 1958 biopic *I Want to Live!*, and seemed an unlikely choice to direct a big-budget, contemporary musical.

Because of Jerome Robbins' contractual "first refusal" right to direct a movie version of *West Side Story* (and because his original vision was the very core of the production), it was decided that Robbins and Wise would "co-direct" the film, Wise focusing on the dramatic scenes and Robbins on the dance numbers. As Walter Mirisch recalled, "It was clear from the outset that Jerome Robbins was central to the creative heart of *West Side Story*, and we wanted his contribution to the musical side of the picture."

Before casting lead roles, hundreds of dancers were auditioned in New York and Los Angeles. Casting consultant Lynn Stalmaster's initial considerations for Tony included Russ Tamblyn, Warren Beatty, Richard Beymer, Richard Chamberlain, Rick Nelson,

George Peppard, Anthony Perkins, Burt Reynolds, and Dean Stockwell. Diane Baker, Yvonne Craig, Susan Kohner, Barbara Luna, Margaret O'Brien, Suzanne Pleshette, and Roberta Shore were discussed as possible Marias.

Although she had been approached about playing Maria, at this stage, Natalie was not a serious contender. In fact, it was a role that she did not actively pursue, but it seemed to pursue her. As late as June 1960, Natalie claimed she was uninterested in *West Side Story* and was seeking more mature parts, like the one she was currently playing, Deanie in Elia Kazan's *Splendor in the Grass*. But Natalie's work with Kazan in New York was about to lead her to the west side in the most unexpected way.

As Kazan's production assistant, future playwright

ABOVE Natalie put in long hours with vocal coach Bobby Tucker. OPPOSITE TOP "I've never sung before," Natalie said during filming, "so I have to take voice lessons. This is a tough picture because of all the new things I'm doing." OPPOSITE BOTTOM Richard Beymer and Natalie with conductor Johnny Green.

162

Mart Crowley, remembers, "One day a call comes from the Mirisch office. They were requesting to see a reel of film on Warren Beatty, who they were considering casting in *West Side Story*. So, I set it all up. Robbins and Wise came. . . . And clunk, the lights go out and we have that scene and it goes by very fast." The early love scene featuring Deanie and Bud at the Loomis house after school flickered across the screen. "Suddenly, it's over and the lights come back on, and I say, 'Would you like to see it again?' because their heads are in conference up front. They say, 'No, no, we've seen enough.' And before Wise and Robbins leave, I say, 'I'm just curious, but what did you think of Warren Beatty?' to which they replied, 'Oh, he's a terrific actor, he really is. But we've found our Maria.'" Beatty forgotten, Wise and Robbins returned to Los Angeles to tell the Mirisch Company that Natalie Wood was their ideal female lead.

In late July of 1960, Wise and Robbins returned to New York to meet with the actress and to finalize

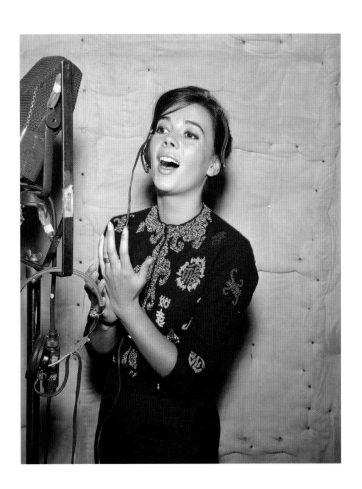

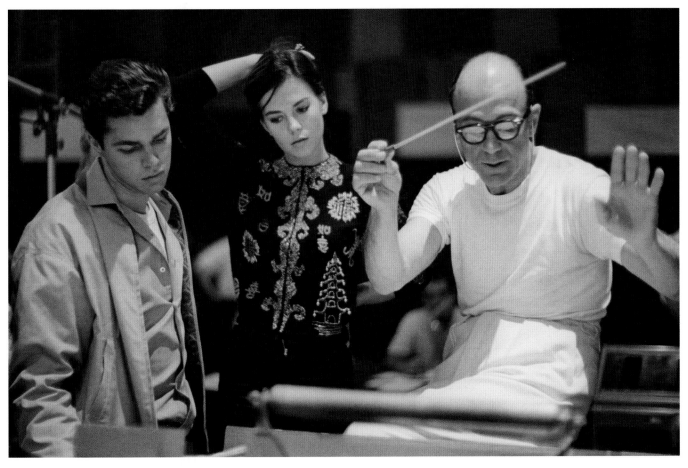

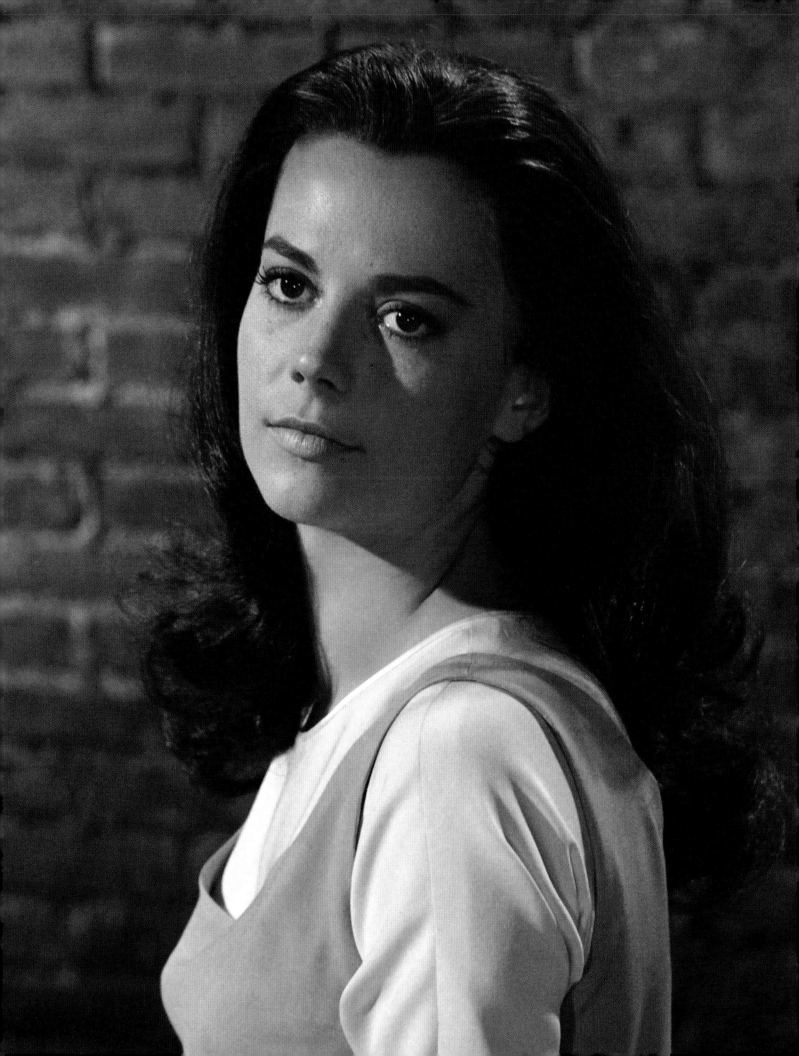

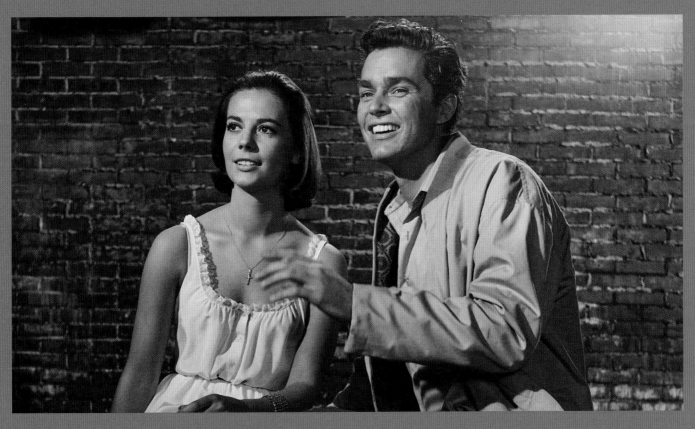

OPPOSITE AND TOP Sydney Guilaroff was flown in from London, where he was styling Elizabeth Taylor's hair for *Cleopatra*, to create a hairstyle for Natalie as Maria. **ABOVE RIGHT** Although Natalie and costar Richard Beymer did not share a close personal connection, cameras captured a believable rapport between the screen lovers.

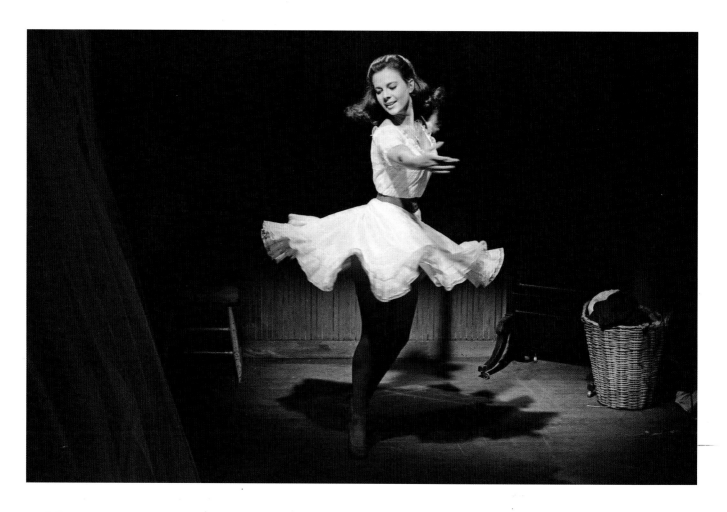

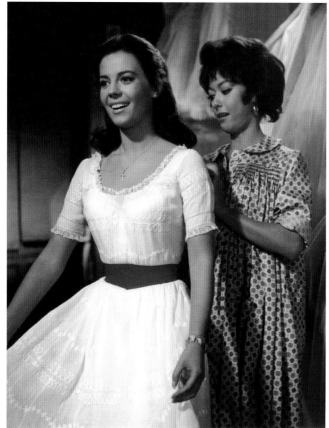

her loan-out with Warner Bros. and the William Morris Agency. "We clicked at once," Robbins later said of the meeting. "There was an immediate understanding."

Meeting Robbins and discussing his creative vision imbued Natalie with enthusiasm for the project; suddenly she was excited by the idea of portraying Maria, and by the film's possibilities. She was also thrilled by a clause in her contract allowing her to record the songs herself, with a provision giving the producers final say on whether to use her voice or bring in a professional singer to dub it.

By the first of August, it was official: Natalie Wood would play the coveted role of Maria in the film

TOP Maria's twirl in the dress shop segues into the "Dance at the Gym." **LEFT** Maria and Anita. Mart Crowley addresses the topic of ethnic casting with levity: "In that day and age . . . they didn't cast that way at all. Rita Moreno had just played Tuptim in *The King and I*, for Chrissake. Was she from Thailand? I don't think so." **OPPOSITE** With George Chakiris as Maria's brother, Bernardo.

version of *West Side Story* for the then-handsome sum of $250,000. Before contracts were signed, Harold Mirisch contacted Natalie's agent with a counter-offer of a $200,000 salary plus an extra $50,000 or 5 percent of the profits. As Robert Wagner later recalled, "I advised her to take the percentage, but Abe Lastfogel convinced her that musicals never made much money, and the $50,000 was a much safer bet." Natalie would later bitterly regret this decision.

Rounding out the leads in the $5 million, Super Panavision 70mm production were Richard Beymer as Tony, Rita Moreno as Anita, George Chakiris as Bernardo, and Russ Tamblyn as Riff—all talented and charismatic performers, but not big stars. Natalie was *West Side Story*'s star power and its most valuable asset; the entire shooting schedule was rearranged to accommodate her. As *Variety* reported, "Major production shift has all scenes which include Maria—about half the film—to be lensed on Hollywood sound stages. Original intent was to have the character of Maria appearing in many of the location scenes, but Miss Wood will be at work in *Splendor* through the third week in August."

Natalie's last day of shooting on *Splendor* was Friday, August 19, 1960, and on Monday, August 22, she reported to the Goldwyn Studios and hit the ground running to catch up to the other cast members, who were weeks ahead in rehearsals. Hair tests and costume fittings were followed by a grueling schedule of dance rehearsals, vocal training, and the recording of her songs.

The instant *simpatico* relationship Natalie had struck with Jerome Robbins proved beneficial for her. While she had some dance experience—lead roles in childhood ballet recitals, dance numbers with Bob Hope on his variety specials, and strutting her stuff in *Marjorie Morningstar*—she was intimidated by the large-scale production featuring the best professional dancers around. Furthermore, portraying the Puerto Rican Maria brought back bad memories of her "Mexican spitfire" Maria in *The*

Burning Hills, an embarrassing characterization that she had tried to forget. Natalie, feeling out of her element and filled with doubt, clung to Robbins for support. He was not only a great ally, teacher, and mentor, he also became a dear friend of Natalie's during production of *West Side Story*. "Since then," she wrote in 1966, "distance has separated us often, but every time we see each other, our friendship grows." They would remain friends for life.

"He's a real perfectionist," Natalie said of Robbins. The other perfectionist on the set was Howard Jeffrey, Robbins's assistant, who worked with Natalie on the choreography in Los Angeles while Robbins was shooting the opening scenes on location in New York. Between the encouragement of Robbins and Jeffrey, Natalie grew into a confident Maria. "I worked at least twelve hours a day in rehearsals, lost weight, and my body was sore from the rigorous training. But when I was judged worthy of joining the professional dancers, I felt pretty proud."

Though Maria in the original Broadway production (played by Carol Lawrence) had few major dance numbers, Robbins saw such potential in Natalie that he created a special dance for her. As he recalled, "We went into a studio and began working on a little sequence that wasn't in the

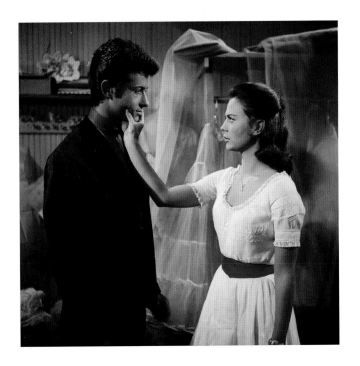

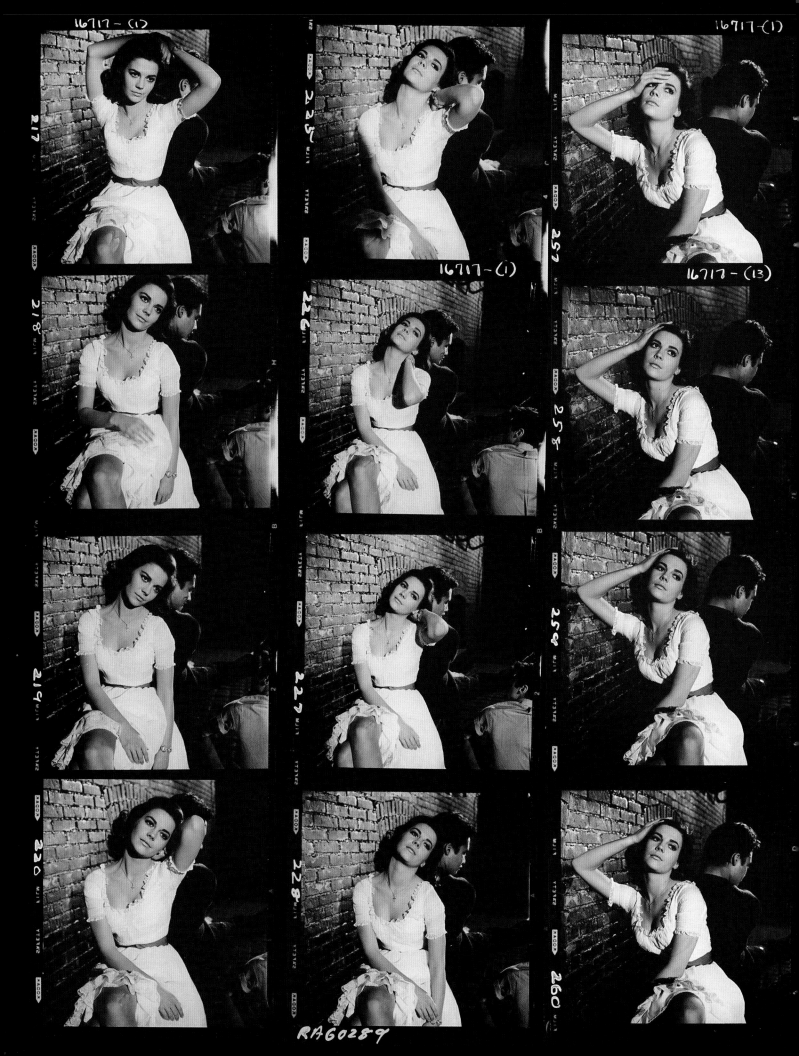

16717-(1)

16717-(1)

16717-(1)

16717-(13)

RAG0289

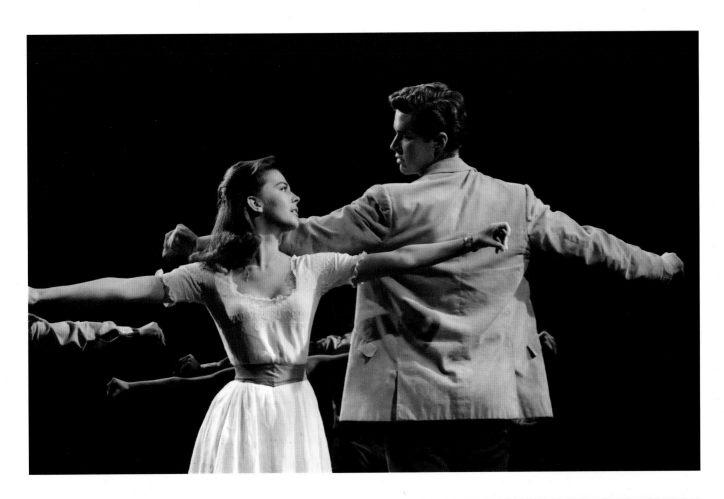

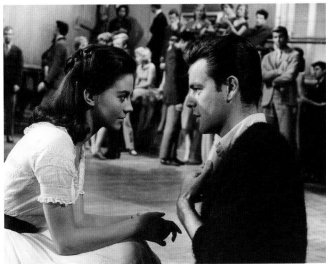

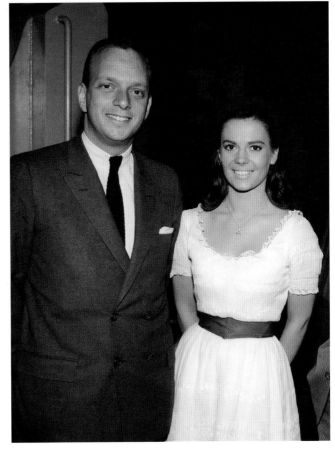

OPPOSITE On set with costar Jose De Vega, who played Chino.
TOP The *pas de deux* performed by Maria and Tony at the gym
was recreated on film just as it was performed onstage.
ABOVE AND RIGHT Visitors to the "Dance at the Gym" set included
Natalie's husband, Robert Wagner, and Hal Prince, co-producer
of the original stage production.

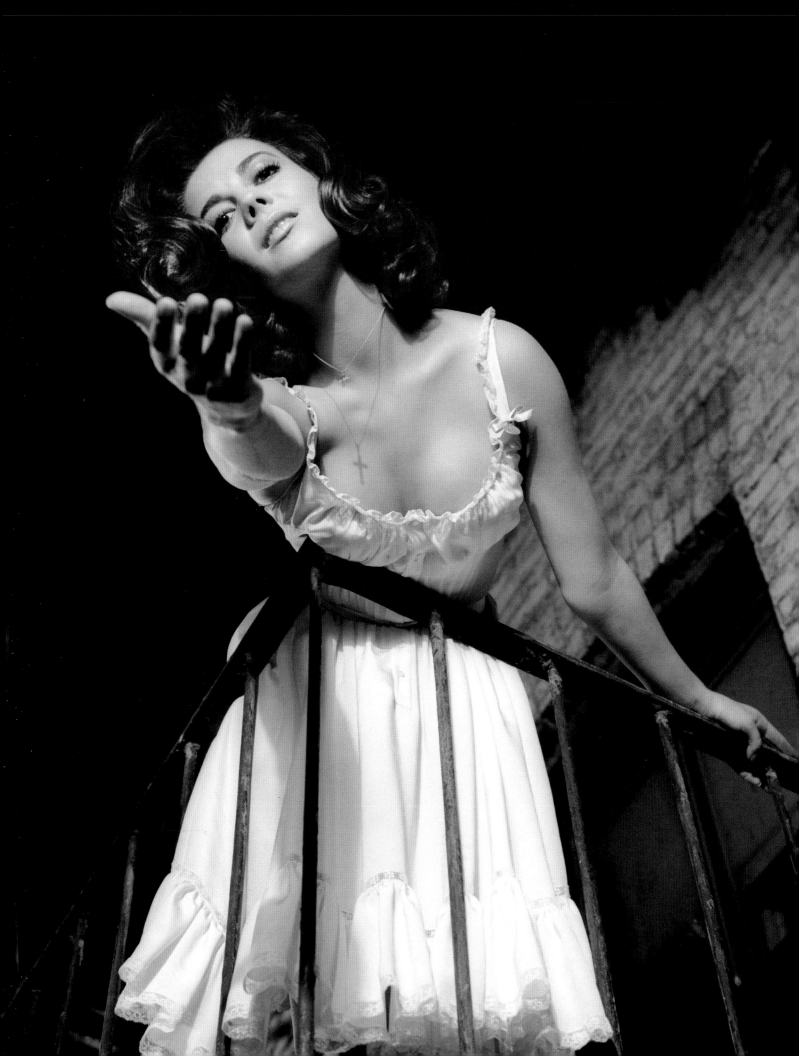

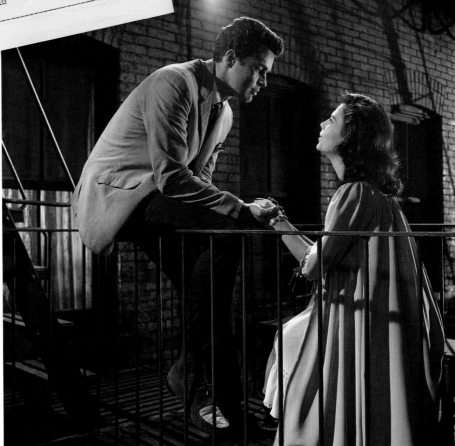

OPPOSITE Natalie on the fire escape set, caught in a rare moment without a bracelet on her left wrist. THIS PAGE The romantic fire escape scene, inspired by the balcony scene from *Romeo and Juliet*, was filmed on Stage 5 at the Goldwyn Studio on November 2, 1960.

171

original Broadway musical, a sequence along the rooftop. It was very simple, it wasn't very complicated, but she was musical and she understood what the mood of the piece was When she was waiting for Tony, she had a date with him that night, and she was up on the roof thinking about the anticipation of being with him." Maria's rooftop ballet is a stunning moment for Natalie in the film; graceful, expressive, and touching. It echoes the dance steps Maria and Tony share when they first meet, and wordlessly conveys the joy of first love.

More challenging for Natalie than the dancing were the songs, arguably some of the greatest ever written for a Broadway musical. Natalie loved the Bernstein-Sondheim compositions, and wanted to *sing* the part as well as she could *act* it. After working with vocal coach Bobby Tucker, Natalie gave it her all and made it though recording sessions in September, feeling proud of her accomplishment. These "pre-records" were used during the actual filming of the musical numbers, beginning with "I Feel Pretty."

But Natalie faced a grave disappointment when her voice was later deemed not strong enough to handle the demands of the complicated operatic score. Robert Wise waited until the last day of shooting to tell her. "He must have known for months that my voice wouldn't work," Natalie recalled, "but what really hurt was the fact that he didn't feel I could take a blow and get over it, so he postponed the bad news." Marni Nixon, who had sung for Deborah Kerr in *The King and I* (1956) and would do the same for Audrey Hepburn in *My Fair Lady* (1964), ended up dubbing Natalie's singing voice. Richard Beymer was dubbed as well, and even Rita Moreno's voice was dubbed for certain notes in the difficult score.

The acting came easier for Natalie. The original book of the play offered very little character insight, only that Maria was "an extremely lovely, extremely young girl" who has lived in America for one month. Natalie worked hard to make Maria a real person, with a spirit all her own. Determined to

make her Puerto Rican accent sound authentic, she practiced with a coach and had some help from costar Moreno. By today's standards, casting Caucasian actors in Puerto Rican roles seems insulting, even racist, but it was still common practice in late '50s and early '60s Hollywood. In the case of *West Side Story*, the producers did audition many Latina actresses, but chose Natalie, partly because she was a veteran of over thirty films. In the not-yet-racially-integrated movie industry of 1960, there were no young, bankable Latina stars. The producers needed a selling point, and Natalie was it; her name was top-billed over the rest of the cast in the credits, and in the advertising.

Jerome Robbins's perfectionism drove him to spend hours on lighting and camera set-ups, and to insist on multiple takes of most scenes, until the film was behind schedule and over budget by October. After eleven weeks of filming, just as he was about to start the "Dance at the Gym" sequence, the Mirisch brothers fired Robbins from the production. The entire cast was shocked and Natalie threatened to walk off the picture unless he was reinstated. Robbins was touched by her gesture, but persuaded her to back down and continue with Wise at the helm.

The drama behind the scenes coupled with some heavy drama on-camera created a tense atmosphere, and Natalie remembered that she and her costars sometimes devised "funny shtick to fight the tension." At the dance in the gym where Maria first meets Tony, the lines "My hands are cold . . . yours too" prompted her improvised punchline "Maybe you ought to turn the air conditioner down." Once, in her big emotional scene at the end of the film, when Natalie points a rubber prop gun at the Jets and Sharks, shouting, "You all killed him," one of the dancers walked up, bent the gun the other way, and said, "Not me, lady. I'm just waiting for a bus." The take was ruined, but everybody had a good laugh.

Natalie's last day on *West Side Story* was Friday, April 7, 1961, as she filmed some final process shots with Richard Beymer for their duets. In March, weeks

THIS PAGE Yvonne Othon, Suzie Kaye, and Joanne Miya join in the "I Feel Pretty" number as Natalie performs to the playback of her original voice. Later, Marni Nixon painstakingly matched the movement of Natalie's mouth, recreating her performance note for note.

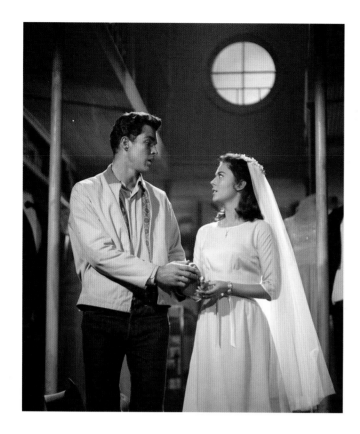

before her final scene was in the can, Manhattan's Rivoli Theatre reported advance ticket sales totaling $30,675. The film was already becoming a hit, seven months before its release.

When it finally debuted in the fall of 1961, *West Side Story* was a triumph for all involved. A box-office smash and a breakthrough in the art of cinema, it received mostly rave reviews (*Film Quarterly*'s Pauline Kael was in the minority with her scathing criticism). Natalie's notices were some of the best of her career. "Reaching heights she had never before remotely approached," raved the *New York Post*, Natalie is "heartbreaking in her exquisite portrayal of the role." Bosley Crowther of the *New York Times* found Natalie "full of luster and charm," and called the film "nothing short of a cinema masterpiece." The word "art" was used frequently by critics, many also commenting on Natalie's "radiance" and "glow" as Maria. She exceeded expectations, adding heaps of star quality, beauty, grace, and genuine emotion to the film.

Although Natalie (nominated not for Maria but for Deanie in *Splendor*) came up empty-handed at the 34th Annual Academy Awards, *West Side Story* swept the night, winning ten of the eleven categories for which it was nominated, including Best Picture and Best Director. Natalie later called that night her "most pleasant memory from the film," as Jerome Robbins shared the Best Director award with Robert Wise and was also awarded a special Oscar for "Brilliant Achievements in the Art of Choreography on Film," making her loss more bearable. "There was a very real compensation in sharing Jerry's evening with him."

Today, *West Side Story* continues to enthrall generations with its electrifying energy, powerful music, and timeless theme of tolerance. Though its 1968 theatrical reissue and 1972 network television premiere were popular, the film took on a whole new life with the 1980s home-video boom and 1990s–2000s DVD releases, a trend that started after Natalie's untimely death in 1981. Because she was not around to participate in audio commentaries or revival house screenings, Natalie's role in *West Side Story*'s legacy has been increasingly marginalized over the years.

Triple-threat talents Rita Moreno and George Chakiris won Oscars for their roles, and rightfully so. Contemporary critics champion both as the true stars of *West Side Story*, and they have a good case— but Natalie gives an equally powerful performance. The writers intended for Maria to be a simple, sweet young woman in love, her subtle character arc rising to a final emotional crescendo. Natalie delivered every nuance the role required, and then some. As Chakiris said, "I never like anybody disparaging anything Natalie did because I think she's so wonderful in the role and the fact that it ended up not being her [singing] voice, to me made absolutely no difference." Over a half a century after its debut, *West Side Story* remains a brilliantly crafted work of art and, to me, Natalie Wood will always be its heart and soul.

Matt Tunia

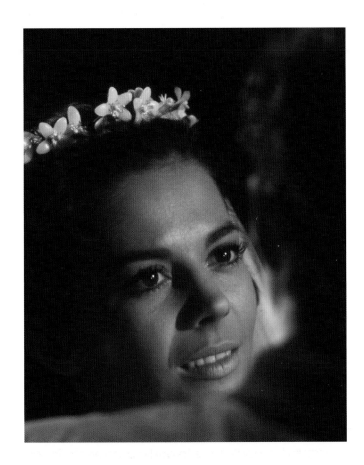

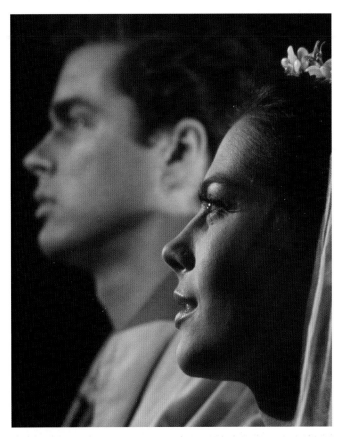

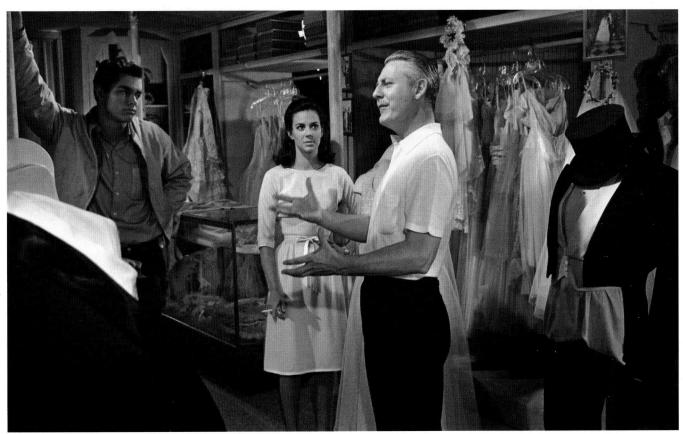

OPPOSITE AND TOP Madame Lucia's Bridal Shop is transformed to a mock church altar where Tony and Maria imagine their wedding as they sing "One Hand, One Heart." **BOTTOM** Robert Wise directs Richard Beymer and Natalie in the bridal shop scene. The cast found Wise a pleasant man but a perfunctory director.

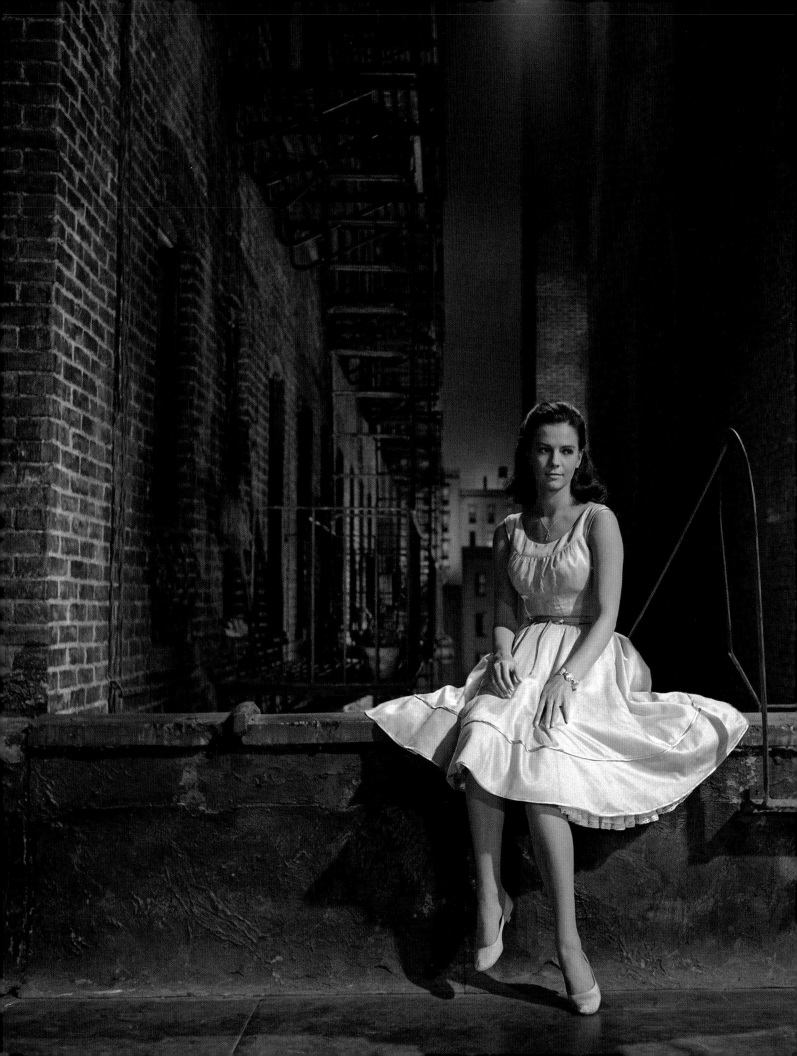

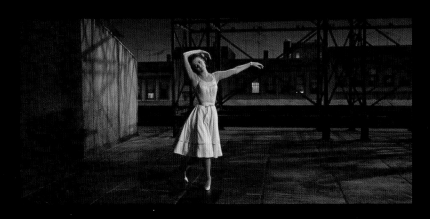

LEFT AND ABOVE With her dance training as a child and her work with Jerome Robbins, Natalie mastered what she described as "a lyrical, balletic kind of dancing."

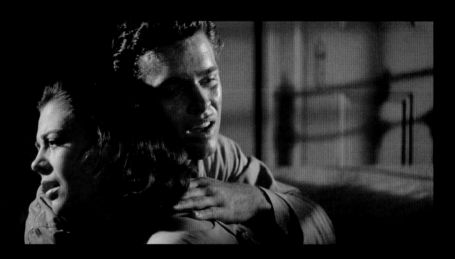

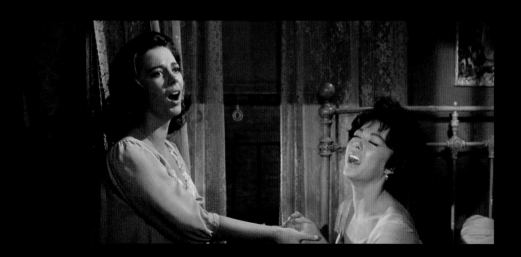

ABOVE The Technicolor film's Academy Award-winning art direction and cinematography are displayed in the "Somewhere" and "A Boy Like That/I Have a Love" numbers. **RIGHT** In 1961, Natalie likened the character of Maria to Judy in *Rebel Without a Cause*. "In a way, the two girls are similar. *Rebel* had many strains of the *Romeo and Juliet* story in it. . . ."

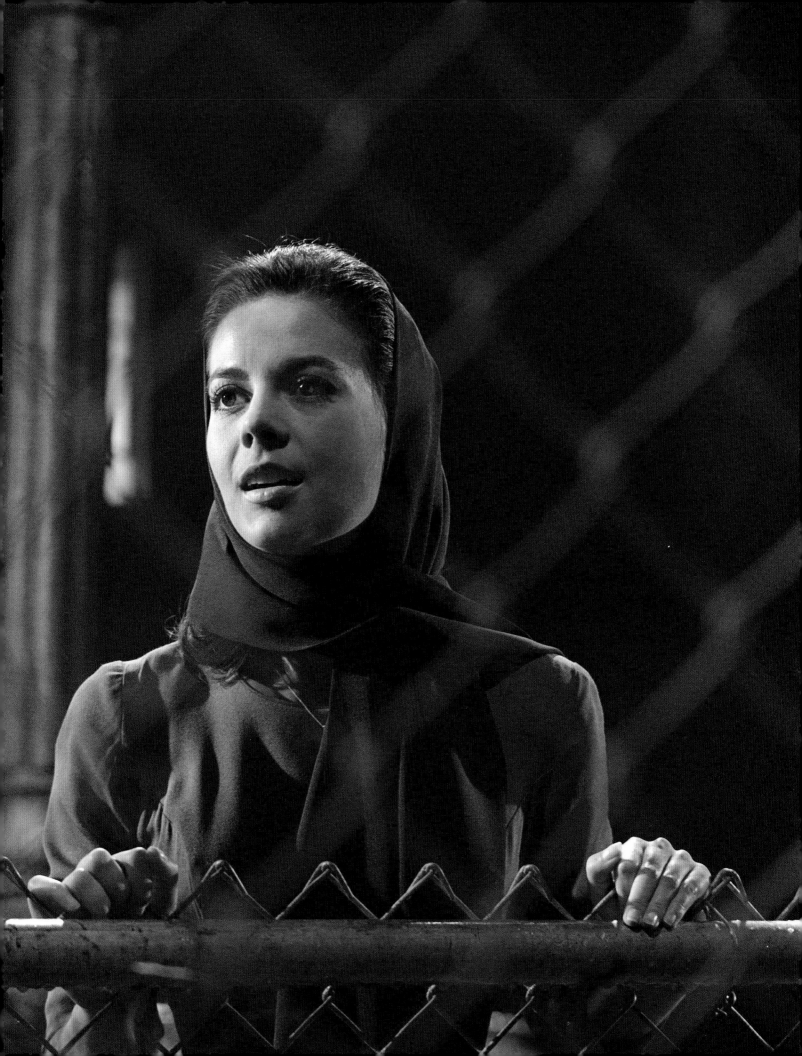

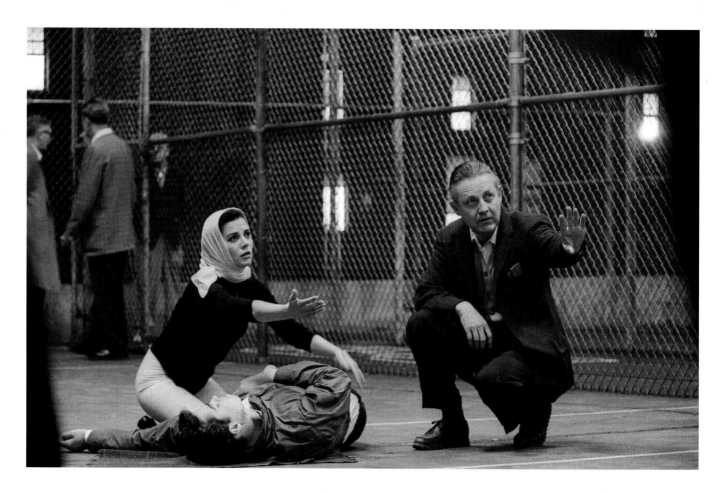

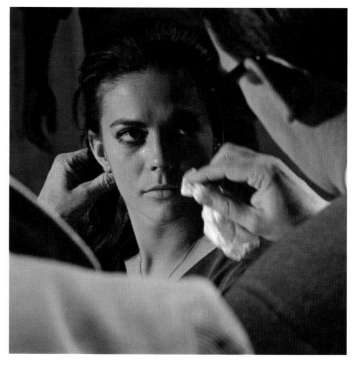

THIS PAGE Robert Wise directs Natalie in the film's final scene. The director observed, "This is a violent picture in its action, but Natalie threw herself into it literally. She dropped to her knees so hard in rehearsing that I thought she had injured herself. But she got up and did it again."

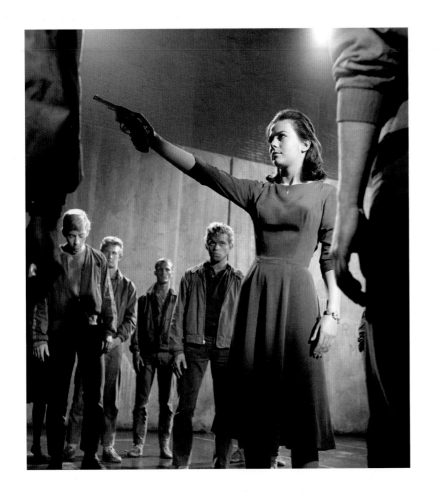

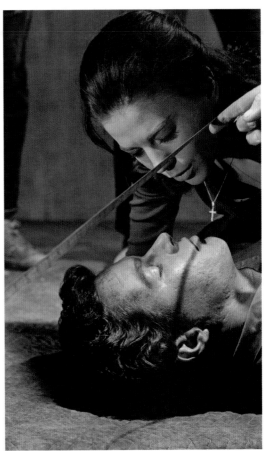

THIS PAGE A heartbreaking conclusion is enacted for the camera, helmed by Robert Wise. Natalie later reflected on her two directors. "Robbins, one would have thought, would be more into the dance and Wise would have been more into the acting. Strangely enough, though . . . the interesting internal direction for me that I got on that part was from Jerry Robbins. I thought he was just . . . well, he is a genius."

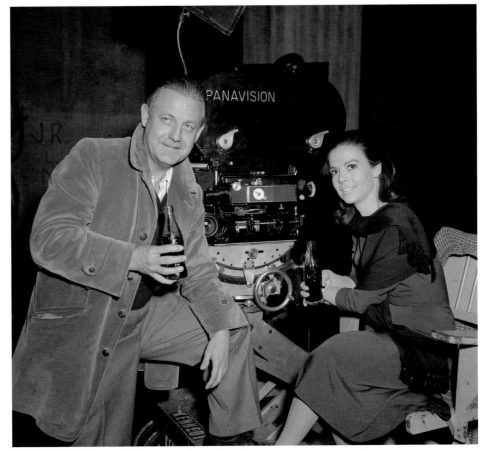

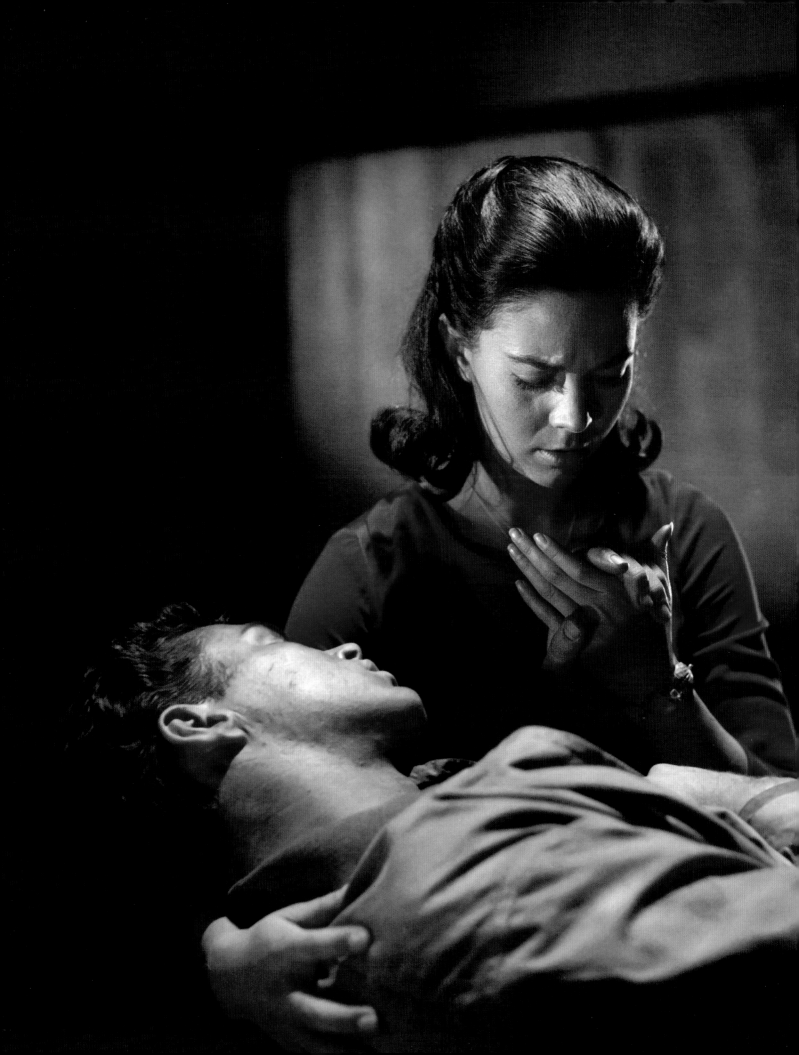

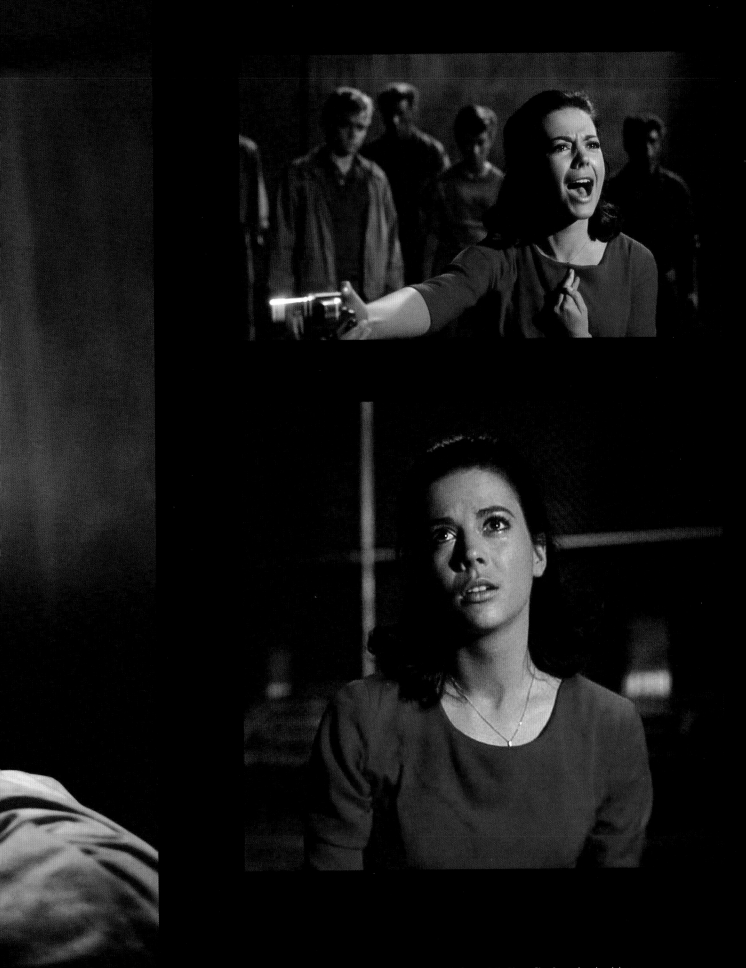

LEFT AND ABOVE The *New York Post* called Natalie "exquisite" in a film "most valuable as an expression of regret that there is hatred between different peoples."

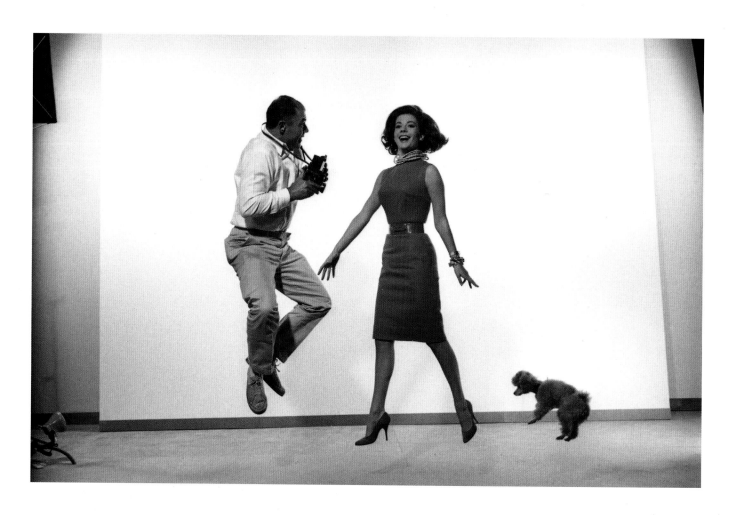

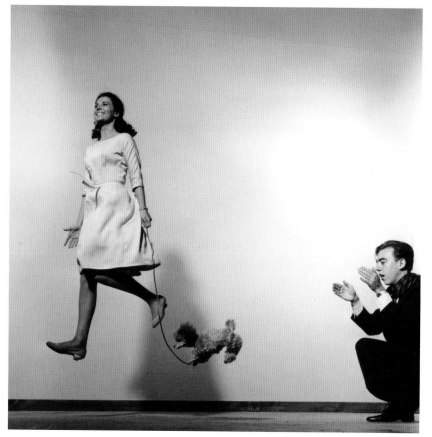

TOP AND OPPOSITE Photographer Phil Stern works with Natalie on the "West Side Jump" publicity shoot. **LEFT** Natalie's assistant Mart Crowley gets in on the fun by helping Chi Chi with her jumps.

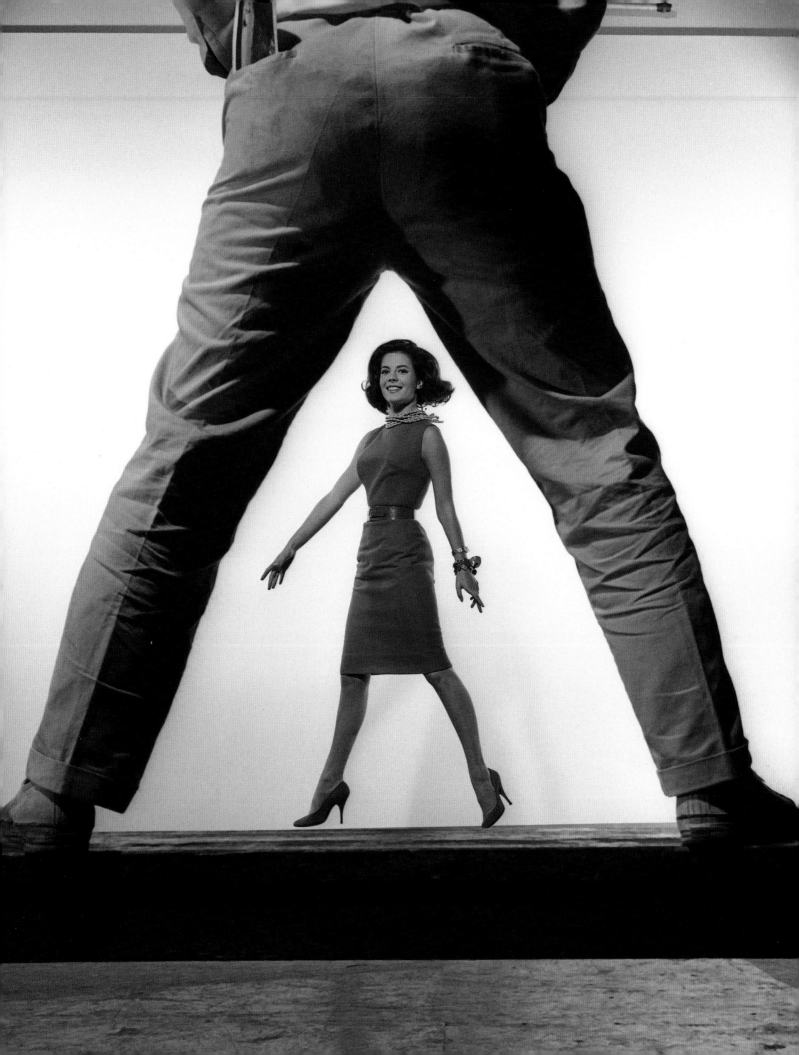

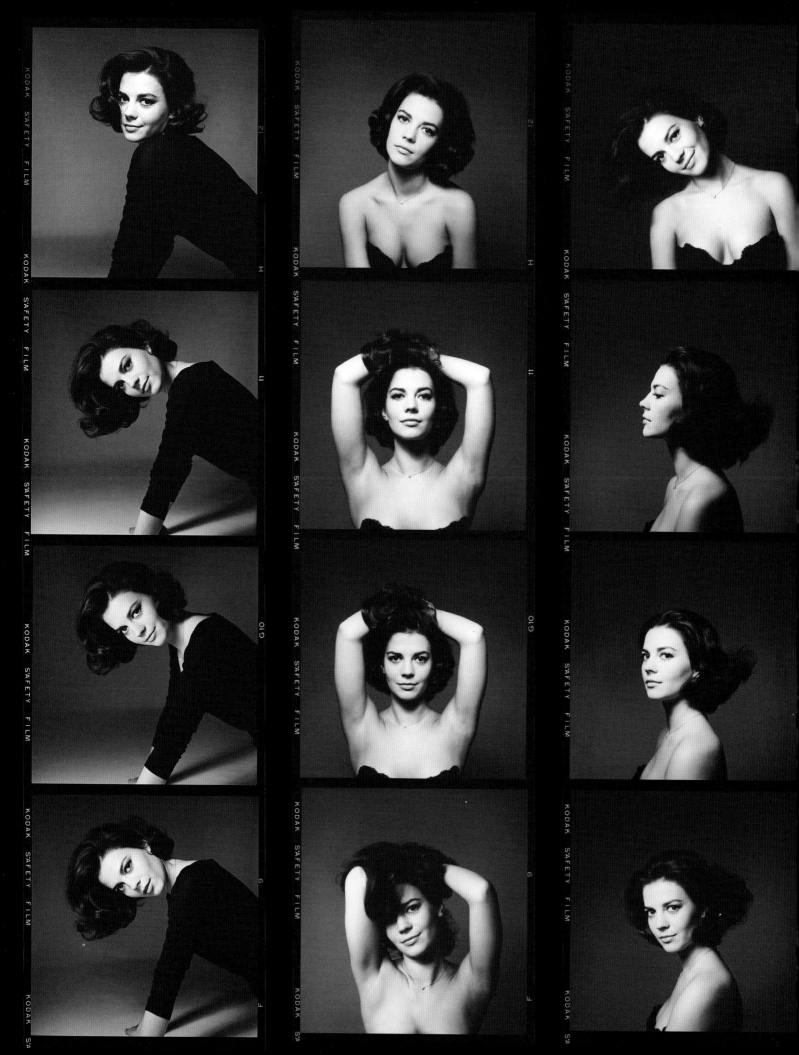

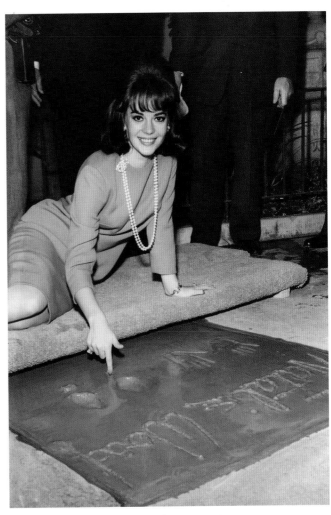

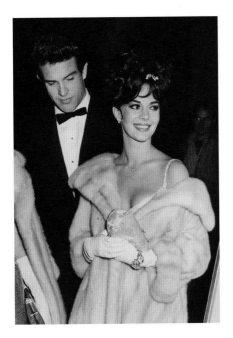

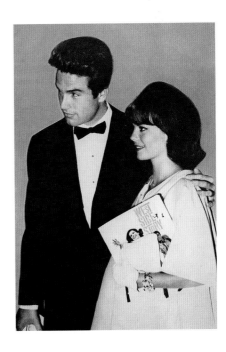

OPPOSITE Proof sheet from a *West Side Story* publicity portrait sitting. **TOP** On December 5, 1961, Natalie became the 136th star to imprint her hands and feet in the cement in the forecourt of Grauman's Chinese Theater in Hollywood. The Gurdin family attended the special event. **BOTTOM** Warren Beatty escorts Natalie to *West Side Story*'s Hollywood premiere, the 34th Annual Academy Awards (where the film won a total of ten Oscars), and the world premiere on October 18, 1961, at New York's Rivoli Theatre.

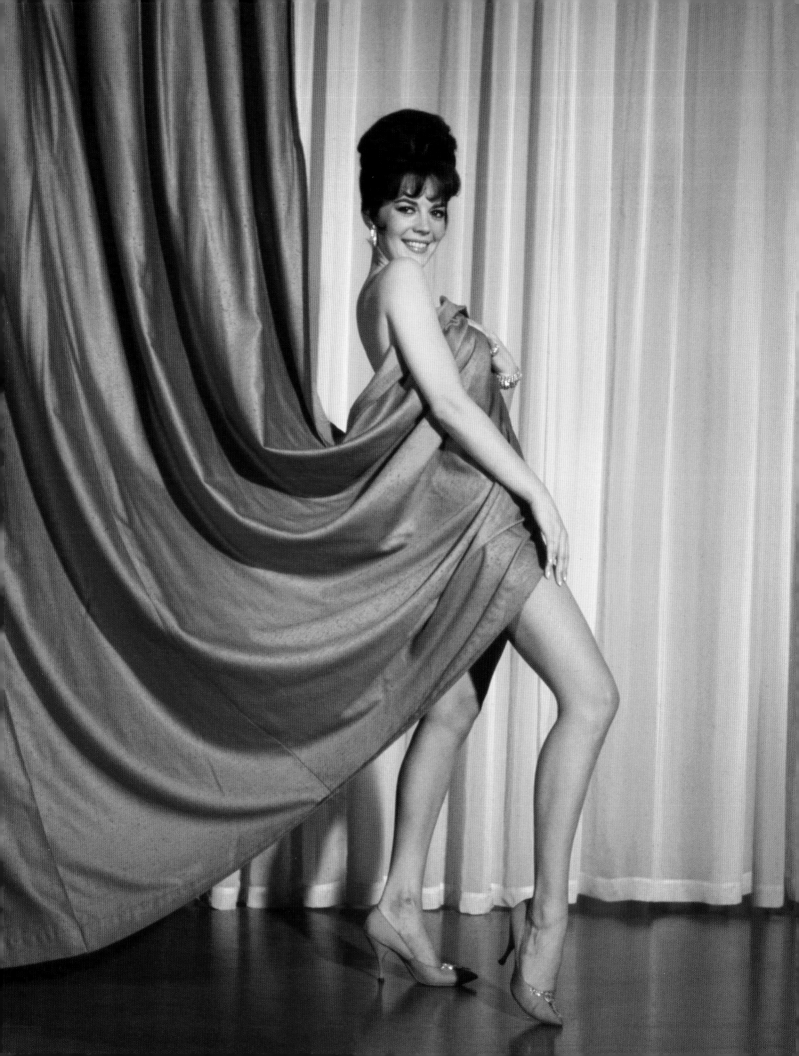

GYPSY

"I'm very versa-tile..."

In early 1962, Gypsy Rose Lee visited the Warner Bros. soundstage, where Natalie Wood was starring in a film based on Miss Lee's life. The burlesque legend herself passed on a trade secret to Natalie, as the young star prepared to strip for the camera. "Don't do it fast," Lee confided. "Take your time. Take all the time in the world."

Natalie had been drawn to the role of Gypsy Rose Lee without even realizing it. While filming *West Side Story* the year before, and having no idea she would play the part, ". . . all day long in the trailer, I would play all the songs from *Gypsy*. I loved that score. . . ." Warner Bros. considered up-and-coming musical star Ann-Margret for the title role in *Gypsy*, but opted instead to cast Natalie, their very own queen of the lot. She was assured by the picture's director, Mervyn LeRoy, that she would be singing her own songs, an opportunity denied her in *West Side Story*. Natalie then did some personal research, and slipped into a Sunset Boulevard strip club to observe the professionals, exotic dancers with names like Fran Sinatra and Natalie Should.

The memoir of Gypsy Rose Lee had been freely shaped into the quintessential showbiz saga for Broadway by Arthur Laurents, with superlative songs by Jule Styne and Stephen Sondheim, and staged by Jerome Robbins. Screenwriter Leonard Spigelgass adapted the script to tell the tale of the *ne plus ultra* of stage mothers, Madame Rose, who battles and bullies her way across the country in the waning years of vaudeville, demanding stardom

OPPOSITE In *Gypsy*, Natalie stars as burlesque striptease queen Gypsy Rose Lee. RIGHT Italians came to know Gypsy as "The Woman Who Invented the Striptease" from this sexy poster featuring artwork by Angelo Cesselon.

for daughter "Baby June." Elder sibling Louise must fumble in the background with the unpaid chorus boys. Soon sixteen, "Dainty June" defiantly elopes with one of her Farmboys. Devastated and in a fury, Rose transfers her deluded ambitions to talentless Louise. A mistaken booking into a Wichita burlesque house provides a way out—and a way in—when Rose literally pushes Louise into the spotlight for a modest solo strip, and launches a star.

Madame Rose, one of the plum movie roles for actresses of a certain age in the early '60s, was played by a star who could act the part, but only sing about half of it. Bicoastal producer Frederick Brisson owned the film rights to *Gypsy*, and sold them

TOP "They made her too beautiful, too chic," Ethel Merman said of Russell's Mama Rose. "The critics felt that too." BOTTOM Feeling alone and forgotten on her "tenth" birthday, Louise ponders her confused young life with the poignant ballad "Little Lamb," the first song Natalie sings in the film. OPPOSITE Jack L. Warner and producer/director Mervyn LeRoy wish Natalie well on her first day of shooting. "It was one of the very, very nice things that Jack Warner did when he let me play that without any fuss," Natalie recalled of Gypsy.

to Warners with his wife, Rosalind Russell, as part of the deal. Russell was of the opinion that Broadway's Mama Rose, Ethel Merman, deserved her shot, but Roz took some advice from old friend Myrna Loy, "Grab 'em if they come up."

In support of Wood and Russell is the solid Karl Malden (Natalie's screen dad from *Bombers B-52*), as well as Morgan Brittany and Ann Jillian as the two Junes. Natalie sings "Little Lamb" sadly and sweetly, performing live for the camera, not to a prerecorded track. Russell's on-edge arias are an expert mix of her own voice and that of Lisa Kirk. Roz as Rose recalls her signature role of Auntie Mame, but flinty and loud, and from the wrong side of the tracks.

Orry-Kelly, with assistance from Howard Shoup, designed costumes for the highs and lows of vaudeville and burlesque, keeping the clever ensembles extra-sleek as Louise transforms from dowdy daisy to bird-of-paradise. Sydney Guilaroff gave Natalie a short bob for her long stint as one of the boys, then a soft pageboy as the girl emerges, and finally pumps her hair to heights befitting a star (though not the period). Dingy earth tones give way to refreshing color only in the bright stage lights in which Gypsy strides, shot from below, to take Natalie from petite to statuesque.

Budgeted at $4 million, and released on November 1, 1962, the movie took in over $11 million at the box office. Three Oscar nominations followed in early 1963, for color costuming, color cinematography, and music adaptation.

From its brassy overture to "Rose's Turn," with its musicalized nervous breakdown, *Gypsy* is funny and absorbing, intimate and raucous, and anxious to "entertain you." And it does so, slyly, without a big signature production number. It is a character-driven piece, a fable about mothers and daughters, the quest for recognition, and the need for love. Natalie could identify. "The warmth and friction that pervaded Gypsy's relationship with her mother reminded me of my own past."

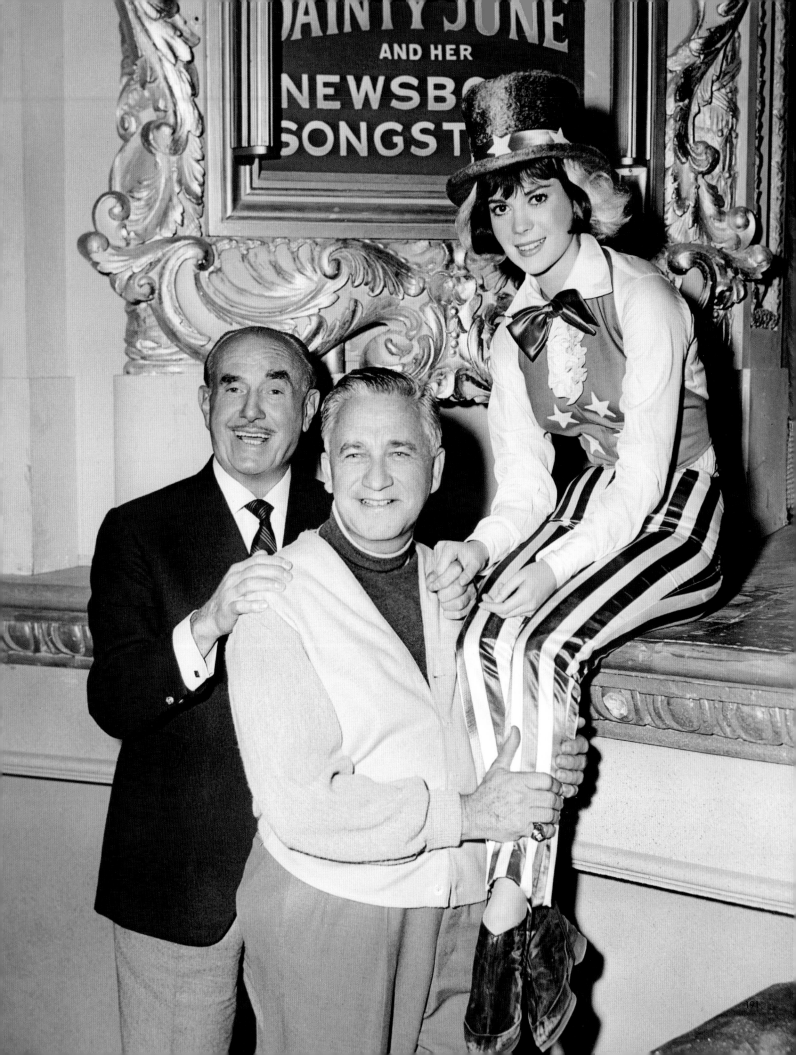

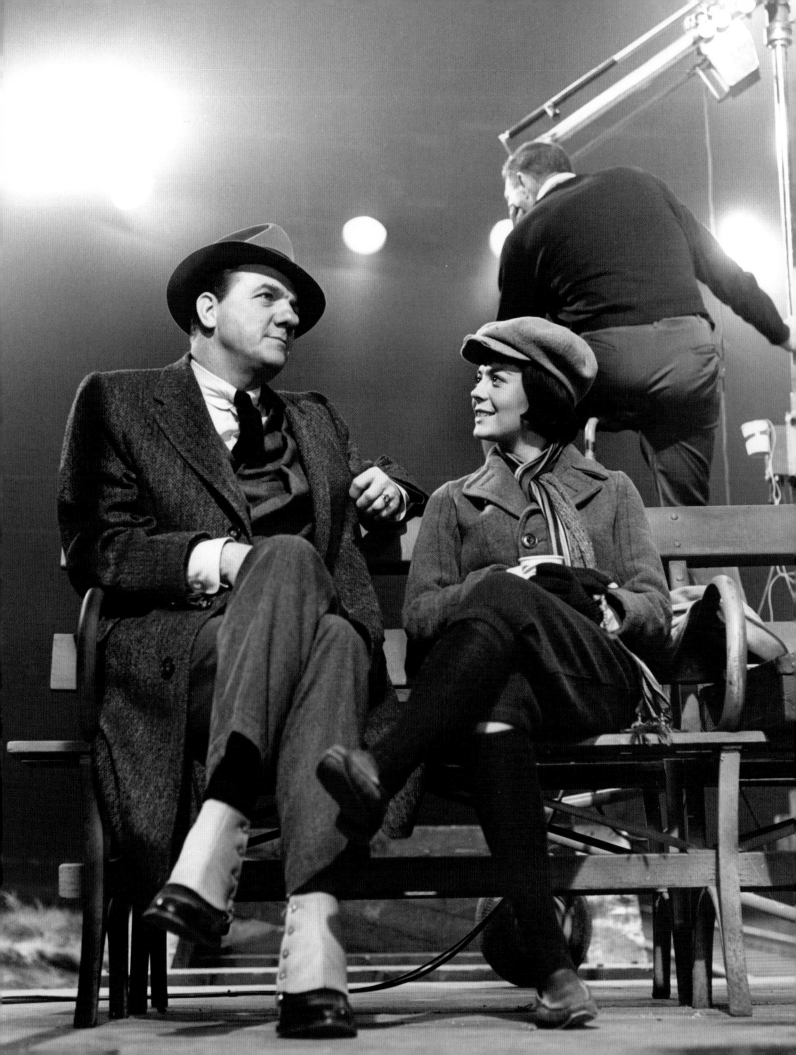

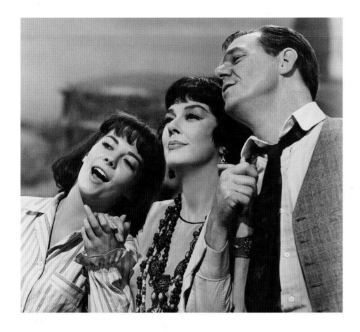

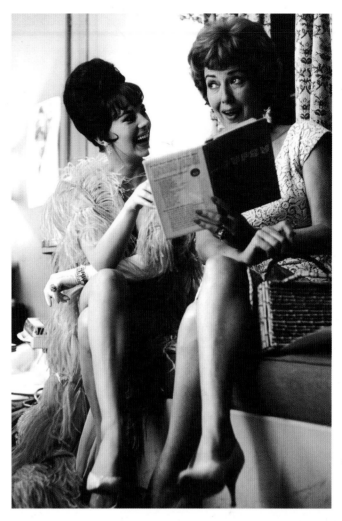

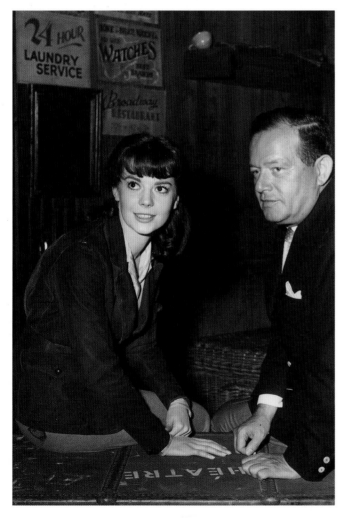

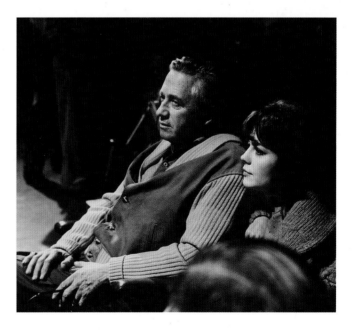

OPPOSITE Costar Karl Malden was impressed with Natalie's ability. "I've never seen a girl develop so much for the better," he said. ". . . She could become a really great actress. It's a great thing for Hollywood." **CLOCKWISE FROM TOP LEFT** Natalie, Rosalind Russell, and Karl Malden perform the song "Together Wherever We Go," a number that was cut from the final film; When Gypsy Rose Lee saw Natalie performing one of her routines, she burst into nostalgic tears and said, "It's like going back to 1934 and coming home!"; Director Mervyn LeRoy felt that Natalie continued the great tradition of Hollywood stars. "She has tremendous sincerity and talent."; Composer Jule Styne visits Natalie on the Wichita Opera House set during filming of the "You Gotta Have a Gimmick" number.

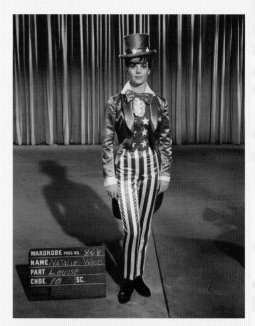
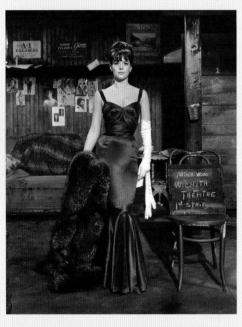

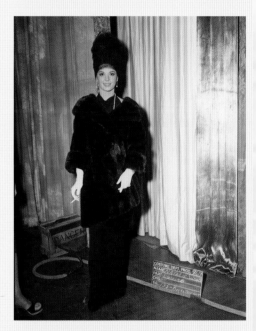
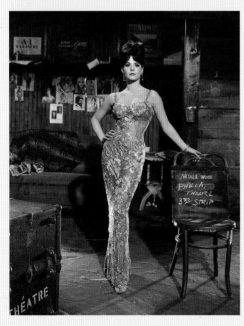
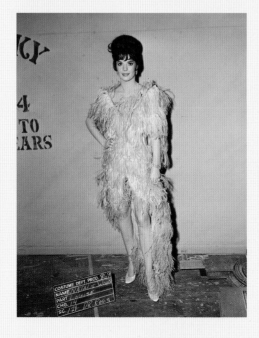
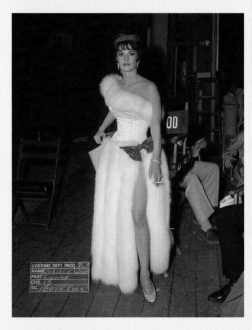

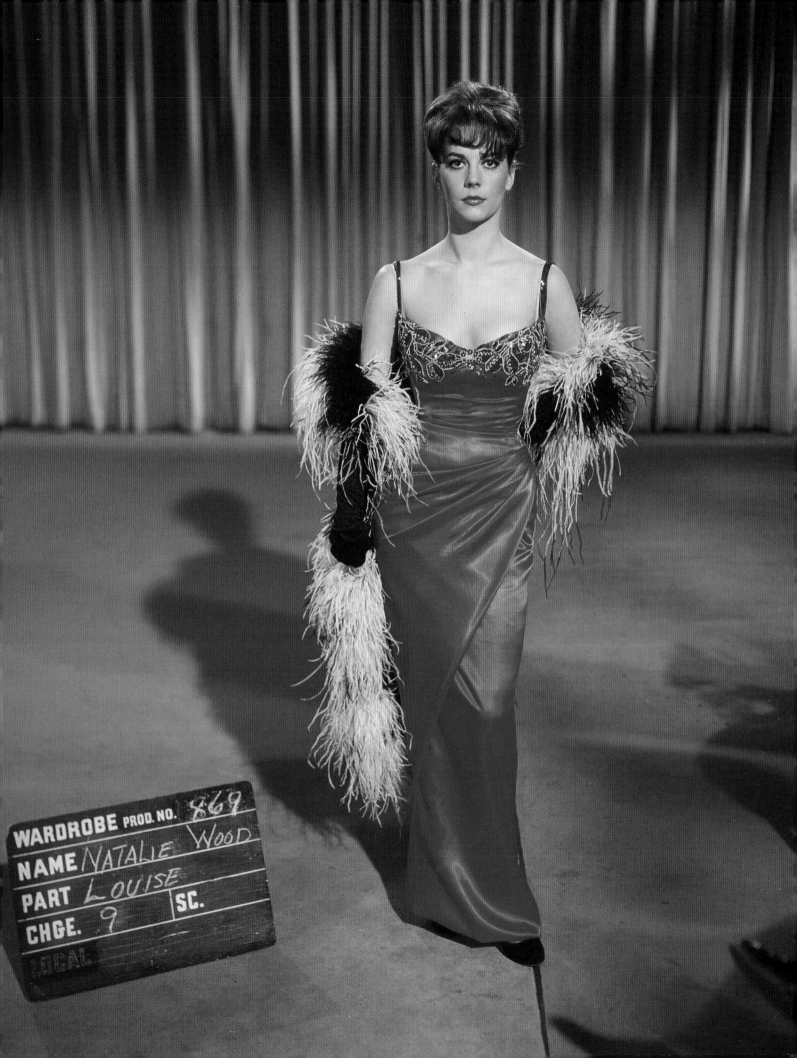

WARDROBE PROD. NO. 869
NAME NATALIE WOOD
PART LOUISE
CHGE. 9 SC.
LOCAL

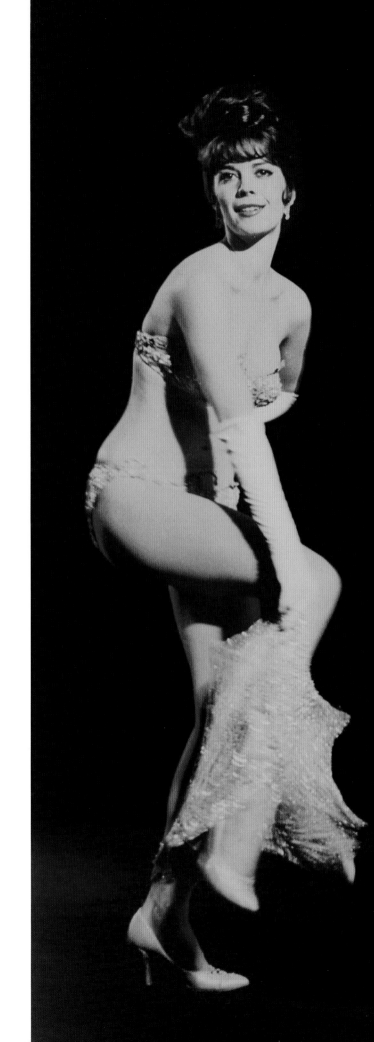

PREVIOUS SPREAD Orry-Kelly spent over $25,000 on the eighteen costumes that he designed for Natalie, including a glittering evening dress made up of 15,600 rhinestones, 450,000 beads and sequins, and 10,000 rhinestone mirrors, which took an entire month to complete.

RIGHT To play a stripper, Natalie recalled, "I had to learn a special walk, a cross between an undulation and a strut. I practiced it so much I fell into it unconsciously later. As a matter of fact, it's not a bad way to walk."

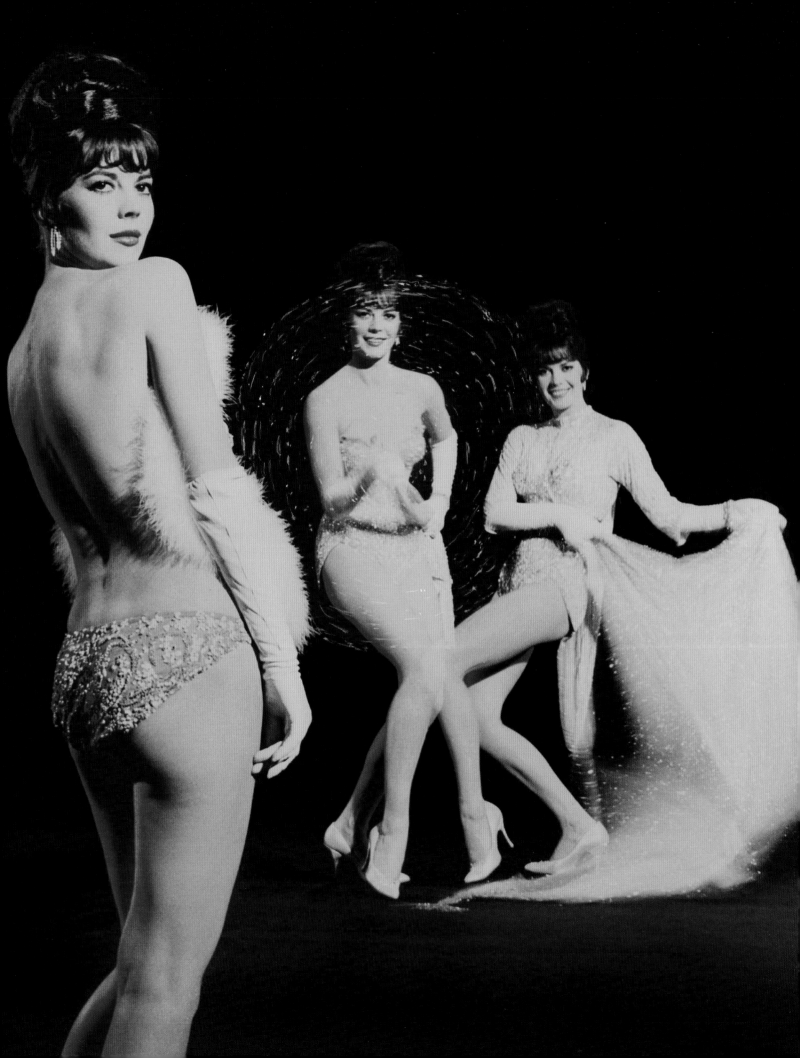

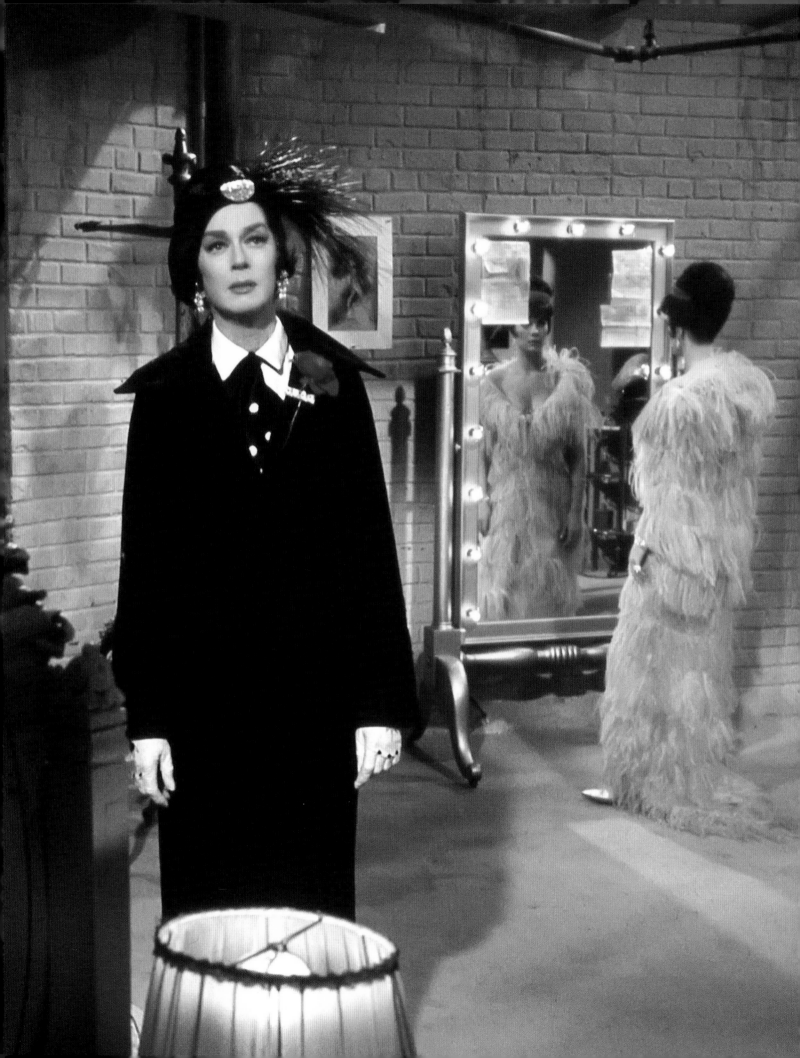

154 East Seventy-fourth Street

January 4, 1962

Dear Maria Louise,

How did you know I needed them? They're so beautiful and I'm very impressed with my initials but more impressed with you as always. I send you all my love and hope we see each other real soon.

Mole and kisses.

How's it going?

Jerry

Sweet— and lovely

NATALIE WOOD

Two top stars... Natalie Wood and Baby Ruth! See them both in the exciting Warner Bros. movie, "GYPSY."

(P.S.: Fresh, crispy Butterfinger "co-stars" also. For a real treat and extra energy, too, try these delicious candy bars today.)

CURTISS CANDY COMPANY • Otto Schnering, Founder • Chicago 13, Illinois

OPPOSITE For the climactic dressing room scene at the end of the film, Natalie turned to her friend Mart Crowley for guidance. "I don't know how to play it," she cried. "Natalie, are you out of your mind?" Crowley responded. "You don't know how to play this scene? It is your life! Just think of Rosalind Russell as Mud." **ABOVE** A thank-you note to "Maria Louise" from Natalie's close *West Side Story* friend, Jerome Robbins. "Mole" was Natalie's nickname for Jerry. **RIGHT** Warner Bros. teamed with the Curtiss Candy Company for a marketing tie-in with *Gypsy*. The film's stars were featured in print ads promoting the Baby Ruth and Butterfinger Contest in which ten lucky people could win a three-day weekend in Hollywood. **OVERLEAF** Natalie poses for publicity portraits wearing gowns and accessories from the film.

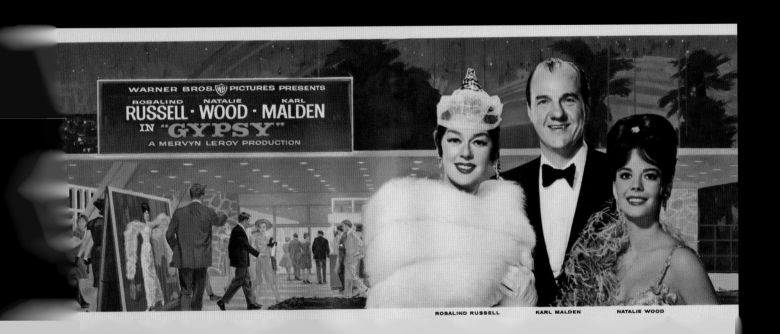

WARNER BROS. PICTURES PRESENTS

ROSALIND NATALIE KARL
RUSSELL · WOOD · MALDEN
IN "GYPSY"
A MERVYN LEROY PRODUCTION

ROSALIND RUSSELL KARL MALDEN NATALIE WOOD

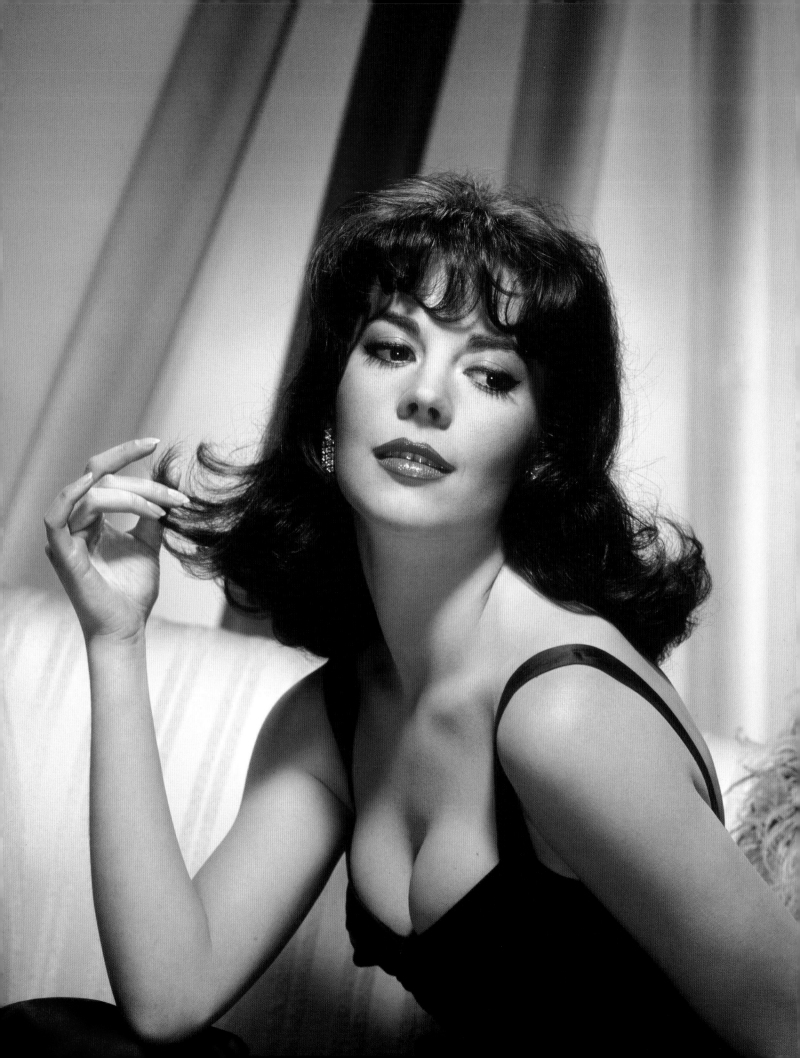

3573 3578 3583 3588

3574 3579 3584 3589

3575 3580 3585 3590

3576 3581 3586 3591

3577 3582 3587 3608

"I'm a pretty girl, mama."

Latest Hollywood and TV Hairdos

Cover Girl
Natalie Wood
introduces the
new 'GYPSY' Do

Teen Hairdos
glitter at
Hollywood's
Deb Star Ball

Pick a Style

Soft and Sweet

Starring Hairdos

Quick Tricks

Suit your Eyedo
to your Hairdo

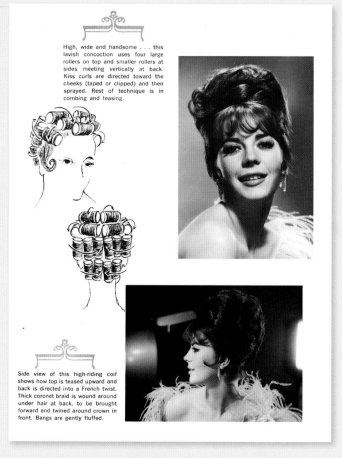

High, wide and handsome . . . this lavish concoction uses four large rollers on top and smaller rollers at sides meeting vertically at back. Kiss curls are directed toward the cheeks (taped or clipped) and then sprayed. Rest of technique is in combing and teasing.

Side view of this high-riding coif shows how top is teased upward and back is directed into a French twist. Thick coronet braid is wound around under hair at back, to be brought forward and twined around crown in front. Bangs are gently fluffed.

ABOVE Famed Hollywood hair designer Sydney Guilaroff created fourteen different hairstyles for Natalie, ranging from the boyish Dutch bob to the piled upsweep that *Gypsy* sports as Minsky's sultry star. **OPPOSITE** After being dubbed in *West Side Story*, Natalie was happy to do her own signing in *Gypsy*. "I must say there is satisfaction sitting in a projection room and watching myself on the screen, and knowing that it is my own singing voice I hear, not someone else's."

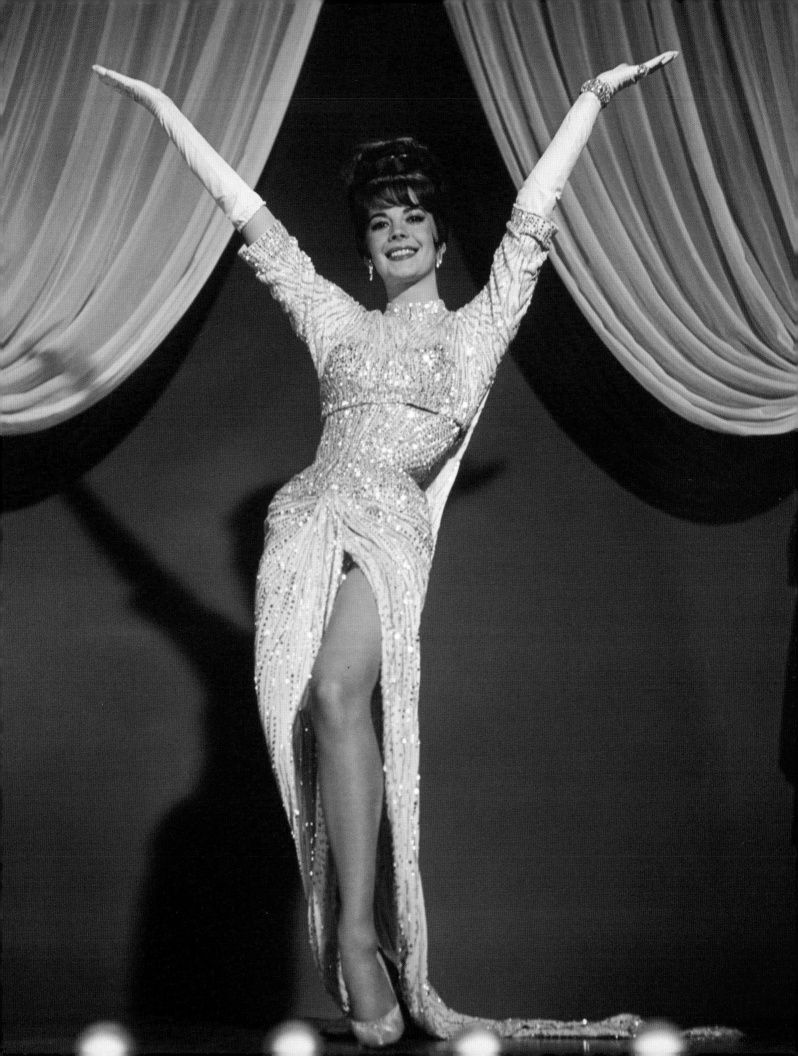

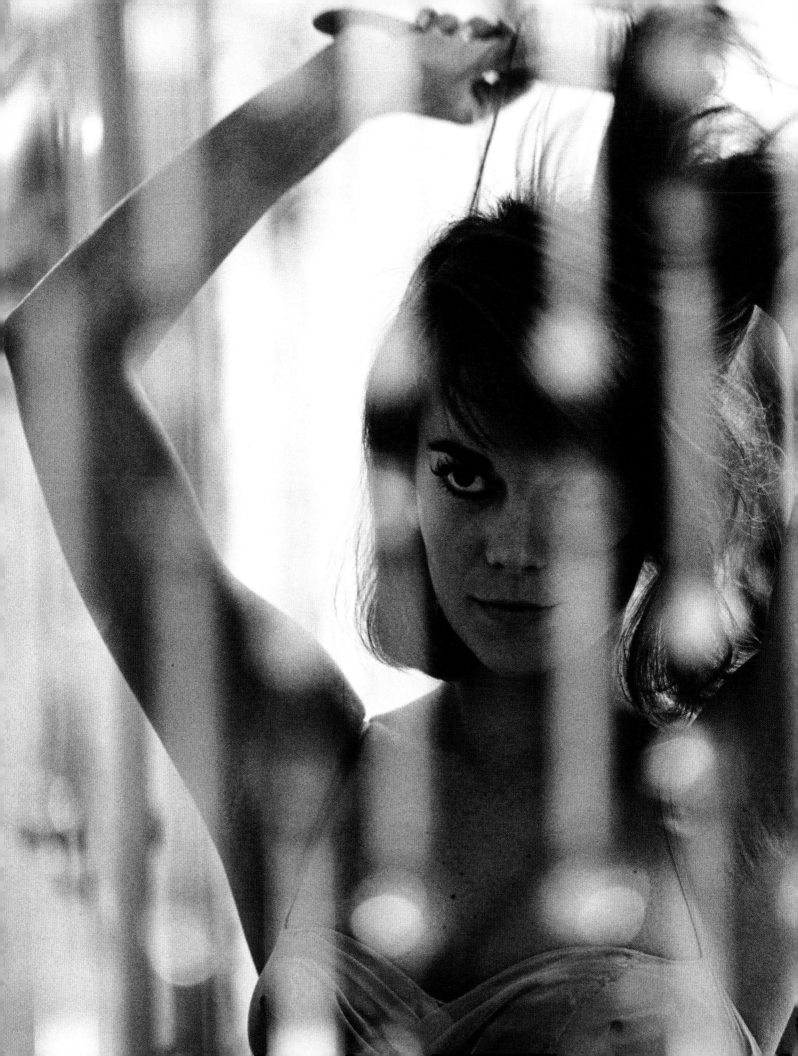

PUBLIC PROPERTY
PRIVATE PERSON

BY NATALIE WOOD
EXCLUSIVE PHOTOGRAPHS BY BILL RAY

Hollywood is where I live. It is the only home I have ever known. I have been making a living here since I was a child. I have performed in forty films, and before I reach the age of thirty I will be eligible for a twenty-five-year pension.

Looking at it from the outside, it must appear to be a very pleasant way to make a living (as indeed it is)—hanging on to your childhood, playing at make-believe, being Cinderella, meeting Prince Charming, happily, tragically, comically, and all the while being paid quite well.

But like most things, there is another way of looking at it too—from the inside.

This is a tough and hotly competitive business, and it is particularly hard on women. Your ego is constantly on the line when your every mood, pound, and inch is scrutinized by experts every day. Part of the bargain is being exploited, misunderstood, and occasionally misled. Being a star can mean that you spend a good deal of your time being sniped at in the gossip columns, or reading that you're engaged to someone you've never even met, or being criticized for your behavior in New York when you haven't left California, and not being able to

defend yourself, because that's part of the deal too.

It's a unique business. In what other profession can you become successful because someone likes your looks, or smile, or figure? No one ever walks up to a kid drinking a milkshake and says, "I like your style, how would you like to be a prominent attorney?" No one "gets discovered" and goes on to be a top architect or a brain surgeon. But instant success does happen occasionally in Hollywood, and it is this topsy-turvy dream that keeps enticing young people out here.

Despite some of the nonsense that goes with being a star, I love being an actress—the work. If you have ever visited a busy studio, you probably know what I mean. There's a feeling when a dark old barn, known as a sound stage, comes alive with light and warmth. I love the noise and bustle of a set: the scurrying of prop men, juicers, and boomers, the clank and whip of hammers and saws, the never-ending conferences and crises.

You show up at the studio before seven AM. If it's a difficult scene, you're usually a bit nervous about how it's going to go, or if you fully understand the character. Sometimes you wonder about how you played a scene yesterday. If you haven't had enough sleep, you worry that you might look tired. But before you can dwell on any of this, someone is shampooing you, a dryer is plunked on your

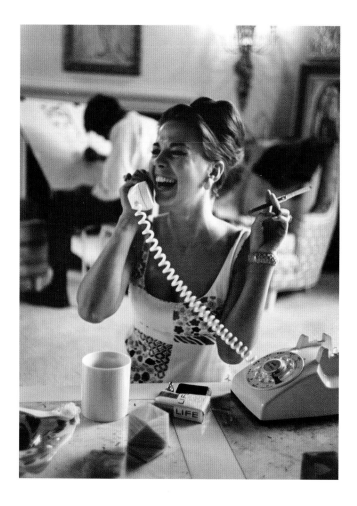 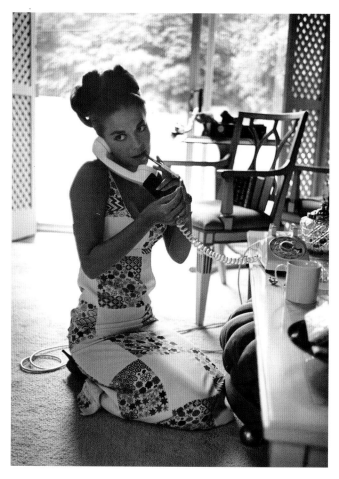

head, two men go to work applying makeup to your face, by then your hair is dry, and two women apply makeup to your body. The wardrobe people get your clothes on while your hair is being styled— and simultaneously you are running lines with the dialogue director. When a bell rings and they are ready to start, the real work begins.

You try to find in yourself the essence of some-one else's feelings, try to make someone else's words and actions and feelings your own. By analogy, by remembering, by cajoling, by using any method that works, you try to achieve that state where you can "live" comfortably, honestly, in the imaginary world that surrounds you. And while you're working, sometimes the characters and plots seem more real, more alive, than the world outside the studio gates.

It's a strange feeling to see people watching you in a film. And it brings with it a barrage of mixed feelings. You remember all the crises associated

with a certain scene, or you remember how good you felt when you were able to make a particular moment work. It may have been months since the film was completed, and by now, you are deeply immersed in another, with other costumes, a different character, another story, new people. It's always seemed bizarre to me that all those months of work, the crises, the turmoil, the decisions, finally get compacted into one hundred minutes of film. In looking at the finished product, there may only be perhaps one or two moments that you feel proud of, and those can be easily missed if someone gets up to buy a bag of popcorn. Sometimes you wish you could say to the audience, "Would you please forget that last scene? I wasn't feeling well that day." But you can't run up and down the aisles, and you can't try to do it better the next night. Once it flashes on the screen, it is *there*. It no longer belongs to you.

That part of me is public property. But there is a private person behind the image. Her name

is Natasha Gurdin, and she is not the child of Hollywood. Instead she is the daughter of two real people, Nikolai and Maria Gurdin, both Russian émigrés. I am the middle of three sisters. My sister Olga, who is ten years older than I, is really a half-sister. My younger sister, Svetlana, is eight years younger than I. She is also an actress and is known professionally as Lana Wood.

My father, Nikolai, is a quiet man with gentle brown eyes. As a boy he lived near the Siberian port of Vladivostok. His father was a soldier. One day he left for the front and he told his son, "When I come home, Nikolai, I will bring you a *kaska*," which is Russian for a helmet. Nikolai thought he meant *skaska*, which is Russian for fairy tale. He waited for months for his father to return home with that special story. But his father never returned from the war. His mother fled to Shanghai during the Revolution. They came to Canada when Nikolai was eight.

At the age of eighteen, Nikolai decided he wanted to be a United States citizen rather than a Canadian; he found work in San Francisco, where he married Maria. My mother is still a beautiful woman with midnight black hair, a perfectly straight nose, and tiny hands. Her startling blue eyes remind me of a line from *The Brothers Karamozov*, when an old man describes the beautiful Grushenka: "She has eyes like razors, they slit your soul." Maria has eyes like that.

My mother came from a fairly prosperous White Russian family near the Siberian city of Tomsk. She spent more time with her governess than with her mother, and yearned for maternal affection. During the Revolution, Maria's family fled to China and later booked passage to San Francisco. When she married my father, his fondest dream was to get a small farm in Oregon and raise his children there. But my mother wasn't a pioneer woman. It took her years to get over feeling sick whenever she rode a few minutes in a car.

I cried quite a bit as a baby, and the doctor said the damp San Francisco climate made my joints ache. We moved to the drier and warmer atmosphere of Santa Rosa, which was then a pleasant, sleepy town about sixty miles north of San Francisco.

Santa Rosa was a typical small town, and pretty as a movie set with its tree-shaded streets and white-frame houses with deliciously cool front porches. The farmers came to town on Saturday for their groceries, but most of the sidewalks were rolled up by nine o'clock. I don't think anyone will ever accuse Santa Rosa of being a likely place for "getting discovered" for the movies. Back then, my earliest ambition was to be a veterinarian.

Our house was full of icons and religious symbols. We were raised in a devout Russian Orthodox atmosphere. Olga and I dressed in our finest clothes for church services every Sunday. The priest, with his flowing robes and long beard, waved a psaltery and filled the air with incense. It was real, and yet it seemed like make-believe. I was puzzled by God. How could he be so far away and so near? It seemed strange that the Creator of the Universe could pay attention to my prayers and sins.

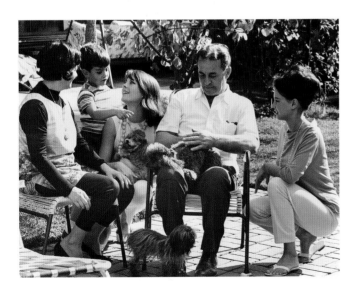

OPPOSITE Natalie pauses for a phone call at home while famed portrait artist Don Bachardy immortalizes her in a sketch. ABOVE "My parents and I visit each other frequently," Natalie wrote in 1966, "but we are no longer burdened with overwhelming ideas about what parents and children should be like. My parents and I are good friends."

I prayed often. I really believed in saints and angels. The world seemed alive and throbbing with mystical wonder and terror. My first encounter with sin occurred when I fell in love with a shiny black leather purse. It belonged to another little girl in church. I told myself she would never miss it; she didn't even take care of it. When she wasn't looking, I picked it up. About an hour after I got home, my mother asked me where I got it. She caught my guilty blush and made me return it. She told me that next Sunday I would have to ask God to forgive my sin. I obeyed, but it was hard.

Not only did I pray, but I also believed in magic, fairies, and elves. I even talked to my dolls and stuffed animals. My mother had told me that at night after I went to sleep, the toys and dolls would come alive, and would dance and sing while we slept. This really fascinated me. I forced myself to stay awake. I lay in bed for hours, rubbing my eyes to keep them open. I didn't even dare to breathe out loud because I didn't want to scare the dolls away. At every noise I started, hoping to see them come alive. But of course, I was bitterly disappointed when they remained lifeless. Looking back at all this, I'm not certain that all that fantasy is good for a child. I wouldn't encourage that much make-believe in one of my children—it would just make reality that much harder to take.

Make-believe was always a big part of my childhood. My father read to Olga and me *The Little Mermaid*, *Bambi*, *Snow White*, and *Grimms' Fairy Tales*. I loved the book *Pinocchio*, but I was terrified of the movie when the little boys on Pleasure Island were turned into donkeys. My mother used to take me for walks in Santa Rosa, and as we strolled along, I found coins and even toys on the sidewalk. "Look, Mama," I cried, "is this magic?"

"Yes," she would say, "there is magic even on the street. But you must look for it. And if you want your heart's desire, you must work hard. And you must always do as you are told." It was a bit shattering to learn eventually that it was my mother

and not magic that placed the coins and toys on the street.

If my mother didn't know where I was every minute, she felt terribly threatened. She never permitted me to be taken care of by babysitters or left alone. In a sense, she overprotected me as a child, and I used to look for times when I could be by myself. Once I tried to be alone by hiding in a closet, but I got so involved with my daydreams that I forgot how stuffy and hot it was. The lack of air made me drowsy, and the next thing I knew, my mother was shaking me awake because I had almost suffocated.

My mother always encouraged me to be outgoing. She urged me to talk to people, tell them stories, and sing songs. And when guests would come for dinner, I entertained them with dances or songs that I had made up. It isn't hard for a child to make people like her.

One day we heard about a movie being filmed in Santa Rosa. It was *Happy Land*, starring Don Ameche and Ann Rutherford. Mothers with daughters clinging to their skirts showed up on location. They had heard a rumor that a child's part was still open. Mother and I went too. The director, Irving Pichel, spotted me in the crowd and my mother whispered, "Smile at him." I did as I was told—as I have always done. "Say, little girl," Mr. Pichel said, "would you sit in my lap?" I looked at Mother. Her face was frozen in a tight smile to cover up her excitement. She nodded. I sat in Mr. Pichel's lap, and he beamed when I put my arms around his neck and sang one of my silly little songs. "Would you like to act?" he asked me. Again, I checked Mother, who hovered like a silent angel. Again, she nodded.

"Okay," he said. "Walk down the street with this ice cream cone. Then drop it and cry."

It seemed easy enough until they gave me

OPPOSITE "I want to be a movie star," a seven-year-old Natalie once told the press. Here at twenty-five, on the set of *Sex and the Single Girl*, her wish is fulfilled.

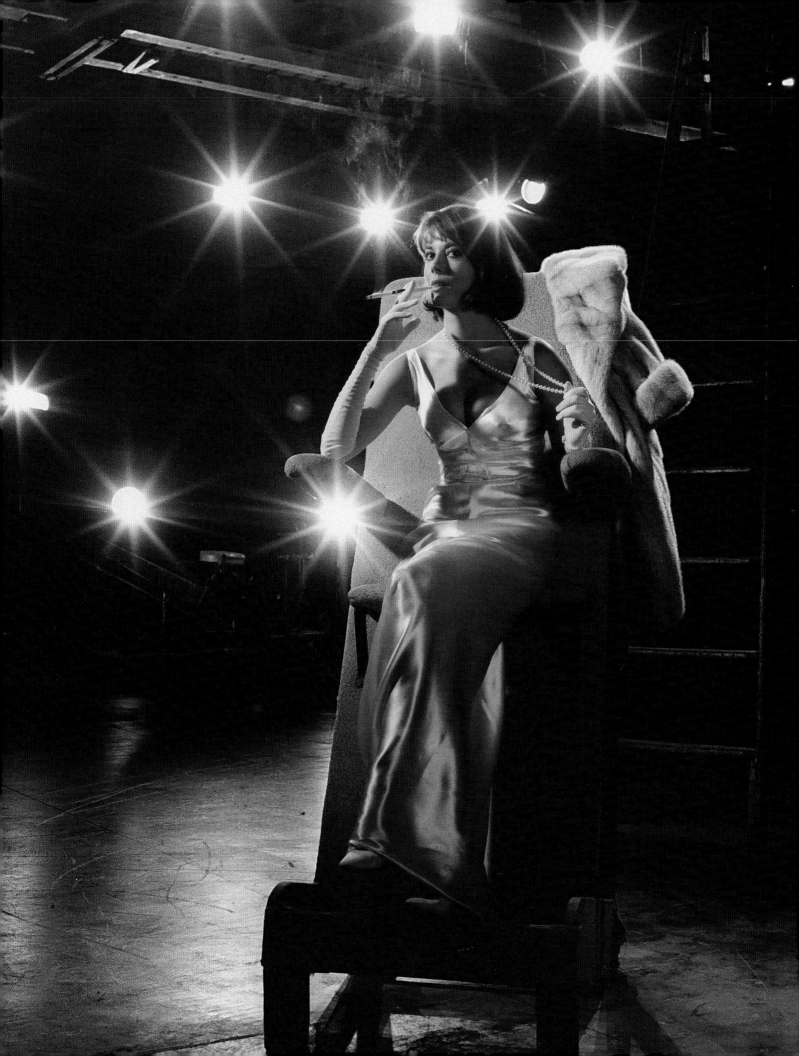

the cone. "I don't want to drop it," I said. "It tastes good." Mr. Pichel looked at Mother. I dropped the cone. I guess that is known as making a sacrifice for the sake of art.

"Now you have to cry," Mr. Pichel said. "I don't feel like crying," I told him. "Well, think of something sad."

"I can't." Another call for Mother.

To get me in the mood, she told me a sad story about a butterfly who burned his wings. I felt tears welling, but they weren't flowing just yet. To top off the sadness, Mother reminded me of my puppy, Terry, who had been killed by a car. The tears came down in rivulets. Now I was acting. If it was make-believe, why did it feel so real?

Well, that was the beginning. I dropped an ice cream cone, and Hollywood taught me to cry. Sometimes, I feel I learned that lesson too well.

When they finished *Happy Land* and everyone went back to Hollywood, Irving Pichel remembered me and used to write me letters and send me toys. Eighteen months later he asked my mother to bring me to Hollywood to test for a film. The request touched off a battle between my parents. My father wanted me to have a normal childhood. He wanted me to excel in school. He didn't object when I worked in the movie in Santa Rosa, but he felt going to Hollywood was crazy.

I remember nights of bitter arguments between my parents. My father banged the table and rattled the walls. He was a quiet man who loved books and music but when he got mad, the hair stood out on his chest. Olga and I never doubted that they loved each other. But my father's temper left the air blue, and a few pieces of furniture broken, when he and my mother disagreed. She sat very quietly while he argued in Russian. "Why should you upset yourself, Nikolai? It will probably come to nothing, and you know your daughter will never forgive you unless you give her a chance. Don't do it for me, do it for your Natasha."

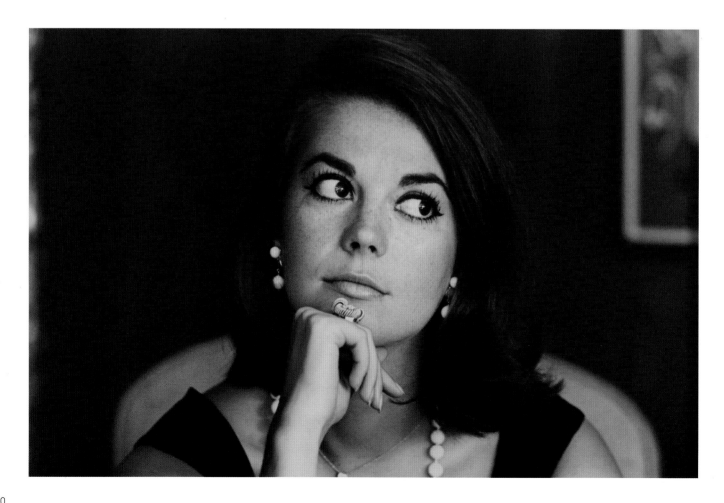

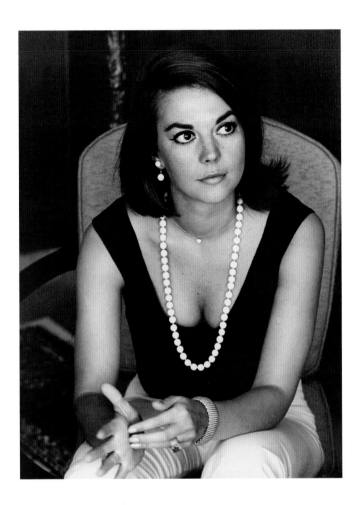

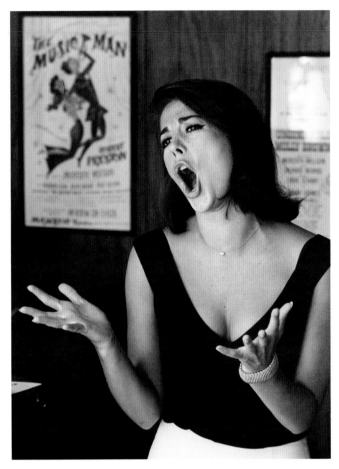

My father just couldn't resist this kind of reasoning. My mother knew how to push all the right buttons and my father ended up feeling a bit embarrassed, as if he had been punching a pillow. He grumbled a bit, but I could tell my mother had won. My family left Santa Rosa for good, and my father said goodbye to his dream of a farm in Oregon.

My mother and I made the trip to Hollywood by train for me to test for the film *Tomorrow Is Forever*, a sentimental drama with Orson Welles, Claudette Colbert, and George Brent. In it, I was required

OPPOSITE "She was divine to look at, and to photograph," recalls Ray, "She had that wonderful face, a great body, those amazing eyes—just a beautiful young woman, and a lot of fun to be around." **ABOVE** In early preparations for *Inside Daisy Clover*, Natalie spent time vocalizing under the guidance of Broadway conductor and Hollywood "voice doctor" Herbert Greene. **OVERLEAF** Natalie had a special clause written into her 1965 Warner Bros. contract requiring that a bracelet be provided on every film to camouflage the protruding bone in her left wrist, and that the bracelet be real and "not costume jewelry."

to cry again. It was the second time I was told to do something which, for all its good intentions, has taken me years to understand and get over. Knowing that it was absolutely essential for me to cry in order to get the part, and that I was much too young to be able to simulate tears convincingly, she did the only thing she knew how to get real ones: she got angry and said things that hurt me very deeply. I'm sure the pain was greater for her than for me, but I didn't understand it at the time. I equated not being able to cry with losing my mother's love, and everyone else's for that matter.

At any rate, it worked—I cried real tears and got the part. Looking back on the incident now, painful as it was, it nevertheless changed the course of my life. And for that I'm grateful.

The reality of Hollywood was a dash of cold water. Instead of glamour, I found myself immersed in work and study. I took ballet lessons and I struggled

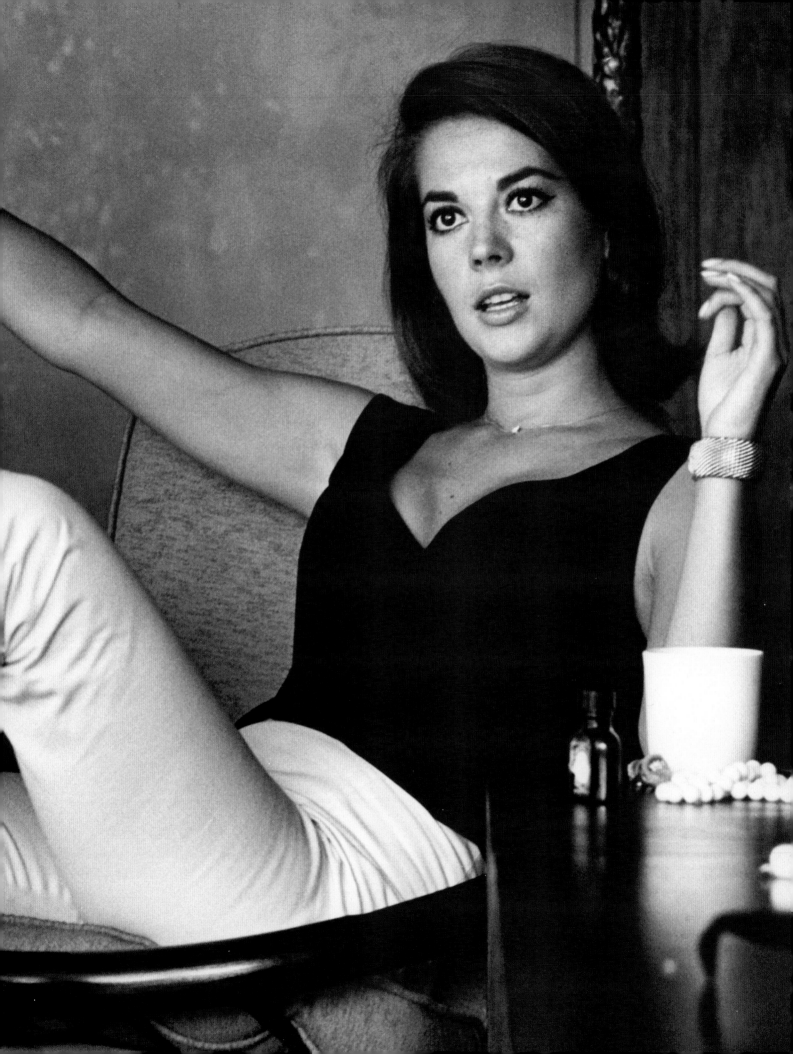

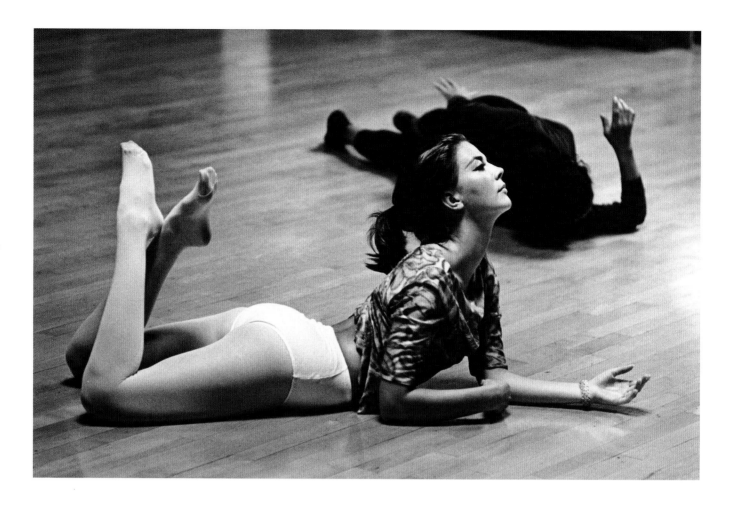

to master the piano. For years I followed a Spartan routine: work at the set, four and one-half hours of school, usually at the studio, return to work and home for supper and lessons. I spent more time with the director than I did with my father. I had very little time for childhood games—and I was so busy, I hardly missed them.

When I was six years old, I learned that I was no longer Natasha Gurdin. "Your name is now Natalie Wood," producer William Goetz told me. He told my mother that he had named me in honor of a friend, producer Sam Wood. "Couldn't it at least be Woods with an S?" she asked. "Don't worry," Mr. Goetz said, "Wood will look good on a marquee."

I never was alone. My mother accompanied me to the set almost daily. And if she wasn't with me, I had a studio teacher or welfare worker as a companion. Mother was terribly afraid someone would kidnap me, and she refused to let me visit at my friends' homes; they always had to come to mine. In some ways, I was

fortunate. I was a child actress instead of a child star, so I didn't grow up as a complete hothouse flower. Far from it—instead of being coddled, it seemed everybody told me what to do, how to walk, talk, and act. Later, the studio wanted to cap my teeth and lower my voice. I resisted.

It takes a while to adjust to some of the nonsense that surrounds a child actress. After finishing *Tomorrow Is Forever*, I made a personal appearance tour. Wherever I went, fans constantly pulled at my pigtails to see if they were real. When you're seven years old, it's very difficult to understand what it means to be a celebrity. I couldn't figure out why people wanted me to sign my name on a piece of paper. What possible value could it have for them?

I made an awful lot of films in those days. When I was eight, I made two movies at the same time: *Miracle on 34th Street*, a modern comedy with

ABOVE Natalie always wanted to be "tall and willowy," but was only 5′ 2″. Dance and exercise helped keep her camera-thin.

Maureen O'Hara and Edmund Gwenn, and *The Ghost and Mrs. Muir*, a costume piece with Rex Harrison and Gene Tierney. In between takes, I went to school, too. It was confusing and I loved it. I wore long dresses and period hairdos one day; the next I dressed in pigtails and pinafores.

Soon after this, I suffered my first professional tragedy when Twentieth Century Fox dropped my option. I didn't know what an option was, but I knew something terrible had happened. We got the news at Fox school, a gingerbread version of a Hansel and Gretel cottage. Another girl got her walking papers first, and she started crying in class. "Have you found out about yours?" she asked. I ran to Mother at recess. The look on her face told me: bad news. I started crying. I couldn't understand what I had done and why they didn't want me anymore.

"It's the studio's fault," Mother said as she hugged me. "Don't worry. It's all for the best. God wants it this way."

We were always at the mercy of the studio in those days. The threat of losing your option was a big cloud over a child actress's life. Nothing was more important to me than earning the approval of my parents, and if the studio dropped me, that meant I was a flop. I thought "flop" was the most painful four-letter word in the world.

My father comforted me. But by the time I was twelve, he suffered the first of a series of heart attacks. For a few years, he couldn't work at all. This meant my acting was the sole economic support of my family, and therefore getting jobs became a tremendous responsibility.

I lost so many jobs as a child actress, I can't count them. It felt like heartbreak time whenever I heard a casting director say: "She's too skinny—too short—too tall—in the awkward stage." The worst one was "Not pretty enough." When I lost a job, I always felt nature had played a dirty trick on me. I felt they were rejecting the real me, not the professional me in relation to the character.

I was growing up fast in some areas. For instance, I was driving a car at twelve. My father was too sick to drive, and Mother got too nervous to learn. Somebody in the family had to drive to get errands done. So one day I climbed behind the wheel of the family Chevy. Luckily, it had an automatic transmission.

For years I went to a private tutor or a studio classroom, but at age twelve I began attending a conventional school. Like most child actresses, I played roles younger than my real age. So, Mother always dressed me in little girl pinafores and braids while the other girls at school wore stockings and lipstick. I felt like Rebecca of Sunnybrook Farm, and I thought the other kids were laughing at me. Actually, I was too shy to admit I wanted to make friends. I really wanted to be a member, to be part of the clubs and social life, but I was too busy with work to know my classmates. And I felt more at ease with grown-ups.

By the time I entered Van Nuys High School, nothing was as important as looking older and sophisticated. I couldn't wait to reach twenty-one and be on my own. To hurry up the aging process, I tried on dreadfully long earrings and smeared my face with lipstick and mascara. I started dating every weekend, and soon realized I had been missing a lot of fun. I had never had any time for friends, no time to loaf or be concerned about normal childhood things. Instead, I had listened constantly to the drone about pictures, parts, options, properties, and tests. A sense of responsibility, out of all proportion, had been weighing me down. Sometimes I had nightmares about the family starving if I didn't act.

Slowly, I started to disentangle myself from my mother's all-consuming embrace. All these years she had been guiding me, and now I was ready to flap my wings and leave her nest. Not that she was evil, not that she was exploiting me, I simply felt I couldn't cope with her all-consuming love. It smothered me like a heavy blanket, and I began to rebel. It no longer mattered whether my parents wanted me to go out or not. I went out. It didn't

matter how they wanted me to dress. I dressed the way I pleased. After years of doing what I was told, I was trying to do what I wanted. The problem, of course, was that it took me years to figure out what it was I really wanted.

If I had an adult's responsibilities, I felt entitled to an adult's privileges. I began making the rounds in Hollywood, the nightclubs and the intimate spots at the beach. The night everyone else went to the senior prom, I went to Ciro's. My date was twenty-eight years old, and I didn't leave the nightclub until they stopped serving champagne. I redecorated my bedroom, ripping down all the ruffles and frills. Everything that was pink and blue, I painted black and white. I began to eat health food, heard lectures on Zen, and thought I had found myself.

Two months later, the health food was making me sick, and Zen started to seem idiotic. The search for me continued. Looking back, I wince when I recall my teenage foibles. I guess I overdid it, and perhaps was so eager to find myself that I got more deeply lost for a while.

I had fled the cocoon of my family, and suddenly I found myself in a goldfish bowl of public exposure. Hardly a day went by that the gossip columns didn't link me romantically with various men-about-town. Every date I had was magnified and distorted—I was public property. I was reported to be involved with Tab Hunter, Lance Reventlow, Scott Marlowe, Elvis Presley, Raymond Burr, Nick Adams, Nick Hilton, and on and on and on. A lot of the so-called dates were arranged by the studio to obtain publicity in the fan magazines. And yet my rebellion wasn't arranged, it was real. I guess it was simply a delayed reaction to having worked as a child, to always doing what somebody else wanted me to do.

At sixteen, I heard about a new property, *Rebel Without a Cause*, the story of three lonely teenagers plagued by insensitive parents. Nothing seemed to me as important as getting the part of Judy, the heroine. Previously, I had tested for parts to keep working or to get parental approval—now I wanted

a part that had an emotional meaning for me. This was the first time I had made any kind of adult choice.

I tested three times for the part. The director, Nicholas Ray, was besieged by dozens of girls wanting to play Judy. After weeks of waiting, I heard the part was mine. But I had to keep it quiet because the studio wanted to announce it at the right moment. I felt like running through the halls at Warners!

Nick Ray gave me the confidence that I lacked, and it's to him that I owe my adult career. He made me understand that I had a responsibility as well as a contribution to make to a role beyond merely following the orders of the director. The first time he asked me how I thought I should behave in a scene, I was amazed. It had never occurred to me that my ideas about a part or a script might have value. For the first time, I began to see that acting for me could be a real means of self-expression.

Everybody was talking about James Dean, the male lead of *Rebel*. I had first met Jimmy a year earlier at a television rehearsal in Los Angeles. He entered through a loft on his motorcycle, his hair flying and a safety pin holding up his pants. He mumbled something like "hello." We became close friends, and we spent a lot of time together, off and on his motorcycle.

After filming had wrapped on *Rebel*, Jimmy went into *Giant*, and I went to New York for a ninety-minute live television show, *Heidi*. A lot of Jimmy's friends— Sal Mineo, Jo Van Fleet, Nick Adams, Dick Davalos, and myself—happened to have dinner in New York that night. During the evening we discussed Jimmy. Was *Rebel* going to be good? How would Jimmy do on *Giant*? After some general discussion, the conversation took a serious turn. They began talking about Jimmy's car racing, rodeo riding, and other

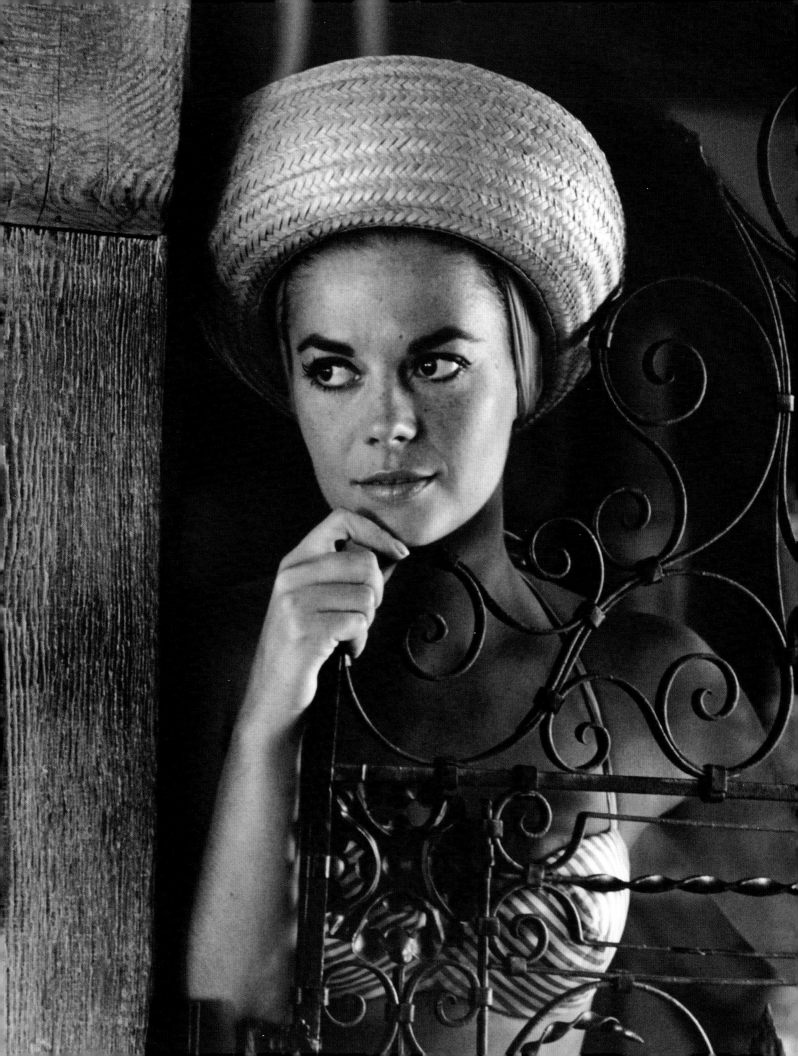

"dangerous" interests. They felt he had a streak of self-destruction. As a matter of fact, Nick Adams said that night, "Jimmy won't live to be thirty." I argued vehemently. I knew he was self-destructive, but I also saw another side—a side that responded in a very positive way to life. We got into a heated argument.

Later, Nick took me back to my hotel room. We bounced in laughing, and I left the room for a minute. When I returned, Nick was talking to my chaperone, Maggie Waite, and I sensed something was wrong. Suddenly, everybody had run out of subjects. Nick stared at the ceiling. "What happened?" I asked. After a long moment, Maggie answered: "James Dean has been killed."

It's difficult for me to describe the exact nature of my feelings at that moment. It was the most severe shock I had ever experienced in my life. It seemed impossible for me to grasp. It was the first time anyone I loved or was close to had died. I thought I was being terribly calm and rational until

I heard Maggie saying, "Please, Natalie, don't be so upset, pull yourself together," and I discovered I was crying hysterically.

Jimmy had a rare thing—a vulnerability, an openness about life. It was something that people could empathize with. And yet, everyone had the feeling that he had been haunted by a dark star.

After the TV show, I left immediately for California. My mother had telephoned me, and I knew she was concerned about my state of mind. I flew back with a friend. Neither of us said a word during the entire flight. There was nothing to say.

Some time ago, I rummaged through my closets. As I leafed through scrapbooks, family albums, and yellowed letters, I came across the top of my wedding cake. It was a simple thing: two plastic figurines, a man and a woman in wedding attire, under a lacy canopy. It had been gathering dust for nearly ten years. For a moment I had an impulse to throw it away. I didn't because it's an important part of my life and I don't want to forget it.

If you love someone and make a commitment to them, the love does not vanish because you have signed a legal document called a divorce paper. The failure of all your hopes, promises, and dreams gives you one more thing in common— mutual sadness.

In the movies, the happy ending is still popular: the boy and girl walking, hand in hand, into the sunset. Presumably, they are heading for the altar, but is that the end, or the beginning, of their problems?

I got married at age nineteen to a handsome actor named Robert Wagner, known to his friends

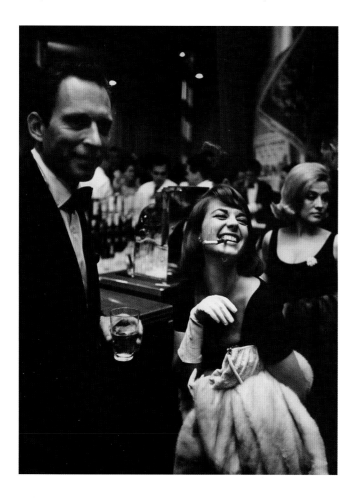

LEFT Natalie enjoys the Los Angeles night life with beau Arthur Loew, Jr. Her cigarette holders were specially imported from a shop in London. OPPOSITE Natalie presides over her "cabinet." Left to right: lawyer Greg Bautzer, agent Joe Schoenfeld, agent Norman Brokaw, public relations representative Henry Rogers, public relations representative Dave Resnik, business manager Andy Maree, lawyer Roger Davis, lawyer Jim Cohen, and agent Abe Lastfogel.

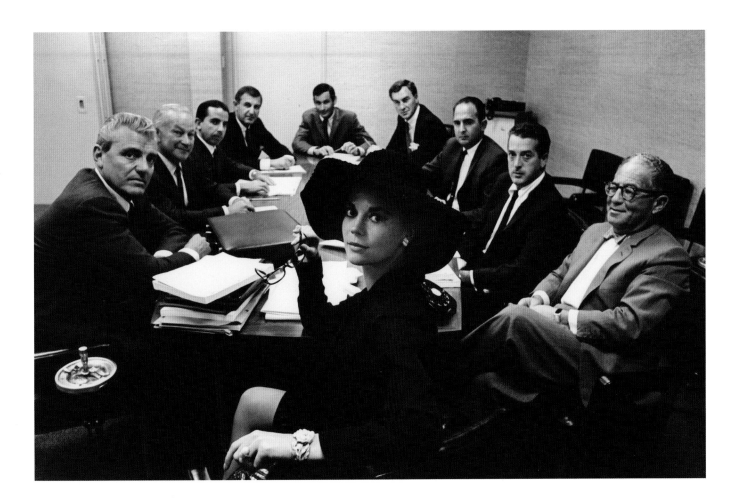

and family as R.J. I first met R.J. at age ten. He brushed by me in the studio hallway, and never looked back. But I did.

R.J. had a comfortable and relaxed home life. As a youngster, he caddied at the Bel Air Country Club, and later developed into a superb amateur golfer. Like the rest of us in show business, R.J. has had his share of setbacks. His good looks were as much a handicap as a help. For years he got nothing but pretty boy roles, and his creative energy was wasted on absurd parts. He showed his talent when he played a wisecracking aviator in *The Hunters* with Robert Mitchum. And anyone who has seen *Harper* can testify that R.J. has overcome his nice boy image. But it wasn't easy.

I met R.J. again when I was seventeen for a brief photo session. We smiled at each other, and if there was any memorable dialogue it escapes me. But a few weeks later, he called and asked for a date. On July 20, 1956—my eighteenth birthday—he escorted me to the screening of *The Mountain*. The next morning he sent flowers and a note, promising, "I'll see you again."

Robert Wagner and I dated for six months without a single line in the press. The fan magazines continued to link me with other men, some of whom I had never met. Meanwhile, R.J. and I met in out-of-the-way restaurants that were not frequented by the press or the movie colony. We sought privacy because we had both been exposed to extreme publicity and had both had previous relationships speculated upon by the press. We knew it would be impossible for either of us to know how we really felt if our every move was weighed by the press and bets were taken on the significance of our relationship.

In March of 1957, R.J. left for Japan to make a film. We both should have bought stock in the phone company that year; he called me each day. I wanted to fly to Tokyo, but I was tied up in movie work.

When he returned from Japan, R.J. accompanied me to Lake Schroon in upstate New York while I filmed *Marjorie Morningstar*. We were there for eight weeks. While I knew that the role of Marjorie was most sought after and was probably important to my career, the work, for the first time in my life, was secondary. The comfort I had always experienced in the atmosphere of work now came from being with someone I loved and who loved me. Those weeks of my life were total happiness. I couldn't wait for shooting to be finished.

We returned from the Adirondacks on December 6, 1957, the anniversary of our first "serious date," and R.J. took me to a restaurant for a champagne supper. I spotted something glittering at the bottom of my champagne glass: a diamond and pearl ring. The inscription said: "Marry me." I said yes.

It all seemed so romantic, so real. It took years for me to realize that romantic gestures are merely the shell surrounding the essence. In those days, I never thought about the real meaning of deep commitment to another human being. Instead, I thought you achieved a state of loving by acting out these airy gestures.

Just before I was married, I did a film with Frank Sinatra called *Kings Go Forth*, and it was Frank who helped R.J. and me to make our wedding plans. We didn't want to have our marriage turned into a publicity circus and Frank suggested that we go out of town. We chose Scottsdale, Arizona, a small town near Phoenix, and invited only our closest friends.

We traveled by train and registered at the hotel under assumed names. The night before the wedding I got this note: "Darling, I miss you. Are you going to be busy around 1 PM tomorrow? Love you, Harold." I replied: "I won't be busy. How about getting married? All my love, Lucille."

We thought we had solved the press problem, except for one detail. We had hired a private photographer whom we thought was trustworthy to take pictures for our personal wedding album. The first time we saw our "private" album was in

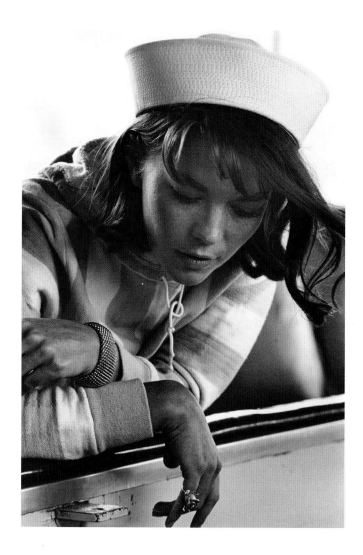

the newspapers. We were appalled at the man's betrayal and even more disgusted to learn he had sold the negatives to numerous fan magazines.

On our honeymoon, we wanted to be alone together, and the only way that seemed possible was to drive cross-country. We drove to motels in out-of-the-way places where the press wasn't likely to find us. We planned a detailed route so we could avoid the major cities. R.J. wore Levis and I put on a bandana, slacks, and sunglasses.

Somehow, reporters and photographers constantly caught up with us, turning our honeymoon into a tiresome game of hide and seek. One evening while we were relaxing at a movie, some

ABOVE Natalie learned all about boating from Robert Wagner during their first marriage. **OPPOSITE** When Natalie had a day off, she would often charter a boat and take a group of friends to Catalina Island.

photographers asked us to step outside so they could take our picture. R.J. declined, but they persisted. R.J. finally lost his temper and told the man that we wanted to see the movie just like anyone else who buys a ticket. They walked off mumbling about temperamental movie people.

When R.J and I returned to California, we moved into his two-story bachelor apartment. Early on, we told the press that our home was off limits—no reporters or cameras inside. That brought down a lot of criticism. One magazine published a personal appeal: "Bob and Nat, don't forget your loyal fans. Don't build a wall around your marriage."

As we struggled to achieve privacy, the magazines made up fantastic stories. One reported that I dated three heavyweight champions in one night, as a practical joke on R.J. One champion lived in Argentina, the other two were in their seventies. I was not a sports fan and had never even heard of, let alone met, any of them.

The magazines ridiculed our "togetherness," speculating: Why were Bob and Nat always together at parties, previews, personal appearance tours? Somehow, the magazines made it seem ominous, or at least in bad taste, for newlyweds to be constantly together. Although we were never separated, R.J. and I were rarely alone together. Because of the nature of our profession, the house was full of well-intentioned friends and there were always premieres, parties, or social business meetings.

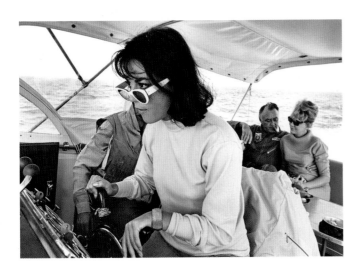

The happiest times in our marriage occurred when we were aboard R.J.'s yacht, *My Other Lady*, usually on cruises to Catalina Island, without other people. On board, I was the first mate. That meant I kept the ship's log and was personally responsible for the galley. As a girl who didn't know how to boil water before she got married, I was really proud of my cooking. Sometimes, it was a challenge just to stand upright when the ship was pitching and rolling. My specialty was *huevos rancheros*—an egg concoction with cheese and peppers on a tortilla. I shopped for the boat's groceries, I learned to maneuver a skillet on the rolling seas—and I loved it.

I was feeling quite salty indeed. R.J. taught me all about yachting: the radio, the mooring, the radar, fire extinguishers, and life jackets. I even caught some fish. I was so pleased that I got careless. One morning as we returned to Balboa from Catalina, while R.J. maneuvered the boat into the slip, I threw over the line—and fell into the water with it. It was January and freezing. R.J. fished me out.

When we got married, we agreed not to have children for a few years. I supposed we realized, even though we didn't admit it, that we weren't emotionally prepared to start raising a family. We also agreed not to work together on a film, but we broke our own rule and did one movie, *All the Fine Young Cannibals*. The critics panned it.

After two years of marriage, things began to change. Now when we were alone we seemed less together. We were aware that we had problems but tried to avoid the real conflicts. We maintained a superficially happy relationship and hoped that by pretending there was nothing wrong, the problem would go away. It was extremely difficult for us to really face serious flaws in the relationship when everything looked so ideal on the surface. Looking at it from the outside we must have seemed like the American Dream. We were both attractive and successful, so what could possibly be wrong?

We not only worked at illusion, we lived in it. We were like a couple of kids playing house in a

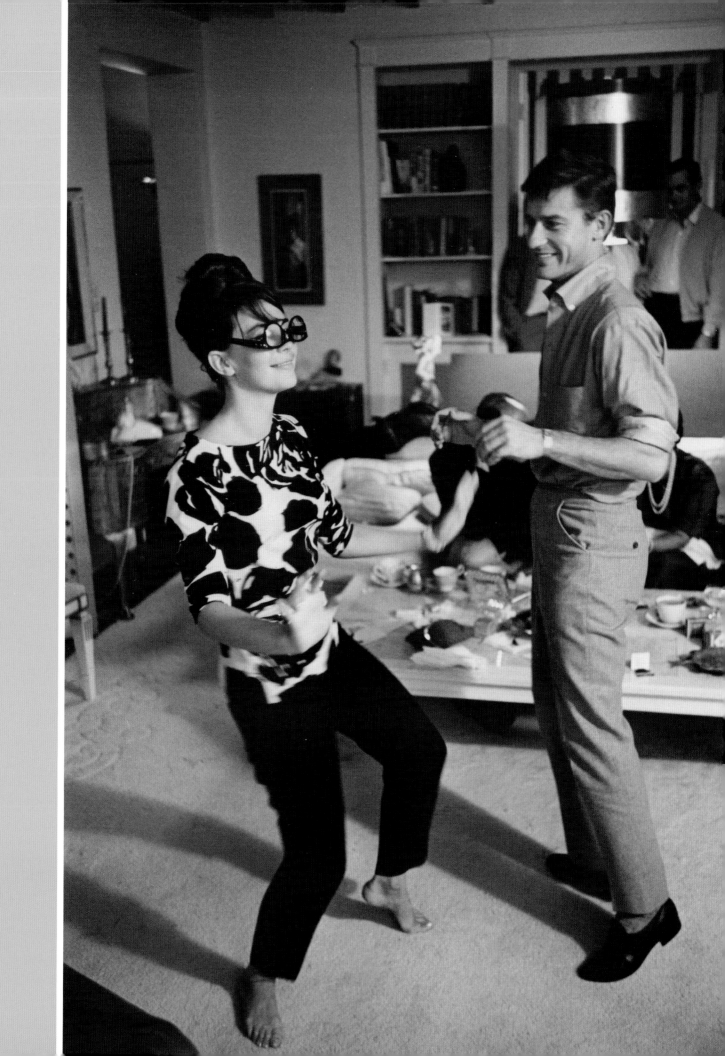

gingerbread world. I had swept my childhood problems under a rug labeled Marriage, and now they were piling up. Now that I was married and on my own, so to speak, they came out of hiding. First of all, I had grown up in the belief that my only worth was in connection with my ability to get parts. The universe seemed to hang in the balance when I waited for word of a job. When I think of my early years, it seems as if I spent most of that time auditioning.

How do you separate reality from illusion when you have been steeped in make-believe your whole life? Marriage requires patience and work, as well as the capacity to accept another human being, flaws and all, without cloaking him in a smothering mantle of perfection. It was unfair to heap all my dreams on one man's shoulders.

As R.J. and I struggled to make our marriage work, the problems continued to pile up. After finishing work on *Splendor in the Grass*, I went directly into *West Side Story* for another solid, rigorous eight months. R.J. and I spent less tim e together. There simply wasn't time for boat trips, parties, or poker games.

During this hectic period, as I worked fourteen months straight, R.J. went through an ordeal that all performers, including myself, have to face. His career hit a momentary lull. It would have been better for my marriage if my work had hit a soft spot at that point. But as tough as it was, R.J. didn't complain. That was part of the problem. R.J. believed strongly in keeping things to himself. Sometimes I waited for him to complain or start a fight, but his calm exterior remained intact. His coolness drove me frantic, because I was used to the emotional intensity of my parents.

As my professional and personal pressures increased, everything seemed magnified and distorted. A careless remark suddenly became a major insult. "Why do you let things upset you?" R.J.

asked. "Don't let your parents upset you." Whatever it was, R.J. always found a way of smoothing over problems. Meanwhile, I was seething underneath, but I didn't know why.

Finally, I told R.J. that I needed professional help. I wanted to try psychoanalysis. My husband thought people ought to solve their own problems. I, too, felt that way once, but at that point, I was willing to try anything. I telephoned an analyst and made an appointment for the following Monday.

But it was too late. My marriage collapsed that weekend.

Of course, I could cite more specific details about why my marriage failed. But I have too much respect for my ex-husband and for myself, and those problems belong only to us. I can only say that it was a problem of communication and that we were growing in different directions.

Since the collapse of my marriage in 1961, I have been consciously trying to examine and unravel the real cause and effect of all my behavior. I think it takes a long time—years—to realize what it means when your marriage fails; all the promises to love forever, the faith, and the belief in another person and yourself.

I started psychoanalysis at this crisis in my life. It was the collision of all my illusions, my idealistic concepts regarding love and marriage, and the ultimate reality. At this crossroads, I sensed that if I didn't somehow come to terms with myself and reality, I would drown in a mechanical make-believe world. One needs something more than approval or fame or wealth to be nourished. No one comes away soot-free from the past, and I paid a certain price for those first seventeen years. I had been on a merry-go-round since I was four, and perhaps it was beginning to need some repairs.

Because I felt I had so few inner resources, I was extremely dependant on other people and their reactions towards me. It was as if I were the sum total of all the parts I had played and I had no idea

who I really was. I had tried to find out from other people, and tried to be what they wanted me to be. I always did as I was told as a child and on the set. These superficial props were no longer satisfying, dependable, or appropriate to my age.

For the first time in my life I considered, in horror, the possibility that I might join that sad parade of famous movie ladies who wind up desperately lonely, with nothing more substantial to sustain them than their scrapbooks and old photos, and memories of romances and divorces. I could no longer expect a magical Prince Charming or even a good doctor to wave a wand and make the pain go away. Nor would I find the answer in work, travel, or material things. Something was wrong and I wanted desperately to put it right. I knew the answer lay within myself.

As I groped for understanding, the crises came in series. R.J. and I had talked about a reconciliation. The California divorce had been granted, but we had a year to think it over before the divorce became effective. The divorce papers lay on my desk, and I was torn between signing them and reconciling. As I considered the alternatives, the professional pressures increased. I was starting a major film, *Gypsy.*

Then I got a terrible blow: my analyst died. We had been making painful but steady progress for eight months. His death knocked the emotional props out from under me. I didn't have the strength to seek a reconciliation. So I signed the final papers.

I can't help speculating sometimes. Had my analyst lived, he might have helped me work out a reconciliation. Had R.J. and I gone to a marriage counselor, we might have worked out the marriage. But speculation is futile. We had broken up, gotten older. R.J. remarried. The external trappings of our lives changed. But I believe that these changes don't, in any real sense, make you a different person. And to deny the validity of my feelings about someone a long time ago would be, for me, to deny that I existed.

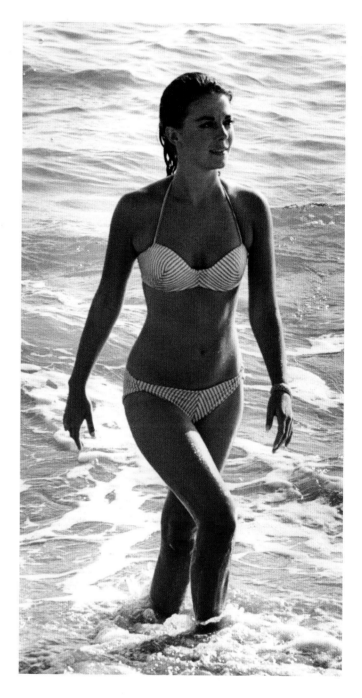

One night, a few years ago, I was dining in a restaurant. Unexpectedly, a mutual friend of R.J.'s and mine walked in and told me he had just come from the hospital—my ex-husband's first child had just been born. I cried when I heard the news. It wasn't only from the sense of loss I felt for something we never shared, it was also happiness for him.

During that time I drifted. It was the first time I was without people to sustain me. I saw very little of my parents. I had no house. I rented a series of furnished homes for short intervals, always thinking

and feeling I did not know quite where I belonged. I considered living in Europe. I thought of moving to New York. I finished *Gypsy* and had begun working on *Love With the Proper Stranger*, and was extremely involved in the work. It was a source of great pleasure to me, and I was totally immersed.

When the picture came to an end, I felt devastated because I knew I had to come out of my safe cocoon. I felt at a loss. I did not feel I had any reason to stay in California, and felt transient and lonely. I had become emotionally involved with Warren Beatty, and he was in the East shooting *Lilith*. The plan was that I would join him when I finished *Proper Stranger*. I had a decision to make—should I escape myself and my problems, avoid them by going to join Warren and continue a relationship that had developed into a charade, or stay in California alone and face my troubles?

After the death of my first doctor, it was extremely difficult for me to begin analysis again. However, I knew I had many problems that were still unresolved. I knew my relationship with Warren was self-destructive. While R.J. never did express hostility, Warren couldn't stop. After my divorce, I was looking for the Rock of Gibraltar. Instead, I discovered Mount Vesuvius, a live volcano with eruptions each day. And I contributed my share of fireworks too. In fact, we were both so confused that we thought fighting and hostility meant real emotional honesty.

I think, in retrospect, I felt that I should be punished for having failed in marriage. I was trying to punish myself by sticking to a relationship that was going nowhere. I knew that to consider another marriage would be catastrophic. Yet somehow I could not bring myself to end the affair with Warren

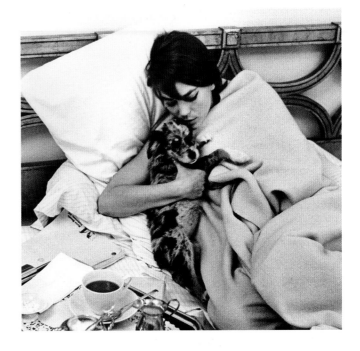

and face the loneliness. In short, I was afraid.

During this chaotic time, I heard about the death of Marilyn Monroe. I had known her and seen her days before her death. Her beauty, charming wit, and joy of life seemed paradoxical to the intense loneliness which she faced in her life and was, to me, clearly apparent. Her death, the waste of her beauty, talent, and worth as a human being had an enormous effect on me. One of the effects was that I decided to stay in California and again seek help in analysis. I realized that her tragedy reminds us all how vulnerable we are, and I chose to try to be stronger.

I rented a beach house, continued the analysis without interruption, and began at last to try to grow up. I had always been drawn to the water, and living on the beach was wonderful. I began to enjoy being alone and found great pleasure in just walking by the water, thinking, trying to find some sort of inner peace. To my surprise, it was not so overwhelmingly ominous to be alone.

Books and poetry began to have much more meaning to me as I matured and sometimes I would read all night, trying to bridge the gap of knowledge and find a rapport with other people's thoughts and philosophies.

OPPOSITE Despite her childhood phobia of dark water, Natalie loved the ocean. "The endless pounding of the Pacific comforted me," she said of time she spent on the beach at Malibu. "I loved to hear the surf, to feel the sand beneath me . . . my reflections ebbed and receded like the tide." **ABOVE** Natalie admitted as a child she "often felt closer to animals" and was "constantly bringing home stray cats and puppies." Here, she shares breakfast in bed with her dogs.

When I was fifteen years old I had a favorite book called *The Little Prince* by Antoine de Saint-Exupéry. It's an allegory about a boy from an asteroid who lands on earth in his travels to understand the meaning of life. The boy is appalled by the insensitivity of adults. Finally he meets a fox who gives him a secret. He says, "It is only with the heart that one can see rightly. What is essential is invisible to the eye."

The author makes the point, beautifully I think, that grown-ups lose their appreciation of life; that its essence—love, truth, and beauty—is lost because they become too preoccupied with externals.

As a child I never had time to ask myself what I really wanted. Before I learned to accept myself, it was hard to accept others. I was guarded and suspicious of other people's motives. Today I want to be open, even at the risk of getting hurt. You can't really live if you are encapsulated in a shell of detachment and non-feeling. The occasional hurt is the price you pay for the full experience that life offers. A lot of things are unfolding before me. Gradually I am learning to say "yes" to life.

I now own a home in Bel Air, and it is a great joy for me. My home is my emotional anchor, and in the past two years I have been decorating it to my taste. It's a cozy house, furnished with a few French and Italian antiques and some sentimental holdovers. My upright piano has endured my rendition of Mozart's "Sonata in C Major" since I was four years old. It's seen a parade of houses and has been painted black, brown, yellow, and is currently olive green.

My favorite painting, which hangs in my living room, is a Courbet oil. It is a simple work showing a tiny boat in a harbor at sunset. Somehow, that fragile craft facing an open and strange sea reminds me of *The Little Prince*.

Right now I enjoy my life. I don't feel completely fulfilled, but there are many compensations. And I know that there are no magic coins on the street as I believed there were in Santa Rosa. You earn what

you get or else it is counterfeit. And at times that realization brings sadness.

Sometimes I regret that I didn't have the opportunity to go to college. When I am between films, I attend night classes at UCLA. Last semester I took an English Lit class. Curiously, the last lecture dealt with a poem by William Wordsworth, "Ode on Intimations of Immortality." "Splendor in the grass" is a line from this poem, and in the film there is a scene where I'm asked to read that particular passage. It has to do with the acceptance of growing older and putting away the illusions of youth. The course helped me to realize that my feelings are not as unique as I once supposed; in fact, they are so common they are universal. Man has always been threatened by demons, especially the ones from within. People have always had to fight the feelings of loneliness, emptiness, and estrangement from other human beings. Everyone deals with these feelings in a personal way.

I don't want to forget the painful memories. It is from remembering that pain of failure and trying to overcome it that one can possibly begin to grow as a woman. A long time ago my mother told me: "No matter what happens, you can use it in your acting." So all the disappointments at least had one redeeming factor—I can have the sadness, remember it, and use it in my acting. She also told me there was another use for sadness: to understand that your capacity to feel pain is also the measure of your ability to feel love.

I was once asked if my goal in life was to be a good actress, and at one time perhaps it was. But now I know that, most of all, my hope is that I will be totally committed to another human being and that that union will bring children and happiness.

Natalie Wood, 1966

OPPOSITE Natalie plays a scene for laughs on the set of *Sex and the Single Girl.* "I'm much better in sad things than in comedies," she mused in a 1966 journal entry. "My goal is to be able to convincingly play a happy lady."

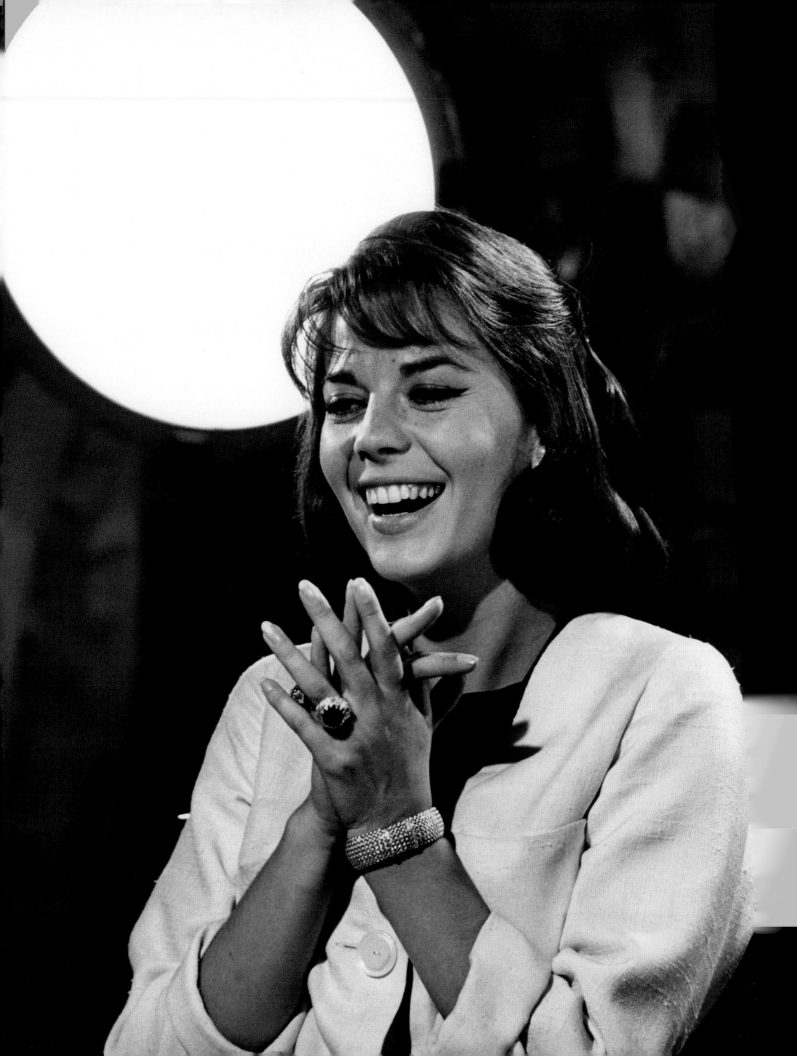

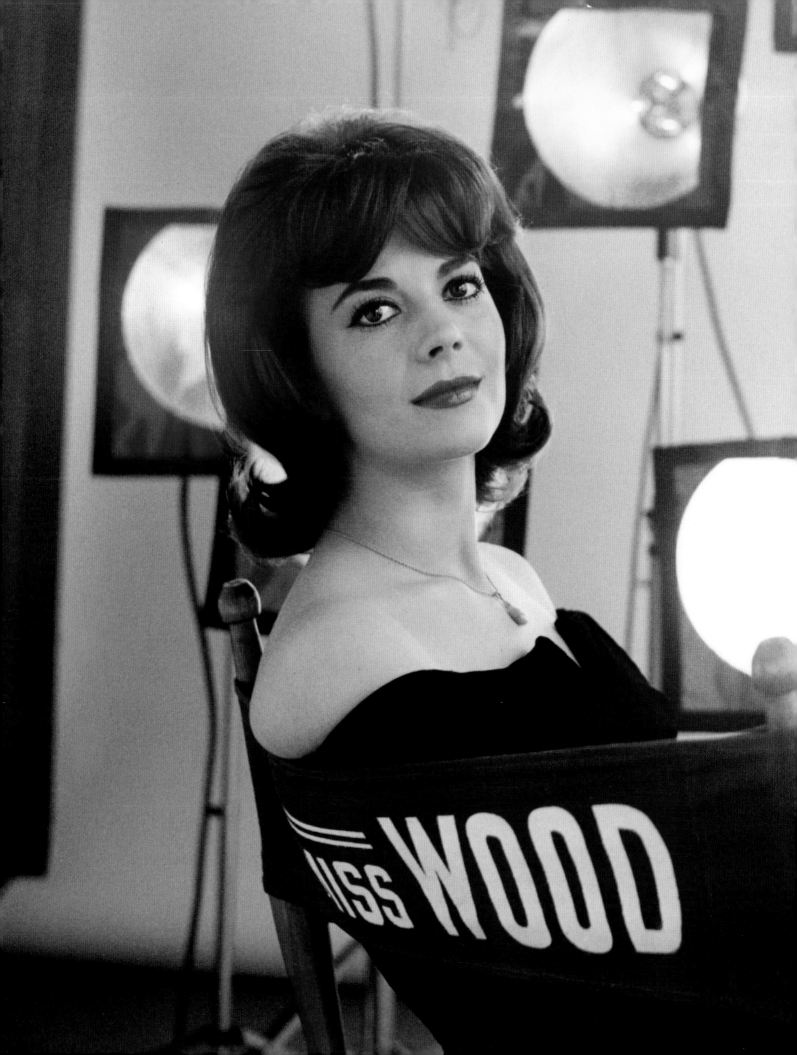

FRONT AND CENTER

1963–1969

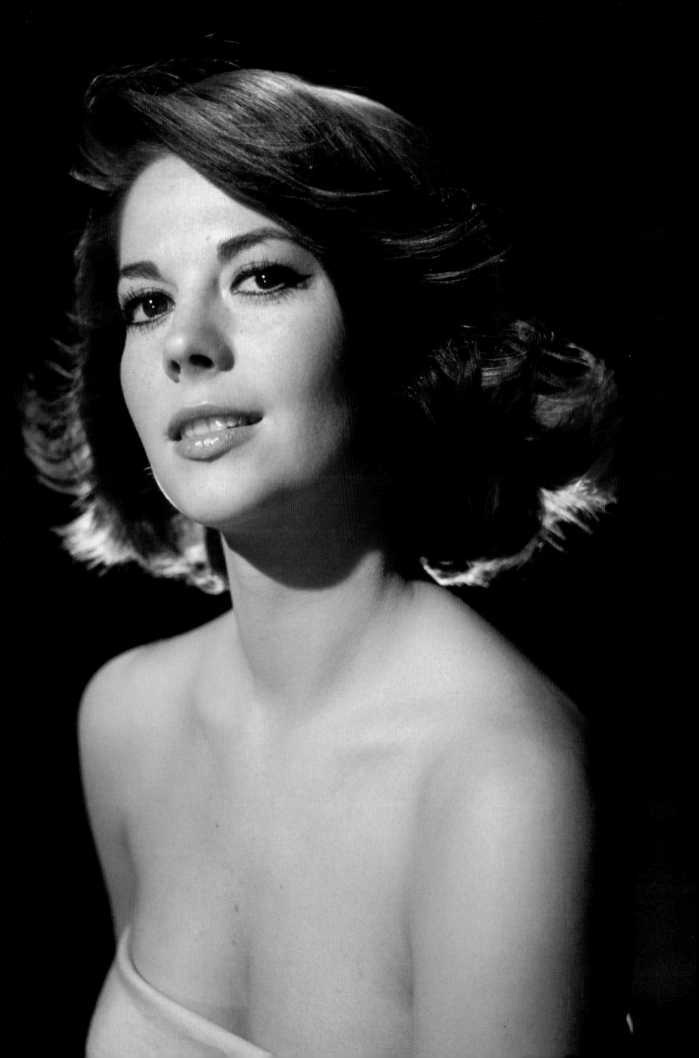

LOVE WITH THE PROPER STRANGER

"I spend my whole life like a nun, waiting for what? A stranger."

Natalie's thirty-fifth motion picture was the first in which she portrayed a fully matured woman from beginning to end. It was about time. The veteran actress turned twenty-five in 1963, and by then, American cinema was growing up, too. The French New Wave movement was exerting some influence on Hollywood, which excited Natalie, who admired the films of Chabrol, Resnais, Godard, and Truffaut. *Love With the Proper Stranger*, to be shot in black and white on the streets of New York City, would be European in tone and texture, she was assured by her director.

"Having helped Gregory Peck to an Oscar, producer Alan J. Pakula and director Robert Mulligan may do the same for Natalie Wood," reporter Bob Thomas speculated. After their critical and commercial success with *To Kill a Mockingbird* (1962), Pakula and Mulligan chose an unorthodox follow-up; an edgy comedy-drama, the plot of which Mulligan summarized as "falling in love in reverse." Screenwriter Arnold Schulman was more blunt and joked, "A funny thing happened on the way to the abortionist. . . ."

Her character, Angie Rossini, was an entirely new type of role for Natalie: a working-class Macy's sales clerk who lives with her boisterous Italian-American family. Her costar was also a new type. "You see

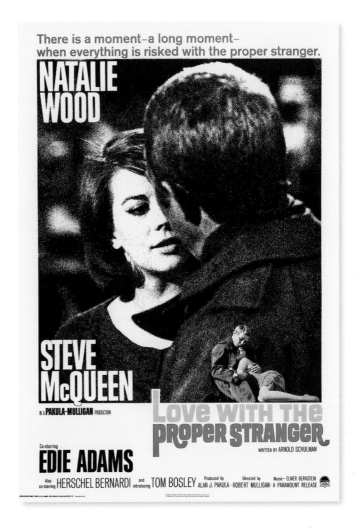

There is a moment–a long moment–when everything is risked with the proper stranger.

NATALIE WOOD

STEVE McQUEEN

IN A PAKULA-MULLIGAN PRODUCTION

Love WITH THE PROPER STRANGER

WRITTEN BY ARNOLD SCHULMAN

Co-starring EDIE ADAMS

Also co-starring HERSCHEL BERNARDI and introducing TOM BOSLEY Produced by ALAN J. PAKULA · Directed by ROBERT MULLIGAN · Music– ELMER BERNSTEIN A PARAMOUNT RELEASE

the unhappy boy in him that he might have been, and you want to mother him," Natalie said of Steve McQueen, who won the role of Angie's love interest, Rocky Papasano, just as his career was catching fire. McQueen described *Proper Stranger* as "a love story without a love scene. Sort of like *Marty*."

The movie gets off to an unconventional start when Angie confronts Rocky, a freewheeling musician, in a clamorous, crowded union hall, with the news that via their one-night stand, she is

OPPOSITE A publicity portrait for *Love With the Proper Stranger*.
ABOVE Advertising for the film skirted the controversial issues of unwed pregnancy and abortion.

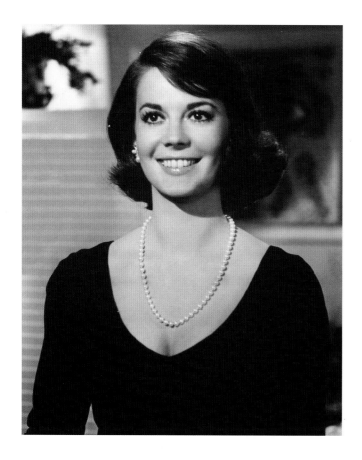

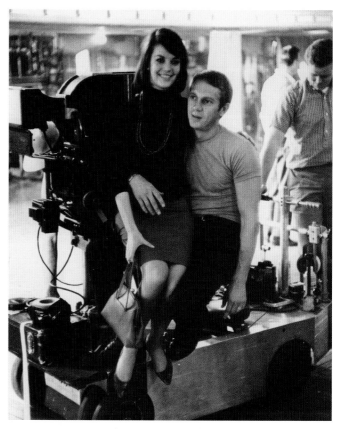

pregnant. She wants the name of a doctor, nothing more. The attractive pair thus begins their friends-or-lovers tango, matter-of-factly, without frenzy, without panic. That "panic" is just what some sputtering reviewers/moralists thought was missing: a sense of the biblical consequences of pre-marital sex and abortion.

Supporting the effortless glamour of Wood and McQueen are Edie Adams (Barbie, Rocky's live-in girlfriend), Tom Bosley (Angie's family-chosen fiancé, Anthony), Harvey Lembeck, Herschel Bernardi, and a screen full of uncredited New York talent. Director of photography Milton Krasner captures the day-to-day grind and grit of 1960s Manhattan, a neo-realism somewhat marred by the upscale polish of Natalie's Edith Head originals, but not fatally.

Natalie's wide-eyed charm was never better displayed than in *Proper Stranger*, and the film's harrowing abortion clinic sequence showcases her dramatic prowess nearly as well as the bathtub scene in *Splendor in the Grass*. "Many of the scenes in *Stranger* were improvised," Natalie revealed. "In the abortion sequence, all the script said was to get hysterical, and Steve and I worked the scene out by ourselves."

The final result of all the improvisation, location shooting, European influences, and star chemistry was an effective, if uneven, little film—something akin to a hybrid of the kitchen-sink drama The *L-Shaped Room* (1962) and the romantic comedy *The Tender Trap* (1955). Critics could not help but accuse the fair-haired, blue-eyed McQueen of being the "most unlikely Italian around," but praised his and Natalie's "performances of considerable vehemence." Natalie was rewarded with her third Oscar nomination, making a total of five nominations for the picture. Though disappointed by her loss, Natalie took comfort in the "substitute family" she had gained in Mulligan, Pakula, and McQueen. "I loved all three of them very much."

ABOVE LEFT Natalie, who wanted a more "off the rack" look for the dinner scene, bought a little black dress at the Jax boutique.
ABOVE RIGHT On set with Steve McQueen. **OPPOSITE** "I think he is one of the most attractive men I have ever known," Natalie said of her costar.

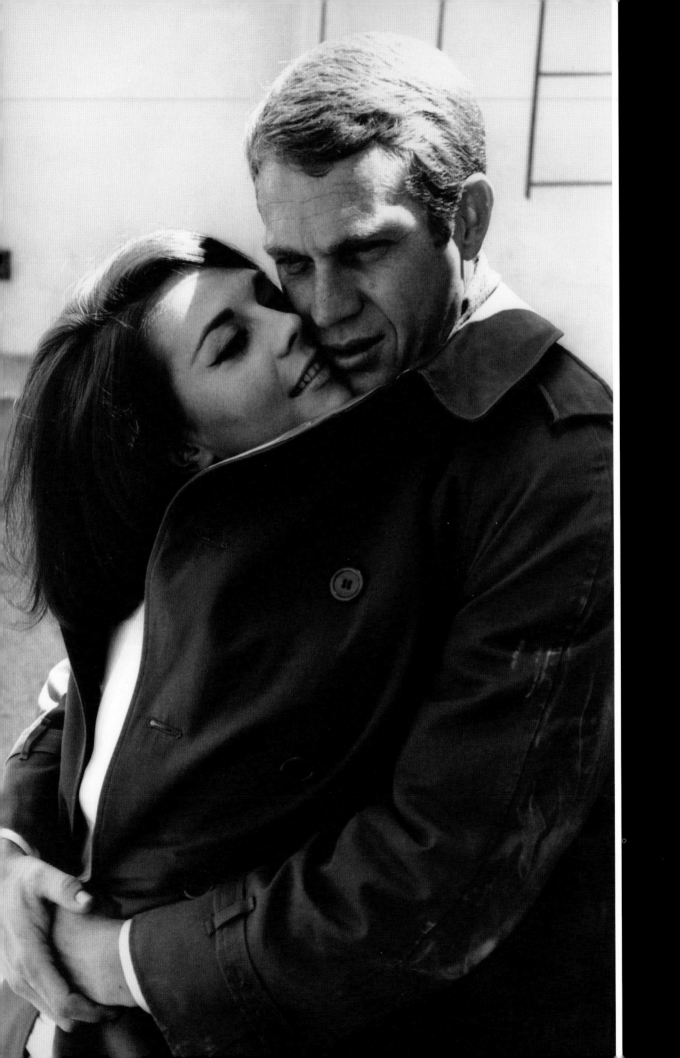

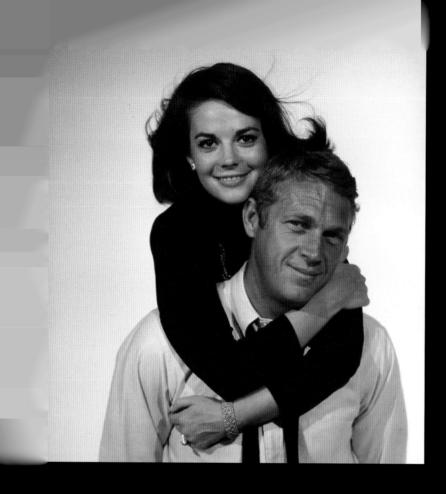

THIS SPREAD, CLOCKWISE FROM TOP LEFT A color publicity portrait for a black-and-white film; Elements of Natalie's personality were written into her character. "Arnold Shulman, the writer, would meet me over a drink at the Polo Lounge three times a week so he could learn things about me which could be incorporated into Angie's lifestyle."; Rocky comforts Angie in the powerful abortion clinic scene, which was largely improvised by the two actors; With director Robert Mulligan. "Natalie was always open to exploring her character in a scene," Mulligan said. "She was unafraid and would try anything. She never once said, 'I can't do that.'"; "Natalie Wood's large and expressive eyes portray everything that is required of the role of Angie," wrote critic Bob Thomas.

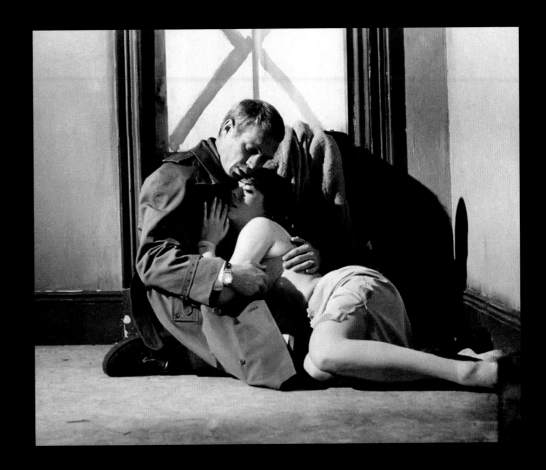

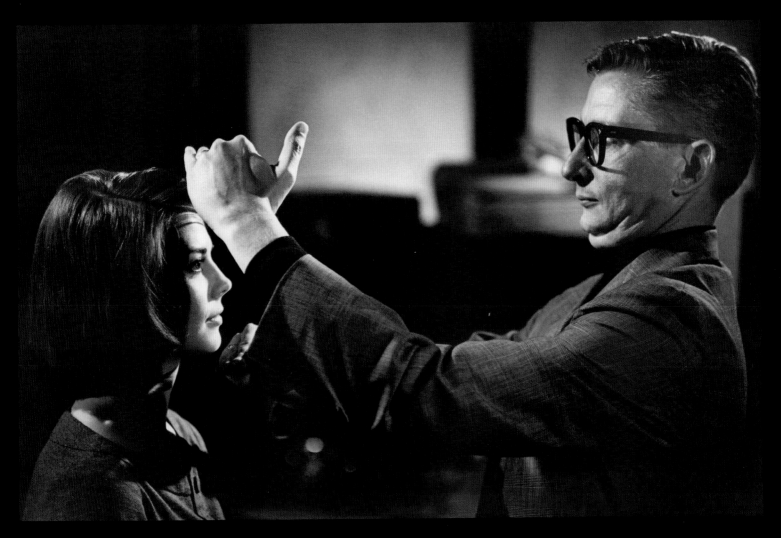

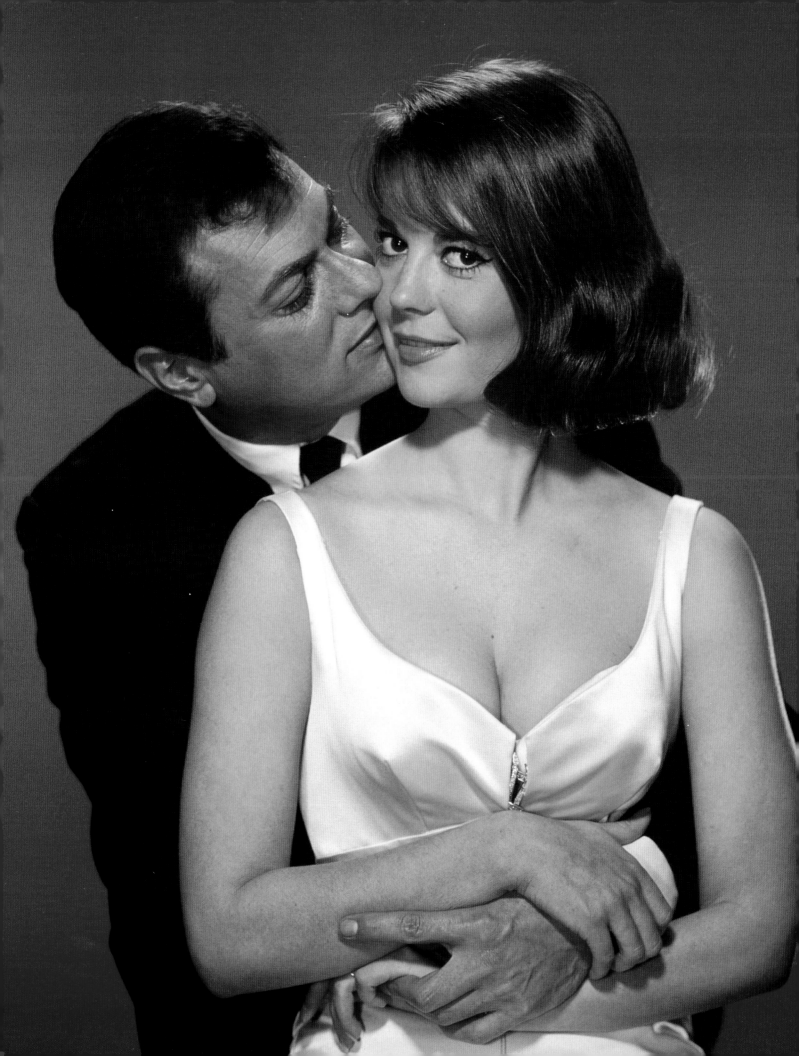

SEX AND THE SINGLE GIRL

"Everybody's doing it...so it must be fun!"

Natalie "didn't want to do the picture," the movie's co-writer Joseph Heller recalled of *Sex and the Single Girl*, but "she owed it to Warner Bros. on a three-film deal. And Tony Curtis needed the money to settle a divorce." Heller had dusted off an old script of his own, *How to Make Love and Like It*, and contemporized it with allusions to the current, media-hyped sexual revolution. A 1964 Warners press release called *Single Girl* a "satire on a provocative subject." But the project was put together in haste, using a scandalously popular book as a pre-sold title. A sharp, witty point of view was lost in the conversion.

The film posits Natalie as a young research psychologist focusing on "marital and pre-marital attitudes and activities," who has written a notorious book, based on a real book penned by Helen Gurley Brown. Natalie's character is even given the name Helen Gurley Brown; she intrigues Bob Weston (Curtis), a single guy and editor at *Dirt*, a sex and sleaze tabloid. In order to expose Helen as a virginal spinster, he adopts his neighbor's (Henry Fonda) name and marital status (to Lauren Bacall) to secure trust and believability during therapy sessions—not as funny as they should be—with her. Fran Jeffries is around to warble a few songs as Curtis's girlfriend, and Mel Ferrer is Rudy, the man Helen is dating.

She plays the leader of the sex revolution in America!

He plays...

Tony Curtis
Natalie Wood
Henry Fonda
Lauren Bacall
Mel Ferrer

Sex and the Single Girl

Tony Curtis and Natalie Wood, reunited from *Kings Go Forth*, look smashing together on screen, and share abundant chemistry between them. But with a shaky script and a director lacking a deft touch, *Sex and the Single Girl* was, according to the *New York Times*, ". . . left to the old-timers—Miss Bacall, Mr. Fonda, and Mr. Ferrer—who really count, as they suavely steal the show." Judith Crist of the *New York*

OPPOSITE The Wood-Curtis chemistry on display. "Natalie looks more enticing than she ever did before on the screen," proclaimed the *Los Angeles Herald-Express*.

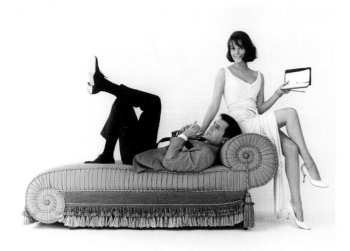

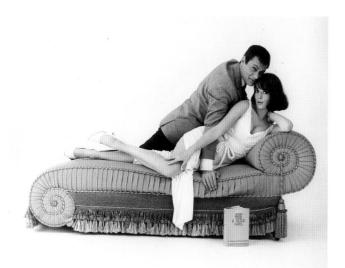

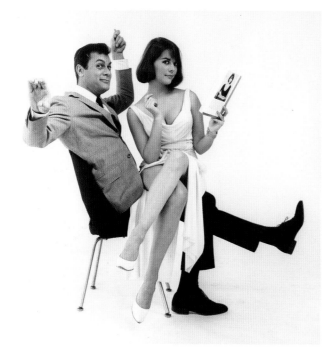

Herald Tribune summed up the film in three words: "dull, dull, dull."

At the time of filming, Natalie's personal life was more convoluted than the movie's plot, and anything but dull. Having endured a painful divorce from Robert Wagner and a calamitous affair with Warren Beatty, she became briefly engaged to movie producer Arthur Loew, Jr. and wore his diamond ring during production. Loew helped with the comedic atmosphere by bringing laughter into her life, she recalled. "Sometimes, I think Arthur should have been a performer. He had a humorist's streak that could see the comic element in the most ordinary things."

Riding high on a string of box-office hits and a third Oscar nomination, Natalie was at the flashpoint of a media blitz as *Single Girl* was made and released in late 1964. David L. Wolper assembled the documentary *Hollywood's Child*; Warner Bros. distributed a trailer called *Born in a Trunk*; the United Theater Owners declared Natalie the Star of the Year; and *Life* magazine published a major profile, "Natalie Wood: Born to Be a Star." The accompanying photos showed her in full superstar mode, ravishing in her Edith Head *Single Girl* ensembles.

The lightweight comedy aspired to be a lively sex farce, a cutting-edge romantic laugh-fest with a good deal of innuendo. It fell far short in execution and reception, and returned just $4 million gross on Warner Bros.' investment. The premise was more successfully retooled and recycled decades later in *Down With Love* (2003), a clever satire on sex, single girls, and the early 1960s. The original *Sex and the Single Girl* may have faltered, but Natalie remained the queen of Hollywood.

LEFT AND OPPOSITE Natalie and Tony Curtis get into character for publicity photos. "The idea that the girl who wrote this handbook about sex was a twenty-three-year-old punk, a cerebral infant trading on the gullibility of the public—that interested me," said director Richard Quine of Natalie's character.

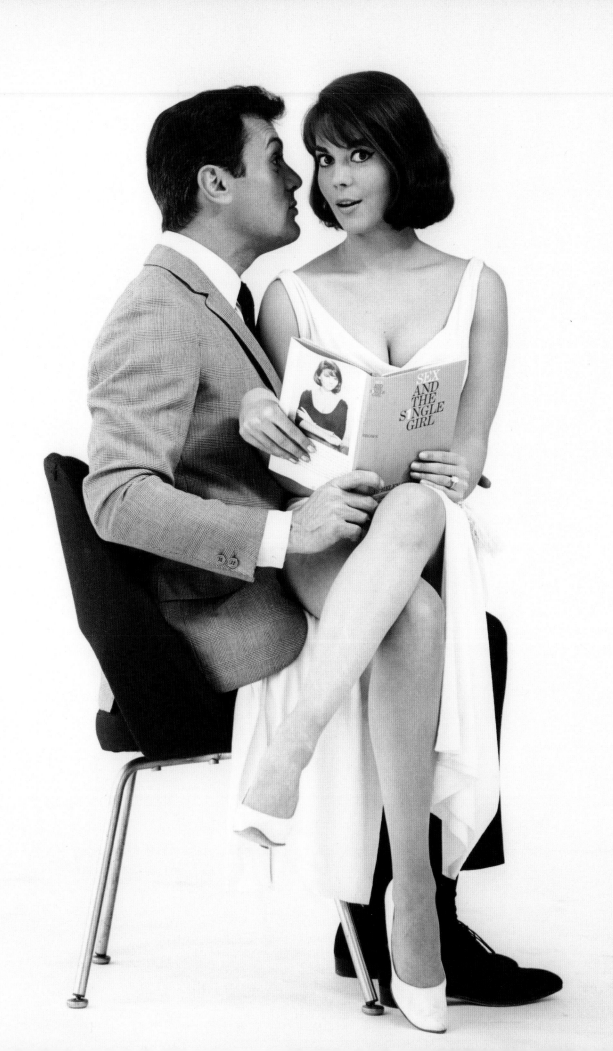

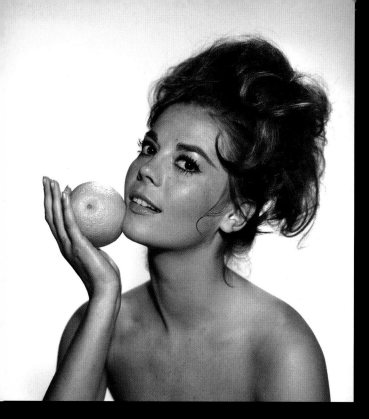

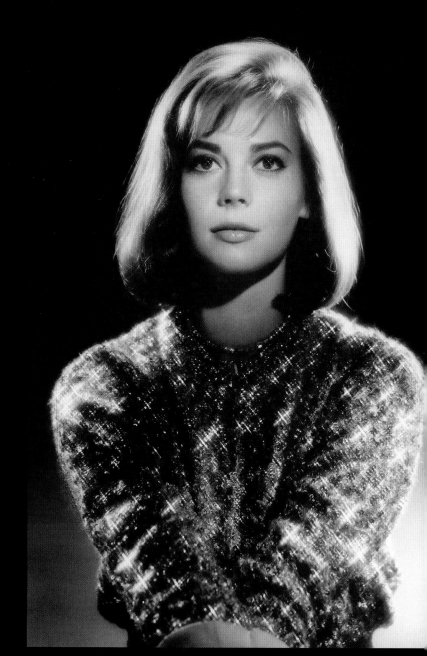

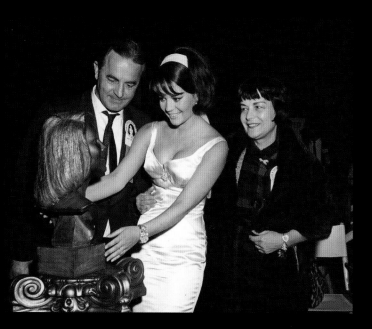

THIS SPREAD, CLOCKWISE FROM TOP LEFT Paramount used this seductive shot of Natalie with an orange to promote *Sex and the Single Girl*, 1964; A 1964 portrait by John Engstead; Famed Hollywood stylist Sydney Guilaroff beautifies Natalie for a photo shoot, 1964; Photographed by her friend Roddy McDowall, 1963; Out on the town with close friend Mart Crowley, circa 1965. "She was a girl who really was a survivor," Crowley later observed; A glamour portrait by Mark Shaw, courtesy mptv; Natalie attends Barbra Streisand's opening night at the Ambassador Hotel's Cocoanut Grove, August 21, 1963; Flanked by her parents, Natalie is honored with a bronze bust of herself at the Hollywood Wax Museum in Buena Park, California, January 1965.

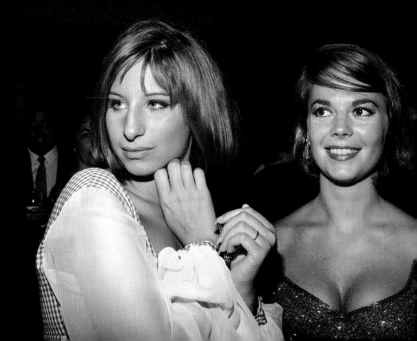

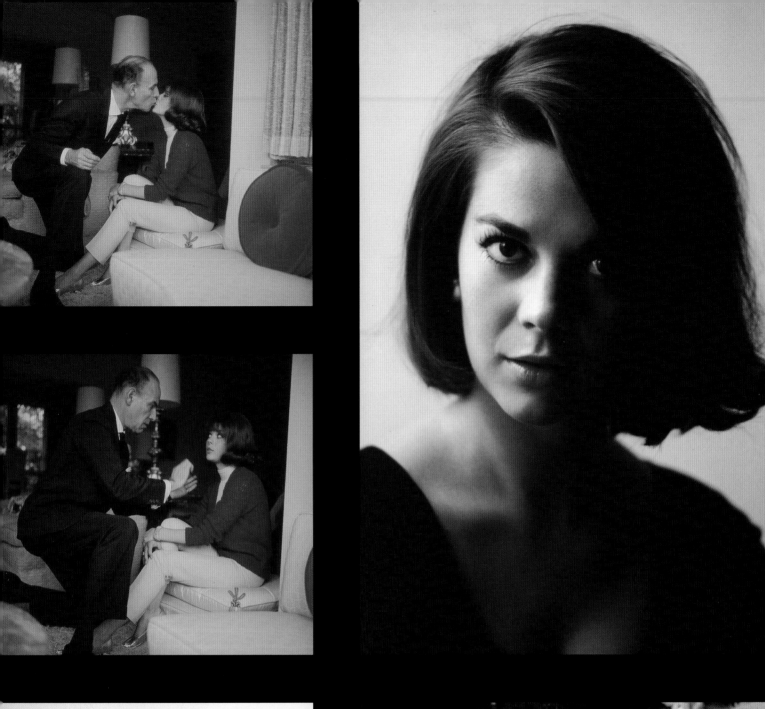

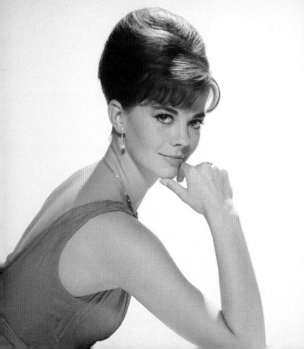

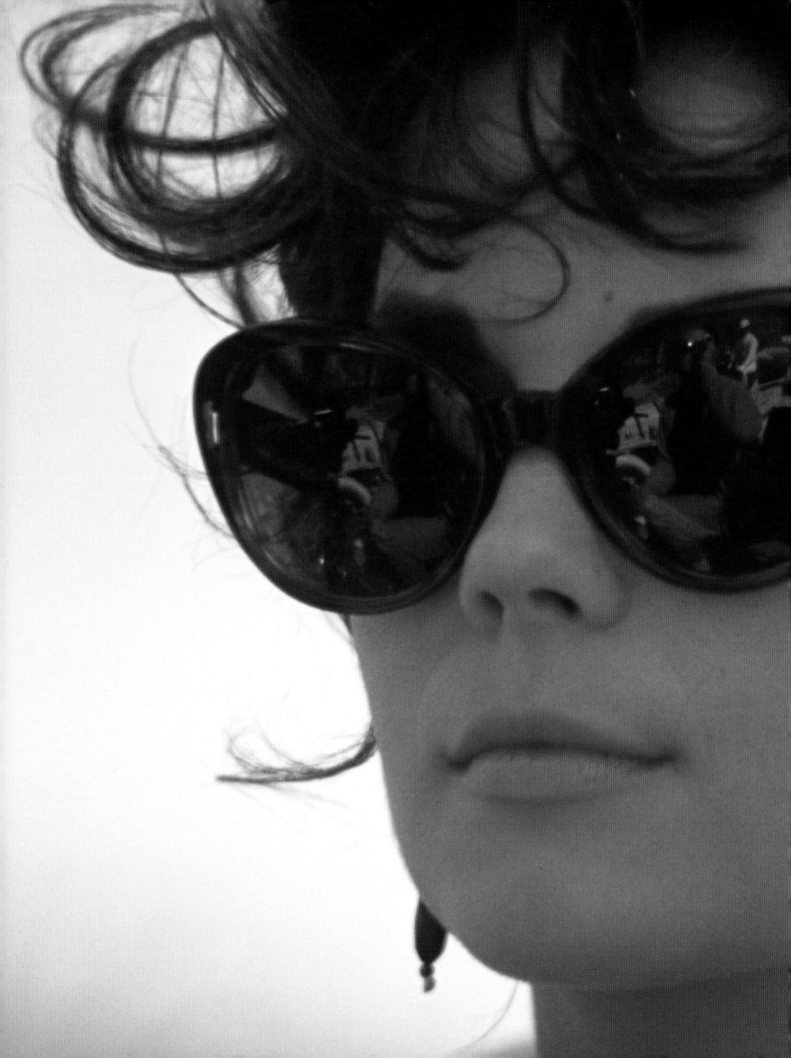

THE
GREAT
RACE

Featuring Photographs by
BOB WILLOUGHBY

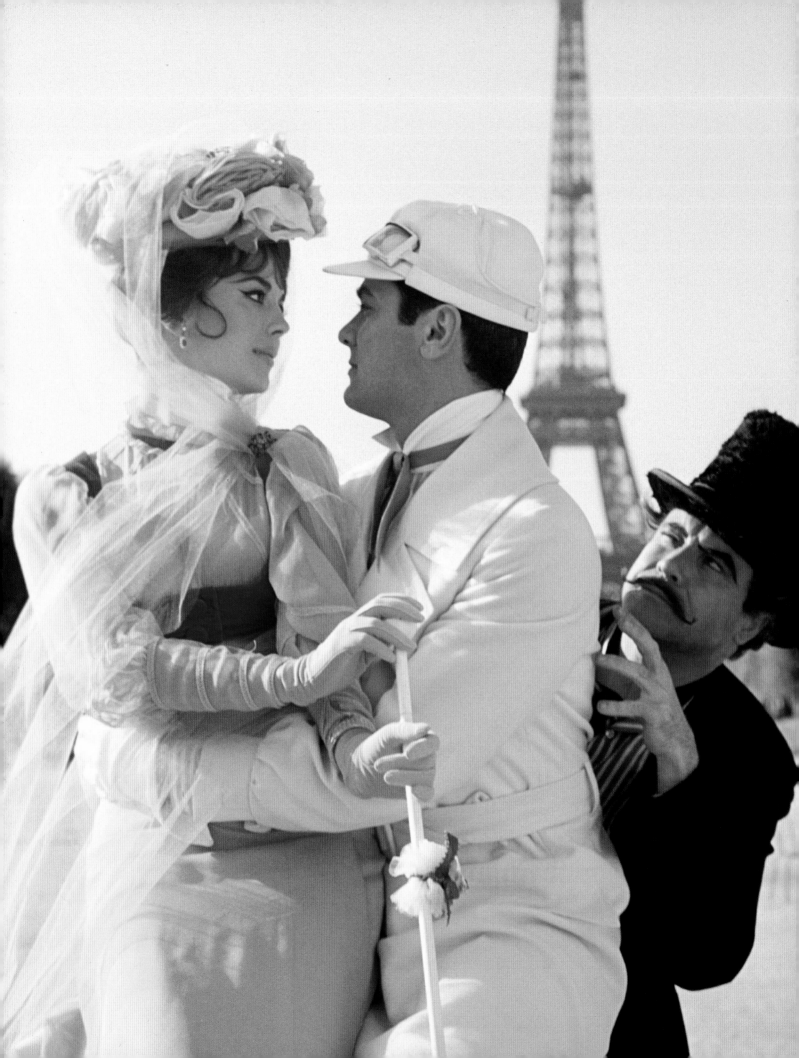

Maggie DuBois (Natalie Wood), a sort of freelance agitator for women's rights in 1908, is determined to be hired as the *New York Sentinel*'s first female reporter and to cover the Great Transcontinental Automobile Race from Manhattan to Paris. By chaining herself to the men's bathroom, she succeeds, enters the race in her *Sentinel*-sponsored roadster, and issues dispatches and exclusive photos on the wings of carrier pigeons. Two arch-rivals are also the favorites to win: Professor Fate in his pitch-black battle wagon, opposing the Great Leslie and his gleaming white convertible touring car—and the race is on.

Jack Lemmon and Tony Curtis were re-teamed from *Some Like It Hot* (1959) to deliver their raucous physical comedy combustion once again. Natalie and Tony (re-teamed from *Sex and the Single Girl*) were entrusted with the classic screen evolution of hate/attraction/love, performed in broad comic strokes. Director and writer Blake Edwards endeavored to craft an epic homage to silent film comedy, a laugh-out-loud response to the tedious excesses of *Around the World in 80 Days* (1956).

The ambitious production took the film company halfway around the world: Death Valley and various parts of California; Gearhart, Oregon; Frankfort, Kentucky; Salzburg, Austria; and for the big finish, Paris. Though it never shows in her performance, Natalie was miserable trekking the globe, and stayed in regular contact with her analyst via long-distance telephone.

Despite her off-screen sense of humor, Natalie was more comfortable in dramas than comedies, making her antics in *The Great Race* all the more admirable. She throws herself into the role of

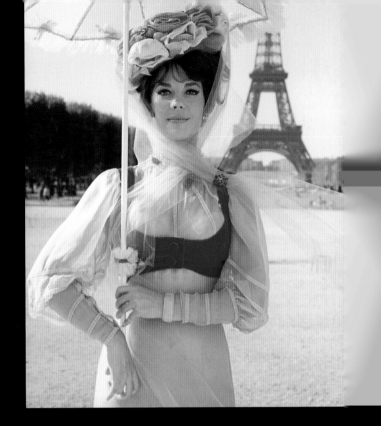

Maggie with fearless gusto, capturing that early silent-comedy physicality as well as the brilliant Jack Lemmon does. Her body language is perfect—confident, zany, sexy.

Lemmon plays the equivalent of four parts in *The Great Race*: the villainous yet addled Professor Fate; Fate impersonating the menacing Texas Jack when the racers make a fuel stop in the dusty town of Boracho ("drunkard" in Spanish); the flamboyant cackling Crown Prince of Potsdorf, Frederick Hoepnick; and finally, Fate assumes the identity of his doppelgänger, the Prince, in an attempt to depose His Highness. Natalie openly admired Jack's total commitment to his roles. "He was wonderful in that film. I have never seen anyone able to go in so many directions identifying every character he

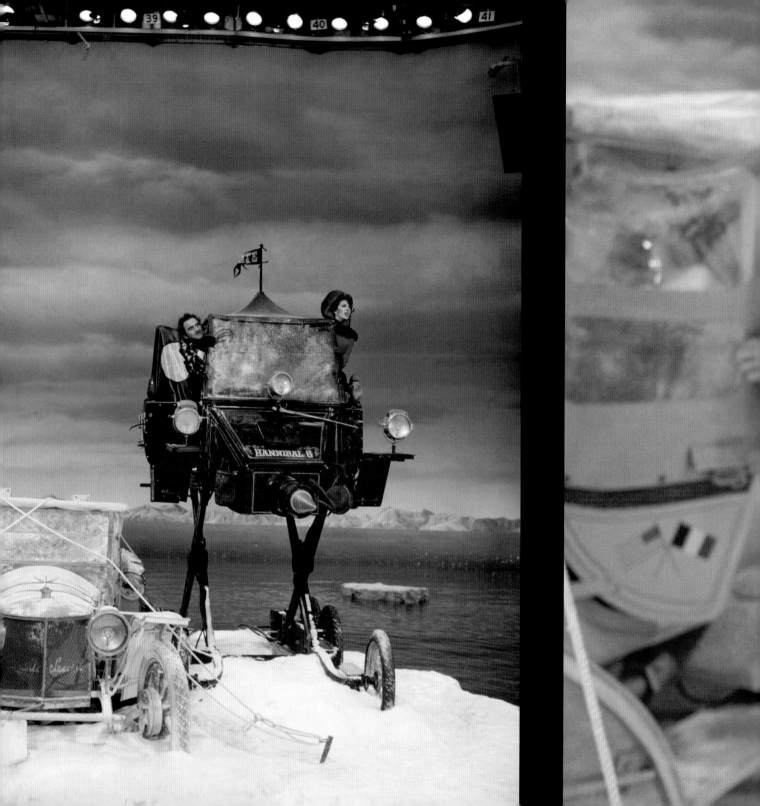

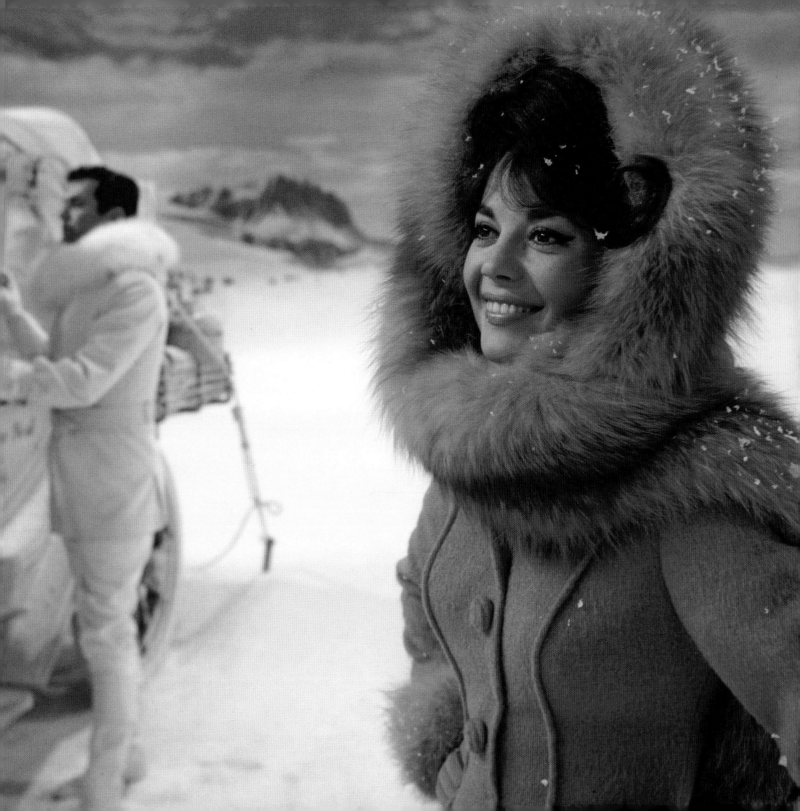

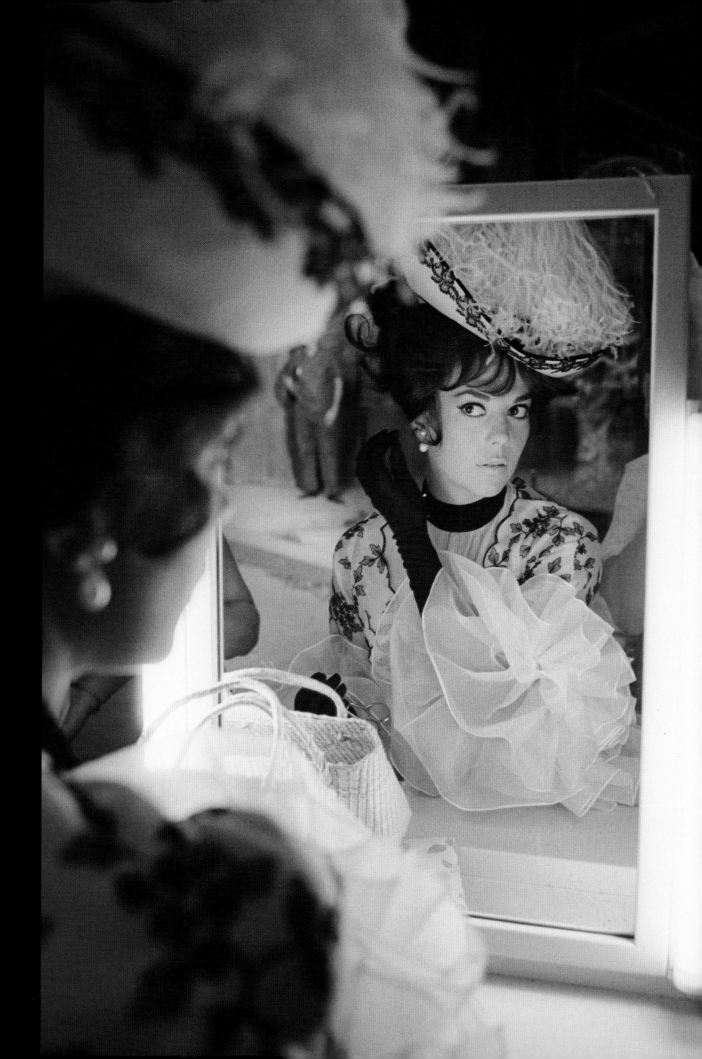

Natalie, who learned to fence (and operate a Stanley Steamer) for the epic, matches Curtis stride for stride, line for line, laugh for laugh. She also lip-syncs a Mancini-Mercer ballad, "The Sweetheart Tree," which was nominated for an Oscar. Rounding out the cast are Peter Falk, Keenan Wynn, Arthur O'Connell, Vivian Vance, and Larry Storch.

The movie is constructed to showcase ultimate takes on two tried-and-true American cinema tropes: the barroom brawl and the pie fight. The first follows saloon singer Lily Olay's (Dorothy Provine) big solo number, guns firing, chairs busting—a slugfest as large as the wide screen. The second battle is waged in the royal pastry kitchens of Potsdorf, everyone slinging pie with admirable accuracy and magnitude. Natalie is bombarded head to toe with cream, crust, and filling, but not before we catch a glimpse of her in a fetching merry-widow designed by Edith Head.

Head dreamed up Natalie's period frills in what she called "the bonbon colors," bright confections that would pop against Lemmon's all-black and Curtis's solid white. Donfeld outfitted the rest of the ensemble, and Sydney Guilaroff soufflé-ed Natalie's hair into an elaborate network of waves and curls. Natalie, never more gorgeous on film than as Maggie DuBois, remains perfectly made-up, whether she is stranded in the southwestern desert or adrift on an iceberg in the Bering Sea.

Behind the scenes, Natalie's attitude mirrored Maggie's onscreen feminism. The testosterone-filled set often literally became a boy's club, particularly at daily luncheons with Edwards, Curtis, Lemmon, the male producers, and Natalie—who was allowed to sit at the table, but not exactly welcomed into the club. According to producer Marty Jurow, Natalie responded to the chauvinistic atmosphere by demanding equal rights with her male costars in every respect. Early in shooting, she crept into Lemmon and Curtis's dressing rooms, measured their telephone extension cords, and complained that they were longer than hers. "In all things, I must be

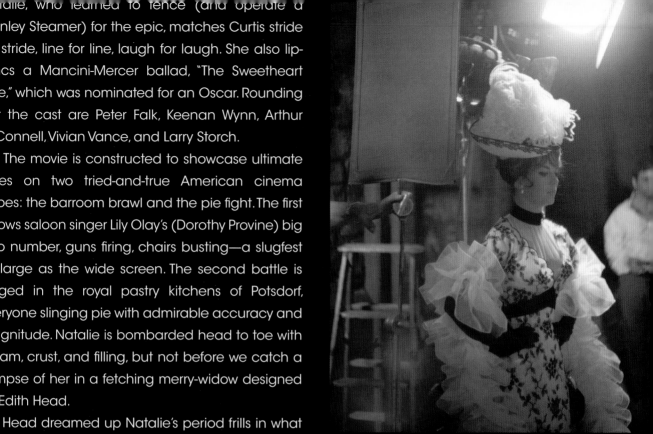

on the same level as Jack and Tony," she told Jurow. "I don't want to start this film giving away an ounce of my position." Jurow half-jokingly threatened to bar Natalie from the luncheons as punishment for her demanding behavior. She laughed and relented, but privately longed for the production to wrap.

With a budget over-run to $11 million, The Great Race underperformed at the box office, initially bringing in just $12 million. It has since become a cult comedy classic. Jack Lemmon recalled the 1965 Moscow International Film Festival, where the movie was screened alongside recent American films of distinction—To Kill a Mockingbird, The Best Man, Lilies of the Field. Lemmon recounted, "Then we showed The Great Race, $11 million-worth of sheer fluff. They let out a guffaw at the beginning of the picture and then never stopped laughing for three hours." Blake Edwards' epic farce won the festival's silver prize.

OPPOSITE AND ABOVE Natalie dons one of her most elaborate Edith Head creations for the scene at Professor Fate's house.

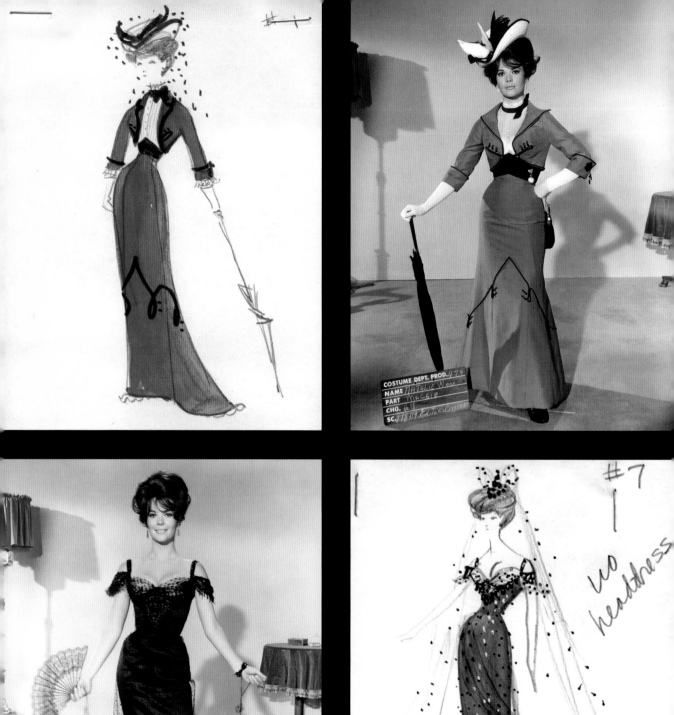
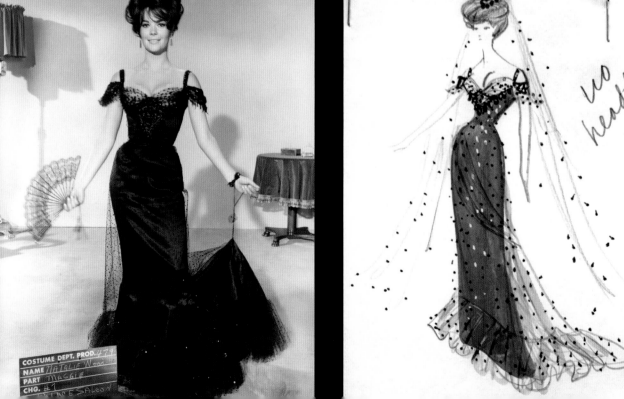

#7

no headdress

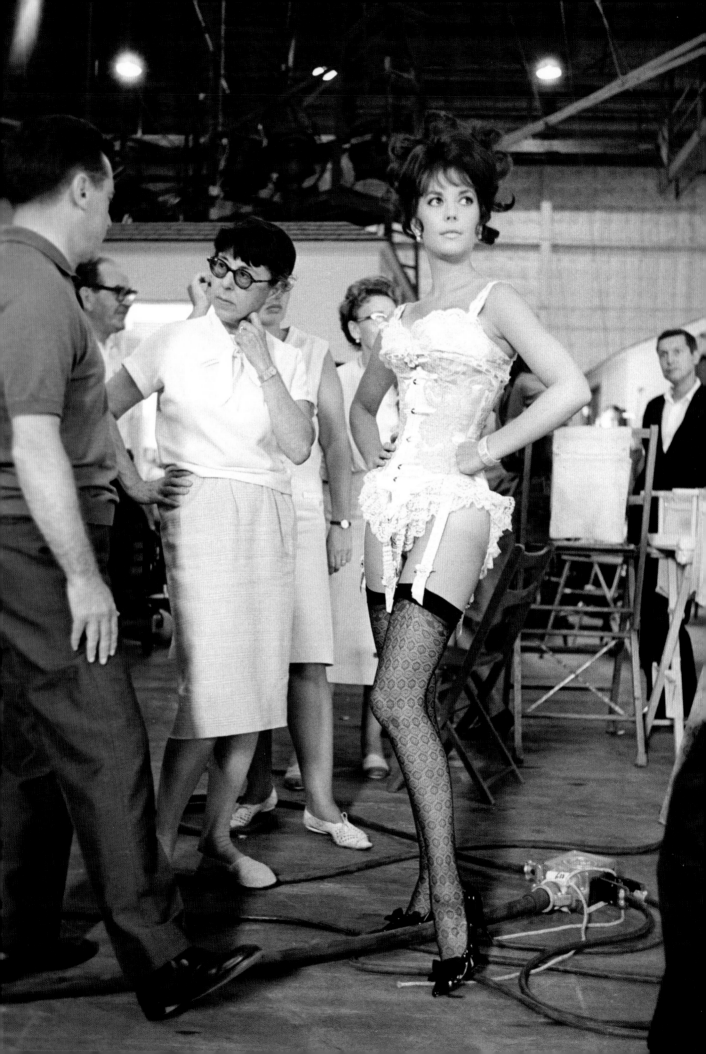

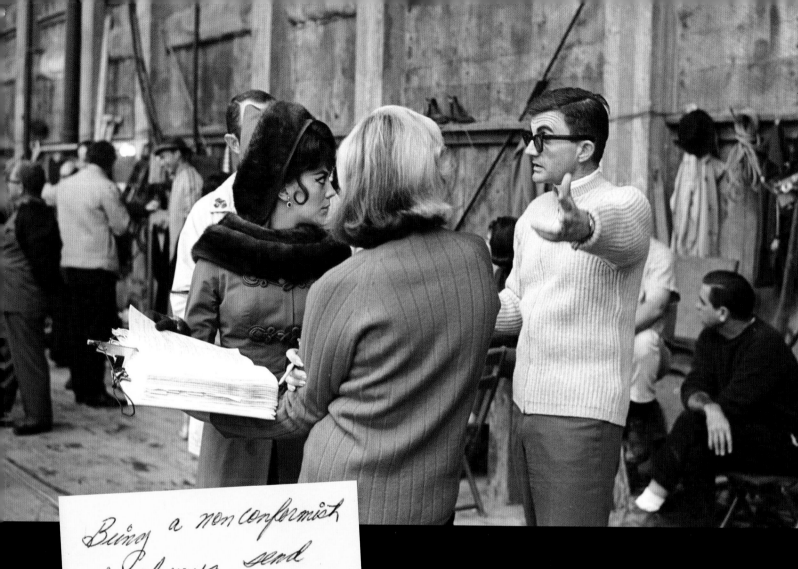

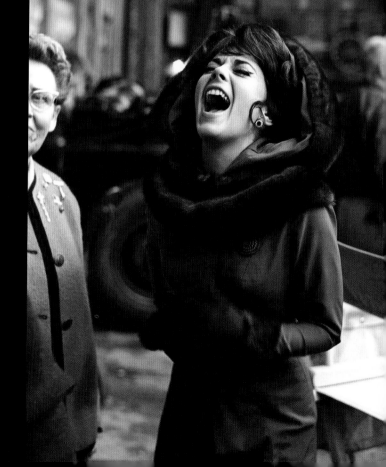

Being a non conformist I always send flowers on the second day. Love Blake

THIS SPREAD, CLOCKWISE FROM TOP LEFT "She was constantly involved in very difficult physical business," director Blake Edwards recalled, "the pie fight, the fight in the saloon, the car chases. But Natalie was a professional. She just *did* it."; Edwards orchestrates the pie fight, while Natalie waits her turn; Shooting the pie-fight scene, which took five days to film and used over 4,000 real custard pies; Privately to friends, Natalie expressed her annoyance that Edwards insisted on personally aiming pies at her face; "You just pull out all the stops and go," Natalie said of comedic performing; A card sent with flowers from Edwards on the second day of filming.

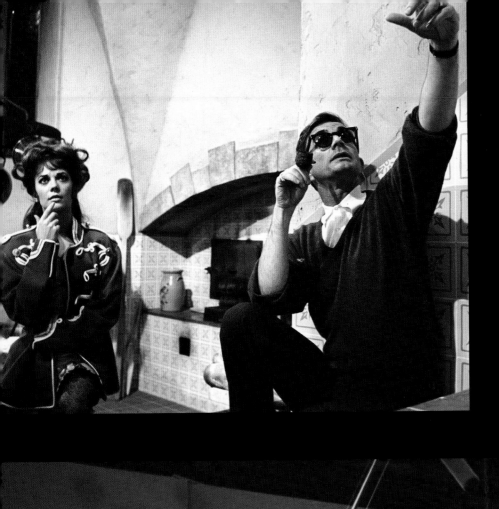
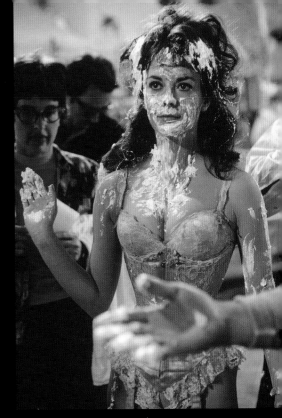
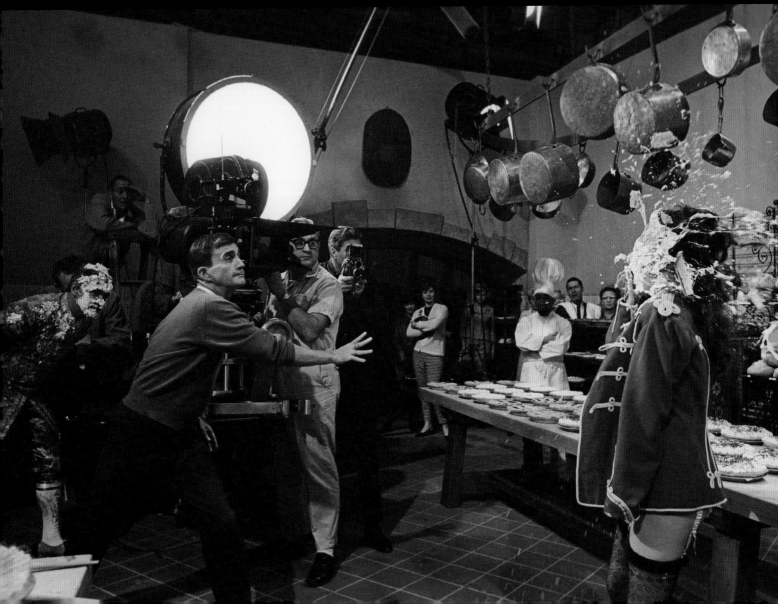

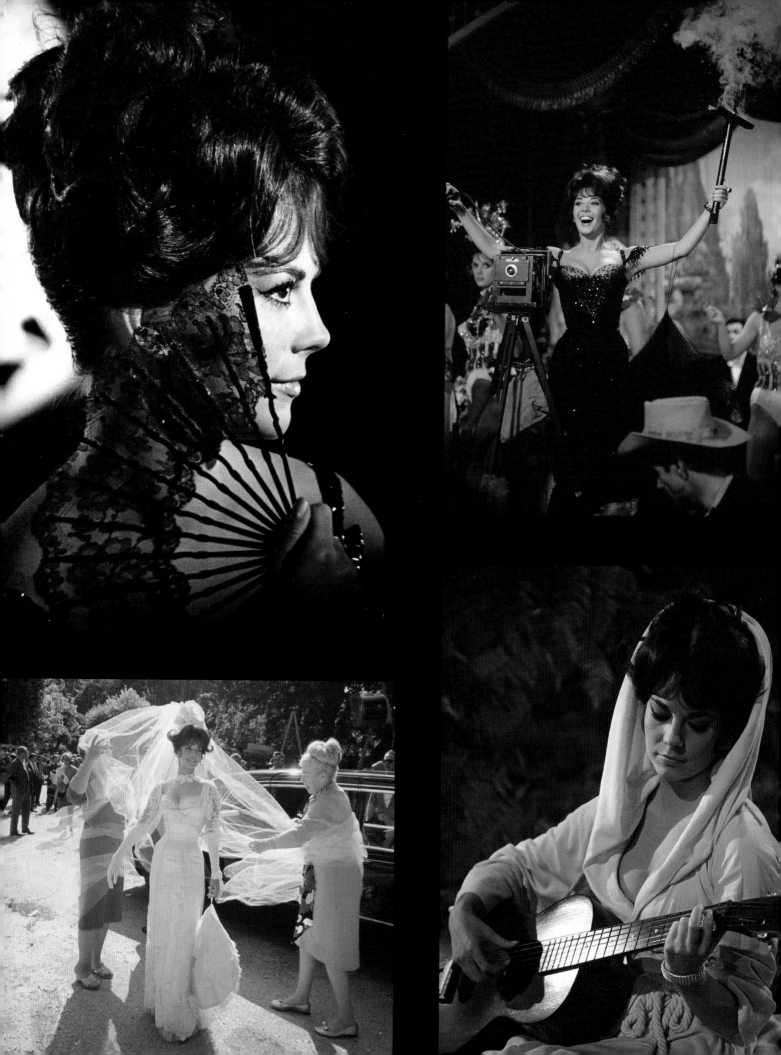

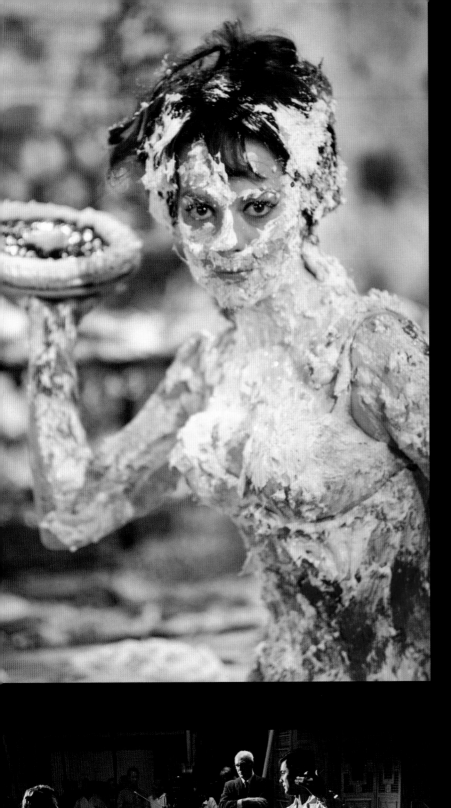
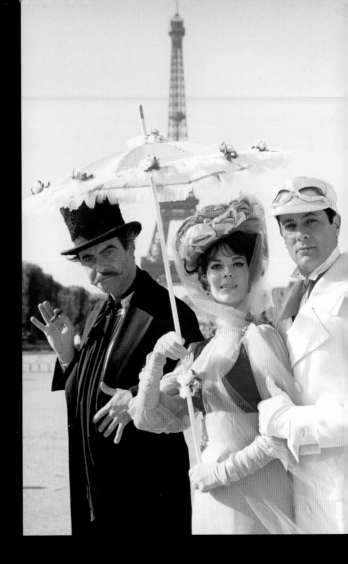
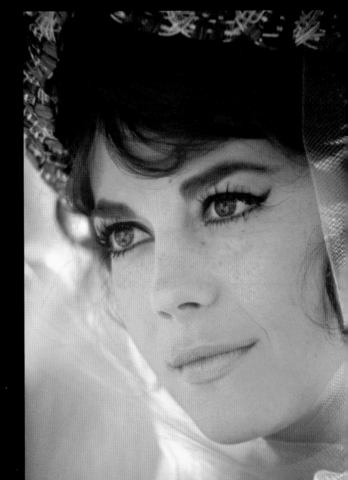
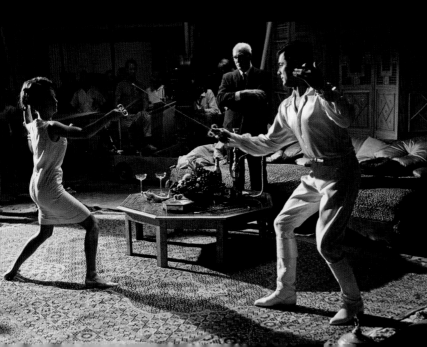

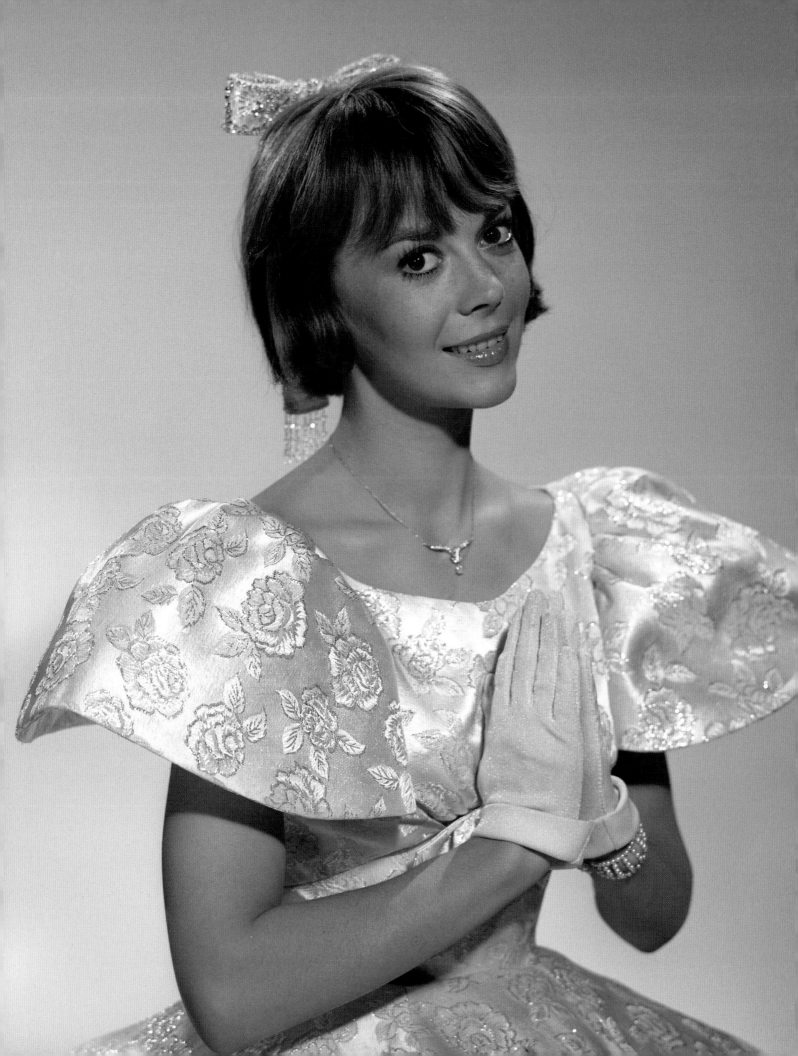

INSIDE
DAISY CLOVER

"...a special word of thanks to all the slobs, creeps, and finks of the world."

"The first time I read it, I wanted to do it," Natalie recalled of the script for *Inside Daisy Clover*. Gavin Lambert had written the novel, a cynical tale of a kid who makes it big in the movies, a subject close to Natalie's heart. When she heard that her *Love With the Proper Stranger* cohorts, Alan Pakula and Robert Mulligan, were developing the film version, Natalie revealed to the author, "I'll kill for that part."

"I know this girl," Natalie told Pakula of Daisy. "She's like a weed. No one is watering it or tending it, yet this tough little weed survives, even though they try to stamp her down." Lambert clarified, "Daisy finds inner strength to overcome the abuses and regain herself. . . . Natalie was ideal for the character, because it was her life story. Daisy's mother didn't want her to be a star and Natalie's did, but otherwise it was similar."

So, Natalie, one of Hollywood's biggest stars at age twenty-seven, turned down the lead in William Wyler's *The Collector* (1965) in order to play Daisy Clover from ages fifteen to seventeen. An extravagant contract guaranteed her $750,000 and 10 percent of the gross earnings, as well as "approval of director, costar, cameraman, costume designer, makeup man, hairdresser, stills photographer, publicist . . . ," establishing Natalie as the power-

player on the picture.

Daisy, a ragamuffin songstress on the frayed edges of 1930s Hollywood, belts out a song into a carnival recording booth, and sends it off to Raymond Swan, head of Swan Studios. He limos her away from her dotty mother and her home on the lowlife Santa Monica Pier to make her a star. Daisy embraces the glamour factory with a profound wariness, finally defying Swan's control of her life.

OPPOSITE "I love her. I totally identified with her," Natalie said of Daisy Clover. "Like Daisy, I think it was my sense of humor that kept me going." Photo by Milton Greene. RIGHT In costume for "The Circus Is a Wacky World."

Natalie used her star power to surround herself with incomparable talent: Christopher Plummer as the manipulative Swan; Katharine Bard as his cynical wife; Roddy McDowall as Swan's all-knowing assistant; Ruth Gordon as Daisy's mother ("The Dealer"); and Robert Redford, in his first major film role, as Wade Lewis (formerly Lewis Wade), another Swan discovery, now a matinee idol with a heavy secret.

After her unpleasant *Great Race* shoot, Natalie thoroughly enjoyed *Daisy*, calling the experience "a love affair from start to finish." She and Roddy McDowall had been friends for years, and she and Ruth Gordon soon became as close as family. Natalie and former high-school classmate Robert Redford bonded while plotting the most "wildly inappropriate birthday present imaginable" for the shy, reserved Alan Pakula. "Redford hired a stripper to celebrate the occasion, and painted 'Happy Birthday' on her stomach," Natalie recalled.

The illustrious André Previn composed the film's music. His wife, Dory Previn, wrote the lyrics for Daisy's three songs: "You're Gonna Hear From Me," "The Circus is a Wacky World," and "Back Lot Kid," Natalie's favorite, which was cut from the film after previews. Jackie Ward's singing voice was used along with Natalie's own in the final soundtrack. The 1936–38 period aesthetic is not strictly observed, failing most notably in its presentation of Daisy's production numbers, altogether too contemporary to the eye and ear.

Inside Daisy Clover was a late 1965 release. A decided box-office flop, it grossed $3 million against its $4.5 million budget. For Natalie, the film "proved to be another disappointment, but it didn't start out that way. We all had high hopes and did our best to make an honest picture." Pelted by mostly poor reviews, Natalie showed the world a brave face, but later reflected on the film's failure in her journal. "*Daisy* . . . was something I was emotionally committed to, something I believed in. . . . Perhaps in most people's careers it occurs that they are bitterly disappointed in the one thing that really counted."

Inside Daisy Clover found a more appreciative audience in Europe. A review in the French magazine *Positif* asserted, "Natalie Wood is an actress scandalously derided on the other side of the Atlantic, unrecognized in proportion to her triumphs." Natalie had the last laugh when she surprised the *Harvard Lampoon*—who had voted her the year's worst actress—by showing up to accept her award in person. "I presented the *Lampoon* staff with my sweatshirt from *Daisy*," she recalled. "It was oversized, torn, and dirty—and gift-wrapped in an air-sickness bag."

OPPOSITE In a pivotal scene, Wade Lewis (Robert Redford) suddenly reappears in Daisy Clover's life while she is costumed for a film. He removes her wig, and will wipe her face clean of makeup. Natalie personally selected the unknown Redford as her leading man.

ABOVE Herbert Ross staged all the musical numbers in the film. Here, he shows Natalie a move for the "You're Gonna Hear from Me" sequence. "Daisy is very bright, tough, and a real original," according to Natalie. "She buys the dream and finds it doesn't mean anything. She's left at the end only with herself." RIGHT Daisy performs in a circus ringleader-inspired costume designed by Edith Head. For her work on *Inside Daisy Clover*, Head earned her 29th Academy Award nomination, one that she shared with co-designer Bill Thomas.

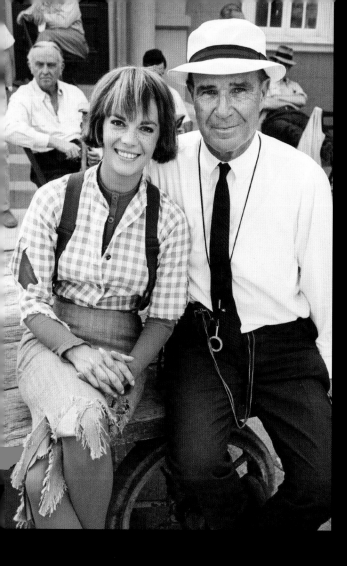

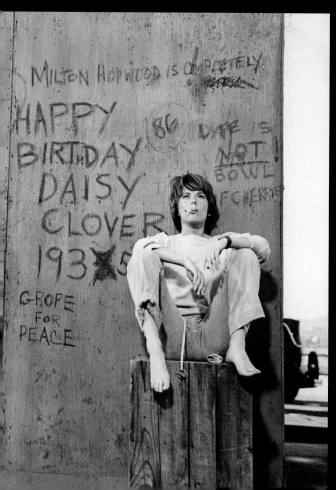

THIS SPREAD, CLOCKWISE FROM TOP LEFT Behind the scenes with acclaimed cinematog
Charles Lang. Natalie had known Lang since *The Ghost and Mrs. Muir* in
Natalie poses with an original oil portrait of herself by artist Margaret Kea
1964. Keane (along with her then-husband, Walter Keane) painted Natal
times. Photo © Peter Basch; With Robert Redford in his film debut. "I thoug
was brilliantly talented. He was terrific to work with, a wonderful person, v
professional."; Ruth Gordon as Daisy's mother. "I think that I've never know
with a greater capacity for living than Ruth," Natalie later wrote; Promotic
photograph, 1965; On April 23, 1966, Natalie became the first recipient of
Harvard Lampoon acting award to collect her certificate in person when
voted the Worst Actress of "Last Year, This Year, and Next." The staff made H
honorary *Lampoon* member and declared that henceforth, the honor w
named the Natalie Wood Award. "It was an absolute riot," she recalled; D
the Santa Monica Pier, wearing the dirty sweatshirt Natalie later presente
Harvard Lampoon.

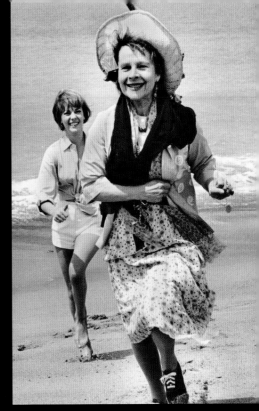

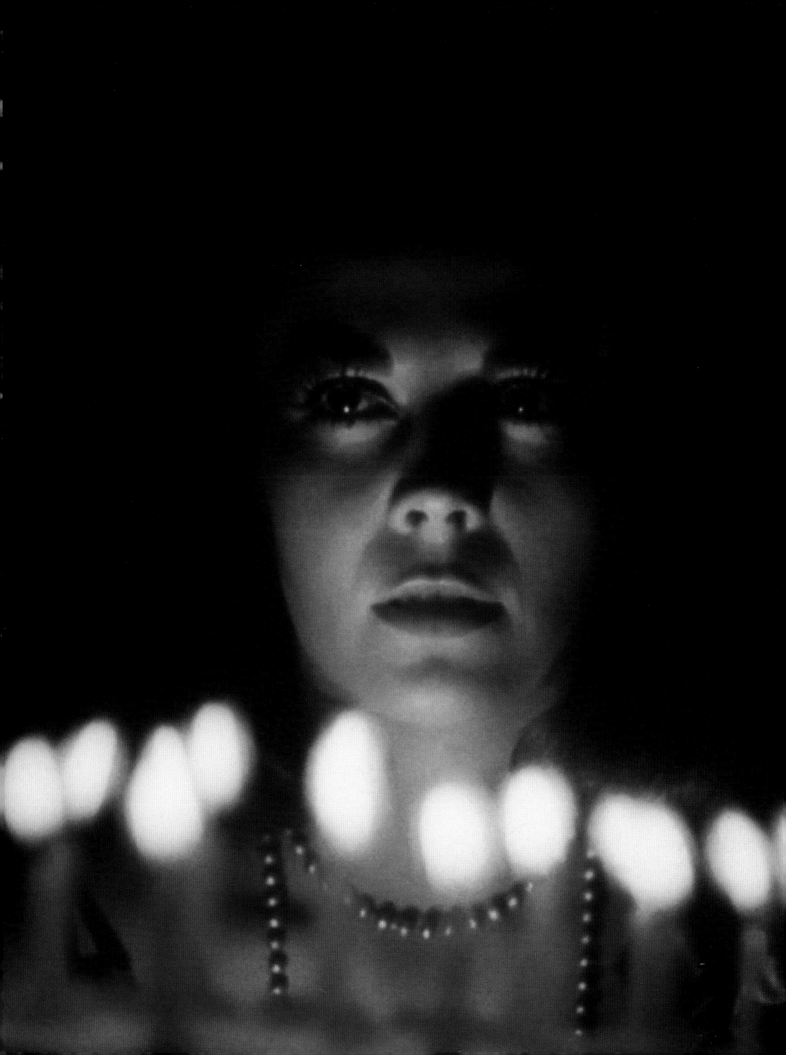

THIS PROPERTY IS CONDEMNED

"...the nearest I'll ever get to playing Blanche DuBois."

Natalie harbored a lifelong dream of following in the footsteps of Vivien Leigh and embodying an iconic Southern belle. Fortunately for her, Tennessee Williams had conjured up another tarnished small-town beauty, Alva Starr, for a 1946 one-act play set in back-country Mississippi during the Great Depression. A film starring Leigh never materialized, and later, Elizabeth Taylor and Montgomery Clift were said to be attached to another version of the script, with Richard Burton directing. An expression circulated in 1960s Hollywood for a time, born of the fact that Natalie often accepted roles first offered to Liz. "If Taylor Won't, Natalie Would."

After several more rewrites, the final Williams adaptation was penned by Francis Coppola (before he installed the "Ford" into his name), Fred Coe, and Edith Sommer. Natalie leapt at the property, and asked her friend Robert Redford to costar. The list of possible directors was nearly exhausted when Redford suggested his buddy, upstart director Sidney Pollack. Natalie quickly warmed to the young newcomer and asked if he thought the script could be improved. Pollack then tore apart eleven versions of it, and reconstructed them into a single viable piece.

Shooting on *This Property Is Condemned* began in October 1965, on location in the Depot

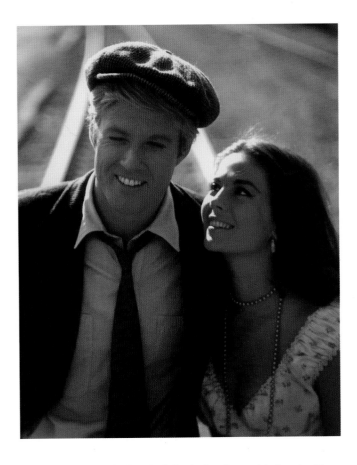

District of Bay St. Louis, Mississippi, and later, in New Orleans. Kate Reid was cast as Alva's mother, Hazel, with Charles Bronson, Robert Blake, and Dabney Coleman in featured roles. Mary Badham played Willie, Alva's younger sister, and the teller of the tale in flashback, or, as some have suggested, the weaver of a needy fantasy.

Hazel Starr's rooming house in run-down Dodson, Mississippi has a bad reputation, as does her daughter. Alva welcomes Owen Legate (Redford) to a brief stay while he shuts down the railroad spur that serves the town. A forceful attraction between the two goes wrong, prompting Alva to marry her

OPPOSITE Alva makes a wish before blowing out the candles on her mother's birthday cake. **ABOVE** "I always thought Redford would become the giant star he did," Natalie later said of her costar.

mother's rough-hewn beau. Alva escapes to New Orleans, hoping to run into Legate. The lovers enjoy a short, sweet affair until Hazel tracks them down and, poisonously, exposes the news of Alva's marriage.

Ultimately, none of the succession of screenwriters was able to cook up a satisfying meal out of the leftovers in front of them. Redford called the screenplay "a mass of scotch tape." Pollack defended the movie's second half, noticeably different from the first. "The New Orleans scenes are done with a liquid, dreamlike flow because they show (Alva's) downfall." In the end, *This Property Is Condemned* fails to hold together, but provides Natalie with a wealth of powerful scenes to steal, aided by the sultry, dreamy Technicolor camerawork of legendary cinematographer James Wong Howe.

Natalie's personal recurrent leitmotif—terror of unfamiliar murky waters—became an issue once more for a scene in which Alva stands in a steel tank that holds water for cattle. The old fears rose unabated until her friend and cast mate Robert Blake stepped up, dove under, and steadied Natalie's legs from below.

The film was in release by the end of October 1966. Expectations may have been high—big star Natalie and handsome newcomer Redford, after all—but critical and audience enthusiasm were low. The Paramount/Seven Arts production, budgeted at $4 million, grossed a disappointing $2.5 million.

Natalie, in an interview with Rex Reed, stated that "Alva is a great character, the hardest role I've ever done." The actress fondly recalled the sequence in a dilapidated railroad car. "I was particularly proud of that scene because Redford and I helped Sidney Pollack write it." Even the most hard-nosed critics praised Natalie's work, if not the film as a whole. Bosley Crowther, in his *New York Times* review, had strong reservations about *This Property Is Condemned*, but could not resist giving Natalie her due, calling her Alva "as pretty, bright-eyed . . . a specimen of a poor little white-trash gal as ever nibbled a piece of Southern fried chicken. . . ."

ABOVE Clowning for the camera on location. **OPPOSITE** "I spend the time by the Mississippi in nothing but rags," Natalie told a reporter during pre-production. "Wearing these clothes will be something to look forward to all during the shooting."

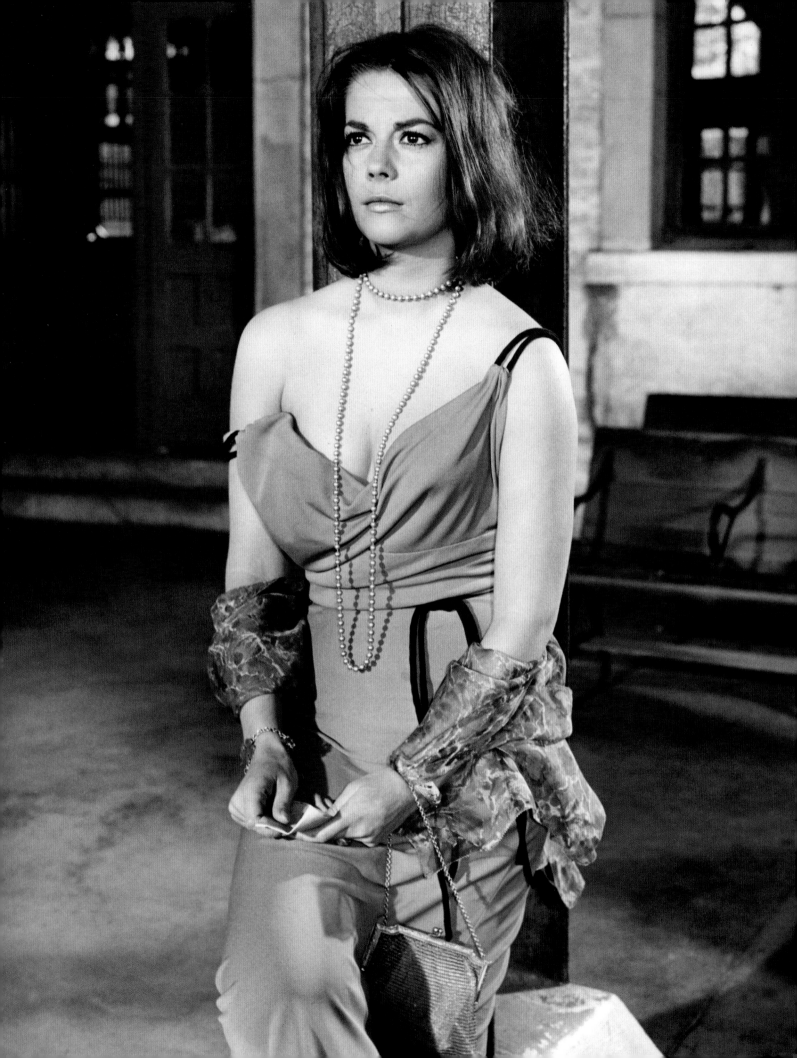

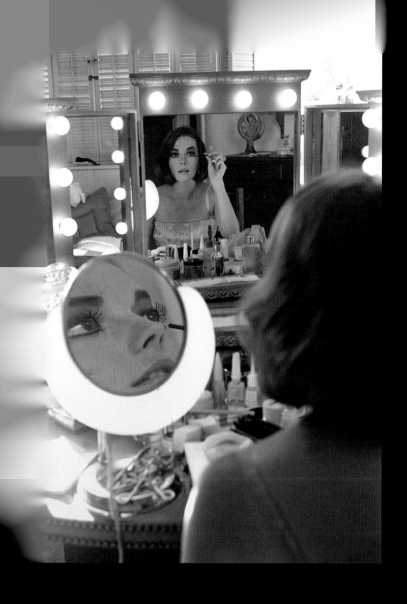

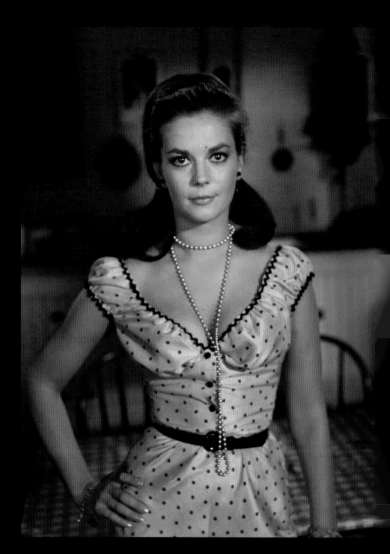

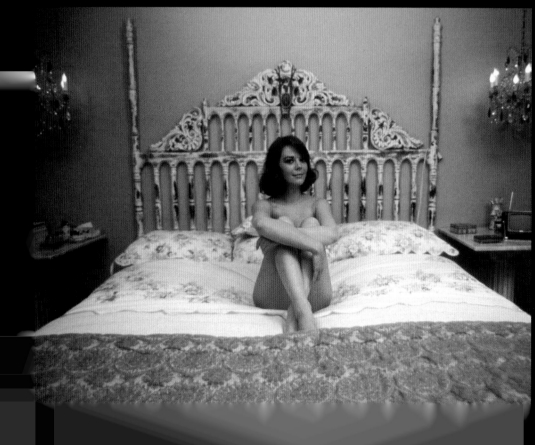

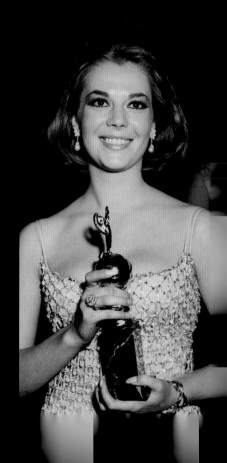

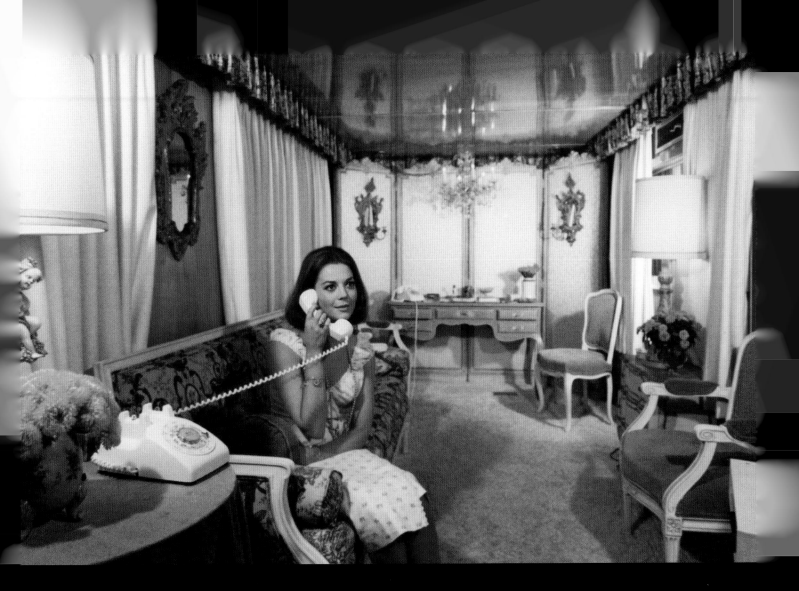

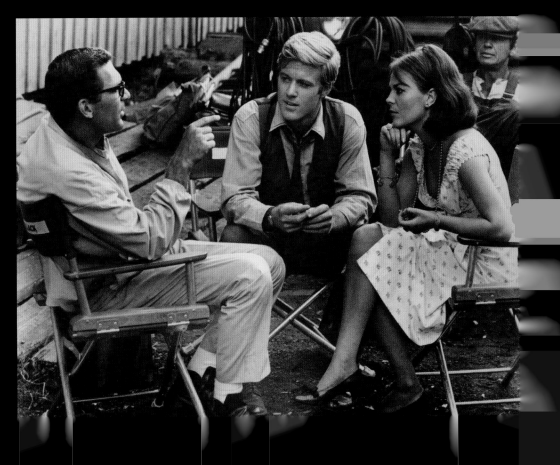

THIS SPREAD, CLOCKWISE FROM TOP LEFT Natalie's home vanity and makeup mirror, 1966. Photo by Curt Gunther, courtesy mptv; A hair and makeup test featuring a long wig that does not appear in the film; The star takes a phone call in her elaborately furnished location trailer. Natalie, who needed to feel at home wherever she traveled, decorated her surroundings to match the interior of her Beverly Hills house; Robert Redford and Natalie discuss a scene with director Sydney Pollack. Costar Charles Bronson is behind them; Natalie won the Henrietta Award for World Film Favorite at the 1966 Golden Globes. The following year she was nominated for Best Actress in a Drama for *This Property Is Condemned*; A rare nude portrait of Natalie in her French rococo-inspired bedroom, 1966.

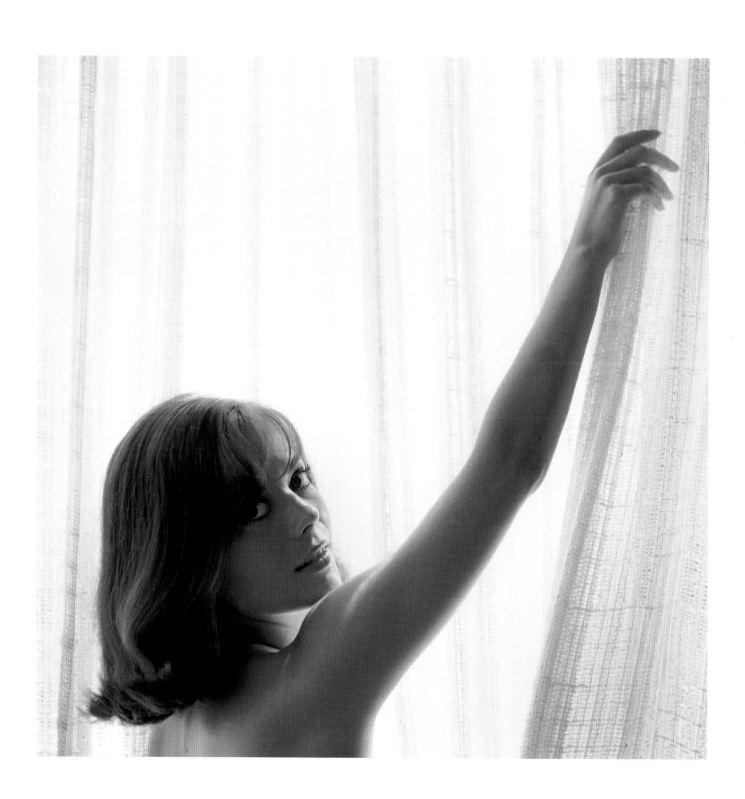

ABOVE AND OPPOSITE Natalie at home in her living room, 1966.

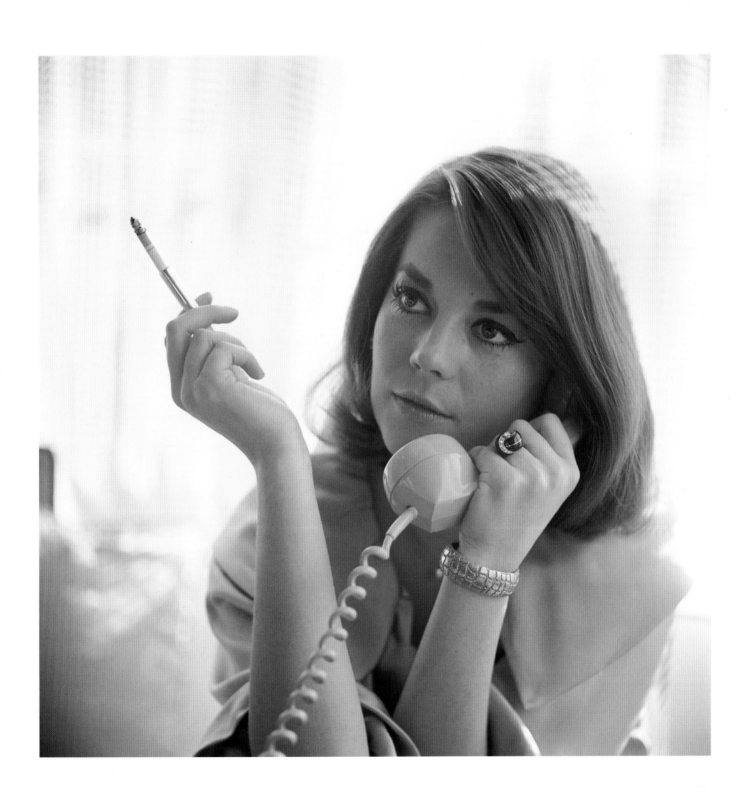

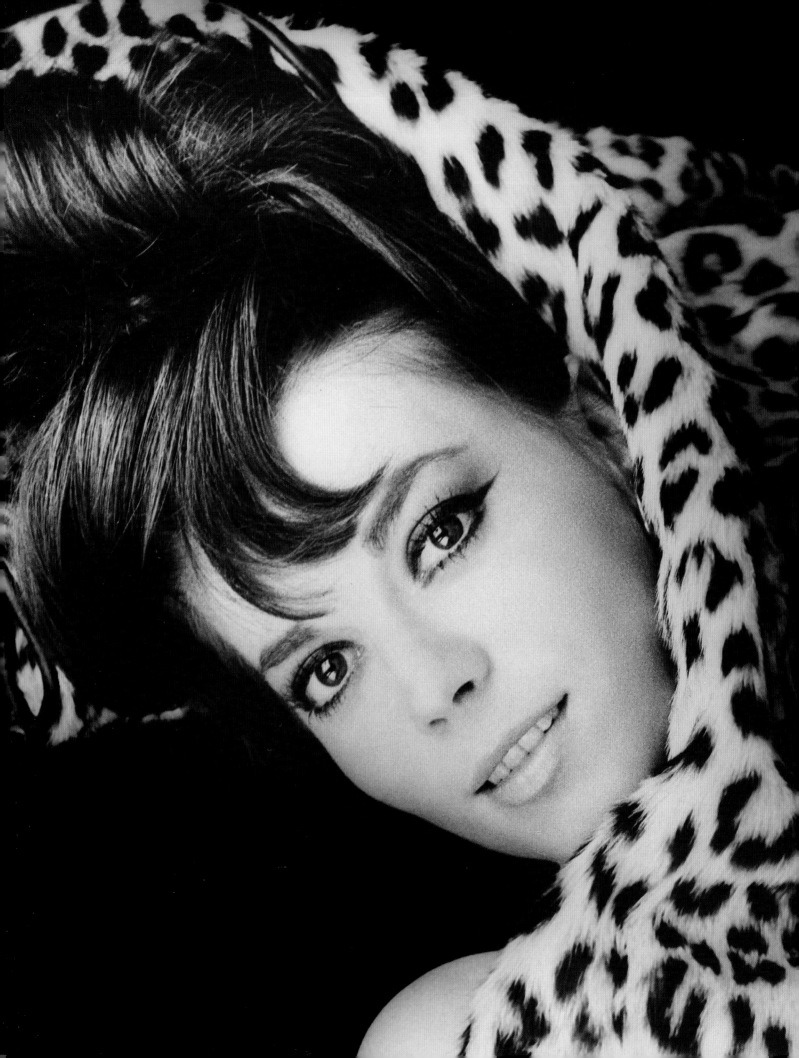

PENELOPE

"How did a nice girl like that ever get into a mess like this?"

Posters for the 1966 romp *Penelope* proclaimed Natalie "the world's most beautiful bank robber," and posed her barefoot in a bikini, as if that were the standard uniform for a heist. The plot of the glossy farce unfolds as Penelope Elcott recounts her criminal past to her analyst, which includes the $60,000 recently stolen from her neglectful husband's (Ian Bannen) bank. Penelope exchanges her chic apparel for the disguise of an old woman's gray wig and frumpy suit, and commits the holdup in broad daylight.

The premise gave Natalie a break from the emotional demands of Daisy Clover and Alva Starr, but she went from dramatic to traumatic. "I broke out in hives and suffered . . . very real pain every day we shot," Natalie remembered. Director Arthur Hiller kept saying, "Natalie, I think you're resisting this film." Ever the pro, she clowned through the distress, telling a reporter, "It's just a fun movie. I get to rob banks, steal fabulous jewelry, and get chased by a lot of attractive men. What could be better?"

Off camera, Natalie expressed her doubts to the filmmakers, begging them to let her confidant and former secretary, Mart Crowley, punch up the flimsy script. Crowley, who would go on to write the groundbreaking play *The Boys in the Band*, was considered a novice by the producers. "Why do you keep pushing this friend of yours?" they asked Natalie, and refused his rewrites.

Expert comics were signed up in support of Natalie: Dick Shawn, Peter Falk, and Jonathan

Winters as Professor Klobb, who pursues young student Penelope—in lacy bra and panties—around his lab in a flashback. Arlene Golonka is hooker Honeysuckle Rose, and Lila Kedrova plays Sadaba, who tries to blackmail Penelope with her partner, Ducky (Lou Jacobi). A highlight of the film is Natalie's performance of "The Sun Is Gray," a haunting Gale Garnett ballad.

Edith Head outdid herself with a spectacularly sexy wardrobe for Natalie at a cost of $250,000. The fashions were so important to enhance the wafer-thin story that a short film titled *Penelope's Fashion Show* was shown as a promotional event at MoMA.

OPPOSITE To promote *Penelope*, Natalie posed for a series of glamour stills. RIGHT Natalie was ushered into the late 1960s with a mod wardrobe.

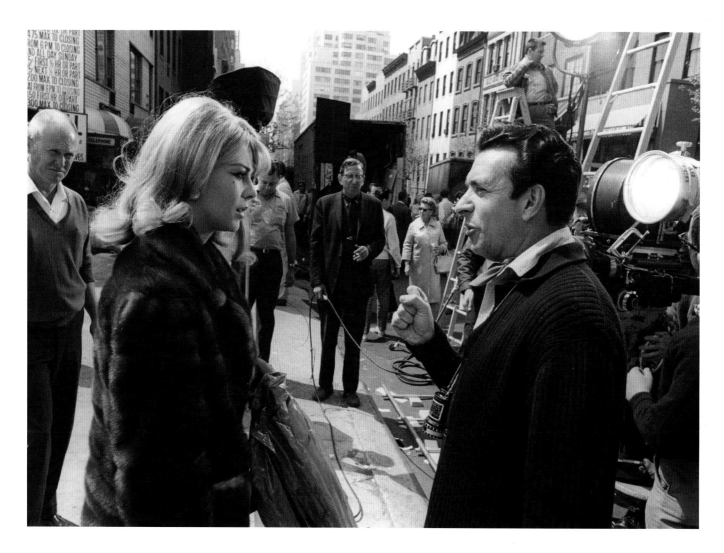

Edith designed her first-ever minidresses for Natalie, one of which was a very short bridal number. Upon an initial glance at his former fiancée as a leggy bride, co-producer Arthur Loew, Jr. is reported to have whispered to Natalie, "Stay in that. I'll go call a rabbi."

The summer of 1965 was a turning point for Natalie. She completed work on *Penelope*, which she intuited would not be successful. She paid Warner Bros. $175,000 to cancel her contract, and fired her entire support team: agents, managers, publicist, accountant, and attorneys. Natalie went further into analysis, turning down Warren Beatty's offer to costar in *Bonnie and Clyde* (1967), which would have interrupted her therapy as she traveled to the Texas locations. She was determined to re-prioritize and take charge of her own life, maybe start a family, but not with Arthur Loew.

The trailer for *Penelope* asked audiences, "Are you ready for a kinky kleptomaniac with a hang-up for holdups?" Apparently, they weren't. The box office at Radio City Music Hall broke its opening day record with *Penelope*, but interest subsided swiftly and the movie tanked. The reviews were lukewarm, but Natalie was lauded by sources such as the *Hollywood Citizen-News*: "This is certainly not her best role to date, but she injects enough fun, imagination, wit, and sparkle to give the picture the verve it needs." It was not only far from Natalie's best role up to that time, it was her last role for nearly three years.

ABOVE Natalie and director Arthur Hiller on location in Manhattan. OPPOSITE Penelope expresses her wild side in a gold mesh micro-minidress. In a short promotional film, Head describes Natalie's character as "a mixed-up girl who uses clothes to express how she feels."

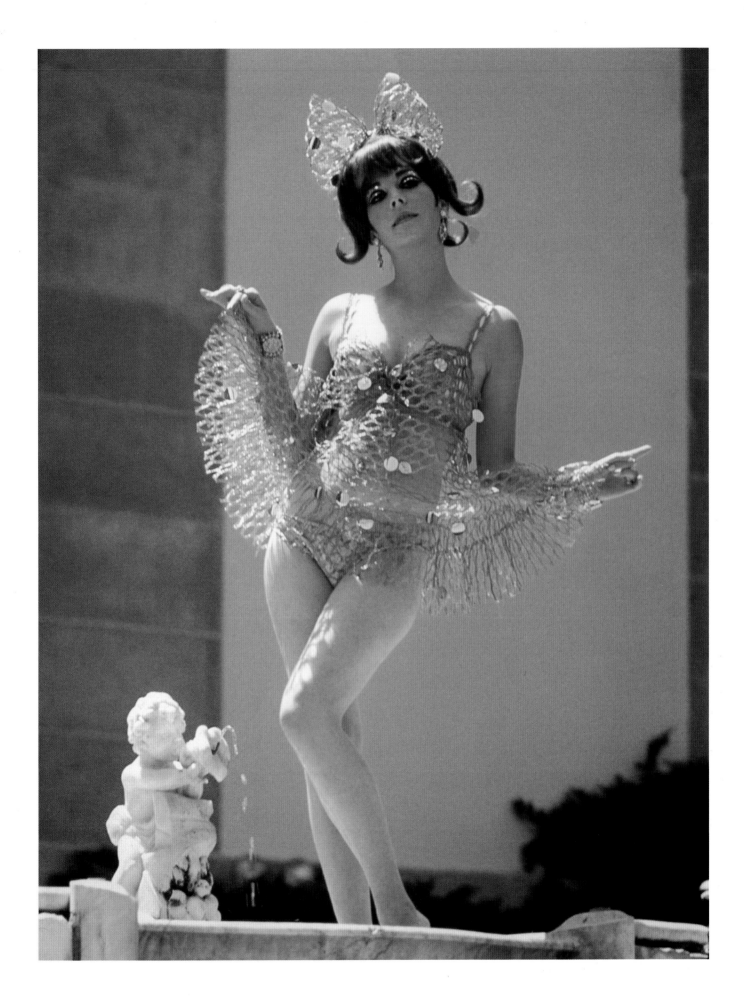

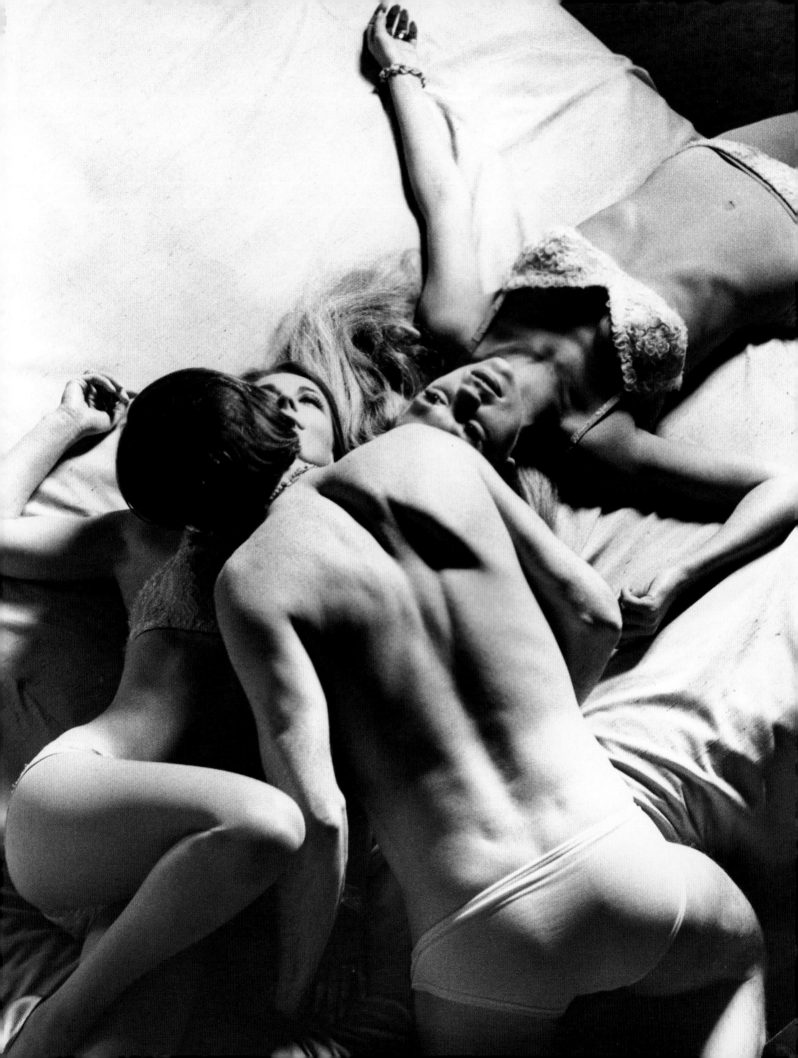

BOB & CAROL & TED & ALICE

"I did it because I wanted to do it."

Carol's declaration to husband Bob is matter-of-fact, a response to his own fling, a feminist awakening, an embrace of marital honesty, and a harbinger of the "Me Decade." Unexpected, funny, and inspired by the self-empowerment craze of the times, the line is pivotal in Paul Mazursky's first screenplay (co-written with Larry Tucker) for *Bob & Carol & Ted & Alice*, a quirky gamble of a movie, and a big hit.

Mike Frankovich, Mazursky's producer, suggested that he consider Natalie Wood for his female lead. At first he was ambivalent. "She's gorgeous, she's sexy, but will she do it, and if she does it, can she handle satire?" A quick jet-set meeting with Natalie—by then living in swinging London with Richard Gregson—was arranged, and both sides were convinced. Natalie would be "Carol" of the titular quartet.

She was intrigued by the project as a manifestation of the continuing trend in American movies, that of the small-budgeted, shot-on-the-fly, auteur-driven picture. "Now is the most exciting period in film," the former studio child asserted. "It's the end of the studio production made by numbers. Studios are being sold. That's healthy. Let the director shoot on the street."

Frankovich, something of casting guru, zeroed

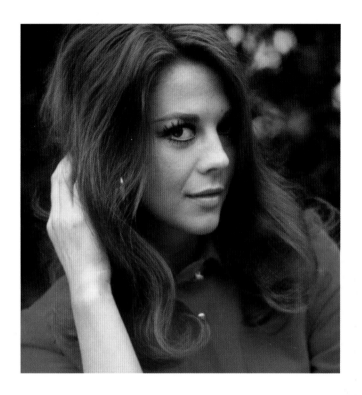

in on Robert Culp as Carol's middle-aged hipster husband, a documentary filmmaker. As Carol and Bob's less free-thinking, less mellow friends, Alice and Ted, new faces Dyan Cannon and Elliott Gould were judged perfect when screen-tested together.

The movie begins at "The Institute," a group therapy retreat, where Bob is researching a documentary. He and Carol respond to the promptings of their enlightenment guide, Tim (Greg Mullavey), in order to connect first by touch, then emotionally, with other couples, and then with each other. They return to Los Angeles and zealously spread the news of their self-discovery which, for Bob, includes sex with his assistant on his next business trip. Carol surprises herself with her understanding response—"That's beautiful"—and has a fling with

OPPOSITE Mazursky's *ménage à trois*: Natalie Wood, Robert Culp, and Dyan Cannon respond to Elliott Gould's line, "First we'll have an orgy, and then we'll go see Tony Bennett." ABOVE Natalie as Carol Sanders, the first film role that excited her in nearly three years.

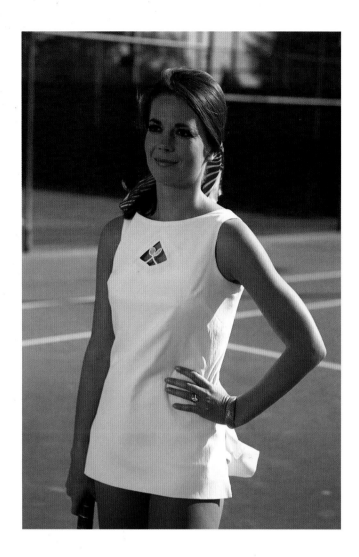

joined a Felliniesque circle of dozens of couples, all searching for the 'answer.'"

There was a significant amount of improvisation, as well as a great deal of risk involved in *Bob & Carol*. Columbia gambled on a first-time writer/director; Mazursky and his cast all took a mutual leap into unfamiliar territory; the music score was topical, yet unconventional. For a low investment of $2 million, the returns were stratospheric. The picture grossed $30 million, of which 15 percent went to Natalie in a deal negotiated to off-set her huge pay cut (to $50,000) and assure her participation. That display of confidence made her a millionaire, three times over.

Bob & Carol & Ted & Alice premiered at the New York Film Festival on September 17, 1969, very much a touchstone for the times, and sent critics into a tizzy with its unsettling blend of warmth and cynicism, its irreverent examination of sexual mores. The *New Yorker* called it "a slick, whorey movie, and the liveliest American comedy so far this year." *Variety* applauded the cast's "superb" acting, and declared, "The film is almost flawless." Recognized by the Academy with four nominations, the picture heralded the arrival of a hip new director, and the welcome return of Hollywood royalty, Natalie Wood.

Writer Mike McCrann encapsulated the aftermath: "Natalie was back on top. She was at the very zenith of her career. Scripts poured in daily." Having proved she was still a hot Hollywood property, Natalie Wood did the unexpected. She promptly stepped away from her twenty-five-year career, married Gregson, and became pregnant. When their daughter, Natasha, was born in 1970, the role of motherhood would take center stage.

her tennis instructor, Horst (Horst Ebersberg), which Bob interrupts in nearly violent outrage. Psycho-babble peace is restored; shocked friends Ted and Alice are included in an intimate exploration that leads to Las Vegas and a very large hotel bed.

Real locations in Los Angeles and Pasadena were utilized during the October-to-December 1968 schedule, in addition to the Riviera Hotel and Casino in Las Vegas. Costume supervision—lots of miniskirts—was by Moss Mabry (who had outfitted Natalie in *Rebel Without a Cause*); hair and makeup—lots of maxi-hair and maxi-lashes—was by Virginia Jones and Ben Lane. Quincy Jones supervised the film's music, which included placing the original "What the World Needs Now Is Love," recorded by Jackie DeShannon, under the final sequence. The two couples "exited the hotel arm in arm," as described by Mazursky, "and outside

ABOVE "I learned to play tennis, to cook, and I got myself a fiancé," Natalie said of her three years off before making *Bob & Carol & Ted & Alice*. **OPPOSITE TOP** Location shooting in Las Vegas. **OPPOSITE BOTTOM LEFT** Letter to Natalie from Hollywood power agent Sue Mengers. **OPPOSITE BOTTOM RIGHT** Photographer Bruce McBroom's proof sheet of Natalie at a December 1968 press conference promoting the film. Photo courtesy mptv.

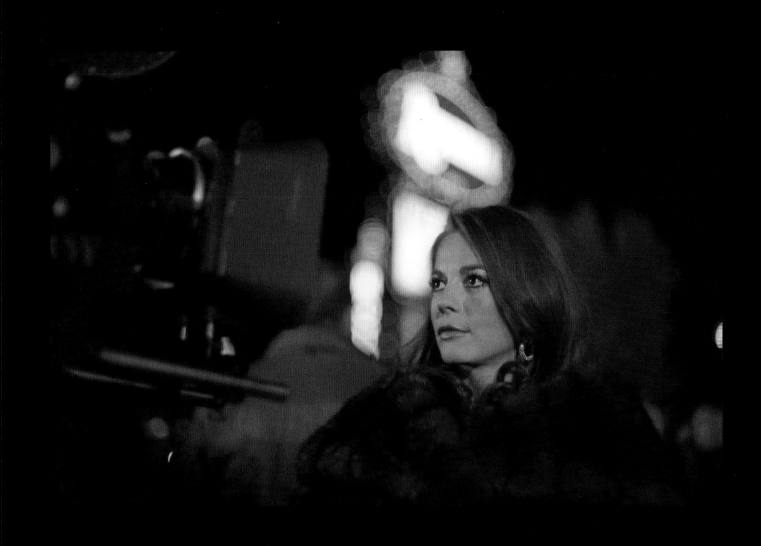

CMA

CREATIVE MANAGEMENT ASSOCIATES

9255 SUNSET BOULEVARD · LOS ANGELES, CALIFORNIA 90069 · (213) 273-2020

February 26, 1969

Miss Natalie Wood
Hotel Munischan
Kitzbuhl 2962
Austria

Natalie dear,

Just a note to tell you how terribly excited I
was by your performance in "Bob & Carol etc".

Not only are you super--but the picture couldn't
be better and I prophesize it will make millions.

You look more beautiful than ever, and the only
fallacy in the film is that I cannot believe any man
would ever cheat on you.

My congratulations and love.

Yours,

Sue

Sue Mengers

SM:ah

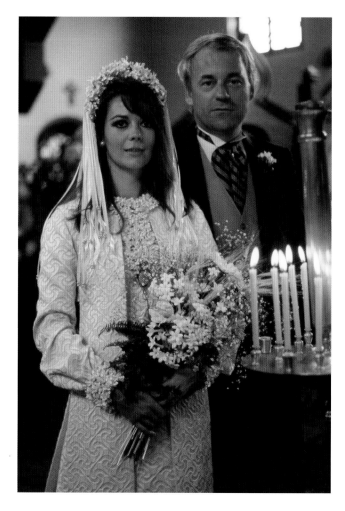

ABOVE LEFT Natalie, as Carol, shows off her fabulous figure in a bikini. **ABOVE RIGHT** Natalie married Richard Gregson on May 30, 1969, at the Holy Virgin Mary Russian Orthodox Cathedral in Los Angeles. With Edith Head's help, the bride designed her own wedding dress. **LEFT** Natalie, Robert Culp, Elliott Gould, and Dyan Cannon at the *Bob & Carol & Ted & Alice* premiere on September 16, 1969. It was the first time an American film had opened the New York Film Festival. **OPPOSITE** Modeling a Zandra Rhodes original, Natalie strikes a pose for the January 1970 issue of *Vogue*. Photo by Gianni Penati.

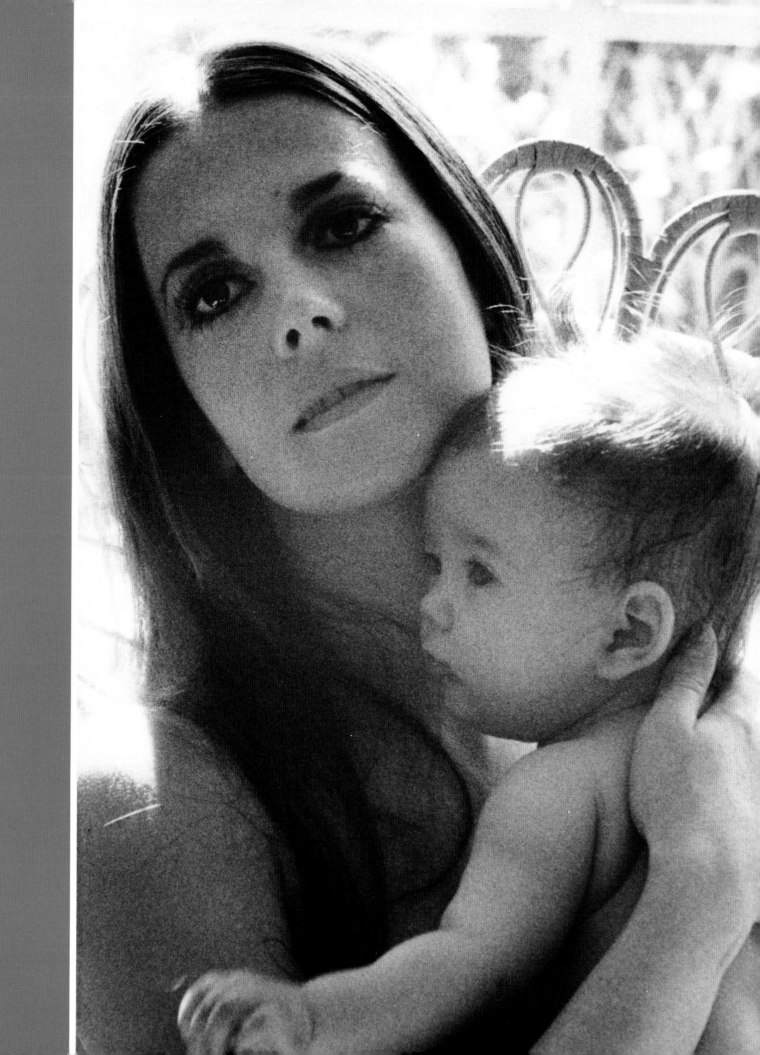

A REMINISCENCE

BY NATASHA GREGSON WAGNER

When I was very young, I did not fully understand what made my mom so special. I just knew that she seemed a little shinier, a little more beautiful than my other friends' moms. Both my mother, Natalie Wood, and my stepfather, Robert Wagner, seemed to have a shimmer around them that other moms and dads did not have. I was aware that they were actors and I may have suspected that the shimmer was related to acting, movies, and the glamour of Hollywood, but as a child, all I knew was that my mother radiated love.

She loved me, my younger sister Courtney, my stepsister Katie, and my dad with an inclusive, all-encompassing kind of devotion. She was a very cozy, comforting mother; accessible, warm, loyal, but also strong and tough. There was no doubt that my mom was the boss of our family, of my dad, of us kids, even of her friends. Though her softness and sweetness was genuine, if anyone tried to push her around or harm those she loved she could turn on a dime, with no fear of defending herself and speaking her mind. She was joyful and fun-loving, but underneath it all was a very strong woman in command of her world. Today, I am the grateful recipient of the strength she possessed. When I watch her on the screen, I see what is often described as her vulnerability, but in real life I never saw her as vulnerable.

She had so many powerful emotions. It makes perfect sense that she was a performer who was passionate about the arts, music, dance, literature, poetry, and all creative outlets for emotion. She was

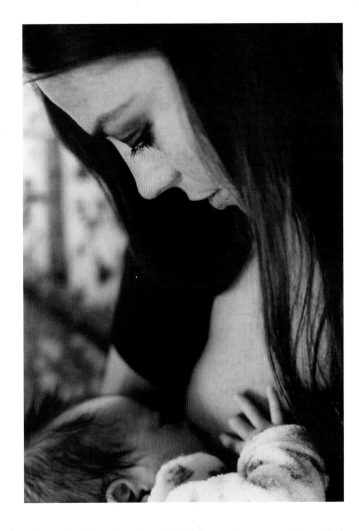

also a fighter; she fought for happiness and mental well-being her whole life. A quote by the poet Jack Gilbert reminds me of her: "We must have the stubbornness to accept our gladness in the ruthless furnace of this world." Though she suffered her share of unhappy times, the Natalie Wood I knew was a fundamentally happy person. She refused to accept anything less than gladness.

One of her gifts to me, and to everyone who knew her, was her sense of humor. In my memory, my mom's humor was usually related to standing up

OPPOSITE AND ABOVE Natasha with her mother, Natalie Wood, 1970.

for herself or others. I remember when I was ten, my father, Richard Gregson, helped convince my mom that I was old enough to attend sleep-away camp in Malibu for a week. Mom packed me up, drove me to the camp, met the woman in charge, and asked one simple question: "When can I call Natasha?" The camp director replied, "Oh no, we don't allow parents to call the children. You can just pick her up on Friday." That did it. My mom's anger and her humor were both unleashed. "When I was visiting *Russia* I called my children every single day," she said. "This is *Malibu*. If I can't call her, then we're leaving. Come on, Natasha, let's go." When the camp director made a special allowance for her to call me every night, I was so glad she had insisted; the warmth of her voice was such a comfort to me in an unfamiliar environment. Once, when an eager fan stepped on Courtney's foot during a family vacation in Hawaii,

my mom managed to shout "Schmuck!" at the top of her lungs while maintaining her camera-ready smile. She was quick to fight for her rights, but just as easy to reason with, or to try a charming, subtle approach over a full-throttle one. In fact, I learned that method of negotiation from her—how to get what I want with humor and charm, not with an iron fist.

For decades my mom had put her whole self into her acting career, and after I was born she put her whole self into parenting. She made a decision that when she had children she wanted to be very present for us, and she was. Perhaps because she never felt like she could talk to her parents openly about her deepest feelings, she made a real effort to be there for her kids, not just physically, but emotionally. We always discussed our feelings honestly, and she had a deep emotional perception. She could always sense when something was wrong, and also had a keen sense of how to make things right.

One of my happiest memories is the day my mom picked me up from school and told me that she had a surprise for me. She drove me to a studio lot where she had arranged a special screening of *Penelope*, a comedy she made in 1966 that had flopped critically and commercially. Somehow she sensed that I would enjoy seeing that particular film, especially the scene of her disguised as an old lady robbing a bank at gunpoint. She was right. I thought it was hilarious! The two of us shook with laughter together, and she seemed to love seeing the movie through her nine-year-old daughter's eyes. Now when I look back I realize this may have been a healing balm for her, a way to turn the disappointing failure of *Penelope* into a joyous experience. We both had so much fun that day.

By the time I was eleven and Courtney was seven, my mom had started to work in films again. She waited until she felt we were old enough, and she struggled to prevent her work from interfering

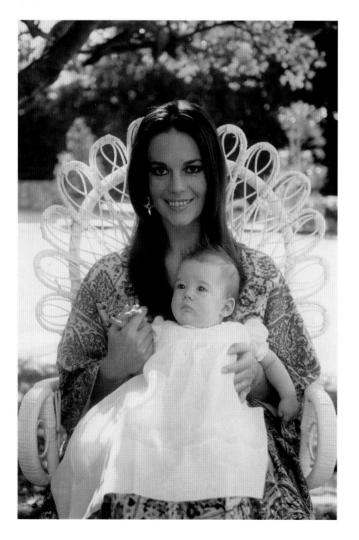

LEFT Natasha and Natalie, 1970. **OPPOSITE LEFT** Natalie Wood at Knott's Berry Farm, 1942. **OPPOSITE RIGHT** Natasha Gregson Wagner at Knott's Berry Farm, 1975.

with her family life. Juggling motherhood, celebrity, and career was a challenge, and I know my mom felt deeply conflicted when fans interrupted family dinners to ask for autographs. Because she was raised in the old Hollywood studio system, she had a tremendous respect for her fans. Sometimes she was torn between her desire to be gracious and please her admirers and her need for private time with her husband and children, but in those days fans and the press were rarely intrusive. In fact, I never saw the ugly side of fame until the day my mom died in 1981. Suddenly the shimmer around my parents' lives was twisted into an intrigue surrounding her death, wild speculations, and swarms of paparazzi. After we lost my mom, we had to move because so many reporters were staking out our house we could barely get inside.

My dad, my sisters, and I were shattered by my mom's death. As difficult as that time was, I knew I had to find the strength to go on with my life.

Somehow, through the confusion and chaos, I was able to make a promise at her funeral. I think I was worried that she felt alone and afraid, or that she was concerned for me, and I wanted to reassure her. "Don't worry, Mommy," I remember saying. "I'm going to be okay. We're all going to be okay." As my life has gone on and I have suffered my own share of pain, fear, and hardship, I always remember that promise I made even in the darkest times. I remind myself that I *must* be okay because I told her that I would be.

Having a strong network of parents, stepparents, siblings, and friendships has helped me keep that promise to my mom. There was never a shortage of love in our family, and the Wood-Wagner "family" was stretched to include ex-spouses, ex-stepchildren, close friends, housekeepers, and domestic staff. I even had the benefit of two dads. After my mother divorced my biological father, my dad Robert Wagner raised me like I was his own daughter from

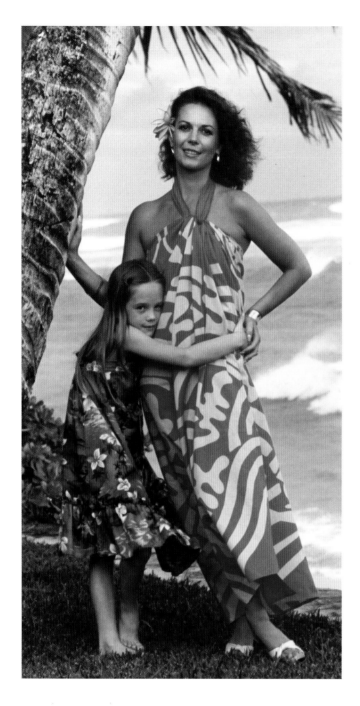

my mom and dad would surface, but I am surprised that people could actually believe them. Anyone who knew my parents knows that my mother's death was a tragic accident, and any rumors to the contrary do a great disservice to her memory.

Today I am married to the love of my life. Being the mother of a little girl and two stepsons is my greatest joy. In a way, I miss my mom now even more than ever. Becoming a mother was such a life-defining moment for her, as it has been for me, and I would give anything to be able to share the experience with her. When my daughter, Clover, was one year old, I turned forty-three—the same age as my mom when she died. It was a lonely feeling to realize that I was going to outlive her. I wish I could ask her how she felt about being in her forties, about looking in the mirror and starting to see lines on her face, about the struggles of being a parent.

With the perspective that maturity and hindsight bring, I think I now understand what made my mom so special. But I also see that she was not perfect. She overprotected me to the point that I was not allowed to walk around our Beverly Hills block by myself at age ten. She could be judgmental, her tenacity bordered on stubbornness, and she had a fiery temper. Her faults are so clear to me now, but I have such empathy for them, because I see her in me. I see her bossiness and her resilience, her controlling side and her forgiving nature all reflected in myself.

One appropriate gift from my mom was my name; she named me Natasha after herself. During her lifetime, my mother and I shared a connection so strong that we were almost too close for our own good. I was not just *in* my mother's shadow, I often felt like I *was* my mother's shadow. Losing her forced me to develop my own identity, but because we were so fused, it took years for me to come to terms with myself, my mom, our relationship, and her memory.

the time I was nine months old. He has protected and guided me through the saddest parts of my life and has shared with me many of the happiest. My mom left the care of her daughters and of her entire estate in his hands because she loved and trusted him completely, and for thirty-five years he has honored her in the noblest way. He loved my mom so much he married her twice, and has suffered profoundly over losing her twice. In this age of sensationalism and toxic media saturation, I am not exactly surprised that preposterous stories about

ABOVE Natasha and Natalie, Hawaii, 1978. **OPPOSITE** In the pool at their Beverly Hills home, 1980.

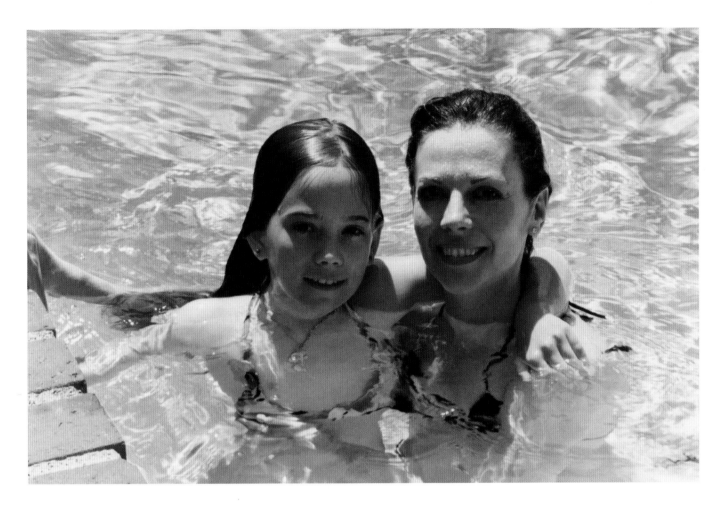

My mom grew up before she was ready because she became an actress at such a young age, and had to make grown-up decisions for herself before she was a grown-up. I grew up before I was ready because she died when I was a child. I think I must have tried to stay young longer than I needed to because it was my way to feel closer to her. *If I never grow up*, I thought, *I will always be her little girl.* I never felt like a woman until I had my daughter, and now that I have grown up, I long to be able to talk to my mom woman to woman, mother to mother. I miss her profoundly. Yet, as I promised her I would be, I am okay.

Though I only had her for eleven years, she gave me so much in that brief time. To the rest of the world, my mom has given the legacy of her films. Her radiant beauty and talent live on year after year in her performances on television and the internet. Devoted fans of my mom from back in the 1950s are still in contact with me and my stepdad, and have even sent presents to Clover. When my husband and I planned to watch an outdoor movie projected on a big screen in our yard, he suggested *West Side Story.* My daughter was only three and I was afraid she would be too young to appreciate it, but she loved it. I have told her about her grandmother, and when she saw this beautiful young woman dancing across the screen, she looked up and asked the sky, "Grandma Natalie, where are you?"

She may not be here in person, but my mom is very much alive in memory. I sense her presence and her guardianship every day, and feel guided by her through the ups and downs of my life. My mother was my champion. She made me feel so loved, so valued, that I was able to carry her love forward long after she was gone. She taught me how to truly love somebody, enabling me to love my husband, my stepchildren, my daughter, and myself, because her love was so unconditional and eternal. That may be the greatest gift she has given me.

A NEW FOCUS

1970–1981

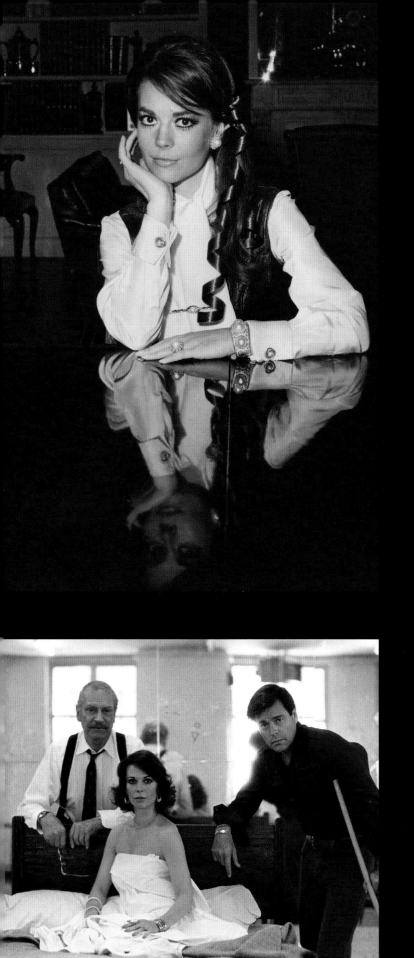

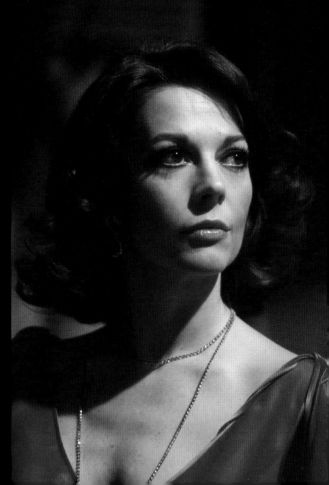

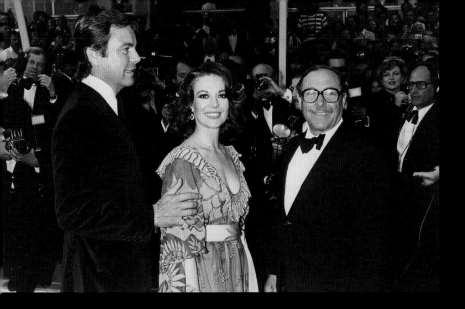

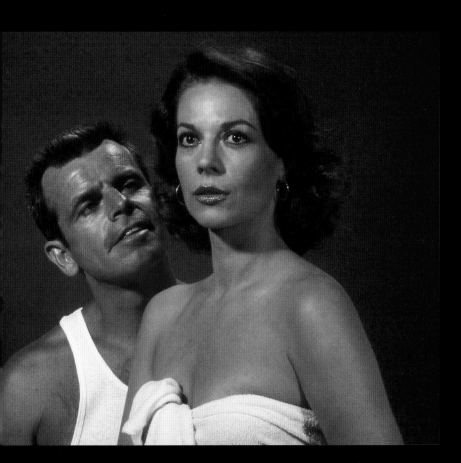

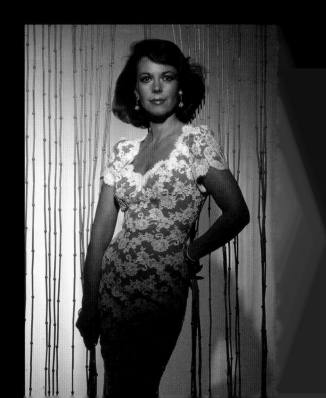

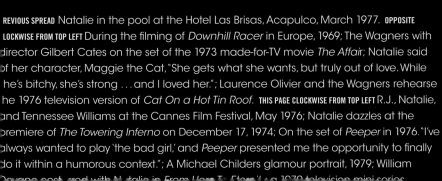

REVIOUS SPREAD Natalie in the pool at the Hotel Las Brisas, Acapulco, March 1977. OPPOSITE LOCKWISE FROM TOP LEFT During the filming of *Downhill Racer* in Europe, 1969; The Wagners with director Gilbert Cates on the set of the 1973 made-for-TV movie *The Affair*; Natalie said of her character, Maggie the Cat, "She gets what she wants, but truly out of love. While he's bitchy, she's strong . . . and I loved her."; Laurence Olivier and the Wagners rehearse he 1976 television version of *Cat On a Hot Tin Roof*. THIS PAGE CLOCKWISE FROM TOP LEFT R.J., Natalie, nd Tennessee Williams at the Cannes Film Festival, May 1976; Natalie dazzles at the remiere of *The Towering Inferno* on December 17, 1974; On the set of *Peeper* in 1976. "I've lways wanted to play 'the bad girl,' and *Peeper* presented me the opportunity to finally o it within a humorous context."; A Michael Childers glamour portrait, 1979; William evane cost red with N talie in *From Here To Stars* in a 1979 television mini series

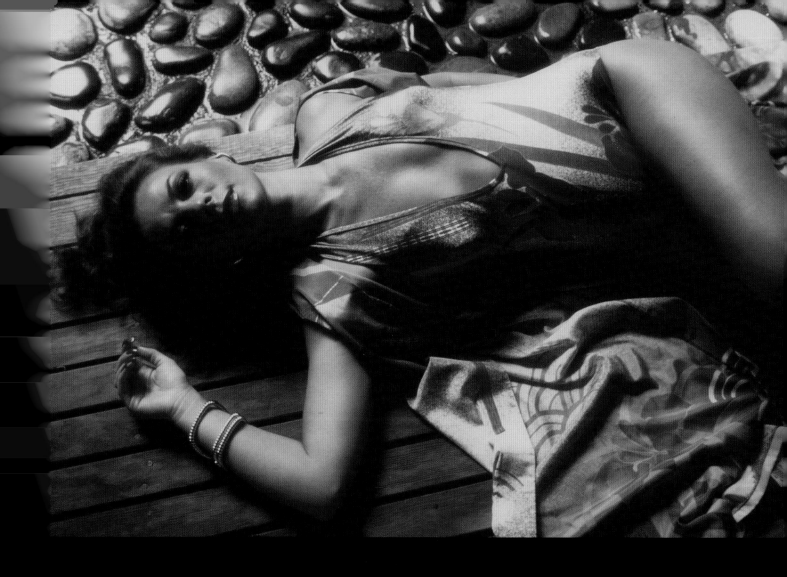

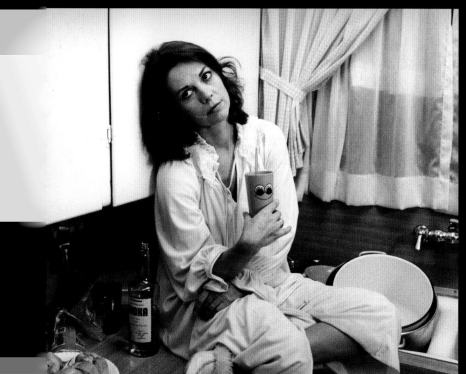

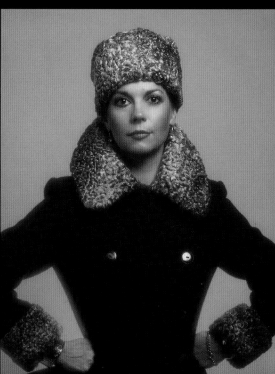

OPPOSITE CLOCKWISE FROM TOP Natalie was photographed for *Town & Country* at the Golden Door resort in Escondido, California, 1978; In 1977, Michael Childers photographed Natalie in an Albert Wolsky-designed costume for *Meteor*; Of her role in 1979's *The Cracker Factory*, Natalie said, "I loved playing Cassie. She was a hard character to shake off—I didn't want to say goodbye to her."

THIS PAGE CLOCKWISE FROM TOP Released in 1979, *Meteor* was the last of the big-budget '70s disaster films. L to R: Joseph Campanella, Martin Landau, Brian Keith, Natalie Wood, Sean Connery, Karl Malden, and Henry Fonda; On the historic M-G-M lot where *Meteor* was filmed in 1977. Photo: Michael Childers; Backstage at the 50th Annual Academy Awards in 1978 with Darth Vader and John Mollo, Best Costume Design winner for *Star Wars*.

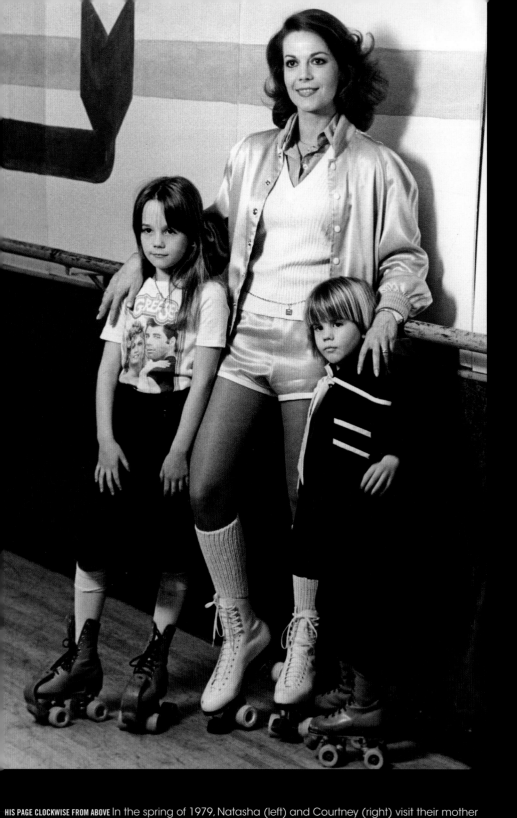

THIS PAGE CLOCKWISE FROM ABOVE In the spring of 1979, Natasha (left) and Courtney (right) visit their mother on the set of *The Last Married Couple in America*; Natalie's passport photo, issued July 11, 1981; Natalie played her first death scene in the 1980 television film *The Memory of Eva Ryker*. "It's something that I've never done before. There's an art to acting out that final meeting with death."; In 1981, Michael Childers shot publicity portraits for what would have been Natalie's stage debut in the Ahmanson Theatre production of *Anastasia*. OPPOSITE CLOCKWISE FROM TOP LEFT At the 51st Annual Academy Awards ceremony on April 9, 1979, Natalie wore an Edith Head original from *The Last Married Couple in America*; Natalie was one of many celebrities who posed for the Winners! print campaign advertising designer Jean-Paul Germain and Macy's; A provocative Michael Childers shot late 1970s; In 1981, Bill King photographed Natalie for Blackglama's famous ad campaign

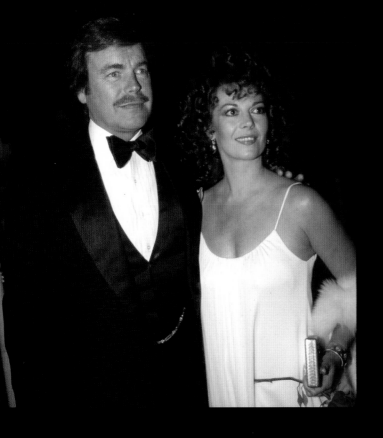

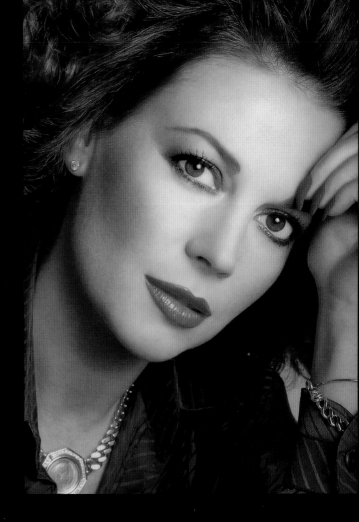

What becomes a Legend most?

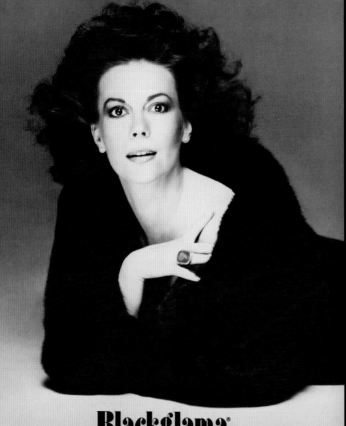

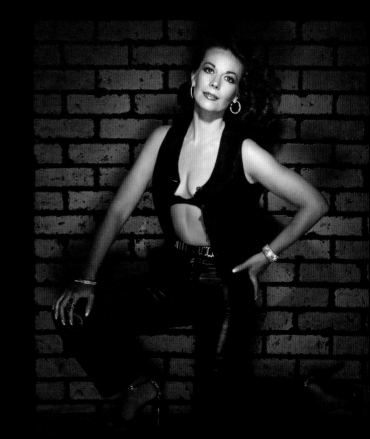

Blackglama®

NAME NATALIE WOOD

HEIGHT 5'-5'-3"	WEIGHT	BUST	WAIST	HIPS	DRESS 5	SHOE 6B

1 HEAD	21½	
2 COLLAR	12	
3 shoulder 5 ACROSS FRONT I	14½	
4 ACROSS FRONT II	21½	
5 ACROSS BACK I	16	
6 al-al 14½ ACROSS BACK II	16½	
7 BUST	34½	
8 UNDER BUST	29½	
9 SPAN I 10		
10 SPAN II – 8¾		
11 WAIST	23¾	
12 HIPS 35 31"	35	
left 20½ R 21¼ EEVE 14½ inside 15	12½	
14 UPPER ARM		
15 GIRTH I Armscye	17	
16 W-W 28" GIRTH II inseam 31"		
17 THIGH	21½	
18 BELOW KNEE		
19 CALF		
20 ANKLE		
21 BACK TO WAIST	16	
22 BACK TO KNEE		
23 BACK TO FLOOR 3" heels	56	
24 FRONT TO WAIST	14½	
25 FRONT TO FLOOR	45"	
26 SHOULDER TO WAIST		
27 WAIST TO FLOOR	42	
28 inseam		

COMMENTS: pant 28½ – short rise / skirt length / sweater length / wrist – 6¼ / back at ankle = 34 – each / 6½ elastic, underarch.

Sketch annotations: Vanilla lace over / Vanilla crepe / shadowed in chiffon / Natalie wedding "Brainstorm"

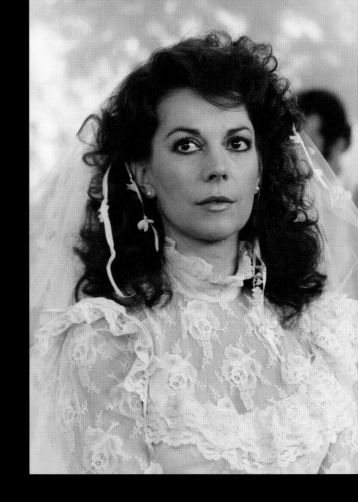

KODAK SAFETY FILM 5037 ... 5A

ABOVE LEFT AND RIGHT Oscar-nominated Donfeld designed costumes for Natalie's character of Karen in *Brainstorm* without making "a fashion statement." Natalie's head-to-toe measurements are pictured here with Donfeld's original sketch of the wedding dress Natalie wears in a flashback sequence. **LEFT** Original *Brainstorm* slide from photographer Michael Childers. After Natalie's death made headlines, M-G-M hole-punched slides and negatives to prevent tabloids from publishing the images. **OPPOSITE TOP** Natalie began location shooting in Raleigh, North Carolina on September 28, 1981, and was scheduled for a total of eleven weeks. Tragically, she would never finish. Here, Douglas Trumbull directs Natalie and Christopher Walken in a romantic scene. **OPPOSITE BOTTOM** On the set with Trumbull. In the aftermath of Natalie's death, M-G-M immediately shut down production and planned to shelve the incomplete footage. But Trumbull fought to finish his film and to honor Natalie's final screen performance. The dedication at the end of *Brainstorm* reads simply: To Natalie.

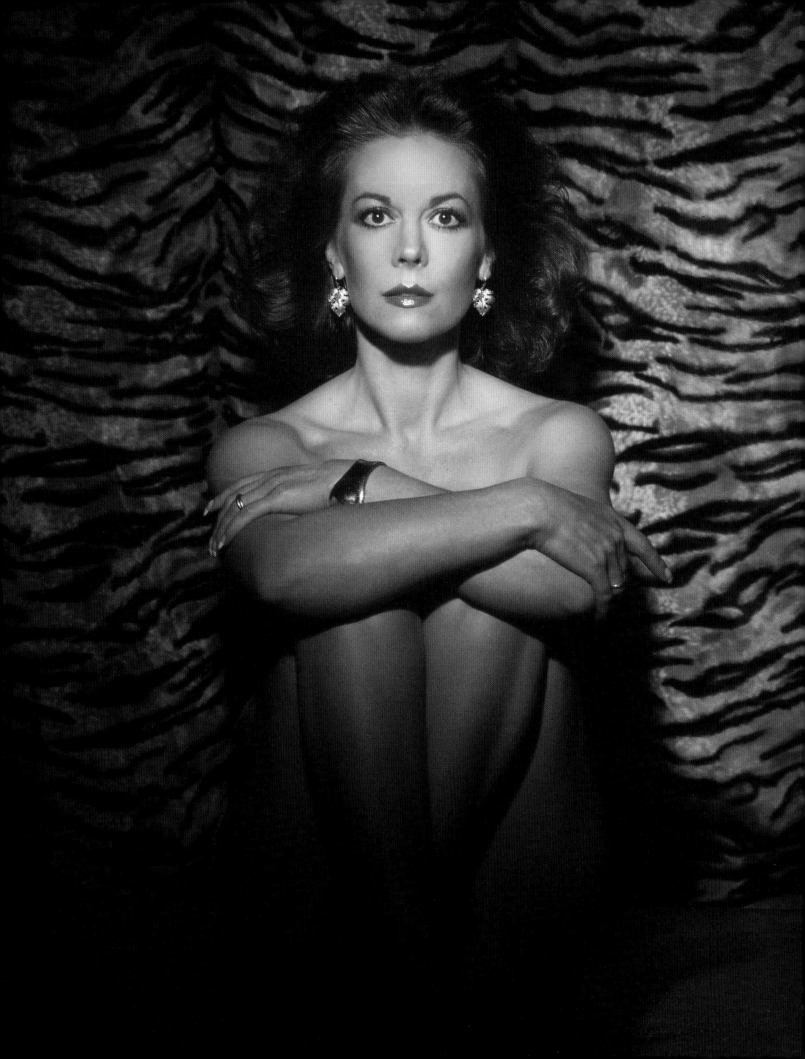

PICTURE THIS

PHOTOGRAPHING NATALIE WOOD

An Interview with MICHAEL CHILDERS

What was Natalie Wood like as photographer's subject? Was she your muse?

Natalie was the most exciting star that I ever worked with. She was my first star, my first muse, my mentor, my friend. She became part of our family—my partner John Schlesinger's and mine. Luckily, she adored the first photographs I ever took of her and her beautiful new baby, Natasha. I became part of her tight-knit circle of photographers she allowed to be in her personal group. I did thirty or forty sessions with her. I went on her honeymoon with Robert Wagner to Venice. I had never been on a honeymoon before!

How long did you work with her?

From 1970 until her death in 1981. But I met her in 1968. I was in film school. We were having Jacques Demy and his wife for dinner on a Saturday night. I said, "John, would you bring Natalie Wood? You'd make my month." On Monday morning the campus was in an uproar. "Students had a party and Natalie Wood was there!" I don't think she had ever met film students or acting students. She was a movie star. She was old school. But she was so cool. Everyone's passing a joint and she had a tiny little thing of it. She was relaxed and couldn't have been nicer.

To what do you attribute your lengthy professional and personal relationship?

It was about trust and mutual respect. Natalie loved talented people. She only wanted first-rate people around her. If you were in her family, you had to be the best.

I have heard she was even more beautiful in person than on film. How do you explain that?

She had this personality that was so electric, magnetic. She'd look you in the eye and it was so direct. When a star, a great star, enters a room, you are in the presence of a thoroughbred. A god. It may sound corny, but there is that jolt of electricity when they walk in a room. When Natalie walked in a room, it changed color. It didn't hurt that she wore Jungle Gardenia, which was delicious. It would linger for three days in your room after she walked out. She was charming and enchanting and very vulnerable and great. I was privileged with Natalie. I don't think any photographer was allowed to get as close to her as I was.

You once said that, although she was small in stature, she seemed six feet tall.

She brought in her own light. She was surrounded by beautiful light, it came from within. She lit up. There was a radiance. The radiance was overpowering. It made her look a foot taller.

What was her humor like?

She had a great sense of humor. Her humor was

cute, really cute. There was nothing stuck-up about Natalie. She never had the attitude of a movie star—and I have seen some mean divas. I was spoiled by Natalie. Like I said, she was my first star. I thought all the rest of the stars would be like that, but they never were. They never were. . . .

Why did you shoot her mostly on 35mm?

I was shooting Nikon then, and it was for magazines. I was always doing it for magazines. I loved Kodachrome. The skin tones you get for women were incredible. Natalie loved it!

Do you have any favorite shoots done by other photographers?

Oh yes. Douglas Kirkland, William Claxton did some great early stuff of her. Bob Willoughby did some great things.

Did she ever allow you to shoot without the bracelet on her left wrist?

We did sometimes, but she was very conscious of that. There was a big bump there! You notice on the portrait from *Peeper*. The bracelet. We couldn't get the buttons closed around that damn bracelet. We had to leave the buttons open because the tight sleeve wouldn't fit over it.

Did Natalie have a preferred side?

She looked pretty great at every angle—straight on, above, or below. Below usually doesn't work, but it worked with her. Her left side was the better side. Left side was her favorite side as well. I also introduced her to some great new makeup people, and her favorite was Franklyn Welsh. He created a whole new look for Natalie. The makeup was beautiful. It wasn't that hard Maybelline look. We softened the eyes. He did the makeup for the iconic 1974 shots.

Natalie wanted to reinvent herself in the 1970s. Who came up with the ideas?

I came up with the ideas to reinvent her image. I

wanted to sex her up! She was still young, looking beautiful. I wanted to get rid of the perfect Hollywood image. I wanted sex . . . skin. Have you seen those shots of her in *Look* magazine? She was so outrageously gorgeous. I had her in négligées and see-through this and that. I photographed her in leather. She would normally never do that.

You shot nudes of her. Was she comfortable with exposing her body?

No, she was shy and a little nervous. I had mirrors everywhere for her to look at. I'd say, "This is covered and that is covered," and she'd say, "I can see it in the mirror." I'd respond, "Yes, okay." I think those photos turned out perfect.

Were these private shoots?

No, I had six people on the nude shoots. Hair, makeup, and two assistants. I had the makeup girl hold a towel over her while she sat down, and then the towel came down. I didn't want her to feel exposed. A couple of glasses of wine didn't hurt. I put on a Frank Sinatra record—she loved Sinatra. She knew him very well. Once I was staying with her and Robert Wagner in Palm Springs, and R.J. said, "We are going over to Frank's for drinks. Want to come with us?" I said, "Oh yeah, to Sinatra's? Wow!" R.J. said "You have got to behave, and don't say anything unless he asks you something. Sinatra is an old friend of ours, but he's like a rattlesnake—you never know when he's going to strike. So just be cool." Sinatra was okay. He loved R.J. because he was going to marry his daughter Tina, and Frank had apparently had an affair with Natalie before she married R.J. Very incestuous (laughs). No wonder she loved Sinatra!

Natasha said the world perceived Natalie as vulnerable, but she never saw that herself. She saw her mom as dynamic and self-assured.

She was dynamic, but I would never say self-assured. Those of us who knew her would not say that. Of course Natasha didn't really see the dark, dark side

of the moon. All of us felt very protective of Natalie. Her moods would change and her doubts and her darkness would come over her. I probably saw her cry, but not often, mind you. I think having Natasha and Courtney changed her life. That was the purest joy that she ever felt. She was a great mother. She was this sunbeam; she couldn't let these beautiful babies go. Natalie's own mother, on the other hand, was as cold as ice.

There are so many photos of Natalie gazing at R.J. looking star-struck, even in the late 1970s. What made their relationship so special?

Since she was a little girl she was in love with R.J. The story is true about her walking down the street with her mother at Fox and seeing Robert Wagner, who is about ten years older than her. He was the heartthrob of Twentieth Century Fox, and he was so gorgeous. She said something like, "Mommy, that's what I want when I grow up. I want to marry someone like that." This was the core of their relationship. He was her anchor; she had been through some really low points. One was her relationship with Warren Beatty, which drove her crazy. Sometimes I felt sorry for R.J. Her demons were hard on him. There weren't enough therapists in Beverly Hills to deal with that many demons!

I know she had a strong support network of friends.

Yes, there was Delphine Mann and especially Mart Crowley, who was her best friend. They had a great relationship that went back many, many years. Then there was Howard Jeffrey, myself, and Roddy McDowall. She loved her posse of gay boys.

Tell me about the second honeymoon.

I was working in London on *Sunday Bloody Sunday*, and I got the call that Natalie wanted me to shoot a world exclusive of her and R.J. in Italy. I met them in Venice and spent six days photographing them in gondolas and at St. Mark's Square. It was like a dream. One day, we were in the most expensive jewelry store in Venice, and I said, "Natalie, look at these blue sapphire earrings and the necklace. You should get them." She called R.J. over, fluttering her eyelashes with her beautiful smile, and asked him to buy her the set. R.J. went red in the face and made a motion like, "Childers, would you please shut up?" But he bought them and, walking out of the store he said, "Childers, you just cost me $80,000. Thanks a lot."

Both R.J. and Natalie formed a close bond with Laurence Olivier, didn't they?

Natalie was always in search for an older man to give her guidance in life, like R.J. and Elia "Gadge" Kazan, who she worshiped. She was missing a strong father figure in her life. Olivier filled that role, and she adored him and trusted him. When he directed her, she worked extra hard! Olivier was very close to R.J. too, very friendly. Once, we all sailed to Long Beach, right past the Queen Mary, because Olivier wanted to see it. I have pictures of Olivier looking at the Queen Mary and crying. I asked, "Why are you crying?" and he said, "When Vivien Leigh came from England to meet me in Hollywood, she sailed on this boat. And this means so much to me." Olivier said Natalie reminded him of a young Vivien, and Natalie, who had always been a big fan, asked a lot of questions about her.

Did Natalie ever talk to you about her older movies and that era of Hollywood?

Yes, a little. She said on *West Side Story* she had a horrible time. But she loved her fame. She loved her fans, and she loved being a star. She had guidelines for being a star: Stars should dress well, not go out in jeans looking sloppy, things like that.

Did she ever express to you a worry about aging?

Yes, especially towards the end. At age forty she started worrying about that. I know she was really worried about the future. She had been a star since six years old—how does someone deal with that?

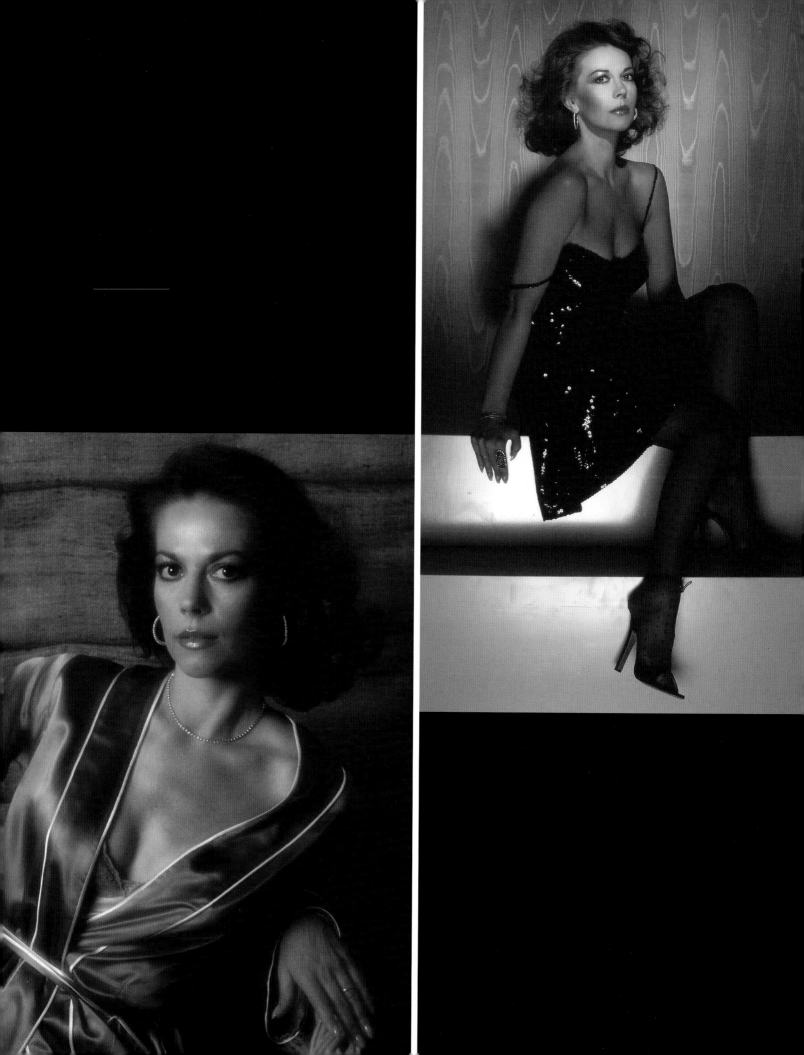

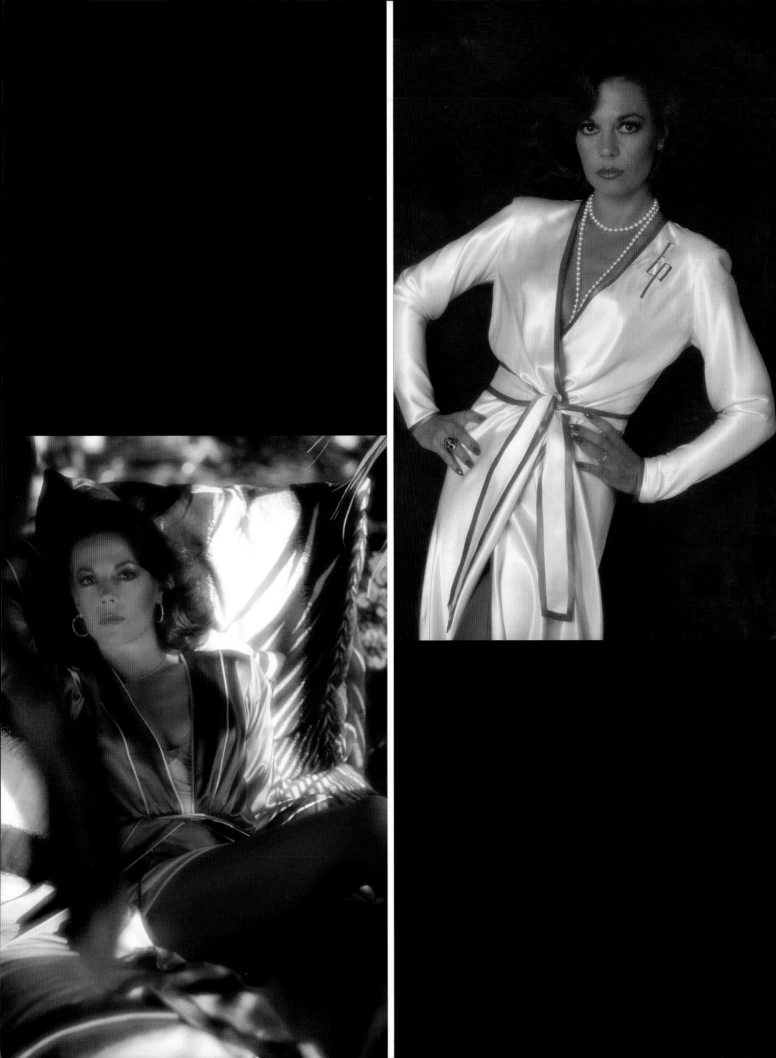

Do you think if she had lived her status would have been elevated to living legend like Taylor, Brando, and Hepburn?

I don't think so. If she had been careful and done good roles, maybe. Maybe not, though. She was only a really good actress when she had a great director. Similar to Liz Taylor, who can be quite bad, but when she gets Mike Nichols to work with, she's absolutely incredible.

You were working with her on the set of her last film, *Brainstorm*. What do you remember about that?

I was on location with the cast and crew in North Carolina in the fall of 1981. It was a very strange set, an unhappy set. The director was technically brilliant, but he knew nothing about directing actors. The actors seemed lost, upset, and angry. It didn't help that one of the producers ended up in a drug rehab facility, and was absent from the set. I remember Natalie asking me about Christopher Walken, who I had worked with on *Pennies from Heaven*, and I found to be kind of a dark person. Natalie was enamored of his talent, and was drinking a little too much, and the mood on the set made me uncomfortable. But we were very excited about a photo session we had scheduled for right after Thanksgiving. In fact, she asked me if I wanted to come with her, R.J., and Chris on the boat to Catalina that weekend. Delphine Mann was invited too. Being around her and Chris on set was awkward enough, so I was not anxious to be trapped for the weekend with them out at sea. I called Delphine and said, "I'm not getting on that boat," and she said, "I'm not either."

How did you find out that she was gone?

That Sunday morning, I took my two dogs for a walk in my garden up in the hills. It was a clear, sunny day, and I could see Catalina sparkling off in the distance. I thought, "Well, they're all out there on the boat having a nice time." When I got back to the house, the phone was ringing. It was John Foreman, one of the producers of *Brainstorm*, and he said, "I think Natalie is gone. She's been lost at sea." I was so stunned, I felt like I'd been hit in the stomach. I went out to the garden again, this time in tears.

You said her funeral was profoundly moving.

The service in Westwood cemetery was devastating. It was the saddest event I had ever attended. The three little girls, Natasha, Courtney, and Katie, all came out holding hands. Natasha was eleven and so conscious of what was happening—the impact hit her like a ton of bricks. When she placed a gardenia on her mother's casket, I broke down completely. Everyone was choking back tears. Practically all of Hollywood was at the memorial afterward at their house on Canon Drive. R.J. was a wreck, of course. Gregory Peck and Elizabeth Taylor were devastated. I remember Liz said, "Oh, honey, I've known Natalie since I was fourteen years old. We both had the same sort of stage mothers. I know those kinds of demons." We were all getting a little tipsy, and with good reason at such a sad event. Liz said, "I think I'll just have one more drink before I go. I've got a performance of *The Little Foxes* tonight at the Ahmanson, and if the theater director sees me take one drink, he'll fire me. So can you just pour this into a Styrofoam cup for me?" By then she was flying, and she was funny. That must have been the wildest performance of *The Little Foxes* ever seen.

Is there anything you wish you had said to Natalie, but didn't get a chance?

I wish I could have expressed to her how much confidence she gave me. She was one of the five biggest stars in the world at one time. Working with her gave me confidence I never had before. She was the absolute best.

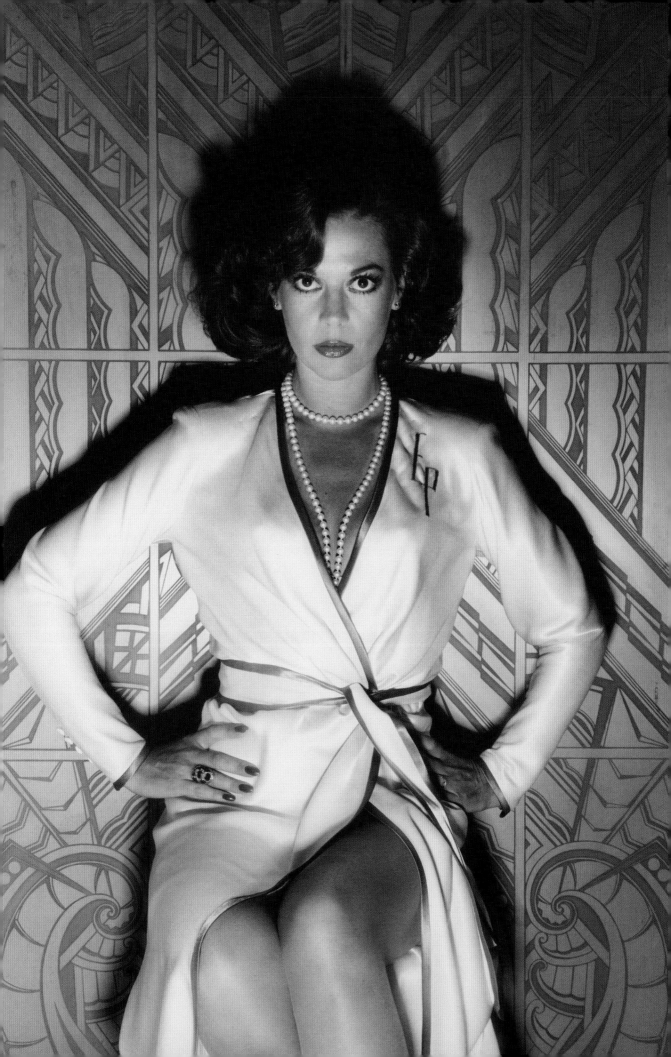

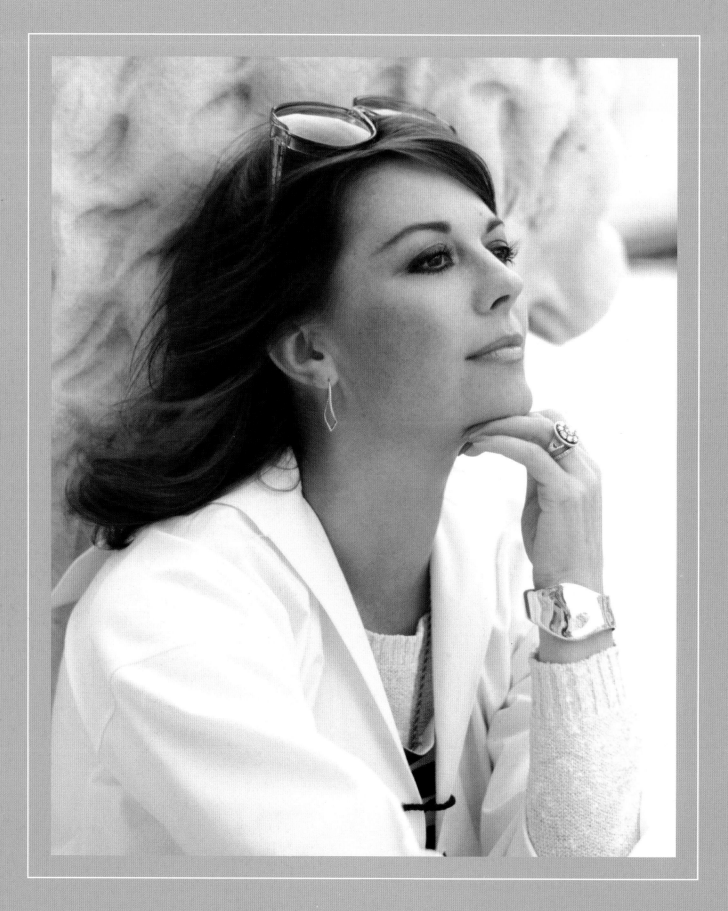

COURTNEY'S FAMILY ALBUM

My mom always wore stylish clothes, makeup, and jewelry, even when running errands or dropping me and Natasha off at school.

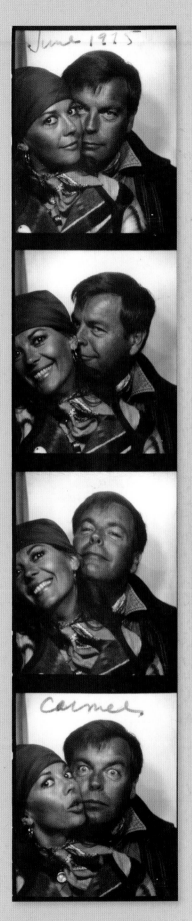
June 1975

Carmel

OPPOSITE One of my favorite portraits that Michael Childers took of my mom, June 1977.

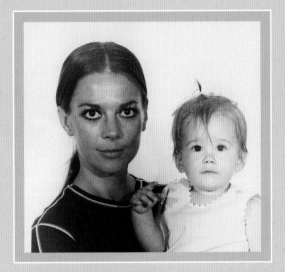

My sister Natasha's first passport photo, taken in 1971.

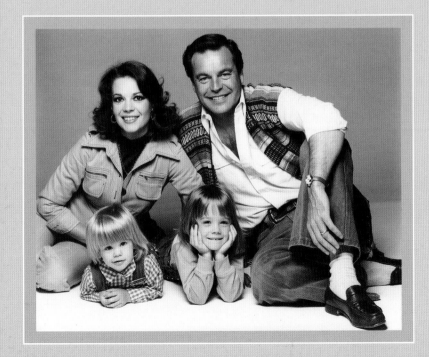

Family portrait, 1977. Natasha has a drawing of this photo hanging in her home today.

My parents had these taken in Carmel in 1975. They always seemed to have so much fun together.

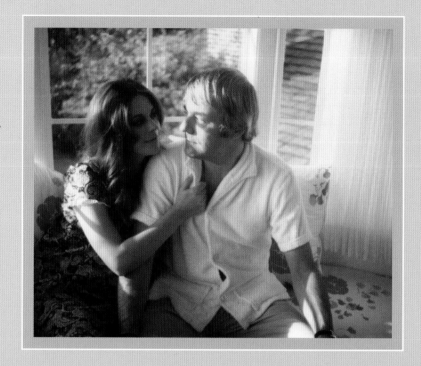

Mom with Natasha's father, Richard Gregson, before they separated in 1971.

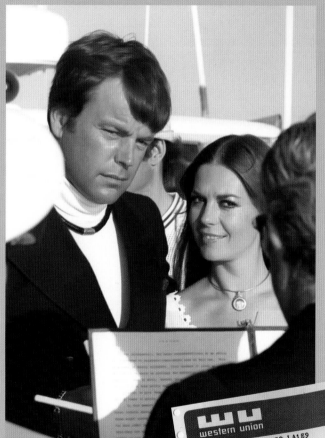

My parents had an amazing love story. After their first marriage ended in divorce in 1962, they fell in love and married all over again—this time for keeps—aboard the *Ramblin' Rose*, off Catalina Island on July 16, 1972.

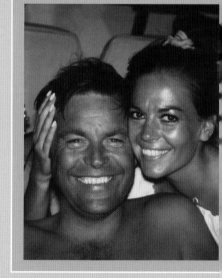

They were such beautiful people. I always remember my mom's delicate, expressive hands.

Telegram

western union

851P PDT JUL 16 72 LA189
L XLG173(2247)(1-011355C198)PD 07/16/72 2245
ICS IPMLSLF LSA
ZCZC 01159 F TW (00390 G IE) TDL WEST LOS ANGELES CALIF
PMS 16-924A PDT
NATALIE WOOD, DLR
191 NORTH BENTLEY DR WEST LOS ANGELES CALIF (VIA BEVERLY
HILLS CALIF)

IF YOU'RE NOT BUSY TODAY LETS GET MARRIED
UNSIGNED.

Mom and Natasha on vacation in Palm Springs, March 1972.

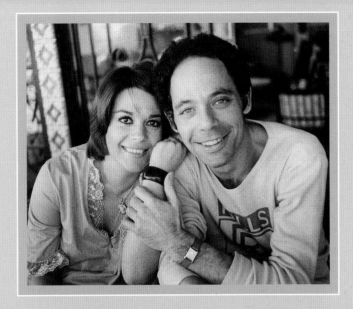

Choreographer Howard Jeffrey was a dear friend of my mom's since the *West Side Story* days. Our nanny Willie Mae still owns the nightgown my mom is wearing. Photo by Michael Childers.

I love this picture, taken when I was just a few months old in 1974.

My mom loved us so much! Though we had a nanny, she was a hands-on parent and did everything with us.

Ruth Gordon was Natasha's godmother. She used to send us presents, like toy animals made of balloons and candy.

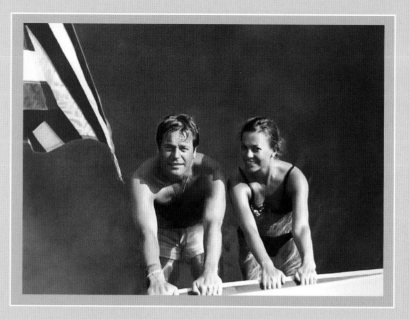

My parents both loved being on their boat, the *Splendour*, named in honor of *Splendor in the Grass*. Those were some of the happiest times.

Close family friend (and my godmother) Delphine Mann shares some eggnog with my mom on Christmas Day 1975.

Christmas with the whole family. Left to right: Our grandfather Nick Gurdin, Natasha, grandmother Maria Gurdin, grandmother Chat Wagner, Mom, me, my half-sister Katie, and Dad.

This is my favorite picture of me and my mom. I'll never forget the warmth and comfort of being near her.

I was too young to understand that some of my parents' friends were big stars, like Fred Astaire and David Niven. To me, they were just nice men who enriched the joyous family atmosphere.

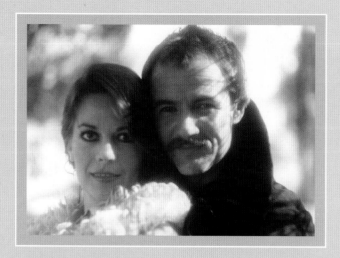

Mom with photographer Michael Childers, another good friend.

Me with Sean Connery in our home on Canon Drive. I will never forget that house or those stairs—I was standing on them a few years later when my dad told me I would never see my mother again.

Roddy McDowall was another Hollywood star who was a genuine family friend. On the *Splendour* in the summer of 1977, he shows off his t-shirt of Bette Davis, a mutual friend of his and my mom's.

My mom loved Edith Head, who designed some of her greatest movie costumes. I still have that coffee table today.

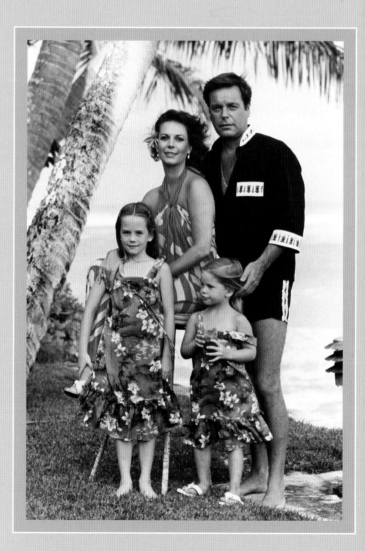

A 1978 family trip to Hawaii, just before my dad started working on the TV series *Hart to Hart*.

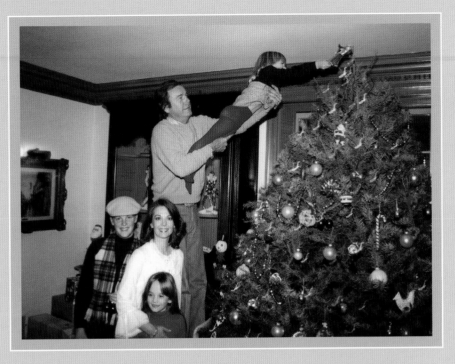

On my first day of kindergarten at the Curtis School, I threw such a fit my mom took me home and waited another year before enrolling me in school again!

This photo says it all. Mom, Dad, Katie, Natasha, and me—the original posse. I remember the joy of the holidays, the smell of the Rigaud Cypres candles my mom burned, laughter, friends, pets, presents, and love. It feels like a lifetime ago.

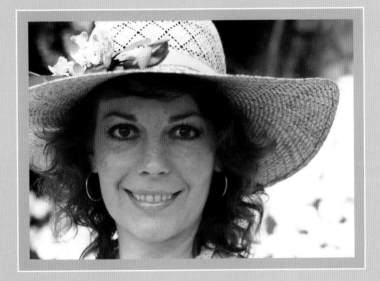

This is exactly how I remember my mom. I used to have this photo in a pink heart-shaped ceramic frame in my bedroom.

Mart Crowley was more than my mom's best friend, he was a member of the family. Dad, Natasha, and I are still close to Mart today.

My mom remained friendly with her parents, and they were frequent guests at home and on the boat.

The ladies of the Wood-Wagner family, including my aunt, Lana, and my cousin, Evan. When I look at this photo, I notice how much Katie looks like her son, Riley, born in 2006.

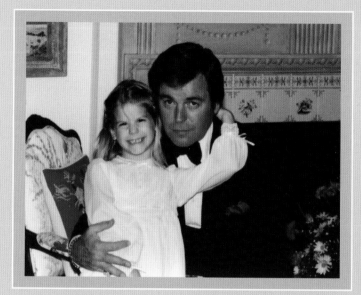

I used to think my dad must be very complicated because he's so loving, charming, sincere, and always a gentleman. Now that I'm grown I realize he's just a wonderful man, pure and simple.

Elia Kazan had given my mom her breakout role in *Splendor*, and she never forgot it.

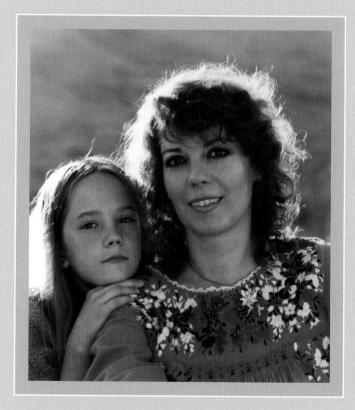

Growing up, I kept this picture in a frame, and even tried painting an oil rendition on canvas for Natasha years ago.

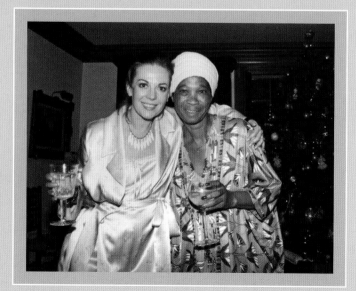

My two moms: Natalie Wood and Willie Mae Worthen.

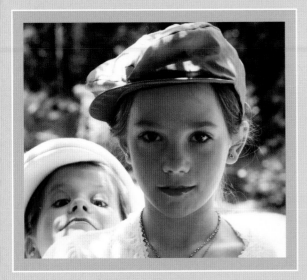

I remember the day Natasha and I put on our mom's makeup and tried on her hats. This was taken in 1981 right before we lost her.

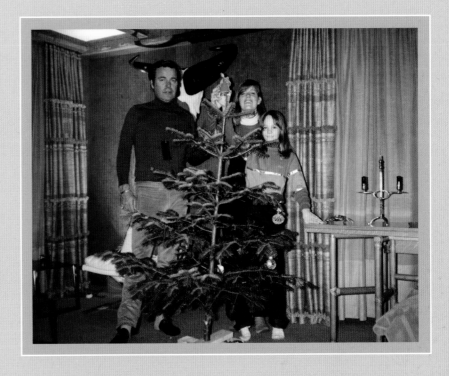

Our first Christmas without my mom, at David Niven's cabin in Gstaad, Switzerland. The bountiful holiday atmosphere of the past seemed to end so suddenly. None of us were ever quite the same after my mom died.

After Christmas, we traveled to Wales to visit the Gregsons. Willie Mae, Mart, and Katie's half-brother Josh Donen came along, and Richard Polo is on the far left. As sad as that time was, I remember a warm feeling of camaraderie because we were all grieving together. At least we had each other.

Natasha and I wish Katie a happy twenty-first birthday at her big party in 1985. Josh was dating Cher at the time—they even got matching tattoos.

My dad's so cool. He brought his two youngest daughters to the 1986 Emmy Awards.

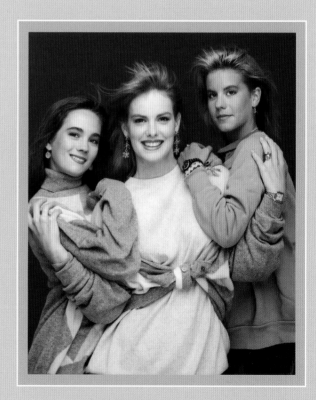

All three Wagner girls in 1992.

Pieces of my mom's jewelry have inspired my own jewelry designs. I still wear the gold heart necklace my dad gave her, inscribed in his handwriting: "N.W.W., You're my Valentine forever. 2/14/76."

My mom loved butterflies, and I still think of her when I see one. So do Natasha and her daughter, Clover.

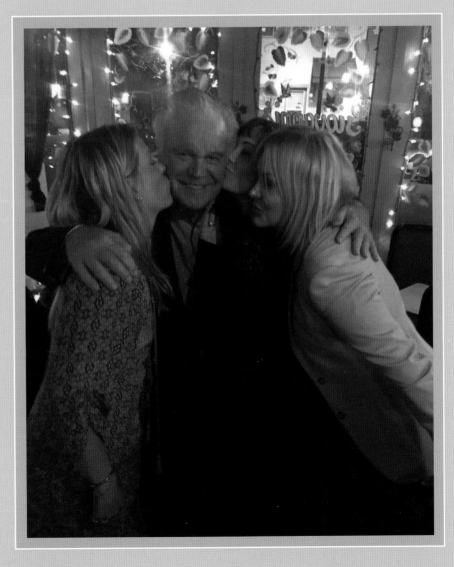

We're okay.

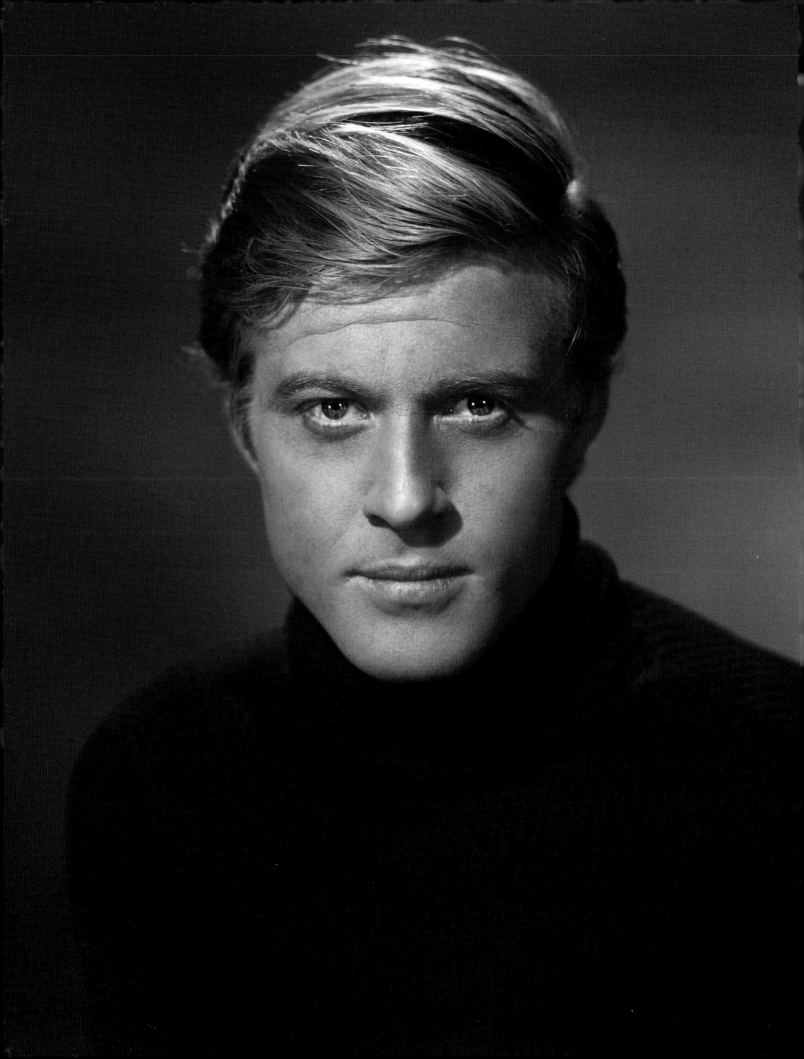

AFTERWORD

BY ROBERT REDFORD

My relationship with Natalie was fraught at the beginning.

It was high school in Van Nuys, California.

It was customary that child actors in film had to attend a public school on the first and last day of the semester. In between, they would be tutored on movie sets.

The auditorium at school was oval in shape with about five doors of entry at different intervals. Those of us who were on sports teams were allowed to skip opening-day ceremonies if we would stand as guards to the various doors until proceedings began. We would then be free for the day to do whatever. For me and my fellow guard, it was to hit the beach in Malibu.

We were just ready to leave, since all students were in, when this little girl with dyed blonde hair (at the time, Natalie was working on a film with Paul Newman called *The Silver Chalice*) came running up saying, "Wait, wait" because she was late. The door we guarded was under the letters A through E.

I asked her name and she said, "Wood." I told her that her door was around the other side of the auditorium. She pleaded to go in our door because she didn't want to cause a commotion (I might add my fellow guard instantly spotted who she was and was frozen in place). I told her no, she had to go around to the other side (I was seriously working to become a complete asshole, which in those times and that place, was considered cool). She pleaded once more and I resisted once more. She then took off, but turned around and said, "Thanks, you son of a bitch." My friend then confirmed that indeed I was a prize asshole.

That was then.

A decade later, I was an actor on Broadway and she a major film star, when she came backstage after the show to pay compliments. Soon after, I received word that she had requested me to be her costar in an Alan Pakula-Bob Mulligan film, *Inside Daisy Clover*. It was my first Hollywood film and the beginning of a film career.

During and after, Natalie and I enjoyed a full, rich, and lasting relationship up, through, and after her marriage to Richard Gregson, who also happened to be my agent. I was asked and honored to be best man.

Her passing left a scar on my fond memory. She was not only talented, but a youthful, eager beauty who seemed always to be blossoming. Hers was a personality that enjoyed and loved life.

She is very much missed.

OPPOSITE Robert Redford, 1966. ABOVE Natalie with Redford on the set of *Downhill Racer*, 1969.

REFERENCES

BOOKS

Acevedo-Munoz, Ernesto R. *West Side Story as Cinema*. Lawrence, Kans.: University Press of Kansas, 2013.

Basinger, Jeanine. *The Star Machine*. New York: Alfred A. Knopf, 2007.

Biskind, Peter. *Star: How Warren Beatty Seduced America*. New York: Simon & Schuster, 2010.

Callan, Michael Feeney. *Robert Redford: The Biography*. New York: Alfred A. Knopf, 2011.

Chierichetti, David. *Edith Head: The Life and Times of Hollywood's Celebrated Costume Designer*. New York: HarperCollins, 2003.

Curtis, Tony and Peter Golenbock. *American Prince: A Memoir*. New York: Three Rivers Press, 2008.

Bogdanovich, Peter. *Allan Dwan: The Last Pioneer*. New York: Praeger Publishers, 1971.

Dick, Bernard F. *Forever Mame: The Life of Rosalind Russell*. Jackson: University Press of Mississippi, 2006.

DK Publishing. *Musicals: The Definitive Illustrated Story*. London: Dorling Kindersley, 2015.

Done, Philip. *The Charms of Miss O'Hara: Tales of Gone with the Wind and the Golden Age of Hollywood from Scarlett's Little Sister*. Mountain View, Calif.: Gateway Publishing, 2014.

Falk, Peter. *Just One More Thing: Stories from My Life*. New York: Carroll & Graf Publishers, 2006.

Frankel, Glenn. *The Searchers: The Making of an American Legend*. New York: Bloomsbury, 2013.

Frascella, Lawrence and Al Weisel. *Live Fast, Die Young: The Wild Ride of Making Rebel Without a Cause*. New York: Touchstone, 2005.

Freedland, Michael. *Jack Lemmon*. New York: St. Martin's Press, 1985.

———. *All the Way: A Biography of Frank Sinatra*. London: Weidenfeld & Nicolson, 1997.

Garner, James and Jon Winokur. *The Garner Files: A Memoir*. New York: Simon & Schuster, 2011.

Harris, Warren G. *Natalie & R.J.: Hollywood's Star-Crossed Lovers*. New York: Doubleday, 1988.

Head, Edith and Paddy Calistro. *Edith Head's Hollywood*. New York: E.P. Dutton Inc., 1987.

Hunter, Tab and Eddie Muller. *Tab Hunter Confidential: The Making of a Movie Star*. Chapel Hill, N.C.: Algonquin Books, 2006.

Jurow, Martin and Philip Wuntch. *Marty Jurow Seein' Stars: A Show Biz Odyssey*. Dallas: Southern Methodist University Press, 2001.

Kraft, Jeff and Aaron Leventhal. *Footsteps in the Fog: Alfred Hitchcock's San Francisco*. Santa Monica, Calif.: Santa Monica Press, 2002.

Lambert, Gavin. *Natalie Wood: A Life*. New York: Random House, 2004.

Laurents, Arthur. *Mainly on Directing: Gypsy, West Side Story, and Other Musicals*. New York: Alfred A. Knopf, 2009.

Lawrence, Greg. *Dance With Demons: The Life of Jerome Robbins*. New York: Putnam, 2001.

Mazursky, Paul. *Show Me the Magic*. New York: Simon & Schuster, 1999.

McCrann, Mike. *Natalie Wood: Hollywood's Child*. Unpublished manuscript, 1976. Wood-Wagner Private Collection.

McGilligan, Patrick. *Nicholas Ray: The Glorious Failure of an American Director*. New York: Itbooks, 2011.

Merman, Ethel with George Eells. *Merman: An Autobiography*. New York: Simon & Schuster, 1978.

Moreno, Rita. *Rita Moreno: A Memoir*. New York: Penguin Group, 2013.

Munn, Michael. *John Wayne: The Man Behind the Myth*. New York: New American Library, 2003.

Nickens, Christopher. *Natalie Wood: A Biography in Pictures*. New York: Doubleday, 1986.

Nixon, Marni and Stephen Cole. *I Could Have Sung All Night: My Story*. New York: Billboard Books, 2006.

Nollen, Scott Allen. *The Cinema of Sinatra: The Actor, on Screen and in Song*. Baltimore: Luminary Press, 2003.

O'Hara, Maureen with John Nicoletti, *'Tis Herself: A Memoir*. New York: Simon & Schuster, 2004.

Peary, Danny. *Cult Movie Stars*. New York: Simon & Schuster, 1991.

Ray, Bill. *My Life in Photography*. Blurb, 2014. http://www.blurb.com/books/5178724-my-life-in-photography.

Russell, Rosalind and Chris Chase. *Life Is a Banquet*. New York: Random House, 1977.

Schickel, Richard. *Elia Kazan: A Biography*. New York: HarperCollins, 2005.

———. *Keepers: The Greatest Films—and Personal Favorites—of a Moviegoing Lifetime*. New York: Alfred A. Knopf, 2015.

Sennett, Ted. *Hollywood Musicals*. New York: Harry N. Abrams, Inc., 1981.

Spoto, Donald. *Rebel: The Life and Legend of James Dean*. New York: HarperCollins, 1996.

Vaill, Amanda. *Somewhere: The Life of Jerome Robbins*. New York: Broadway, 2006.

Wagner, Robert J. with Scott Eyman. *Pieces of My Heart: A Life*. New York: HarperCollins, 2008.

Wiley, Mason and Damien Bona. *Inside Oscar: The Unofficial History of the Academy Awards*. New York: Ballantine Books, 1986.

ARTICLES

"A Cry in the Night." *Motion Picture Daily*, August 15, 1956.

"Actress Natalie Wood Chosen 'Child of the Year.'" *Los Angeles Times*, Sept 29, 1949.

Anderson, Melissa. "Yesterday's Angel: Natalie Wood." *Village Voice*, August 18, 2009.

Archer, Eugene. "'All the Fine Young Cannibals' Arrives." *New York Times*, September 23, 1960.

Archerd, Army. "Just For Variety." *Daily Variety*, July 22, 1959.

———. "Just For Variety." *Daily Variety*, June 30, 1960.

———. "Just For Variety." *Daily Variety*, September 16, 1960.

———. "Just For Variety." *Daily Variety*, April 6, 1961.

Bacon, James. "Natalie is Queen at Warners." *Los Angeles Examiner*, July 14, 1958.

———. "Warner Lot Dominated by 19-Year-Old Actress." *Eugene Register-Guard*, July 14, 1958.

Bahrenburg, Bruce. "Natalie Wood Makes It as Actress." *Newark Sunday News*, June 15, 1969.

Baker, Rob. "Natalie Wood's Defiant Streak." *New York Daily News*. September 24, 1983.

Beckley, Paul V. "All the Fine Young Cannibals." *New York Herald Tribune*, September 25, 1960.

"Big 'Side' Money." *Daily Variety*, March 29, 1961.

"Bob & Carol & Ted & Alice." *Variety*, July 2, 1969.

"Bonus Sneak Peek: Michael Caine and Natalie Wood Take a 'Fat Chance.'" *Rona Barrett's Gossip*, May 1975.

Brent, Robert. "The Biggest Love Stories of the Year! How Bob & Steve McQueen Are Fighting to Marry Natalie—Fast!" *Silver Screen*, June 1972.

Byron, Stuart. "'The Searchers': Cult Movie of the New Hollywood." *New York*, March 5, 1979.

Carroll, Harrison. "A Very Slick Comedy 'Sex, Single Girl,' Funny." *Los Angeles Herald-Express*, N.d.

Champlin, Charles. "Care and Feeding of Child Stars." *Los Angeles Times*, May 26, 1965.

Clein, Harry. "Natalie Wood: On Acting, Nudity, and Growing Up in Hollywood." *Entertainment World*, January 30, 1970.

Connolly, Mike. Rambling Reporter. *Hollywood Reporter*, December 11, 1958.

"Current Cinema 'Growing Pains.'" *New Yorker*, May 3, 1958.

Cuthbert, David. "Natalie & R.J. & Larry & Tennessee." *Times-Picayune*, December 5, 1976.

Dunne, John Gregory. "Star!" *New York Review of Books*, January 25, 2004.

Eyman, Scott. "Equipped for Stardom, Alas—Natalie Wood's Unhappy Career." *The Observer*, January 26, 2004.

"East Lynne Revisited." *New Yorker*, June 11, 1964.

"Films Sign 8-Year-Old Miss for $1000 a Week." *Los Angeles Times*, July 18, 1947.

Garrett, Gerard. "Why Natalie Buys Pretty Things." *Evening Standard*, September 25, 1964.

Giasome, Barbara. "Natasha & Natalie . . . Her Heritage, Her Life." *Biarritz*, July 1980.

Green, Abel. "Bob Blumofe, Ocean-Hopping Liaison For UA: Revolutions All the Time." *Weekly Variety*, June 24, 1959.

Haber, Joyce. "The Maturing of Natalie Wood." *Toledo Blade*, January 21, 1968.

"Happy Birthday Natalie." *Modern Screen*, August 1958.

Harrod, Horatia. "50 Years of West Side Story." Telegraph.co.uk, July 20, 2008. http://www.telegraph.co.uk/culture/donotmigrate/3556882/50-years-of-West-Side-Story.html.

"Highly Profitable Sex Will Go on Forever." *Sunday Herald-Fairfield County Edition*, March 31, 1963.

Hopper, Hedda. "Natalie Wood, Tab Hunter Paired Again." *Los Angeles Times*, April 7, 1956.

Hyams, Joe. "Sex and the Single Girl: Can A Best-Selling Nonbook, Written by a Simple City Girl, Find Happiness in Hollywood as a Successful Nonfilm?" *Cosmopolitan*, April 1964.

Johnson, Erskine. "It's All Serious Business Now for Steve McQueen." *Ocala Star-Banner*, March 14, 1963.

———. "New Films Reviving Art of Natalie Wood." *Ottawa Citizen*, December 24, 1960.

"Kings Go Forth." *Daily Variety*, June 13, 1958.

Kleiner, Dick. "Bob and Carol and Ted and Alice?" *Tuscaloosa News*, December 14, 1968.

———. "On Those Walks, She Seeks Privacy." *Tuscaloosa News*, November 28, 1965.

Lemon, Richard. "Movie Star into Actress: The Story of Natalie Wood." *Newsweek*, February 26, 1962.

Lipscomb, Richard. "The Star." *Hollywood Citizen-News*, December 25, 1952.

Mann, Roderick. "'Anastasia': A Big Steppe for Wood." *Los Angeles Times*, July 23, 1981.

Maynard, John. "Better to Be Neurotic." *Screenland*, September 1956.

Meltsir, Aljean. "The Taming of the Shrewd." *Coronet*, February 1960.

Michener, Charles. "Natalie Wood: The Last American Girl." *The Movies*, October 1983.

Modderno, Craig. "Centerfold Interview: Natalie Wood." N.p., n.d.

"Natalie and the Wild Dance You'll Never See on the Screen." *Movie Life*, May 1958.

"Natalie Wood: Born to be a Star." *Life*, December 20, 1963.

"Natalie Wood Grows Into Her Biggest Screen Role." *World-Telegram and Sun*, August 12, 1961.

"Natalie Wood to be Sheriff's Rodeo Queen." *Los Angeles Times*, August 5, 1956.

"Natalie Wood's Song and Dance Act." *Milwaukee Journal*, October 30, 1960.

Pacheco, Patrick. "And in This Corner . . . Natalie Wood, Back for Another Round." *After Dark*, October 1979.

Parsons, Louella O. "Natalie Signs Up for $250,000." *New York Journal-American*, August 1, 1960.

———. "Studio Goes All Out for Natalie." N.p., n.d.

———. "Warner Loans Natalie Wood to Ross for 'Kings Go Forth.'" *Milwaukee Sentinel*, July 3, 1957.

Pollock, Dale. "Cameras Rolling Again on Natalie's Last Film." *Los Angeles Times*, February 15, 1982.

"Revamp 'West' Schedule for Natalie Wood." *Daily Variety*, August 3, 1960.

R.W.N. "Tasteless Melodrama." *New York Times*, September 1, 1956.

Schallert, Edwin. "Novel Trio Heralded; Garson to Go Abroad." *Los Angeles Times*, January 14, 1946.

Schroeder, Carl. "Tape Recorded Confessions of Natalie Wood and Nick Adams." *Modern Screen*, November 1956.

Scott, Vernon. "Natalie and Bob in Movie Together." *Beaver Valley Times*, December 28, 1959.

"Sell 'West Side' Tix 7 Months in Advance." *Daily Variety*, March 17, 1961.

"Seventeen, Seventeen." *Modern Screen*, January 1956.

Shearer, Lloyd. "Natalie Wood: The Teenagers' Teenager." *Ottawa Citizen*, February 7, 1958.

Siskel, Gene. "Natalie Wood Put Career on Hold." *Lakeland Ledger*, October 5, 1979.

———. "Natalie Wood Reflects On the Past, Takes Her Career Out of Mothballs." *Chicago Tribune*, September 23, 1979.

"Studio Lifts Suspension of Natalie Wood." *Los Angeles Times*, February 25, 1959.

Summer, Anita. "Natalie Wood: Photoplay's Star of the Month." *Photoplay*, March 1979.

Taylor, Tim. "Talented Teen-Ager." *Cue*, September 8, 1956.

"The Bride Who Said No." *Modern Screen*, May 1959.

Thomas, Bob. "Natalie Wood, McQueen Shine in 'Proper Stranger.'" *Evening Independent*, January 1, 1964.

———. "Natalie Wood Shifts from Presley's Bike to Wagner's Yacht." *Kentucky New Era*, September 27, 1957.

Thomas, Kevin. "Natalie Wood Finds Stardom Right in Her Own Backyard." *Los Angeles Times*, July 25, 1966.

Turker, Colin. "'West Side Story': Classic Musical Stands Test of Time." N.p., n.d.

Walker, Helen Louise. "Don't Call Her Wholesome!" *Screenland*, March 1957.

"West Side Story." *Film Facts*, November 3, 1961.

"'West Side Story' Acquired By 7 Arts." *Daily Variety*, July 17, 1958.

"What the Showmen are Doing!" *Film Bulletin*, October 29, 1956.

"When I Grow Up." *Radio-TV Mirror*, November 1953.

"Why Do They Lie About Me?" *Screenland*, July 1957.

Williams, Rochelle. "The Way They Were: Natalie Wood." *Rona Barrett's Gossip*, July 1979.

Wood, Natalie. "Natalie Wood's Confidential Diary." N.p., n.d.

Wood, Natalie. "Public Property/Private Person." Unpublished article written for *Ladies Home Journal*, 1966. Wood-Wagner Private Collection.

Wood, Natalie. "Some Day He'll Come Along." N.p., n.d.

AUDIO/VIDEO

O'Hara, Maureen. "Commentary." *Miracle on 34th Street*, special ed. DVD. Directed by George Seaton. Century City, Calif.: 20th Century Fox, 2006.

Plomly, Roy. "Desert Island Discs." Recorded for BBC Radio May 1980. YouTube video, 26:01. Posted December 28, 2015. https://www.youtube.com/watch?v=biyscOdcQT8.

Starring Natalie Wood. Videocassette. Directed by Susan F. Walker. 1987, Ellen M. Krass Productions.

The Oklahoma Historical Society Film and Video Archives. "Great Race Premier Interviews Part II." Recorded 1965. YouTube video, 9:42. Posted January 17, 2013. https://www.youtube.com/watch?v=q_dOPEEkeyl.

"West Side Memories." *West Side Story*, Limited 50th Anniversary ed. Blu-ray. Directed by Robert Wise. Culver City, Calif.: M-G-M, 2011.

Wood, Natalie. 20th Annual San Francisco Film Festival Tribute, October 23, 1976.

OTHER MATERIALS

Gypsy Production Notes File. Lincoln Center Library for the Performing Arts, New York.

The Green Promise Press Clippings File. General Collections. Margaret Herrick Library, Academy of Motion Picture Arts and Sciences, Beverly Hills, Calif.

Wood, Natalie. Personal scrapbooks, correspondence, and files. Wood-Wagner Private Collection.

WEBSITES

afi.com/members/catalog	filmsite.org
googleimages.com	imdb.com
lapl.org	latimes.com
lecinemadreams.com	mediahistoryproject.org
museum.tv	newrepublic.com
npr.org	nytimes.com
rockmusictimeline.com	rottentomatoes.com
selfstyledsiren.com	tcm.com
timelife.com	wikipedia.org
youtube.com	

PHOTO CREDITS

All photos courtesy Independent Visions Archive and Wood-Wagner Private Collection, unless otherwise noted, with the exception of: Pages 12, 288 (bottom left and bottom right), 289 (bottom left and bottom right), 290 (bottom left), 291 (bottom right), 292 (bottom right), 293 (bottom right), 294, and 295 courtesy Michael Childers. Pages 204–227 © Bill Ray.

Pages 30, 44, 50, 56, 65 (bottom), 81 (top and bottom right), 84 (top left), 90, 98 (top), 99 (top), 105 (top right), 238, 239, 240 (bottom right), 262, and 275 courtesy Photofest.

Page 101 (top left and bottom left) Warner Bros./Courtesy Neal Peters Collection.

Pages 116, 117 and 188 © Everett Collection.

Pages 121, 130, 194, 232 (top right), 252 (card), 261 (bottom left), and 294 (top left) courtesy Michael A. Tom Collection.

Page 290 (top) © Larry Dale Gordon.

Page 291 (bottom left) © AMPAS.

Courtesy mptv: Pages 133, 196, 197, 200, 203; Page 79 (top left) Paul Hesse; Pages 88 and 92 © Sid Avery; Page 126 Wallace Seawell; Pages 108, 109, 110, and 241 (bottom left) © Mark Shaw; Pages 190 (bottom), 192, 193 (top left), and 201 Mel Traxel; Pages 54, 85 (top), 86, 93, 94, and 95 © 1978 Bob Willoughby. These and all other images from the Independent Visions Archive, John Engstead, Curt Gunther, and Bruce McBroom are exclusively represented by mptv. For more information regarding licensing or purchasing images from mptv, please contact mptvimages at www.mptvimages.com.

While every effort has been made to identify the proper photographer and/or copyright holders, some photos had no accreditation. In these cases, if proper credit and/or copyright is discovered, credits will be added in subsequent printings.

ACKNOWLEDGMENTS

Manoah Bowman's Acknowledgments

Creating this book has been something akin to climbing Mt. Everest. I could not have scaled the precipitous heights alone, so special thanks must be given to those who helped.

As two hands are better than one, I must first thank my right hand, Sloan De Forest. Truly, her contributions are such that her name should be on the cover next to mine. Next, this book would have been impossible without Natalie Gregson Wagner. She brought not only the encouragement, patience, and perception that informed her beautiful and moving text, but also glimmers of her mother with just a turn of her head, a smile, or a laugh.

Special thanks to Robert Wagner for allowing this book to go forward, and to Robert Redford for taking the time to pen a thoughtful remembrance. Many thanks to Stephen Schmidt, whose art direction, design, and commitment to perfection have produced a stunning volume that will surely stand the test of time, to Matt Tunia for his thorough research, ideas, captions, and support, and to David Wills for providing guidance, diplomacy, and commitment to making sure this book lived up to the hype. Thanks to Leonard Evans, Evan Macdonald, Gregor Meyer, and Joshua Kadish for their substantial contributions.

Thanks to Mart Crowley for sharing his memories with the humor and honesty for which he is known; to photographer Michael Childers for granting access to his stunning photographs of Natalie and his insightful, revealing interview; to Don Bachardy for allowing us to use one of his beautiful sketches as the opening artwork.

Thanks to editor Cindy De La Hoz and designer Frances Soo Ping Chow at Running Press. Their dedication and faith contributed greatly to making this book spectacular. Thanks also go to Kristin Kiser, Stacy Schuck, and Seta Zink at Running Press, to Jennifer Dorian, Genevieve McGillicuddy, Heather Margolis, and John Malahy at TCM, and to Aaron Spiegeland and John Parham at Parham Santana.

Further thanks go to Christopher Nickens and his book *Natalie Wood: A Life in Photographs*. As the first author to publish a photo book on Natalie, he inspired and informed us all in the creation of this book. Writer Mike McCrann also provided inspiration with his thoroughly researched manuscript on the films of Natalie Wood, and his dedication to keeping her memory alive with his Hollywood column and online essays.

Thanks to Howard and Ron Mandelbaum for their knowledge and humor, and for arranging interviews and filling in the blanks with images from the Photofest archive. Thanks to my agent, Stan Corwin, for fighting the good fight.

Thanks to Neal Peters and David Smith for allowing us to use images from the Neal Peters Collection, and to photographer Bill Ray and wife, Marlys, who are the living embodiment of patience and goodwill.

Special thanks to Andy Howick at mptv. Thanks to Matt Severson, photograph curator at AMPAS, and Christina Ha for their support and efforts, and to Michael A. Tom for allowing us to use one-of-a-kind material on Natalie from his substantial archive.

Finally, a most sincere thank-you to Joseph DiCicco, who not only believed in me from the beginning, but also helped me refine the kind of leadership skills needed to recruit a team to make something this special.

Additional thanks to Maggie Adams, Ron Avery, Mark Biberstine, Laurent Bouzereau, Carol Bowman, Leslie Broadbelt, David Chierichetti, Brett Davidson, David Del Valle, Ken Eckert, Nicole Eckert, Carey Embry, Diana Gabaldon, Chole Ginnegar, Debbie Harvey, Jessica Iovenko, Jay Jorgensen, Krista Kahl, Chris Kennen, Merica Koch, Jack Ledwith, Laura Owen Mbow, Nazanin McCaffe, Cory Milton, La Toya Morgan, Dianne Palmer, Sue Peck, Missy Handy Reidmatter, James Richman, Ron, Rita, David and Teresa Ross, Victor Segura, Michael Seven, David and Norma Smith, James Sutherland, Barb Tashjian, Karl Thiede, Christy Read Thierbach, Shelley Brocksmith Toth, Irene Tunia, Lou Valentino, Jeffrey Vance, Jon Varese, John and Norma Ward, Catherine Williamson, Christopher Willoughby, Cassie Wilson, Tom Wilson, and Roy Windham.

Natasha Gregson Wagner's Acknowledgments

First and foremost, this book would not have seen the light of day if not for five incredibly talented, tenacious people: David Wills, Manoah Bowman, Sloan De Forest, Stephen Schmidt, and Matt Tunia. Thank you for your devotion to my mom and your authentic desire to bring these incredible photos and essays to the forefront for all to witness. And special thanks to Running Press and TCM for making this book a reality.

Thank you to my Daddy Wagner and my Daddy Gregson. Aristotle wrote: "We become just by performing just actions, temperate by performing temperate actions, brave by performing brave actions." You both are my example.

Thanks to the wonder women of MMLPR: Merritt Loughran, Claire Nilsson, and Kim Perry. It is rare to find the savviest women who also have real human hearts. Thanks to Amy Guenther of Gateway Management. You are the gateway for all good things and I am grateful every day for your counsel, wisdom, and protection.

Deep and dear thanks to my longtime friend and family protector Alan Nierob at Rogers and Cowan. Thanks to Babette Campbell and Lawrence Rudolph of FFO, friends and protectors. Further thanks to Jeff Briggs, Elizabeth Applegate, everyone at Rene's Van and Storage, and to Lucy Carr and Catherine Williamson at Bonhams. Many thanks to Don Bachardy and Robert Redford.

Thanks to my OG tribe: Mart Crowley, Delphine Mann, Katie Wagner, Courtney Wagner, Willie Mae Worthen, Sarah Gregson, Charlotte Gregson, Hugo Gregson, Poppy Gregson, Julia Gregson, Jill St. John, and Amanda Anka. And special thanks to my four favorite people in the whole world: Barry, Oliver, Felix, and Clover Watson. This life is no life for me without you guys.

Finally, thank you to my mom. Without your beauty, your grace, your talent, there would be no book. The deep love that you showed me growing up is why I am okay. I love you.

Sloan De Forest's Acknowledgments

A world of thanks to Natasha Gregson Wagner, Robert Wagner, and Courtney Wagner for being so warm, welcoming, and willing to share the woman who touched all of their lives so deeply. This book would not exist without their generous participation.

Many thanks are also extended to Tab Hunter, Marc Wanamaker, Luisa F. Ribeiro, the old staff at Scribbulus, the Los Angeles Public Library, and my mom, Gary Lynn De Forest, for introducing me to Maggie DuBois at an impressionable age. Last but not least, thanks to Manoah Bowman for allowing me to be a part of this once-in-a-lifetime project.